Enlightened Animals in Eighteenth-Century Art

Material Culture of Art and Design

Material Culture of Art and Design is devoted to scholarship that brings art history into dialogue with interdisciplinary material culture studies. The material components of an object—its medium and physicality—are key to understanding its cultural significance. Material culture has stretched the boundaries of art history and emphasized new points of contact with other disciplines, including anthropology, archaeology, consumer and mass culture studies, the literary movement called "Thing Theory," and materialist philosophy. **Material Culture of Art and Design** seeks to publish studies that explore the relationship between art and material culture in all of its complexity. The series is a venue for scholars to explore specific object histories (or object biographies, as the term has developed), studies of medium and the procedures for making works of art, and investigations of art's relationship to the broader material world that comprises society. It seeks to be the premiere venue for publishing scholarship about works of art as exemplifications of material culture.

The series encompasses material culture in its broadest dimensions, including the decorative arts (furniture, ceramics, metalwork, textiles), everyday objects of all kinds (toys, machines, musical instruments), and studies of the familiar high arts of painting and sculpture. The series welcomes proposals for monographs, thematic studies, and edited collections.

Series Editor:
Michael Yonan, University of California, Davis, USA

Advisory Board:
Wendy Bellion, University of Delaware, USA
Claire Jones, University of Birmingham, UK
Stephen McDowall, University of Edinburgh, UK
Amanda Phillips, University of Virginia, USA
John Potvin, Concordia University, Canada
Olaya Sanfuentes, Pontificia Universidad Católica de Chile, Chile
Stacey Sloboda, University of Massachusetts Boston, USA
Kristel Smentek, Massachusetts Institute of Technology, USA
Robert Wellington, Australian National University, Australia

Volumes in the Series

Enlightened Animals in Eighteenth-Century Art

Sensation, Matter, and Knowledge

Sarah R. Cohen

BLOOMSBURY VISUAL ARTS
LONDON • NEW YORK • OXFORD • NEW DELHI • SYDNEY

BLOOMSBURY VISUAL ARTS
Bloomsbury Publishing Plc
50 Bedford Square, London, WC1B 3DP, UK
1385 Broadway, New York, NY 10018, USA
29 Earlsfort Terrace, Dublin 2, Ireland

BLOOMSBURY, BLOOMSBURY VISUAL ARTS and the Diana logo
are trademarks of Bloomsbury Publishing Plc

First published in Great Britain 2021

For legal purposes the Acknowledgments on p. xvii constitute
an extension of this copyright page.

Cover design by Irene Martinez Costa
Cover image: Chardin, Jean-Baptiste-Simeon, detail of *The Monkey Painter*,
1739–40 © Getty Images / Photo Josse/Leemage / Contributor

A catalogue record for this book is available from the British Library.

Library of Congress Cataloging-in-Publication Data
Names: Cohen, Sarah R., 1957- author.
Title: Enlightened animals in eighteenth-century art : sensation, matter,
and knowledge / Sarah R. Cohen.
Description: New York : Bloomsbury Visual Arts, 2021. | Series: Material
culture of art and design | Includes bibliographical references and index.
Identifiers: LCCN 2020037770 (print) | LCCN 2020037771 (ebook) | ISBN
9781350203587 (hardback) | ISBN 9781350203594 (pdf) | ISBN 9781350203600 (epub)
Subjects: LCSH: Animals in art. | Senses and sensation in art. | Animals–Symbolic
aspects–Europe. | Art, European–18th century–Themes, motives.
Classification: LCC N7660 .C63 2021 (print) | LCC N7660 (ebook) | DDC 700/.462–dc23
LC record available at https://lccn.loc.gov/2020037770
LC ebook record available at https://lccn.loc.gov/2020037771

ISBN: HB: 978-1-3502-0358-7
 ePDF: 978-1-3502-0359-4
 eBook: 978-1-3502-0360-0

Series: Material Culture of Art and Design

Typeset by Integra Software Services Pvt Ltd.
Printed and bound in Great Britain

To find out more about our authors and books visit www.bloomsbury.com
and sign up for our newsletters.

For Martha

Contents

List of Plates

List of Figures

Acknowledgments

This book results from research I have long been pursuing on animal representation in the early modern era and the value artists and audiences placed upon the animal as an independently compelling subject. The eighteenth-century component of my work, represented here, focuses especially upon Enlightenment concerns with the sensory acquisition of knowledge and the material forces of life, for which animals and their configurations in art served as particularly apt exemplars. I would like to thank Michael Yonan, the editor of the Bloomsbury series on the "Material Culture of Art and Design" for his continuous support and encouragement, as well as for the astute guidance he has given me in thinking about the multidimensional significance of materiality both in my own objects of study and in the field of art history as a whole. I would also like to acknowledge Paula Radisich and the late Angela Rosenthal, who included my initial study of "Chardin's Fur" in their jointly edited issue of *Eighteenth-Century Studies* devoted to "Hair," a topic that continues even now to merit more serious scholarly attention.

Over the many years that my ideas for this book have been in formation I have lectured at numerous institutions, and I am grateful to the individuals who invited me to speak as well as to the audiences for their questions and comments. These include Ann Bermingham and the late Mary Sheriff, who included me in their seminar series on "Sensibility" at the Getty Research Center; Ewa Lajer-Burcharth, who invited me to lecture at Harvard University; the Center for Eighteenth-Century Studies at Indiana University, in whose yearly workshops I twice participated; Jeffrey Collins, at whose invitation I contributed to the Selz Lectures on 18th- and 19th-Century French Decorative Arts and Culture at the Bard Graduate Center; Catherine Girard, who included me in the conference she co-organized at the Musée de la chasse et de la nature in Paris; Mimi Hellman, who invited me to lecture at Skidmore College; and Dorothy Johnson, who invited me to lecture at the University of Iowa. All of these experiences helped me to hone my arguments and develop my thinking in new and important ways.

I am grateful to Kristel Smentek and Susan Taylor-Leduc for assistance with bibliography, as well as to Rebecca Bedell, JoAnne Carson, and Susan Sidlauskas for their helpful suggestions. The two anonymous readers of this manuscript

for Bloomsbury offered extremely useful advice ranging over every chapter of the book. I am also enormously grateful to Andrée and Patrick Pouyanne, who generously welcomed me into their home outside Paris on my numerous research trips to that city. The staff of the University Libraries at the University at Albany, particularly in the departments of Special Collections and Interlibrary Loan, provided indispensable assistance for my research, and significant parts of this book's publication have been aided by a grant from the University's Faculty Research Awards Program. All aspects of the book have benefited from the attention of my editor at Bloomsbury, April Peake, as well as the design and copy editing team.

Above all, I wish to thank my research assistant, Marissa Barnes, whose extraordinary efficiency and attention to detail facilitated the acquisition and documentation of the many images that illustrate this book. And the ongoing support and encouragement of Vance Mordecai quite literally made my work possible.

Introduction

From the shadow of a rocky outcropping, a howling wolf thrusts itself into the light (Figure 0.1). With its left foreleg broken almost all the way through in the closure of a metal trap, the animal lets out an anguished cry, mouth stretched wide to reveal the glistening tongue and sharp canine teeth. Its bright, staring eye focuses our attention upon the creature's combined sensations of pain, anger, and the terror of inescapable entrapment. The right foreleg, planted on the base of the trap, tenses from shoulder to claw in a display of sinuous strength that contrasts pitifully with its now-useless counterpart. Given the similarity between the wolf's limb and the internal structure of a human arm, a sensitive viewer might immediately be able to identify with the pain the animal must be suffering, although one's emotional response to such identification would vary considerably depending upon the circumstances of history, social place, and values.

Prince Friedrich of Mecklenburg, who saw and sketched the work in the studio of the artist, Jean-Baptiste Oudry, a few years after it was completed, wrote excitedly to his father, "The wolf is truly special!"[1] His rough sketch of the painting, included the letter of 1739, makes little of the trap and broken leg but heavily accentuates the gaping maw,[2] as if to suggest that what made the painting so "special" in his eyes was not the depiction of wolf-trapping itself—a common enough practice in Europe, where wolves were universally feared and blamed for encroaching upon livestock[3]—but rather the animal's unforgettable expression. Very likely the German prince's attraction to the painted animal as a living, emotive creature was that which a hunter might imagine in confronting a challenging adversary, especially an adversary who could easily sever his own royal limbs should the animal overpower him in the wild. Oudry's painting is in fact constructed like a portrait of animal experience, with all five senses on display in the center of the painting: pricked ears; glistening eye, nose, and tongue; and the two eloquent forelegs. The harsh illumination of the animal's torment, as in Baroque scenes of martyrdom, keeps us fastened upon the unnerving spectacle

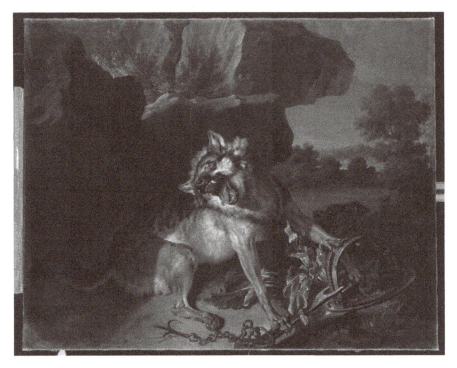

Figure 0.1 Jean-Baptiste Oudry, *Wolf in Trap*, oil, early 1730s; Schwerin, Staatliches Museum; photo: bpk/Staatliches Museum, Schwerin/Elke Walford/Art Resource, NY.

of a willful body forced to endure such suffering. Regardless of what opinion a viewer of this painting might hold about wolves, whether it be the fearsome predator of the eighteenth-century imagination or the vital keystone species heralded in twenty-first-century rewilding initiatives, Oudry's animal terrifies in its appeal to our own experience of pain and fear.

Although he was received into the French Royal Academy of Painting and Sculpture as a history painter, Oudry made a specialty of dramatic animal painting, and his works would become as prized as history painting—indeed, would sometimes be taken *as* a kind of history painting—by his eighteenth-century contemporaries.[4] Slowly gaining favor in France in the second half of the seventeenth century, animal themes would become central to eighteenth-century painting, prints, tapestry, ceramics, and other portable arts, having gained added impetus through the success of Oudry's older contemporary, Alexandre-François Desportes. Desportes, who had been received into the Royal Academy in 1699, was himself heir to the seventeenth-century Flemish tradition of animal painting established by Frans Snyders and developed by Jan Fyt and numerous other Netherlandish painters; these included Nacasius Bernaerts, Desportes's

early teacher, who worked for the court of Louis XIV and was the first animal specialist admitted into the Royal Academy in 1665.[5] With collectors' growing favor for Dutch and Flemish painting and prints in eighteenth-century France, nonhuman subjects—animals, landscapes, still lives—which Netherlandish artists had developed into specialties gained new prominence and helped to nurture the careers of Desportes, Oudry, and other animal artists in the first half of the century. Jean-Siméon Chardin, who took up a number of Netherlandish themes in the course of his long career, notably transformed the animal subject into intensely focused depictions in which actively applied paint works as an agent of vital substance, standing in for creatures' material bodies in life and animating them even after death. Material focus upon animal vitality also found myriad expression in physical objects crafted for interior spaces from the domestic to the palatial.

Oudry's wounded, desperate wolf presents an extreme example of what might have made the animal a particularly compelling subject for eighteenth-century viewers: while the lifelike treatment of the animal's anatomy and hairy coat may have inspired wonder at the artist's fine touch, and the varied textures of the landscape, the strong lighting, and the perspectival composition offered much for the cultured eye to study, the vital heart of the painting lies in its incarnation of physical existence and sensation. By the eighteenth century, comparative anatomical study had advanced to the point that one could tell how closely related a canine foreleg was to a human limb not just from external observation but from the evidence of repeated dissections as well.[6] Violence visited upon an animal was, in the early modern era, considered a facet of human dissection as well, since anatomizing was a sentence delivered in addition to death for the worst of criminal offenses. Even if the culture of the hunt and consideration of the wolf as an enemy would have steeled a viewer of Oudry's painting from feeling compassion for the creature, these cultural factors would not have precluded an intense vicarious response to the animal's intensely visceral experience.

Continental European art had no counterpart to William Hogarth's well-known conclusion to the ignominious progress of Tom Nero in *The Four Stages of Cruelty* engravings (1751), in which the corpse of the human torturer and murderer is summarily dissected while an emaciated dog gingerly takes a bite out of the lifeless heart whence it has fallen to the floor.[7] But even such scientific publications as Jacques Gamelin's *Nouveau recueil d'ostéologie et de myologie*, an annotated set of etchings after the French anatomist's drawings illustrating the human bones and muscles, are filled with allusions to violence and destruction visited upon the human. A plate opening the section on muscles features a flayed

corpse surveyed by two onlookers, one of whose sleeves is rolled up to show the muscular arm on his intact body (Figure 0.2). This onlooker's hand resting on the edge of the table almost touches the hand of the flayed cadaver, driving home the sensation of touch, here so vulnerably exposed. While his companion gazes at the body from behind the table, the man with the hat, his eyes hidden, shows us that to understand the material world one must rely upon one's senses working together: sight complements, rather than replaces, what touch can tell us.[8] Meanwhile the sharp instruments of dissection loom larger than life on the raking table in the foreground. Ostensibly demonstrating how the opening and exploration of the body were achieved, they also serve as a vague yet unsettling threat of bodily violation. Gamelin noted that his publication was intended as much for artists as it was for anatomists, and dramatic illustrations throughout his text show that he clearly shared with Oudry an appeal to his audience's lived experience of multisensory performance.[9]

Sensationism, as John C. O'Neal has demonstrated, held a key place in eighteenth-century philosophy and culture: what one felt through the senses, physically and psychologically, served as the foundation for those seeking knowledge about all forms of life and the nature of material reality.[10] In his *Essay*

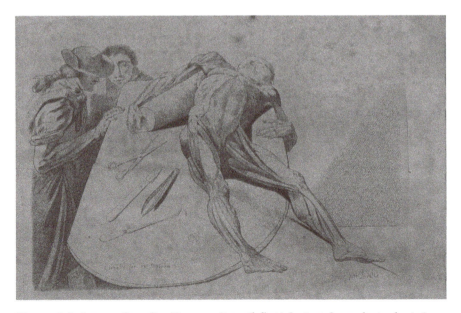

Figure 0.2 Jacques Gamelin, *Nouveau Recueil d'ostéologie et de myologie, dessiné d'après nature par Jacques gamelin … pour l'utilité des sciences et des arts*, etching (Toulouse: J.F. Desclassan, 1779), introduction to Part II, "De la Myologie," n.p.; photo: BIU Santé (Paris).

Concerning Human Understanding of 1690, a translated "Epitome" of which was first published in the French journal *Bibliothèque universelle et historique* in 1688,[11] John Locke set forth the essential premise of knowledge gained through sensory apprehension: "Perception is the first Operation of all our intellectual Faculties, and the inlet of all Knowledge into our Minds. And I am apt too to imagine, That it is Perception in the lowest degree of it, which puts the Boundaries between Animals, and the inferior ranks of Creatures."[12] Locke's full *Essay* first appeared in a French translation by Pierre Coste in 1700 and proved to have a formative impact upon subsequent theorizing of knowledge and its sensory basis in France.[13]

Although Locke himself, as the title of his treatise implies, was primarily concerned with human understanding and took pains to distinguish human rationality from the purely material thought processes of all other animals, later eighteenth-century philosophers would hold up the nonhuman animal as a paradigm of sensory consciousness, for, as the radical materialist physician Julien Offray de La Mettrie argued, "If there is a being steeped in feeling, it is the animal. Animals seem to have been paid completely in this coin, which (in another sense) so many men lack."[14] For La Mettrie as for a number of other theorists of sensory experience, it was animals' blunt and unapologetic physicality that gave them the gift of a richly sensational life. Objecting to theories such as that put forth by René Descartes in the previous century which posited matter as "simple extension," or inert substance, La Mettrie argued that "motive force and the faculty of feeling" were in fact essential to material existence.[15] The bodily "machine" proposed by Descartes, far from existing apart from desire, motivation, and feeling, according to La Mettrie constitutes in itself everything "animate bodies ... need to move, feel, think, repent and ... behave in the physical sphere and in the moral sphere which depends upon it."[16] La Mettrie was among the most extreme of eighteenth-century European philosophers in his efforts to downplay the exceptionality of human reason, but he shared with many of his contemporaries—including Étienne Bonnot de Condillac, Denis Diderot and Paul-Henri Thiry, baron d'Holbach—a conviction that the earthly existence of all animals, human and nonhuman alike, constituted the vital essence of sensory knowledge. This is what Diderot meant when he acutely declared that a blind and deaf man seeking to locate the soul might quite logically find it in the tips of his sensitive fingers.[17]

In this book, I contend that the proliferation of animal imagery in eighteenth-century art, particularly in France, contributed uniquely to this century's larger quest to define knowledge acquired through sensory interaction with the

material world. Paid, as La Mettrie would have it, completely in the "coin" of feeling, the animal subject proved a compelling protagonist in the context of eighteenth-century efforts to reconstruct the building blocks of a psychology based upon lived experience rather than upon abstract notions of consciousness and thought. Oudry's wolf, although exceptional in its depiction of overt physical violence and its horrific howl, captures the essence of an artistic genre that appealed to its viewers through vicarious sensation and that "motive force" which is derived from and felt within the body. As noted above, a good portion of the animal art that flourished in the eighteenth century moreover took the form of physical objects which themselves directly engaged the tangible world: Oudry himself held key supervisory positions at the royal tapestry works of Beauvais and Gobelins,[18] and his creaturely imagery proliferated in chairs, sofas, and screens whose woven fabrics invited interaction between human users, depicted animal bodies, and the substantive fibers of colored wool, silver, and gold. Sculptural metalwork and ceramics, many intended for use or decoration at dining tables, further materialized sensory animal experience, in effect bringing cutting-edge philosophical discourse into the realm of lived practice.

My study of the material culture of animal art focuses particularly upon the first half of the eighteenth century, which saw the ascendance of art fashioned in the sensually appealing style known today as the Rococo. Called in its own era simply the "Modern" style, the Rococo capitalized upon tactile, shimmering surfaces, flowing forms evocative of natural movement, and a notable emphasis upon iconographic play in lieu of narratives that "read" like a book. Intra-sensory bodily experience was central to Rococo expression, and in this respect it correlated with sensationalist and materialist philosophy and found a compelling artistic protagonist in the feeling animal. Even Oudry's terrifying, struggling wolf occupies the vortex of a richly textural environment whose rocks, foliage, and long diagonal lines invite kinesthetic and tangible response.

In examining the ways in which this sensually grounded art form works to embody animal experience, I have also found useful recent efforts on the part of scholars in science studies and social theory to consider the agential force, or innate vitality, of all material beings, and indeed of all earthly matter. Aspects of these writers' arguments surprisingly echo the most radical of eighteenth-century materialist theories, such as the baron d'Holbach's contention that all matter exists in a dynamic continuum, varying only in the fluctuating entities produced through momentary assemblages.[19] In our own era, Jane Bennett has argued, somewhat similarly, that "materiality [is] experienced as a lively force with agentic capacity" whose pervasive vitality breaks down boundaries between

entities and allows instead constant interaction between them.[20] Karen Barad, who draws upon quantum physics to highlight a scientist's "material engagement with the world," emphasizes the entanglement of all material entities, each acting upon the other with its own agential force.[21]

Within the material culture of animal art, tangible substance likewise operates through multiple, mutually interactive agents—depicted animal body, appeal to a user's or viewer's own sensory capacities, and a physical object composed of substances which sometimes directly stand in for creaturely physicality. Feeling, matter, and lively forces activate the entire experience and make the animal—the vital center of it all—uniquely captivating. Although painters who specialized in the depiction of animals tended to feature those creatures closest to the human both in anatomical likeness and in familiarity, above all mammals and birds, beings less prone to inspire vicarious response, such as insects, reptiles, amphibians, and fish, claimed figural status as actors in portable arts that quite literally "enlivened" eighteenth-century interiors. Eighteenth-century philosophy, while generally following Locke's example in supporting the Aristotelian "scale of nature," at the same time disrupted its hierarchy of beings by elevating the latest discoveries of empirical inquiry—such as the regenerative "polyps" that for La Mettrie proved the existence of an agential principle in every filament of living matter.[22] For materialists such as d'Holbach and Diderot, mineral matter embodied its own potential for animation, a point of view I carry over into my analysis of physical objects whose mediums not only represent but incarnate animals within their material surrounds.

Consider the palpable legacy of Oudry's tableau: very soon after the painter completed his work, the silversmith Jacques Roëttiers created a table centerpiece for Louis Henri, duc de Bourbon whose lower level showcases the same trapped and howling wolf, sharp silver canines glittering in reflected light (Plate 1).[23] A tactile rocky arch supports a pack of dogs combatting a stag above, while fierce boars' heads glower like a porcine Greek chorus from the four corners of the Rococo extravaganza. Lacking the utensils that such centerpieces traditionally supported, Roëttiers's work becomes a veritable sculpture in the round whose dynamic actors are exclusively animal. Our own position as spectator of this sensuous display is appropriated by a spaniel who has wandered down from the pack to approach the ensnared wolf, cautiously sniffing the dreadful trap. Cruel as it may appear to us today to so merge physical torture with sensual appeal, a legacy of art beautifying Christian martyrdom may have prompted its eighteenth-century audience to see the work not as vicious but as piercingly apt. The sculpture projects, moreover, its

own epitome of sensory knowledge and expression: canines demonstrate the senses of touch, sound, and smell, while the silver medium itself seems "alive" with the dynamic forces of decorative scrollwork, intricately worked detail, and faceted sparkle. Human diners would have completed the material cycle with their own bodily experiences of sight, smell, and taste.

Because ornamental arts such as Roettiers's centerpiece capitalize upon sensory engagement, it is understandable that they assumed such importance during the first half of the eighteenth century when natural philosophy and the nascent field of psychology were coming to terms with perception as "the first operation of all our intellectual faculties." Artists with a stake in the representation of animals had special access to depicting such foundational knowledge, and those who specialized in fashioning objects that could stand in materially for the animal body—metalworking, tapestry, and the "white gold" of porcelain—seized their opportunity. Ceramics, including both true, hard-paste porcelain and the soft-paste imitations still produced commonly in the first half of the eighteenth century, figure prominently in this book, occupying the entirety of Chapter 4, and prompt the one in-depth examination that takes us outside of France. In the 1730s, Johann Gottlieb Kirchner and Johann Joachim Kändler created for the Elector of Saxony, Augustus the Strong, a large "menagerie" of porcelain animals, many of them life-size and all of them dynamically posed in space to emphasize their physical presence and awareness.[24] Kändler's she-wolf, for example (Figure 0.3), shields her two, wide-eyed pups beneath her body while turning her head to growl out a warning; ears pricked, eyes bright, and mouth open to reveal an impressive array of teeth, this wolf acts as an independent agent of feeling, showing us in no uncertain terms how she understands and engages with her world. Whether one considers the she-wolf as the sculpture originally appeared, covered in dark oil paint to simulate the natural coat of a black wolf, or in the gleaming white condition in which it exists today, the transformative effect of firing captures the creature's animating "force"—a term sometimes used by eighteenth-century philosophers such as Gottfried Wilhelm Leibniz to characterize the active agent that gave a creature life, sensation, and awareness, or what many early moderns called animal "soul."[25] In our own era, Bennett has used the term "vibrant matter" to characterize the vital agency of substances, a vibrancy that breaks down boundaries between the active and the inert in the physical realm. A miracle of snarling, shimmering clay fired into agential life, Kändler's wolf fairly demands that we engage with her as an energetic being.

What constitutes this "force" that imparts vitality and agency to material substance and, in the case of animals, a full range of sensations with which they

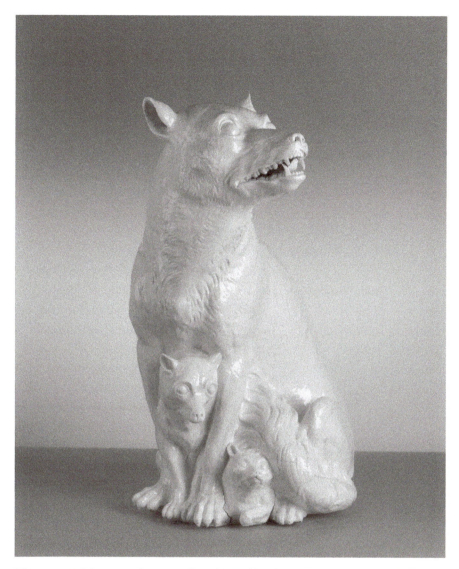

Figure 0.3 Johann Joachim Kändler, *She-Wolf with Two Pups*, porcelain, 1735; Dresden, Porzellansammlung, Staatliche Kunstsammlungen Dresden; photo: Herbert Jäger.

perceive and understand their world? Bennett argues that such questions of causality are necessarily "inscrutable" to human subjects, and she shares with Barad a commitment to theory drawn from our own immediate and immersive experiences.[26] Eighteenth-century philosophers, for their part, debated whether the fully material bodies of animals could exercise perception and agency on the basis of corporeal substance alone, or whether they needed an insubstantial

"soul" to carry out the work of sensory understanding. The question as to whether animals *could* have a soul that gave them a conscious grasp of their own feelings as well as voluntary agency in performing their actions had generally been resolved by the early eighteenth century: Descartes's radical assertion in his *Discourse on the Method* of 1637 that the animal (including the human body) was a "machine" analogous to a finely worked clock had provoked considerable controversy in the seventeenth century, but Locke's treatise, among numerous other writings, was fast supplanting this concept with the new paradigm of sensitive agency. What people called "soul," materialists such as La Mettrie argued, could be defined as entirely physical, even in regard to human rationality; other eighteenth-century theorists perpetuated the concept of soul as immaterial but fully alive within the animal's being.

Both Catholic and Protestant institutional creeds, always suspicious of Descartes's mechanistic theory of the body, in general supported the notion of a sensitive animal soul, which in its most conservative form came directly from Aristotelian philosophy.[27] In the first half of the eighteenth century, however, animals began to appear prominently as test cases in more cutting-edge writing on perception and knowledge. Some of these publications addressed head-on the problem of animal soul, the most important being the Protestant theologian David-Renaud Boullier's *Essai philosophique sur l'âme des bêtes*, a dense treatise which later served as the basis for the article on "Animal Soul" in the *Encyclopédie*.[28] To understand—to feel—the human condition in the eighteenth century, one needed to understand the condition of the animal. But as the three portrayals of wolves examined above make clear, animals also took on exemplary value of their own, perhaps especially when produced by artists for the visual delectation and physical handling of sensitive users. Eye to eye and body to body, these toothy canines share our space as material kin, even if such confrontation takes place psychologically within the fictive space of a painting. As Prince Friedrich attested, Oudry's yowling wolf captured him within a "truly special" experiential realm.

In examining the agency animals wielded in eighteenth-century art, I have engaged several fields of study: the history of art and material culture, eighteenth-century philosophical considerations of animals, as well as the recent theories of material agency mentioned above. The well-known "animal turn" within cultural history and the humanities over the past twenty years, a function of larger efforts to turn a critical eye upon any attempts to universalize lived experience, has also had a formative impact upon my thinking.[29] The eighteenth century has indeed emerged as a crucial period for such re-evaluations of the

nonhuman animal and its relation to the human: just as the Enlightenment itself has been subject to scrutiny for its exclusions of whole groups of people from the category of rational beings, so historians of eighteenth-century culture have increasingly questioned the ways in which Enlightenment society depicted, interacted with, and sought to control aspects of nonhuman life.[30] Critical studies of art and literature have begun to assume a central place in the reassessment of human and animal relations in eighteenth-century France and England, the most in-depth publication to date being Diana Donald's *Picturing Animals in Britain 1750–1850.*[31] Donald's opening sentence is telling in identifying both her own perspective and that which prevails in much of animal studies as the field exists today: "This is a book about a single animal species: the human race." Donald explains that in order to evaluate the way animals were pictured, one must scrutinize the "thoughts and feelings" of those humans who were doing the picturing.[32]

My approach differs from Donald's, and from that of other scholars who have been querying the human-animal relationship, for my focus is upon the animal itself: as artistic protagonist, as conscious subject, and above all as a primary exponent of sensory life in the material world. I of course acknowledge that the objects of my inquiry are complex human productions of art and philosophical writing, made for the sensory and intellectual consumption of other cultured, highly social people, and I pay due attention to these eighteenth-century humanistic intentions and responses. Indeed, the Prince of Mecklenburg's enthusiastic reception of Oudry's suffering wolf, and especially his sketch of the animal with its huge, open maw, goes a long way toward showing how an image that a twenty-first-century observer could find merely "gruesome"[33] could in fact inspire great wonder and admiration within its own era. But I also take seriously the way in which the subjective experience of the animal is privileged in works such as Oudry's and Kändler's, and also the particular stake that a specialist in animal representation would have in taking the perspective of the creature as a means of exciting interest and vicarious response. Although not all of the artists I study in this book were animal specialists as were Oudry and Desportes, even those who also turned their talents to human subjects—Kändler and Chardin, for example—treated the animal as a worthy protagonist, especially in certain concentrated periods of their long careers.

In examining eighteenth-century philosophical writings on natural history and moral concerns, I likewise give special place to those which focus upon the animal as a compelling subject of inquiry itself. Certain writers on animals indeed demonstrated a frank passion for their subjects and an effort to

understand the animal perspective from the inside out. Boullier took a cautious, intellectual approach in arguing his case for the existence of animal soul—that is, consciousness and the ability to think—devoting a good portion of his treatise to weighing seriously Descartes's objections. But he also attempted to explain the process through which animals reason by taking his reader through the imagined thought process of a dog learning what he should and should not do to avoid punishment and receive awards from his human companion.[34] The best known, and most widely read, writer on animals in the eighteenth century was Georges-Louis Leclerc, comte de Buffon, whose thirty-six-volume *Histoire naturelle, générale et particulière*, published in the second half of the century, focused to a great extent upon animals, among which the human was placed.[35] Although Buffon was one of those who took pains to distinguish the rational human from the essentially instinct-based animal, his extensive project to describe and illustrate every known species of creature throughout the world in fact presents a wealth of viable animal protagonists in the story of life on earth.[36] The entomologist Charles Bonnet made no effort to disguise his rapture in recounting the history and imagining the intentions of a colony of caterpillars—his "little republicans"—in his early treatise on insects, and much later in his career he drew upon his lifelong study of the tiny creatures in composing a treatise on the soul.[37] Although Bonnet declined to state definitely that animals possessed souls, the nonhuman self (*Moi*) in fact hovers like a winged creature throughout Bonnet's treatise on the soul. Even Christian resurrection becomes, in the entomologist's resourceful language, the metamorphosis of caterpillar to butterfly.[38]

Since my overarching aim is to interpret re-creations of the animal in art through the lens of writings on physical agency, I also owe a great debt to the "material turn" that has taken place recently in the history of art. As Michael Yonan has argued, the field of material culture studies has much to teach art history regarding the impact of matter—the agency of artistic materials, the spatial and temporal status of objects, the implicit logic of functional design—and such problems have recently been taken up in many publications on eighteenth-century art.[39] Examinations of the animal in eighteenth-century art have heretofore focused primarily upon iconographic analysis, with a strong emphasis upon painting and graphic art; although these approaches are richly revealing in themselves, especially as regards human social and political concerns,[40] material engagement—the interplay of an object's substance with its simulation of animal life and agency—has yet to be explored in depth. By integrating Rococo ceramics, metalwork, and tapestry with paintings and drawings, I am able to explore such

entanglement of "real" and fictive materialities as a primary expressive force. My consideration of painting likewise takes a strongly materialist bent, above all in the two sections of the book that address the painting of Chardin. Having crafted a highly subtle strain of Rococo sensuality and tactility in his compositional strategies and painterly process, Chardin used the animal subject above all other eighteenth-century painters to achieve an ineffable transformation of material substance into paint. Precisely because animals are capable of feeling, moving, and acting on their own, their appearance in one of Chardin's kitchen scenes or still lives distinguishes them from all the other substantive objects that surround them, even when the creatures are dead. Although this had been true of Netherlandish still lives featuring animals as well, Chardin's animation of living or once-living bodies through paint shows how apt a physically based medium could be in projecting sensory subjectivity.

For example, in a painting of a suspended hare from about 1760, Chardin used skeins of color to compose the fragile body of the creature, which he depicts as both distended and collapsed in the manner of a particularly realistic crucifixion (Figure 0.4). The flowers and onions might objectify the animal in their suggestions of the butcher's display and the pot of the cook, but the panoply of brush marks that stroke the body of the animal into substance convey, by contrast, the commonality of artistic and animal touch. Around the time Chardin was painting this work, "sensibility" was becoming central to French moral and scientific philosophy alike. Merging the physical with the emotional, the sensibility movement elevated feeling in all its manifestations as a standard of critical judgment and empirical inquiry.[41] In France, Jean-Jacques Rousseau personalized sensibility as vicarious experience, and made much of the human tendency—nay duty—to identify with animals' suffering, so near was it to our own.[42] Although artists such as Oudry and his follower Jean-Baptiste Huet much more explicitly appealed to the culture of sensibility in rendering their animals with overt emotionality, Chardin's late, intensely painted animal bodies offer a more fundamental, physically based demonstration of how it feels to touch and be touched—above all for creatures whose very lives depend upon sensory understanding.

In the chapters that follow, I address select art works, artistic practices, and themes that illuminate the ways in which the sensory animal subject takes material shape. My trajectory takes a roughly chronological approach and stays generally within the boundaries of France, with an excursion into Germanic territory in Chapter 4, as mentioned above. I begin with Desportes, whose *Self-Portrait as a Hunter* upended the Royal Academy's presumed hierarchy

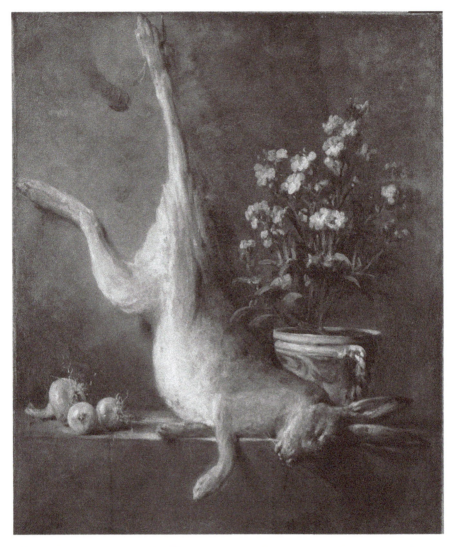

Figure 0.4 Jean-Siméon Chardin, *Hare*, oil, *c.* 1760; Detroit Institute of Art; photo: Courtesy Detroit Institute of Art.

of genres when he submitted the painting as his reception piece in 1699. The artist depicted himself at one with his dogs and surrounded by the animals he has just "shot" with his gun—that is, painted with his brush; he thus merged portraiture with still life painting and at the same time made a pitch for the validity of the animal as principal subject. He may even have intended to include his own, wigless personage as an elegant animal along with the rest. I argue that in his subsequent portraits of dogs and especially in his sociable animal groups,

Desportes created nonhuman versions of the sensually kinesthetic gatherings that his colleague Antoine Watteau was simultaneously constructing with people in the *fête galante*.

Chapter 2 introduces the work of Chardin by taking a close look at his early depictions of live animals interacting with the dead. Drawing upon the lifelike situations of Netherlandish kitchen scenes, Chardin often used his animal subjects as surrogates for the viewer of the painting: cats, in particular, observe, touch, and leap upon stilled "prey" as if demonstrating how the various senses can be used to gain knowledge of what something is and how best it might be appropriated for a living animal's use. I consider Chardin's approach in relation to Locke's presentation of "Molyneux's question," a problem of the relationship between sight and touch that would be taken up by later "sensationalist" French philosophers, most notably Condillac and Diderot. Chardin's watchful, dexterous animals might be said to anticipate this French philosophical trend, just as the animal itself offered humans a model of sensory experience as the essence of creaturely life.

Witty and self-mocking but equally compelling as a model of animalistic sensibility was the theme of the monkey artist, which I examine subsequently in Chapter 2: artists such as Chardin, Christophe Huet, and Watteau used the monkey to make sport with received notions of ontological status among species and to identify their own, sensory-based expertise with that of the creative animal. La Mettrie's radical rejection of human reason in favor of creaturely feeling sheds light on the contemporary implications of the monkey artist, and I consider in particular La Mettrie's use of monkeys and apes as paradigms of native intelligence. I argue that artistic and philosophical visions of the ingenious monkey took a parallel turn after the middle of the century, when the Academy once again began to demand human distinction within its highest artistic subjects and Buffon sought to separate the many simians that appear in his *Histoire naturelle* from the rational man.

In the seventeenth century, Descartes had used language as the finest test through which we can understand the distinctiveness of human intelligence and psychology, and his theory has persisted in many quarters through to the present day. It received a serious challenge, however, from several eighteenth-century philosophers who attended closely to animals, including Boullier, Condillac, and Rousseau, as well as writers aiming to charm their readers, notably Guillaume-Hyacinthe Bougeant. As I argue in Chapter 3, it is in art, above all, that we can find the strongest case for the demonstration of an animal "language" which is founded upon sensory and bodily communication

rather than literal text. Oudry's illustrations for the *Fables* of Jean de La Fontaine—themselves a landmark work of literature in support of animal intelligence—transform the poet's incisive dialogues into a language of action and sensory inflection based upon the artist's abundant store of "natural" animal postures and expressions. Many material outgrowths of Oudry's fable illustrations—upholstered furniture, decorative painting ensembles—brought communicative animal action into elite salons, as if offering a fully corporeal means of sociable talk. Oudry and certain other mid-eighteenth-century artists also engaged the growing culture of sensibility through their creatures' large, appealing eyes, as if seeking further to draw their audiences into an alternative sensory semantics.

In Chapter 4, I turn to artistic medium as it was used to conjure animal existence: both hard-paste porcelain and its soft-paste, imitative cousin were used to create the illusion of fully animated creatures whose bodies encompassed porcelain's unique transformation of inert substance into shining new life. Particularly in Germany (and England), the process through which this transformation took place was considered a kind of alchemy which released matter's animating "force." Leibniz's theories regarding animal soul—a life-giving agent contained within the animal body, but enduring far beyond it—are particularly useful for assessing Augustus the Strong's commission of so many species of porcelain mammals and birds very early in the existence of the Meissen manufactory. In eastern France and the Rhineland, soft-paste porcelain serving tureens fashioned as life-size animals offered a more materialistic transubstantiation of creaturely life: appearing fully animate from the outside on the dining table, the tureens contained within them the actual substance of the animal body, ready to be consumed by diners. Such visceral reminders of the relationship between inner flesh, exterior animal allure, fired clay, and the belly of the diner can be interpreted, I argue, through the materialist philosophy of La Mettrie, d'Holbach, and Diderot, who were seeking to create out of the Aristotelian "scale of nature" an unbroken continuum of life. D'Holbach even created a verb, *s'animaliser*, whereby pure matter gains the ineffable spark of sensitivity that constitutes the lives of all animals.

Materialism, in the writings of all three of these French philosophers, was inextricably bound up with sensibility: what made purely physical beings so endlessly compelling was precisely their potential to feel. In my fifth and last chapter, I examine late works by Oudry and Chardin in light of this highly sensitized materialism: while Oudry's *Bitch-Hound Nursing Her Young* of 1753

appealed to the public for its sentimental evocations of vulnerability and protection, its original buyer, d'Holbach, might have recognized in the painting a more probing investigation of touch as the foundational sensation of animal (and human) life. In Chardin's late still lives depicting animals just past the point of death, it is the artist's own touch that invokes sensible animation and appeals to a viewer on levels both haptic and emotional. In the 1750s and 1760s, several writers, including Pierre Louis Moreau de Maupertuis, Voltaire, and Rousseau, were arguing that the sensitive animal's vulnerability to suffering served as reason alone not to cause creatures harm.[43] Although Chardin's quiet paintings make no such declamatory statement, they nevertheless so elicit vicarious tactility that one cannot help but identify with the animal, if only through physical kinship. It is, in fact, Chardin's paintings of animals that can help us to recognize commonalities among staunch materialists such as Maupertuis and those writers such as Rousseau and Bonnet who identified with the animal subject on an emotional level but set rationality aside as the purview of man. For all agreed that the animal was material, and all agreed that the animal was a being that could feel: paintings "felt" from the inside—through the animating substance of paint and touch—show, in effect, the very essence of how a once-feeling animal experienced and understood the world.

Given the crisis state of the natural realm today, in which the plight of nonhuman animals is particularly acute, the eighteenth century occupies a critical juncture. It was, in fact, during this era in France that the concept of species extinction was first fully acknowledged and initiated as a subject worthy of scientific study.[44] Although the prehistoric zoological research of the great naturalist Georges Cuvier at the Paris Museum of Natural History goes well beyond the scope of this study, it nevertheless shows the extent to which animal life was still valued at the end of a century in which Melchior Grimm could declare Oudry's *Bitch-Hound Nursing Her Pups* as "the premiere painting of the Salon."[45] The celebrated career of the British animal specialist George Stubbs in the latter half of the century, already examined in detail by Donald and others, also demonstrates the willingness on the part of eighteenth-century artists and audiences to see the animal sharing or even upstaging the human as dramatic protagonist.[46] Although this book limits itself to France and Germany in the first six decades of the eighteenth century, I hope that in exposing the animal's importance as exemplar of material understanding in those places and times I might also contribute, albeit at insect scale, to our current, crucial dialogue on the value of animal existence.

Notes

1 "Der Wolf ist gar extra !"; quoted by Danièle Véron-Denise and Vincent Droguet, catalogue entry in *Animaux d'Oudry: Collection des ducs de Mecklembourg-Schwerin* (Paris: Réunion des musées nationaux, 2003), 108. The painting, originally offered to the King of Sweden, remained in Oudry's studio until it found its enthusiastic princely buyer in 1739.

2 See reproduction in Mary Morton, ed., *Oudry's Painted Menagerie: Portraits of Exotic Animals in Eighteenth-Century Europe* (Los Angeles: J. Paul Getty Museum, 2007), 35, Figure 3.

3 Andrée Corval, *Histoire de la chasse: l'homme et la bête* (Paris: Perrin, 2010), 149–62, 182–93 and *passim*. The hunting of the wolf in France was generally considered more a practicality than an exemplar of "noble" sport, although Oudry and his patrons favored the theme. The artist included a *Wolf Hunt* among the Beauvais tapestry cartoons known as *Les Chasses nouvelles* and throughout his career he painted numerous variations upon a battle between a lone wolf and a pack of dogs.

4 See, for example, Étienne La Font de Saint-Yenne, *Réflexions sur quelques causes de l'état présent de la Peinture en France. Avec un examen des principaux Ouvrages exposés au Louvre le mois d'Août 1746* (The Hague: Jean Neaulme, 1747), 8, 68. Critical assessments of Oudry's animal scenes as history paintings are discussed further in Chapter 4. Cf. Hal Opperman, *J.-B. Oudry 1686–1755* (Seattle and London: University of Washington Press for the Kimbell Museum of Art, 1983), 70–2.

5 See Hélène Meyer, catalogue entry in *Les Peintres du roi 1648–1793*, ed. Thierry Bajou (Paris: Réunion des musées nationaux, 2000), 87–8. Several still life painters had been admitted into the Academy before Bernaerts, another sign of the growing French interest in empirical depictions of nonhuman subjects for which Netherlandish artists were known; cf. idem, 222–30. Jean-Baptiste Monnoyer, a specialist in elaborate still lives who had already succeeded in gaining elite patronage, was also received into the Academy in 1665; see Thierry Bajou, idem, 89–90.

6 As early as 1557 Pierre Belon, in his *Portraits d'oyseaux, animaux, herbes, arbres, hommes et femmes, d'Arabie & Egypte* (Paris: Guillaume Cavellat), had juxtaposed a bird skeleton with that of a human in order to "montrer l'affinité des deux" (pp. 3v-4r; quotation from 4r). Comparative anatomy in France in the decades around the turn of the eighteenth century had been greatly advanced by the public anatomy demonstrations of Joseph Duverney at the Jardin du Roi in Paris; see Anita Guerrini, *The Courtiers' Anatomists: Animals and Humans in Louis XIV's Paris* (Chicago and London: University of Chicago Press, 2015), 201–38. Cf. idem, *Experimenting with Humans and Animals from Galen to Animal Rights* (Baltimore

and London: The Johns Hopkins University Press, 2003). On the cultural uses and implications of comparative anatomical study in early modern Europe, see Jonathan Sawday, *The Body Emblazoned: Dissection and the Human Body in Renaissance Culture* (New York and London: Routledge, 1995).

7 Among many scholarly treatments of this important series of prints, the most relevant to this study are James A. Steintrager, *Cruel Delight: Enlightenment Culture and the Inhuman* (Bloomington and Indianapolis: Indiana University Press, 2004), 37–43 and *passim*; Stephen F. Eisenman, *The Cry of Nature: Art and the Making of Animal Rights* (London: Reaktion Books, 2013), 96–103.

8 Cf. Lesley Millar, "Surface as Practice," in *Surface Tensions: Surface, Finish and the Meaning of Objects*, ed. Glenn Adamson and Victoria Kelley (New York and Manchester: Manchester University Press, 2013), 26–32. For the complex interaction of sight and touch in eighteenth-century art and culture, see especially Ewa Lajer-Burcharth, *The Painter's Touch: Boucher, Chardin, Fragonard* (Princeton and Oxford: Princeton University Press, 2018).

9 Jacques Gamelin, *Nouveau Recueil d'ostéologie et de myologie, dessiné d'après nature par Jacques gamelin … pour l'utilité des sciences et des arts* (Toulouse: J.F. Desclassan, 1779), introduction to Part II, "De la Myologie," n.p. Numerous battle scenes conducted by warring human skeletons set the tenor for drama among Gamelin's tableaux.

10 See especially John C. O'Neal, *The Authority of Experience: Sensationist Theory in the French Enlightenment* (University Park, PA: Pennsylvania State University Press, 1996). See also Jessica Riskin, *Science in the Age of Sensibility: The Sentimental Empiricists of the Eighteenth Century* (Chicago and London: University of Chicago Press, 2002). Cf. Anne C. Vila, *Enlightenment and Pathology: Sensibility in the Literature and Medicine of Eighteenth-Century France* (Baltimore and London: The Johns Hopkins University Press, 1998); John W. Yolton, *Locke and French Materialism* (Oxford: Clarendon Press, 1991); Michael Baxandall, *Patterns of Intention: On the Historical Explanation of Pictures* (New Haven and London: Yale University Press, 1985), 74–104.

11 John Locke, Epitome of *An Essay Concerning Human Understanding* [1684 or 1685], translated into French by Jean Le Clerc, *Bibliothèque universelle et historique*, VIII (1688): 49–142.

12 John Locke, *An Essay Concerning Human Understanding* [4th ed., 1700], ed. Peter H. Nidditch (Oxford: Clarendon Press, 1979), Book II, Chap. X, part 15 (p. 149).

13 See Elisabeth de Fontenay, *Le Silence des bêtes: La philosophie à l'épreuve de l'animalité* (Paris: Fayard, 1998), 375–83; Yolton, *Locke and French Materialism*.

14 Julien Offray de La Mettre, *Treatise on the Soul* [1745], in *Machine Man and Other Writings*, trans. and ed. Ann Thomson (New York and Cambridge: Cambridge University Press, 1996), 52.

15 Ibid., 44.

16 La Mettrie, *Machine Man* [1747/8], in *Machine Man and Other Writings*, 26.

17 Denis Diderot, *Lettre sur les aveugles* [1749], in *Œuvres philosophiques*, ed. Paul Vernière (Paris: Garnier Frères, 1964), 97.

18 Oudry was appointed director of the Beauvais tapestry works in 1734 and played a number of significant artistic and administrative roles at the Gobelins manufactory, beginning with his renowned series of *Chasses royales*, commissioned in 1733. See Opperman, *J.-B. Oudry*, 32–3.

19 Paul-Henry Thiry d'Holbach, *Système de la nature ou des lois du monde physique et du monde morale* [1770], 2 vols., ed. Yvon Belaval (Hildesheim: Georg Olms, 1966), I, 47.

20 Jane Bennett, *Vibrant Matter: A Political Ecology of Things* (Durham and London: Duke University Press, 2010), 51; see also Bennett's "Systems and Things: On Vital Materialism and Object-Oriented Ontology," in *The Nonhuman Turn*, ed. Richard Grusin (Minneapolis and London: University of Minnesota Press, 2015), 223–40.

21 Karen Barad, *Meeting the Universe Halfway: Quantum Physics and the Entanglement of Matter and Meaning* (Durham and London: Duke University Press, 2007), 49, 139.

22 La Mettre, *Machine Man*, 27. The entomologist Charles Bonnet, who featured a scale of beings similar to the Aristotelian model at the beginning of his *Observations sur les insectes*, in fact highlighted the agential complexities of insect existence in the course of his long text; Charles Bonnet, *Observations sur les insectes* [1776], in *Œuvres d'histoire naturelle et de philosophie*, 18 vols. (Neuchatel: Samuel Fauche, 1779), I.

23 Gérard Mabille, catalogue entry in *Versailles et les tables royales en Europe XVIIème-XIXème siècles*, ed. Béatrix Saule and Rosalind Savill (Paris: Réunion des musées nationaux for the Musée national des châteaux de Versailles et de Trianon, 1994), 280, no. 73; idem, "Les Surtouts de table dans l'art français du XVIIIᵉ siècle," *Estampille* 126 (October 1980): 70, 72. Cf. Véron-Denise and Droguet, *Animaux d'Oudry*, 108–9.

24 The principal reference for this landmark commission is Samuel Wittwer, *Die Galerie der Meissener Tiere: Die Menagerie Augusts des Starken für das Japanishche Palais in Dresden* (Munich: Hirmer, 2004).

25 Gottfried Wilhelm Leibniz, *New System of the Nature of Substances* [1695], in *Leibniz's "New System" and Associated Contemporary Texts*, trans. and ed. R. S. Woodhouse and Richard Francks (Oxford: Clarendon Press, 1997), 11–12.

26 Bennet, *Vibrant Matter*, 67; Barad, *Meeting the Universe Halfway*, 49.

27 Aristotle, *De Anima*, trans. J. A. Smith, in *The Works of Aristotle*, ed. J. A. Smith and W. D. Ross, 12 vols. (Oxford: Clarendon Press, 1910), III: I, 1, 402a; II, 1, 412a–b. For uses of Aristotle in fifteenth- and sixteenth-century theories of the

sensitive animal soul, see Katharine Park, "The Organic Soul," *The Cambridge History of Renaissance Philosophy*, ed. Charles B. Schmitt et al. (Cambridge and New York: Cambridge University Press, 1988), 464–84. See also Charles H. Lohr, "Metaphysics and Natural Philosophy as Sciences: The Catholic and the Protestant Views in the Sixteenth and Seventeenth Centuries," in *Philosophy in the Sixteenth and Seventeenth Centuries: Conversations with Aristotle*, ed. Constance Blackwell and Sachiko Kusukawa (Aldershot and Brookfield, VT: Ashgate, 1999), 280–95. Aristotle continued to serve as a touchstone for theorists of sensitive animal soul into the eighteenth century, as seen, for example, in David Boullier's *Essai philosophique sur l'âme des bêtes* [rev. ed. 1737] (Paris: Fayard, 1985), 419. On early Calvinist responses to Descartes's *Discourse on Method*, see Theo Verbeek, *Descartes and the Dutch: Early Reactions to Cartesian Philosophy* (Carbondale and Edwardsville: University of Southern Illinois University Press, 1992).

28 Boullier's *Essai philosophique sur l'âme des bêtes* was originally published in Amsterdam in 1728, and then again in a revised and greatly expanded version of 1737. Cf. Fontenay, *Le Silence des bêtes*, 456.

29 The literature encompassed by the "animal turn" is vast and indeed forms the basis for an entire new discipline in the humanities known generally as "animal studies." A foundational work in philosophy that has been particularly valuable for my own study is Fontenay, *Le Silence des bêtes*. Earlier classics, especially important for eighteenth-century studies, include Leonora Cohen Rosenfield, *From Beast-Machine to Man-Machine: Animal Soul in French Letters from Descartes to La Mettrie* (New York: Octagon Books, 1940); Heather Hastings, *Man and Beast in French Thought of the Eighteenth Century* (Baltimore and London: The Johns Hopkins University Press, 1936); and, for English studies, Keith Thomas, *Man and the Natural World: Changing Attitudes in England 1500–1800* (New York and Oxford: Oxford University Press, 1983). Important recent works addressing the animal theme in the work of particular philosophers include Jean-Luc Guichet, *Rousseau l'animal et l'homme: L'aimalité dans l'horizon anthropologique des Lumières* (Paris: Les Éditions du Cerf, 2006) and Christiane Mervaud, *Bestiaires de Voltaire, Studies on Voltaire and the Eighteenth Century* 2006 (Oxford: Voltaire Foundation, 2006), 1–200. Other historical studies include the writings of Nathaniel Wolloch; especially relevant to this study are Wolloch's *Subjugated Animals: Animals and Anthropocentrism in Early Modern European Culture* (Amherst, New York: Prometheus Books, 2006) and *The Enlightenment's Animals: Changing Conceptions of the Animal in the Long Eighteenth Century* (Amsterdam: Amsterdam University Press, 2019). Among numerous historically oriented anthologies, see, e.g., Arien Mack, ed., *Humans and Other Animals* (Columbus, OH: Ohio State University Press, 1995); Erica Fudge, Ruth Gilbert, and Susan Wiseman, eds., *At the Borders of the Human: Beasts, Bodies and Natural Philosophy in the Early Modern Period*

(New York and Basingstoke: Palgrave, 1999); Joan B. Landes, Paula Young Lee, and Paul Youngquist, eds., *Gorgeous Beasts: Animal Bodies in Historical Perspective* (University Park, PA: Pennsylvania State University Press, 2012); Paula Cuneo, ed., *Animals and Early Modern Identity* (Farnham, Surry and Burlington, VT: Ashgate, 2014). For a critical evaluation of artistic representations of animals from the early modern through contemporary eras, see Eisenman, *The Cry of Nature*.

30 This questioning has taken a number of forms. Some scholars of the so-called "Anthropocene" have attributed its origins to the later eighteenth century, both generally in terms of the rise of industrialization and, even more specifically, to James Watt's invention of the steam engine in 1784. See, e.g., Alan Mikhail, "Enlightenment Anthropocene," *Eighteenth-Century Studies* 49 (Winter 2016): 211–31. See also this entire issue of *Eighteenth-Century Studies* (ed. J. R. McNeill), which is devoted to the topic of "Humans and the Environment." There is also a growing body of ecocritical approaches to eighteenth-century studies, especially in the area of English literature. See, e.g., Christopher Hitt, "Ecocriticism and the Long Eighteenth Century," *College Literature* 31 (Summer 2004): 123–47; Erin Drew and John Sitter, "Ecocriticism and Eighteenth-Century English Studies," *Literature Compass* 8 (2011): 227–39. Critical environmental approaches are beginning to inform thematic studies of eighteenth-century culture as well; see, e.g., Laura Auricchio, Elizabeth Heckendorn Cook, and Giulia Pacini, eds., *Invaluable Trees: Cultures of Nature 1660–1830, Studies on Voltaire and the Eighteenth Century* 2012 (Oxford: Voltaire Foundation, 2012). Eighteenth-century understandings of the hierarchical relationship between human and nonhuman life, and its internal correlate of the relationship between mind and body, have also been subject to new scholarly evaluations; particularly important for students of French culture are the writings of E. C. Spary. See Spary's *Utopia's Garden: French Natural History from Old Regime to Revolution* (Chicago and London: University of Chicago Press, 2000) and *Eating the Enlightenment: Food and the Sciences in Paris, 1670–1760* (Chicago and London: University of Chicago Press, 2012).

31 Diana Donald, *Picturing Animals in Britain 1750–1850* (New Haven and London: Yale University Press for the Paul Mellon Centre for Studies in British Art, 2007). Among recent examinations of the animal in eighteenth-century literature, Heather Keenleyside's *Animals and Other People: Literary Forms and Living Beings in the Long Eighteenth Century* (Philadelphia: University of Pennsylvania Press, 2015) sets a particularly important precedent for my study in its identification of a ground-shifting "animal turn" within the eighteenth century itself. See also, e.g., Louise Robbins, *Elephant Slaves and Pampered Parrots: Exotic Animals in Eighteenth-Century Paris* (Baltimore and London: The Johns Hopkins University Press, 2002); Richard Nash, *Wild Enlightenment: The Borders of Human Identity in the Eighteenth Century* (Charlottesville, VA: University of Virginia Press, 2003);

Frank Palmieri, ed., *Humans and Other Animals in Eighteenth-Century British Culture* (Farnham, Surrey and Burlington, VT: Ashgate, 2006); Jacques Berchtold and Jean-Luc Guichet, eds., *L'Animal des Lumières*, special issue of *Dix-huitième siècle* 42 (2010); Glynis Ridley, ed., *Animals in the Eighteenth Century*, special issue of *Journal for Eighteenth-Century Studies* 33 (December 2010); Lucinda Cole, ed., *Animal, All Too Animal*, special issue of *The Eighteenth Century* 52 (Spring 2011); Tobias Menely, *The Animal Claim: Sensibility and the Creaturely Voice* (Chicago and London: University of Chicago Press, 2015); Katherine M. Quinsey, ed., *Animals and Humans: Sensibility and Representation, 1650–1820* (Oxford: Oxford University Studies in the Enlightenment, 2017); John Morillo, *The Rise of the Animal and the Descent of Man, 1660–1800: Toward Posthumanism in British Literature between Descartes and Darwin* (Newark: University of Delaware Press, 2017).

32 Donald, *Picturing Animals in Britain*, 1. Quite different is the aim of a more recent important publication on animals in eighteenth-century art: Katie Hornstein, ed., "Animal," *Journal 18* 7 (Spring 2019). "Pushing back against the idea of the animal as a mere foil for more significant human drama … these contributions reassess the role of animals as the very actors, agents and materials of art's histories." http://www.journal18.org/past-issues/7-animal-spring-2019/(1-10-20)

33 Cf. Morton, *Oudry's Painted Menagerie*, 35.

34 Boullier, *Essai philosophique sur l'âme des bêtes*, 271–2.

35 Georges-Louis Leclerc, comte de Buffon, *Histoire naturelle génèrale et particulière: avec la description du Cabinet du Roi*, 36 vols. (Paris: Imprimerie royale, 1749–1788). Buffon's collaborator on the first fifteen volumes, which addressed animals other than birds, was Louis-Jean-Marie Daubenton. The many subsequent versions of Buffon's *Histoire naturelle* often truncated his encompassing study of nature by restricting their volumes to those on quadrupeds and simians. Many of my references in the course of this book are to one of these revised editions, that of 1785–1791, published in Paris by Sanon & Co. (open access URL: https://www.e-rara.ch/zut/doi/10.3931/e-rara-22933) [cited hereafter as Buffon, *Histoire naturelle* (1785–91)].

36 Buffon also employed the artist Jacques de Sève to draw many of the species in pictorial tableaux, as well as to depict skeletons and internal, anatomized animal parts; a large team of specialists engraved de Sève's drawings for publication. De Sève's illustrations have been the subject of numerous investigations by historians of art and science. They are not addressed in this study owing to their primarily documentary function, although I fully acknowledge the artist's inventiveness, whose complexities and problems are well worthy of further examination. See Elizabeth Amy Liebman, "Painting Natures: Buffon and the Art of the 'Histoire naturelle,'" PhD diss., University of Chicago, 2003; Thierry Hoquet, Introduction to *Buffon illustré: les gravures de l'*Histoire Naturelle *(1749–1767)*, 2 vols. (Paris:

Publications Scientifiques du Muséum national d'Histoire naturelle, 2007), I, 13–175.

37 Charles Bonnet, *Observations sur les insectes*, I, 271–81; quotation from p. 273. Idem, *Essai analytique sur les facultés de l'âme* [1759] (Copenhagen: Frères Cl. & Ant. Philobert, 1760).

38 Bonnet, *Essai analytique sur les facultés de l'âme*, 473.

39 See Michael Yonan, "Toward a Fusion of Art History and Material Culture Studies," *West 86th* 18:2 (Fall–Winter, 2011), 232–48; idem, "The Suppression of Materiality in Anglo-American Art-Historical Writing," in *The Challenge of the Object/Die Herausforderung des Objekts. Proceedings of the 33rd Congress of the International Committee of the History of Art (CIHA), Nürnberg, 15–20 July 2012*, 5 vols., ed. Georg Ulrich Großmann and Petra Krutisch (Nürnberg: Verlag des Germanischen Nationalmuseums, 2014), I, 63–6. Yonan cites Jules David Prown for his pathbreaking integration of art history and material culture studies; see, e.g., Jules David Prown, "Mind in Matter: An Introduction to Material Culture Theory and Method," *Winterthur Portfolio* 71:1 (Spring 1982): 1–19. I myself owe a significant debt to both scholars as I have formulated and developed my own methodology over many years. A few among the many recent examples of the "material turn" in studies of eighteenth-century art give some sense of the depth and breadth of this scholarly movement; see, e.g., Eugenia Zuroski and Michael Yonan, eds., *Material Fictions*, special issue of *Eighteenth-Century Fiction*, 2 vols. 31:2 (Fall 2018); Matthew C. Hunter, "Joshua Reynolds's 'Nyce Chymistry': Action and Accident in the 1770s," *The Art Bulletin* 97:1 (March 2015): 58–76; Hanna Hodacs, "Cheap and Cheerful: Chinese Silks in Scandinavia, 1731–1751," *Eighteenth-Century Studies* 51:1 (Fall 2017): 23–44; Stacey Sladoba, *Chinoiserie: Commerce and Critical Ornament in Eighteenth-Century Britain* (New York and Manchester: Manchester University Press, 2014). For the material turn in Art History considered more generally, see, e.g., the special edition of the *Art Bulletin*, edited by Nina Athanassoglou-Kallmyer: 101 (December 2019).

40 See especially Amy Freund, "Sexy Beasts: The Politics of Hunting Portraiture in Eighteenth-Century France," *Art History* 42:1 (February 2019): 40–67; idem, "Good Dog! Jean-Baptiste Oudry and the Politics of Animal Painting," in *French Art of the Eighteenth Century: The Michael L. Rosenberg Lecture Series at the Dalls Museum of Art*, ed. Heather MacDonald (New Haven and London: Yale University Press for the Dallas Museum of Art, 2016); Julie-Anne Plax, "J.-B. Oudry's *Royal Hunts* and Louis XV's Hunting Park at Compiègne: Landscapes of Power, Prosperity, and Peace," *Studies in the History of Gardens and Designed Landscapes* 37:2 (2017): 102–19.

41 See, e.g., Vila, *Enlightenment and Pathology*; Riskin, *Science in the Age of Sensibility*. Particularly helpful for my analysis of Chardin's art through the lens of sensibility

is Ann Bermingham's assessment of the work of Thomas Gainsborough, an English artist whose approach to the animal subject bears some comparison with that of Chardin; see Ann Bermingham, *Sensation and Sensibility: Viewing Gainsborough's Cottage Door* (New Haven and London: Yale University Press for the Yale Center for British Art, 2005). Cf. also Sarah R. Cohen, "Thomas Gainsborough's Sensible Animals," in Quinsey, *Animals and Humans*, 191–218; Alexander Nemerov, *The Body of Raphaelle Peale: Still Life and Selfhood, 1812–1824* (Berkeley and Los Angeles: University of California Press, 2001).

42 See, e.g., Jean-Jacques Rousseau, *Discourse on the Origins and Foundations of Inequality among Mankind* [1753], in The Social Contract *and* The First and Second Discourses, ed. Susan Dunn (New Haven and London: Yale University Press, 2002), 106.

43 See, e.g., Pierre Louis Maupertuis, *Lettre VI: Du Droit sur les bêtes* in *Oeuvres de Mr. De Maupertuis*, nouv. éd., 4 vols. (Lyon: Jean-Marie Bruyset, 1756), 223; François-Marie Arouet, known as Voltaire, *Dictionnaire philosophique* [1769], 2 vols. (Paris: Garnier Frères, 1935), 72; Jean-Jacques Rousseau, *Émile Or Treatise on Education* [1762], trans. William H. Payne (Amherst, NY: Prometheus Books, 2003), 227.

44 In his *De L'Interprétation de la nature* of 1753, Diderot speculated that since individual beings pass from life to death, the same could hold true for entire species; *Oeuvres philosophiques*, 241. On the late eighteenth-century origins of our own awareness of species extinction, see, e.g., Elizabeth Kolbert, *The Sixth Extinction: An Unnatural History* (New York: Henry Holt and Company, 2014), 24–30.

45 " … Le premier tableau du salon"; Melchior Grimm (attrib.), *Correspondance littéraire*, September 15, 1753; reprinted by Hal N. Opperman, *Jean-Baptiste Oudry*, 2 vols. (New York and London: Garland, 1977), I, 206.

46 Donald, *Picturing Animals in Britain, passim*; Eisenman, *Cry of Nature*, 110–21. The monographic literature on Stubbs is substantial; see, e.g., Judy Edgerton, *George Stubbs, Painter* (New Haven and London: Yale University Press, 2007); Robin Blake, *George Stubbs and the Wide Creation: Animals, People and Places in the Life of George Stubbs, 1724–1806* (London: Chatto and Windus, 2005); Judy Edgerton et al., *George Stubbs 1724–1806* (London: Tate Gallery, 1985).

The Social Animal

Just as the appearance of Cotte's translation of Locke in 1700 likely inspired intellectual debates over the acquisition of knowledge through the senses—a capacity the human shared with the nonhuman animal—artistic innovation around the turn of the eighteenth century was beginning to challenge the traditional hierarchy that always privileged human discourse over the more material concerns of social interaction and sensual appeal. Animal subjects proved particularly adept at capturing the vicarious response of viewers within this new artistic environment, especially when artists projected animal sociality as a central, engaging theme. I use the term "sociality" specifically for its encompassing application to nonhuman and human animals alike: unlike the term "sociability," which conjures humanistic intercourse, "sociality" is used by ethologists to describe the deliberate behavior of animals interacting in groups, and also applies to any group of individuals associating in communities.[1] New forms of interior design and portable arts emerging around the turn of the eighteenth century highlighted such shared sociality by mingling animals and humans in a single realm of ludic interaction. The Royal Academy of Painting and Sculpture, newly receptive to innovations in the more sensual aspects of art—Rubensian color, buoyant compositions, amorous themes[2]—proved equally open to assessing the potential merits of the material, nonhuman realm.

A catalyzing force in this movement toward sociality as well as the shift in Academic expectations was the painter and designer Alexandre-François Desportes. Having received his initial training with Nicasius Bernaerts, a Flemish animal specialist who was himself the first in his chosen genre to receive admission into the Royal Academy, Desportes also worked as a court portraitist in Poland early in his independent career. He was thus ideally positioned to refashion the seventeenth-century genre of animal painting into sensually appealing and surprisingly social tableaux which would elicit interest and even a form of self-recognition on the part of cultured viewers. Like his colleague Antoine Watteau, Desportes mined the new decorative structures of

the *grotesque* for a means of integrating his groups through a seemingly "natural" physical elegance that also connoted communal interaction; but while Watteau's characters emanated from the theater and fashionable society, Desportes's protagonists featured nonhuman animals familiar from the hunt, the boudoir, and, on occasion, the menagerie. Refined but almost never anthropomorphized, the creatures that populate these animalistic *fêtes galantes* model a new kind of engaged sensuality. Both Desportes himself and other designers would further develop the social animal subject as a vibrant agent in the form of portable arts ranging from fire screens to porcelain, yielding a veritable Rococo ecology of lively and interactive matter.

Desportes's *Self-Portrait as a Hunter*

In 1699, Desportes publically allied his own artistic practice with the material life of animals when he displayed his *Self-Portrait as a Hunter* in the official exhibition of the French Royal Academy of Painting (Figure 1.1). He had presented the work as his *morçeau de réception* earlier in the same year, where it was described as "a huntsman surrounded by animals"; now, however, the generic "huntsman" transformed into the painter himself and the animals into his assistants and the very substance of his art.[3] The work immediately impressed its audience, drawing praise for its vividly rendered creatures.[4] Elegantly attired with an aristocratic hunter's slight *déshabillé*, the artist sits beneath a tree at the edge of a spacious park, his gun in one hand and his dogs attentively flanking him. A *trompe l'oeil* pile of dead game spills downward and outward from the triangle formed between dogs and man; fur and feathers soft and glistening, the dead animals complement the hunter's own spiraling posture and richly textured garments. The group unites through a network of interconnected legs, torsos, heads, feet, eyes, ears, and wings, topped by the hunter's arms and hands and his sidelong, outward gaze. Although clearly in command of the animal life and death that surround him, the artist-hunter also demonstrates his material involvement with it, by closely allying his body with those of his dogs and his prey. If our eye at first follows the turned heads and gazes of the dogs to study the hunter's face, it then travels down the arm that embraces the spaniel to encounter the long, human fingers, which are deftly matched by the dog's outstretched foreleg and the brilliant white wing of an upturned duck. A shimmering fold of the hunter's waistcoat abuts the canine foreleg just where the avian wing touches it from the other side, showing three ways in which a body can be clothed

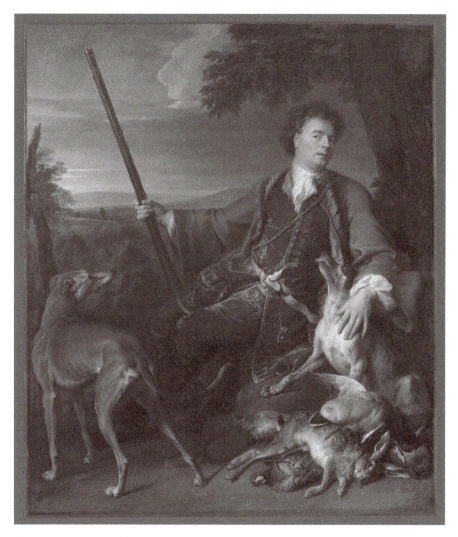

Figure 1.1 Alexandre-François Desportes, *Self-Portrait as Hunter*, oil, 1699; Paris, Louvre; photo: © RMN-Grand Palais/Art Resource, NY.

and ornamented. Using a still life artist's rhymes and repetitions to assemble his carefully crafted forms, Desportes equally joins man to animal through the context of material display.

In his studies of this painting,[5] Pierre Jacky has noted that the artist's subject in effect combines two genres familiar in France, as elsewhere in Northern Europe: the aristocratic hunt portrait and the dead game still life. Having been asked by the Academy, upon his *aggrégation* in 1698, to decide whether he wished to be received as a portraitist or as a painter of animals—Desportes

having demonstrated skill in both capacities through the paintings he had presented—he chose the latter and promised to present as his reception piece "a subject of several animals."[6] Some surprise must thus have attended the Academicians' reception of the *Self-Portrait as Hunter*, whose integrated theme allowed Desportes quite literally to "deliver" the promised animals, captured and presented by the hunter-artist himself.

As Jacky has argued, with his tour-de-force combination of portraiture and painting of animals both alive and dead, Desportes was probably attempting to elevate the genre of animal painting, which fell below portraiture in the Academy's thematic ranking.[7] Although the academicians followed their original plan to receive the artist as an animal painter, Desportes's initiative succeeded from a marketing standpoint, by appealing to the aristocratic culture of the hunt. Immediately following the *Self-Portrait as Hunter*, the artist began to execute numerous other portraits of hunters with their dogs and prey, and the theme was quickly adopted by other artists—portraitists and animal painters alike—such as Jean-Baptiste Santerre and Jean-Baptiste Oudry.[8] Having already secured royal patronage through his position as court portraitist in Poland in the mid-1690s, and, upon his return to France, in decorative work for the Dauphin at his château at Meudon, Desportes may have hoped that the *Self-Portrait as Hunter* would further his career in the French court. Indeed, the artist began to receive commissions of hunt paintings for French royal residences around the turn of the eighteenth century, when he undertook decorative projects for the Ménagerie at Versailles, as well as portraits of Louis XIV's dogs for the château of Marly. Desportes would continue to execute paintings and decorative designs on hunting themes for the French court throughout the rest of his career.[9]

Thus advancing the official status of animal painting, Desportes also advanced the status of the animal itself as a viable pictorial protagonist. So allied is the artist with his living and recently felled subjects, the *Self-Portrait as Hunter* in effect becomes a new kind of group portrait. One would indeed be hard pressed to imagine this human figure sitting alone in the woods. The interaction between the man and his dogs emerges as social, even psychological: the dogs complete the hunter's gestures with their bodies, the spaniel that receives his caress even sticking out his tongue in reciprocation, while the turned heads and gazes of the two dogs conjure the effect of silent communication with their master. Both animals indeed manifest carefully observed canine modes of attending to a human companion—unwavering watchfulness and affection-seeking inclination—thus putting the lie to Louis Hourticq's anthropomorphic formulation that the dogs show "an imploring eye embedded with a desperate

desire to speak with the man."[10] Speaking is not at issue in this tableau of physical reciprocity.

Portraits of hunters with their dogs and game had appeared in seventeenth-century English court portraiture as well as Dutch family groups, and the *Guilden Cabinet* of Corneille De Bie, published in Antwerp in 1661, featured an engraved portrait of Pieter Boel with his hand stroking the head of an attentive greyhound, a possible inspiration for Desportes's use of the gesture.[11] But Desportes's painting alters the conventions of group hunt portraiture by enhancing the role of the dogs and by incorporating even the creatures recently killed into the ensemble. The artfully piled, still vibrant bodies of the dead animals form a structural and tactile base for the living members of the group, as implied by the spaniel's foreleg stretched possessively above the other creatures and by the hunter's corresponding caress.

We can observe the care Desportes took to coordinate his own figure with those of the animals by considering his preparatory chalk study for the painting (Figure 1.2), as well as a preliminary oil that closely follows it (Private

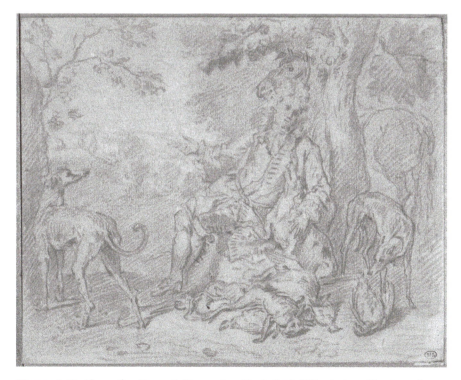

Figure 1.2 Alexandre-François Desportes, *Study for Self-Portrait as Hunter*, red chalk, *c.* 1698–9; Paris, Louvre; photo: © RMN-Grand Palais/Art Resource, NY.

Collection).[12] Horizontally distributed, the figural group in the earlier works appears more haphazard in its arrangement, an effect increased by the inclusion of a third, more aimless, hound on the right and a horse behind the tree. Gazing downward or off to the side, rather than out at the viewer, and with his right hand gesturing in a vague rhetorical flourish, the bewigged artist appears less involved with his animal companions and with his environment than he does in the final painting. When Desportes shifted the composition of the final painting to a vertical, he integrated landscape, man, dogs, and dead game through a flowing triangle of material agents, subtly enhanced by equivalent spirals in the postures of the hunter and the standing dog. The placement of a gun in the hunter's gesturing hand also makes him appear more kin to his dogs: we infer that what he does with the artistry of his marksmanship, the dogs do with their muscular bodies.

By abandoning the wig in favor of his own soft, brown curls, the artist in the final painting links himself physically to his natural environment and to all the creatures that surround him, especially the brown and white spaniel beneath his hand and the tawny hare sprawled in a gentle curve below. While baring his head might not have created quite the scandal in the Academy that Hourticq claimed it would have,[13] it does remind the viewer that this hunter, despite his tools and his clothes, is himself an animal. Even the artist's clothing is likened to the animal "clothing" fashioned by God: the fur and feathers of the animals, praised by contemporaries for their illusionism, form a coloristic and textural match for the artist's voluminous brown coat and rich velvet waistcoat and trousers, while the white of his cravat, emphasized through the turn of his head, is wittily echoed in the white throat of the eager spaniel.

Such material integration of man and animals deftly showed the Academy what one artist could do: originally trained as an animal painter, already active in tapestry and other types of decorative design, and a skilled portraitist in the manner of Hyacinthe Rigaud,[14] Desportes combined all aspects of his artistic formation into a single *morçeau de réception*. His hunt ensemble also exposed how closely linked portraiture and animal painting could be, especially from an artist's perspective. For late seventeenth-century portraiture generally aimed at outward display rather than narration; unlike history painting, whose human figures exercised rational or spiritual thought in a dramatic context, portraiture emphasized the body's look, captured empirically by the artist and evinced through the proportions, the clothing, the stance, and the general facial features that designated character.[15] Animals, whether live or dead, called for similar focus upon optical exactitude and the intrinsic appeal of the body, especially

if the work concerned a hunting theme. Seventeenth-century Netherlandish paintings of dead game often acknowledged the connection between human and animal by featuring the hunter's own accoutrements, such as powder flask and game purse, artfully interwoven with the animal bodies. Desportes himself acknowledged this convention in the hunting purse that lies just behind the hind feet of the hare and the standing dog in the *Self-Portrait as Hunter*.

Desportes's genre-blending painting also captured the continuity between the artist's own medium and the body of the animal, for as the "hunter" of these precisely rendered creatures his gun stands in for his paintbrush[16] and the animals offer up the very substance of his art. In the context of the Academy, this witty allegory may have called to mind the practice, formalized in the 1670s and 1680s, by which portraitists presented as their *morceaux de réception* formal portraits of the Academy's officers—who were always history painters or sculptors—holding or pointing to the products and tools of their art.[17] A good example is Gabriel Revel's portrait of the sculptor François Girardon, one of two required portraits of Academic *officiers* Revel presented as his *morçeaux de reception* in 1683 (Figure 1.3). While the classically inspired sculptor supports the mold of a head of Julius Caesar in one hand, with the other he points to his carving tools, thus drawing a connection between the art of sculpture in general and his own particular accomplishment in this area.[18] Hannah Williams has argued that *morçeaux de reception* such as Revel's were particularly important in emphasizing the Academy's investment in history painting and sculpture, for their display within the Academy and in subsequent engravings would in effect create an official history of the institution.[19] Although the positioning of Desportes's *morçeau de réception* on the Academy's walls left no question that the institution considered it a form of still life painting,[20] the way in which the artist physically engages with the animals and displays the "tool" he used to work with or capture them suggests an effort on the part of this ambitious animal specialist to raise the status of his chosen subject. Animals, especially the living dogs that complement Desportes's own body, take the place of inert sculpted heads and sketched human figures as the essence of his artistry.

Having chosen for his Academic specialty animals rather than portraiture, Desportes now had a professional stake in demonstrating how closely connected man, dog, and recently killed game could be as viable subjects. In André Félibien's well-known lecture presented to the Academy in 1667 and published two years later, the honorary *amateur* had asserted not only that "those who become imitators of God by painting human figures are more excellent than all the others," but also that "those who paint live animals are more worthy of

Figure 1.3 Gabriel Revel, *Portrait of François Girardon*, oil, 1683; Versailles, musée national du Château/Paris, Louvre; photo: © RMN-Grand Palais/Art Resource, NY.

estimation than those who only represent things that are dead and without movement." Landscape, a living thing, is correspondingly more "noble" than inert "fruit, flowers, and seashells."[21] Félibien's hierarchy, which is generally taken to be a summary of Academic standards, echoes the Aristotelian *scala naturae* extending from the human, through the various orders of animals; to the higher and lower plants; to, at the bottom, minerals, earth, and other inanimate substances. Confirmed by the biblical Creation story and a staple of scholastic

discourse on the natural order, the "scale of nature" would continue to be refined as an organizing principle of life (and non-life) through much of the eighteenth century.[22]

But as Arthur O. Lovejoy persuasively argued in his classic *Great Chain of Being*, the philosophical principle of the *scala naturae* also rested upon the assurance of "diversity and plenitude" among all beings, and thus implicitly validated the existence of even the lowliest zoophyte.[23] This point would be emphasized by such eighteenth-century proponents of the principle as the entomologist-philosopher Charles Bonnet, who would propose his own version of a "scale of natural beings" in the Preface to his *Treatise on Insectology* of 1745, in which these tiny but pervasive animals occupied their own special place within the "beautiful spectacle" of organized and non-organized beings that formed one existential chain.[24] The composition of Desportes's *Self-Portrait as a Hunter*, while itself articulating a "scale" that descends from man, to living animals, to inert bodies, to earth, also promotes through its intense, foregrounded focus upon the group as a whole the intrinsic value that each of these natural entities holds in the world. The Academy, although institutionally and politically committed to the primacy of human history,[25] may have been implicitly acknowledging the value of diversity and plenitude when accepting this unusual "huntsman surrounded by animals" as the *morçeau de réception* of an animal painter.

Other aspects of Desportes's painting recall the ways seventeenth-century Dutch and Flemish animal specialists had announced their professional investment in the animal through physical double-entendres. Frans Snyders and his Flemish followers, for example, used red paint to stand in for animal blood in their still lives of just-dead animals. Smeared on white cloths or dribbling from muzzles and beaks in trails of painterly impasto, the paint-blood at once signals the materiality of the artist's creation and the biblical essence of animal life. Several passages in the Old Testament underscore the equation of animal blood with soul: Hebrew priests worshipping in the temple dipped a finger in the blood of a sacrificed bullock and sprinkled it ceremoniously, for—in the words of Leviticus—"the life of the flesh is in the blood" and "it is the blood that maketh an atonement for the soul."[26] Although less histrionic than his Flemish forebears in his use of the blood-paint metaphor, Desportes featured a spot of red paint clinging to the ground beneath the nose of his dead hare in the lower right, like a subtle signature. Animals in Snyders's paintings, particularly dogs, often mimic or even stand in for humans while still retaining lifelike realism, as if to demonstrate the pictorial value of the material world and its chief inhabitants. In

direct imitation of her master's caress upon her chest, Desportes's spaniel plants her own paw upon the mossy belly of a felled duck. Meanwhile the greyhound that closely watches his master for visual cues from the other side of the group reveals his own physical virility through an elegant flick upward of the tail. For Desportes, as for his Flemish predecessors, matter *mattered* as the essence of their profession, and the animal, a fully material yet sentient being, served as its primary representative.

Canine Portraiture

Having developed his artistic skills simultaneously as a portraitist and animal specialist, Desportes demonstrated the many interrelationships between the two—interrelationships that disrupted the Academy's implicit hierarchy of genres, but did not appear unduly to trouble the Academicians themselves. Desportes's son Claude-François, in an account of the life and work of his father presented to the Académie in 1748, suggested that there was a certain interchangeability between human and animal in the artist's working method, but Claude-François's rationale also intimates the dawning Neo-Classical imperatives of his own era: he claimed that in order to understand the anatomy and postures of his animals, his father used human models, animals being far too active to provide sufficient time for the artist to study their bodies. The artist, in Claude-François's account, believed that "only the antique and human figure can provide the true idea of the beauty of forms, the correct proportions, and the elegance of contours, to then apply them to living animals, and even to those that are dead." For, he asserted, it was the painter's responsibility to understand the body underlying the fur or feathers, rather like the history painter's need to understand the full form of the bodies of human figures under their draperies.[27] The many studies of live animals Alexandre-François made throughout his career—and a notable lack of classically inspired human figures—belie his son's efforts to "humanize" his working method, but they do demonstrate the artist's concern with comprehending and capturing the physical truth of his animal subjects. Claude-François correctly perceived the symbiosis between the portraitist's interest in the draped human body and the animal specialist's interest in anatomically accurate mammals and birds "clothed" in coats and feathers.

Three years after he was received into the Academy, Desportes gained an opportunity once again to cross its hierarchical distinctions by painting literal portraits of Louis XIV's favorite dogs, in this case at the king's own behest

(Figure 1.4).[28] Commissioned for the antechamber of Louis XIV's apartment at his pleasure palace of Marly, the large portraits featured specific dogs from the royal hunting pack in almost life-size proportions, both individually and in small groups, each posed alertly before winged game in extensive landscape settings. Desportes painted their names in capitals directly into the portraits and highlighted the letters in gold, a technique that recalls Renaissance court portraiture, such as that of Daniel Dumonstier.[29] In Desportes's triple portrait of *Ponne, Bonne, and Nonne* (Figure 1.4), the artist varied the attitudes of the dogs to suggest their different responses to the partridges they are about to surprise from behind a vegetative screen. Each carefully distinguished as to markings, eye color, and fur texture, the spaniels emerge as three separate canine personalities. They are set in the foreground of the landscape, which is shaped to complement their postures in the manner of human portraiture, with vertical foliage bracketing the group and panoramic, rolling hills that echo their agile movements.[30]

In 1714, Louis XIV commissioned four additional portraits from Desportes to serve as overdoors at the pleasure palace of Marly; for these, the artist painted

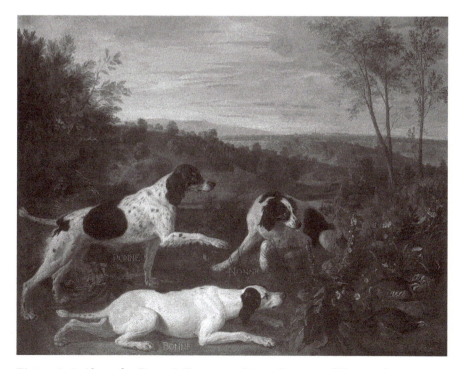

Figure 1.4 Alexandre-François Desportes, *Ponne, Bonne, and Nonne*, oil, *c.* 1702; Paris, Musée de la chasse et de la nature; photo: Nicolas Mathéus.

individual dogs, each confronting a bird of prey within a complementary landscape. One among them, a portrait of Mite with her alert body curved in a particularly pleasing spiral as she stalks a pheasant and a partridge, repeats a portrait, in the same attitude, that appeared of this dog in a double portrait with Folle for the 1702 commission (both works now in Paris, Musée de la chasse et de la nature). While Mite had been alive at the time her first portrait was painted, that of 1714 was posthumous and appears to have been a special request on the part of the old king for preserving the image of a particularly favored hunting dog.[31] In his ensuing career as a painter of generic animal scenes, Desportes would often draw upon the attitudes of his royal canine portraits to create believable animal actors. His oil on paper *Hound Stalking a Pheasant*, which became part of the large bequest of the artist's works to the royal porcelain manufactory of Sèvres, essentially repeats, in reverse, Mite's look and attitude (Figure 1.5).[32] Just as Academic portraitists employed a pictorial discourse of gestures, attitudes, and compositional conventions to imply the particular status of their subjects, Desportes developed a corresponding animal rhetoric that activated

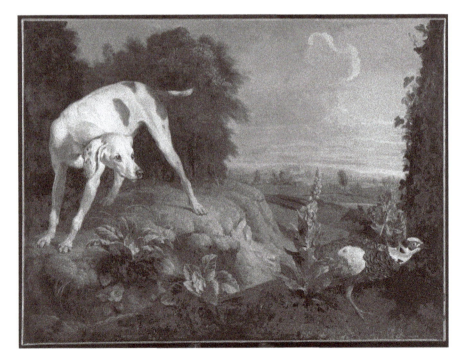

Figure 1.5 Alexandre-François Desportes, *Hound Stalking a Pheasant*, oil on paper, *c.* 1720s–30s; Lille, Palais des Beaux-arts/Manufacture nationale de Sèvres; photo: © RMN-Grand Palais/Art Resource, NY.

his creatures within their material surroundings. Once known and recognized as Mite, the white hound could re-emerge in sundry other paintings—even, perhaps, in an enameled porcelain plaque whose "environment" was a well-appointed salon.[33]

Louis XV would follow in the path of his great-grandfather the following decade, commissioning both Desportes and Oudry to paint portraits of his own favorite dogs for his country château at Compiègne. These group portraits also featured the dogs' names emblazoned in gold directly into the paintings.[34] Although portraits of dogs, especially those of the nobility, had appeared sporadically in European art beginning in the mid-sixteenth century, none before had been identified by name within the painting itself, nor identified so closely with a specific royal household.[35] Both Louis XIV and Louis XV treated their favored hunting dogs much as a canine retinue, a distinction that would be physically matched by the portraits themselves. The French kings moreover constructed interior environments for the most favored canines that gave material shape to Desportes's visual ecologies. At Marly, the first set of dog portraits was hung above two sleeping niches, elegantly veneered in walnut with ebony fillets and flowers ornamenting their entrances.[36] Similarly elaborate sleeping niches were outfitted at Versailles in the "Room of the king's dogs," a practice which Louis XV continued in the sleeping boxes and benches he had installed for his own favorite dogs in the "antichambre des chiens." The coving of this reception room featured a decorative frieze depicting scenes of the hunt: hunting hounds valiantly bring down deer and other game in a restrained Rococo style.[37] Numerous anecdotes attest to the personal favor the kings showed toward their dogs, confirming the oft-repeated assertions in contemporary hunting literature that the dogs—especially the white hounds whose portraits stand out in Louis XIV's series—served their masters as loyal and worthy "soldiers."[38]

Grotesque Inversions

At the time when he was raising the animal into prominence as a pictorial subject, Desportes also fashioned animals as decorative protagonists through his service to the innovative designer Claude III Audran. Like his fellow court artist Jean I Bérain, Audran was dissolving the monumental history paintings and robust decorative flourishes that had dominated ceiling and wall design earlier in the reign of Louis XIV into a sensuous play of human, animal, and ornament. Audran's delicate, filigree patterns, which the French called

arabesques or *grotesques*, recall Renaissance *grottesche*, which were themselves fashioned after ancient Roman prototypes, and featured animals sporting with or even transforming into human figures.[39] Audran brought to this model a new emphasis upon the figures themselves as full-bodied, miniature performers interacting in fragmented scenarios. In their wit and defiance of ontological protocol the resulting *grotesques* were akin to the impromptu performances enacted outside of traditional hierarchy in the context of court masquerade balls.[40] It was to paint these miniature actors into his decorative structures that Audran employed Desportes, as well as Oudry, Antoine Watteau, and other figural artists around the turn of the eighteenth century.

Among the patrons of Audran's arabesques was the king's son, the Dauphin, a leader of court fashion and social life;[41] equally important to the growth of the genre was the young and forward looking duchesse de Bourgogne, for whom Louis XIV commissioned Audran to create his novel arabesque fantasies at the Ménagerie of Versailles. Decorative fragments thought to be ceiling studies either for the Dauphin's château of Meudon or for the redesign of the Ménagerie feature tiny huntresses, leaping and barking hounds, falcons perched moodily on branches of ornament, a wounded stag, and sundry other creatures complementing as if by nature the flow of the lively ornament (Figure 1.6).[42] The motley figural cast, attributed to Desportes, would have been equally at home at Meudon, well known for its extensive woods, and at the Ménagerie, a structure designed expressly to highlight its revolving animal population in radiating enclosures, woodland and farm.[43] Whereas the main viewing pavilion of the Ménagerie featured lifelike and often life-sized paintings of animals

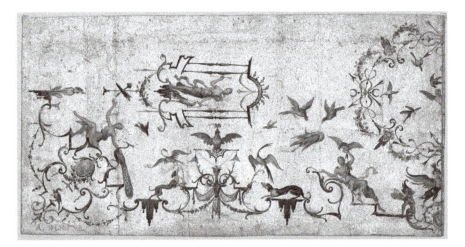

Figure 1.6 Claude III Audran and Alexandre-François Desportes (attrib.), Fragment of Decorative Design, gouache on gold ground, *c.* 1698–9; Paris, Les Arts Décoratifs, musée des Arts décoratifs; photo: ©Paris, Les Arts décoratifs/Jean Tholance.

by Nicasius Bernaerts,[44] the elegant ceilings made subsequently for the duchesse de Bourgogne would have underscored the potential of animal subjects to stimulate the senses through an engaging sense of play.[45]

Cultural progressives such as the Dauphin and the duchesse de Bourgogne might also have noticed how archly these liminal creaturely fantasies invoked the fairy tales of Mme d'Aulnoy, Charles Perrault, and others that were becoming popular among the elite around the turn of the eighteenth century. Perrault drew upon the traditional "personalities" of familiar animals to create memorable heroes and anti-heroes such as Puss in Boots and Red Riding Hood's Wolf. Madame d'Aulnoy, on the other hand, often made her characters change shape, passing from human to animal and back.[46] As in the *Fables* of La Fontaine, which also gained instant popularity when they were published in the last third of the seventeenth century, readers were encouraged to identify with the fairy tales' animal protagonists, who speak and act anthropomorphically, but retain some of their native animal characteristics as well.[47] Humans and animals also readily exchange forms, destabilizing ontological identity and in the process complicating narratives. For example, in d'Aulnoy's *L'Oiseau bleu (The Blue Bird)*, published in her first collection of stories in 1697, the king "Charmant" is transformed by a vindictive fairy into a magnificent blue bird, complete with an avian crown in the form of a white feather. At first expressing his intense emotions through song, in the manner of a bird, when the bird-king finds his beloved princess Florine, who is imprisoned in a tower, he speaks to her in human language in order to convince her who he is.[48] On occasion humans actually fall in love with animals, as the princess Rosette does upon seeing a peacock whose sheer beauty overcomes her.[49] Although Desportes and Audran do not narrate any tales in such designs as that illustrated in Figure 1.6, the free interplay of humans and animals resonates with the species inversions and interactions of d'Aulnoy's stories. The transspecies sprite perched at the lower right edge of the design evokes the actual process of king Charmant's transformation from human to avian, as his arms become feathered wings, his legs and feet dark and thin, his body suited with long blue plumes, and his crown converting to feathers (Figure 1.7).[50]

The art of telling fables and fairy tales had been cultivated in the elite *salon* culture of the seventeenth century,[51] and even at Versailles an entire garden grove—the Labyrinth, installed between 1666 and 1673—was dedicated to the animal fables of Aesop, enacted by animal sculptures spewing "words" in the form of fountains.[52] Cross-species play also found its way into courtly masquerade balls, such as the "sérail du Grand Seigneur" which took place at the royal château of Marly in 1700, in which courtiers and professional performers paraded as animals.[53] Many historians have discussed the breakdown of court protocol achieved by the masquerades, as well as the rise of aristocratic circles

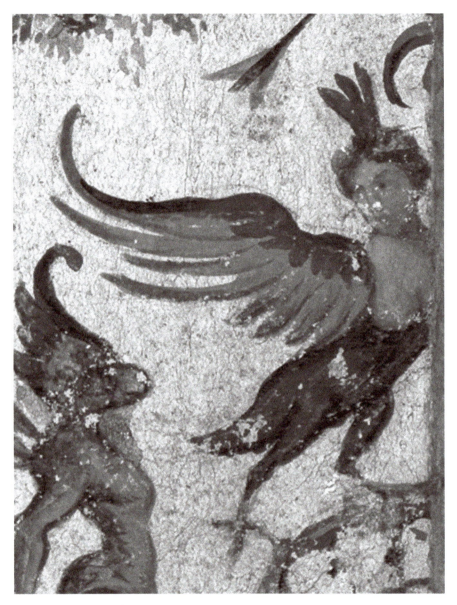

Figure 1.7 Detail of Figure 1.6.

in Paris that minimized distinctions of rank in favor of social interaction.[54] Both
the *grotesque* and the fairy tale complemented such changes within elite culture,
to a considerable extent through the medium of interspecies play. Desportes's
efforts to raise the profile of animal painting within the Academy likewise
counteracted the traditional hierarchy of genres that placed the human subject
above the animal, and the success with which he found patrons for his animal-

centered paintings testifies to the willingness on the part of the cultured elite to embrace this inversion of categories. Fables, fairy tales, and *grotesquerie* prepared cultured viewers to envision humans transformed into animals, but they also suggest a larger interest in the animal as a model for all forms of sensory life.

Animal *Fête Galantes*

Animal and ornament complemented one another at Versailles, where decoratively worked natural imagery provided the indoor environment for the kings' privileged hunting dogs, and the Ménagerie's *grotesques* propelled humans, animals, and even vegetables into dances with continuously shifting species of partners and performers. If the fairy tale helped stimulate the imaginations of visitors to the newly decorated Ménagerie, the elegant sleeping niches made for Louis XIV's dogs and the animal hunts appearing in the covings of Louis XV's "antichambre des chiens" could be said to envision the "dreams" of the rooms' canine sleepers. Desportes drew upon the sensory and imaginative potential of animal bodies infused with ornamental movement as he developed his animal paintings during the first quarter of the eighteenth century. The resulting works, although mostly nonhuman in casting, uncannily evoke social, even talkative group interaction.

In contrast to his paintings of animal hunts, which followed the Flemish tradition of impassioned chases and violent confrontations, Desportes's more decorative depictions of animal life recall the strategies that his contemporary Watteau was employing to create his own scenes of human intercourse inspired by theater, dance, and ornamental design.[55] Both artists resourcefully drew from their experiences working for Audran, as well as other decorative prototypes, to develop bodies subtly infused with ornamental structures that not only complemented a salon but reflected its social dynamic as well. Although Desportes's scenes were always called animal paintings, they intersect on multiple levels with the *fête galante* of Watteau. They were, in effect, animal *fêtes galantes*.

Other projects he undertook for the crown in the years around the turn of the eighteenth century also helped Desportes to work out a more sensual and interactive animal genre. Employed as an artist-restorer in the gardens of Marly between 1704 and 1714, he painted and retouched ornamental sculptures of birds "perched" on rocks in the Pool of the Nymph and the Pool of Carp.[56] The original inspiration for these painted lead garden animals may have been the Aesop fountains in the Labyrinth at Versailles, which also featured many brightly painted birds and which Desportes himself would be employed to retouch in 1722.[57] He also received a commission from the Gobelins tapestry

manufactory to refurbish the monumental cartoons now known as the *Anciennes Indes*. Originally painted by Albert Eckhout and Frans Post and given by Prince Maurice of Nassau as a gift to Louis XIV in 1679, the paintings underwent considerable restoration even before Desportes was employed to repaint the animals in 1692–3 in preparation for weaving tapestries.[58] Although the artist did not make any significant changes of his own at this stage, the experience of reviving these scenes of exotic animal life may have inspired him to use tapestry cartoons as an inventive prospect for his own animal subjects. Both the *Anciennes Indes* and the Gobelins' more monumental *Royal Residences/Months of the Year* tapestries, which feature life-size birds and mammals designed by Pieter Boel moving freely in the lower foreground, demonstrate how adept the tapestry medium was for reproducing the tactility of feathers, fur, and sinewy hide.[59] In the latter half of the 1710s, Desportes produced a number of his own cartoons for panels on decorative screens to be woven by the royal manufactory of Savonnerie.[60] Within elegant Rococo frameworks of ornament and vegetation, mammals and birds play, spar, and appear to converse in woven equilibrium.

A screen composed of five panels, produced by the Savonnerie in about 1740 after Desportes's cartoons, represents the way his various images of animals could be juxtaposed to create tactile intimations of creaturely social life (Figure 1.8).

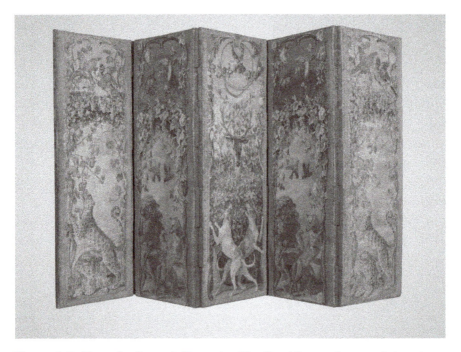

Figure 1.8 Alexandre-François Desportes, Five-Panel Screen, Savonnerie tapestry, *c.* 1740; Paris, Louvre; photo: © RMN-Grand Palais/Art Resource, NY.

The one, centrally placed symmetrical design, featuring two hounds barking at an impassive stag head, distantly echoes heraldic emblems but more immediately recalls the decorative strategies employed by Audran and Desportes in their ornamental ceiling designs. This hunting imagery is flanked by identical screens depicting two Aesopian foxes that appear to be conversing, one of them rising, humanlike, on hind legs (Figure 1.9). The subject of their debate evidently concerns

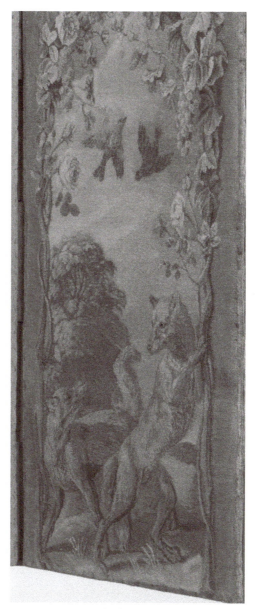

Figure 1.9 Detail of Figure 1.8.

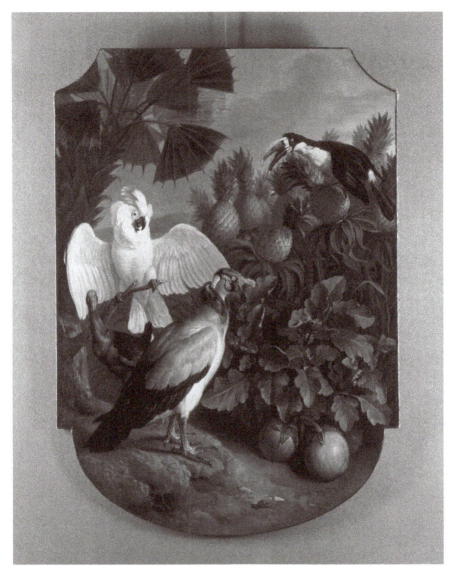

Figure 1.10 Alexandre-François Desportes, *Cockatoos, Vulture, and Toucan*, oil, early 1720s; Paris, Musée de la chasse et de la nature; photo: Nicolas Mathéus.

the feasibility of reaching the bunch of grapes suspended on a vine intertwined with roses above. Modulated values of reddish-brown wool wefts expertly simulate the hairy bodies and fluffy tails of the canine pair; their appeal to our own sense of touch is mimicked by the standing fox, who digs his clawed paws into the viney stalks, matching sinewy foreleg to entwined vegetation. The outer panels feature

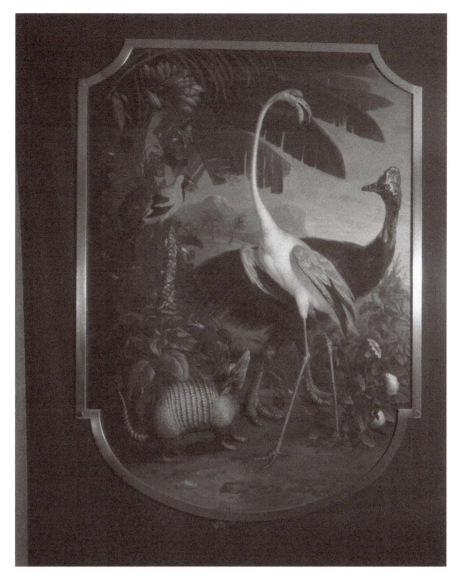

Figure 1.11 Alexandre-François Desportes, *Armadillo, Flamingo, and Cassowary* oil, early 1720s; Paris, Musée de la chasse et de la nature; photo: Nicolas Mathéus.

leopard couples feasting on grapes, perhaps in homage to Bacchus. Together they add the sense of taste to the tactile animal festivities. Like the hounds and the "standing" fox, the leopard that stretches up to reach a hanging bunch of fruit forms a diagonal that both enhances the compositional flow and imparts a sense of graceful animation to its body. Taken as a set that quite literally unfolds before

the eyes, the five-panel screen acts much as a gracious, wooly performance: an animalian *ballet à entrées*.

Animal representation, decorative structures, and woven substance interact in such works as the Savonnerie screen to simulate the material life of a *salon's* refined environment. Canine and feline bodies, receptive to animation by design, could prove particularly adept at fostering the ornamental play that characterized the Rococo interior. In paintings commissioned for such interiors, Desportes furthered his efforts to enliven his animal groups through sensory interconnections among animal subjects and encompassing environments both within and beyond the frame. As Watteau was doing during the 1710s, Desportes mined both the compositional strategies of ornament and its potential for bringing bodies together as social beings within a richly material realm.[61]

In a series of four overdoors that he made for the Château of Bercy, probably in the early 1720s, the artist crafted two pairs of closely integrated confrontations among animals, two based upon canine imagery evocative of the hunt, and two featuring exotic birds (as well as a curious armadillo) (Figures 1.10–11).[62] Intended to be set within carved ornamental frameworks, Desportes's paintings feature crisply painted animals gathered in close proximity to one another within lush landscape environments. In the pair featuring exotic groups, Desportes turned the animals toward one another and opened a number of beaks, as if to imply conversations. Viewers familiar with the fountain sculptures in the Labyrinth of Versailles may have been reminded of the simulated words quite literally pouring forth from the mouths of its foxes, crows, and other creatures. But Desportes's paintings are just deadpan enough to avoid any overt anthropomorphism, and instead convey a pleasing, even elegant sociality.

As an artist equally fluent in painting and decorative design, Desportes may have incorporated into in his overdoors certain tactics of animal representation found in Asian porcelain, especially the Japanese export ware that was beginning to become fashionable in France. Although much more spare in its design, a Japanese plate from *c.* 1700 features a three-way "conversation" among two brightly enameled birds and a sprightly red dragon (Figure 1.12). Their open mouths, shimmering colors, and crossing diagonal relationships can all be found in Desportes's pendants of exotic birds, albeit on a more operatic scale. In their bright, curious "costumes" and convivial, environmentally situated groupings, the assembled animals of the Bercy overdoors also parallel the alluring works Watteau was painting in the years leading up to his *Pilgrimage to the Island of Cythera* of 1716, his *morçeau de réception* for which the Academy would create

Figure 1.12 Japanese Kakiemon Dish, porcelain, *c.* 1700; New York: Frick Collection, Gift of Henry H. Arnhold, 2019; photo: Frick Collection, NY.

the designation *fête galante*. In the proto-*fête galante* pendants by Watteau known as *The Enchanter* and *The Adventuress*, for example, he used elegant diagonals to assemble humans in groups that imply interaction but avoid any literal description of it (Figures 1.13–14).

In both artists' works, a variation of gazes keeps the implied sociality alive: some characters look at one another, others stare into space while displaying their elegantly costumed bodies, and both contain one character that looks directly out at the viewer, as if to imply that we, too, form part of their uncanny gathering.[63] Desportes keeps Watteau's emphasis upon rich surface effects, the variety of postures, and the air of sociality, but he switches—like a fabulist—the identity of his actors from the human to the animal. Indeed, his use of curiously designed creatures rather than costumed men and women calls attention to

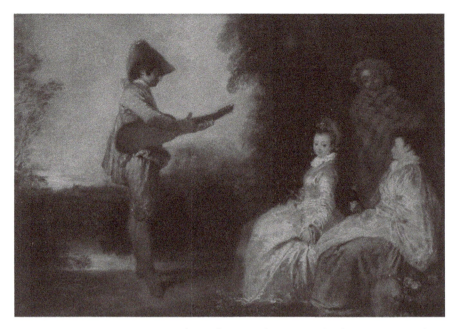

Figure 1.13 Antoine Watteau, *The Enchanter*, oil, *c.* 1715; Isle of Arran, Scotland, Brodick Castle; photo: National Trust for Scotland, Brodick Castle.

the performative agency that they all share. Resisting story-telling, amorous or otherwise, both artists focus instead upon the material animation of their gatherings.

As a specialist in animal painting, Desportes had a vested interest in creating works whose nonhuman protagonists would captivate the interest of his clientele. His ambitious, genre-defying *Self-Portrait as a Hunter* suggests that in making such innovative paintings as the Bercy overdoors he was likewise attempting to make something more out of animal painting than the categories of still life or even hunt scenes would accommodate. The *fête galante*'s replacement of narrative and rhetorical specificity with elegant social dynamics gave it enough flexibility to allow an inventive animal artist to borrow some of its strategies, while the continued fashion for fairy tales and fables in early eighteenth-century France would have also made his audience receptive to moving back and forth between species with alacrity and interest. Over the next several decades of his long career, Desportes would refine the "animal *fête galante*" in works made largely for aristocratic clientele, and he would soon be joined in this pursuit by Oudry and other eighteenth-century animal specialists such as members of the Huet family. A veritable menagerie of animals would meanwhile begin appearing in portable arts intended for the ornamentation of

Figure 1.14 Antoine Watteau, *The Adventuress* oil, *c.* 1715; Isle of Arran, Scotland, Brodick Castle; photo: National Trust for Scotland, Brodick Castle.

interiors—metalwork serving vessels, table decorations, and firedogs; soft- and hard-paste porcelain sculpture; carved *boiserie* and molded plaster reliefs such as those in Louis XV's "antichambre des chiens"; as well as myriad re-workings of tapestry cartoons on furniture.[64] While Desportes's paintings were not the sole inspiration for the prevalence of the animal in Rococo art and design, his animal *fêtes galantes* provided a vital example—material, sensual, and often wittily self-deprecating for the human, in the manner of fables.

All of these elements emerge in the *Allegory of the Senses*, one of a pair of paintings that Desportes made in 1717 for the dining room of the Château de La Muette, a retreat near the Bois de Boulogne that the Regent, Philippe d'Orléans, had recently purchased for his daughter the duchesse de Berry (Plate 2). About ten years earlier, Watteau had painted a large group of *chinoiserie* figures for the "Chinese *cabinet*" installed by La Muette's previous owners, the royal *intendant des finances* Joseph-Jean-Baptiste Fleuriau d'Armenonville and his wife. Desportes's two paintings feature more complex gatherings of animals than those he had assembled for the overdoors at the Château of Bercy, while an exquisite, gilt-bronze mounted Chinese porcelain bowl in the *Allegory of the Senses* pays subtle tribute to the rising vogue for Chinese

objects which the d'Armenonville couple had encouraged.[65] As Georges Lastic and Pierre Jacky have observed, Desportes drew partly upon designs of Gilles-Marie Oppenord—an artist whom Watteau also knew—for designing the architectural setting of the *Allegory of the Senses*, and the use of a balustrade in combination with animals and musical instruments had appeared in the tapestries of the *Royal Residences/Months of the Year*.[66] But while the latter use foreground animals in the manner of servants or courtiers "introducing" the scenic displays of Louis XIV's residences, Desportes makes the complex interaction among birds and mammals the primary event. Desportes's animals, despite the abandoned human trappings that surround them, appear fully to "own" their setting.

In posing and configuring his gregarious animal gathering, Desportes moreover used decorative strategies to give them an aura of aristocratic elegance, much as Watteau was doing in fashioning his later, more complex *fêtes galantes*. Peacocks displaying their sweeping tail feathers had, in the later part of the previous century, begun to make frequent appearances in Dutch animal paintings by specialists such as Melchior d'Hondecoeter and Jan Weenix.[67] The showy birds almost automatically connoted nobility through a long association with palace pleasure gardens and, in earlier European history, with aristocratic dining. Their presumably innate officiousness had been emphasized by Hondecoeter, and Desportes carries on the practice by directing his own peacock's squawking attention to the two crowned hoopoes that perch upon and launch from the urn in the upper right. Other "conversations" occupy most of the rest of the participants: the monkey turns to chatter at the grey parrot while sawing away on his well-used violin, coated with rosin dust, while the white hound stops as he ascends the stairs to glance back at a red macaw that appears to be "speaking" to him. Since the hound stands beside flowers that signal the sense of smell, his own lifted snout could also imply his particularly keen canine capacity for scent. Setting up an interconnective series of diagonals that keep the eye moving around the group, the varied gazes and poses of Desportes's animals imply sociality while also creating a strong composition that could hold its own on the dining room wall.

Desportes may well have been inspired by Watteau in creating the slightly misty, sun mottled trees and sky of the background, as Lastic and Jacky have suggested.[68] But perhaps even more evocative of his colleague's *fêtes galantes* are the postural attitudes of Desportes's animals, particularly the white hound whose complicated, spiraling form recalls such poignant figures as the central

woman poised at the top of the hill in Watteau's *Pilgrimage to the Island of Cythera* (Figure 1.15), a work completed the same year as Desportes's painting for La Muette. Watteau had been exploring the elegant conceit of the spiral posture with turned, slightly angled head as early as in his figures for the Chinese cabinet at La Muette, works Desportes would of course have been familiar with. The hound in his own painting plays a compositional role similar to that performed by the central woman in Watteau's Cythera painting: both link one diagonal slope with another, opposing one through the dual directionality of turned heads and bodies. The dog's lifted paw, while recalling the linear attention for which hunting canines could be trained, also gives the animal an almost balletic grace, reinforcing the axial turn of his body—not unlike the elegant step Watteau's woman takes onto her right foot, while allowing her left foot to remain, momentarily, pointed behind her in the direction of her turned head and gaze. The coincidence of Desportes's and Watteau's strategies in designing their figures testifies to the parallel between their artistic goals in the years around 1717. Watteau himself explored the device of including unused stringed instruments amidst his social groups: the cello angled within the cluster

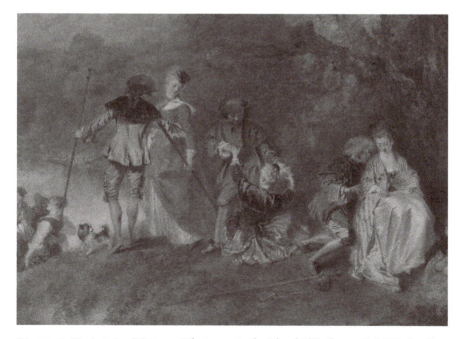

Figure 1.15 Antoine Watteau, *Pilgrimage to the Island of Cythera,* oil, 1717, detail; Paris: Louvre; photo: © RMN-Grand Palais/Art Resource, NY.

of figures on the left side of *The Charms of Life* (London, Wallace Collection) recalls the bass viol in Desportes's *Allegory of the Senses*. It was style, clearly, that the two artists shared—a legacy of their common roots in decorative service— but it was also something more: sociality so accommodating to contemporary fashions for shape-shifting, costume, and altered identities, that animals could form their own *fêtes galantes* on the dining room wall.

Throughout his career Desportes continued to infuse his decorative animal groups with sociality and sensory themes; his nonhuman players lent themselves both to depiction in painting and to recreation in tangible objects with which users could physically engage. While Desportes himself designed some of these artifacts, his imagery was extensively copied and emulated by purveyors of material goods. Watteau's arch gatherings would likewise inspire a more frankly physical afterlife in the form of intimate couples and small groups invented by François Boucher and other Rococo artists, and would be subsequently imitated in the form of porcelain and other objects of luxury, as well as furniture upholstered with tapestry. Just as the decorative uses of Watteau's imagery capitalized upon their sentimental and sensual potential, so decorative emulations of Desportes would often turn his gregarious birds into lovers, without compromising their animalistic identity. Porcelain painters such as Louis-Jean Thévenet, who worked at the royal porcelain manufactories of Vincennes and Sèvres, fashioned interactive bird couples perching, flying, and "speaking" to one another amidst elegant Rococo designs (Figure 1.16). In this soft-paste pot-pourri vessel designed by Jean-Claude Duplessis, gilt bronze leaves and porcelain flowers frame the avian encounter to create a veritable ecology of ornament. A more complex environment sets off four Kangxi bright blue porcelain parrots that perch in conversational pairs within wall lights fashioned of gilt bronze and soft-paste porcelain flowers (Figure 1.17). Likely intended by their original Chinese makers to be seen as chattering pendants, the parrots take on a new kind of domestic sociability in their Rococo settings, whose porcelain flowers, glittering bronze surrounds, and burning tapers would have materially enlivened the avian "conversation."

Desportes was likely familiar with seventeenth-century pictorial depictions of fables featuring animals, including Frans Snyders's somewhat anthropomorphizing paintings of Aesop's fables and the English illustrator Francis Barlow's strikingly lifelike engravings of animals acting out Aesop,[69] as well as earlier Dutch and Flemish prints that first established the interest in animal interaction with a moralizing, allegorical, or narrative edge. Desportes himself favored more

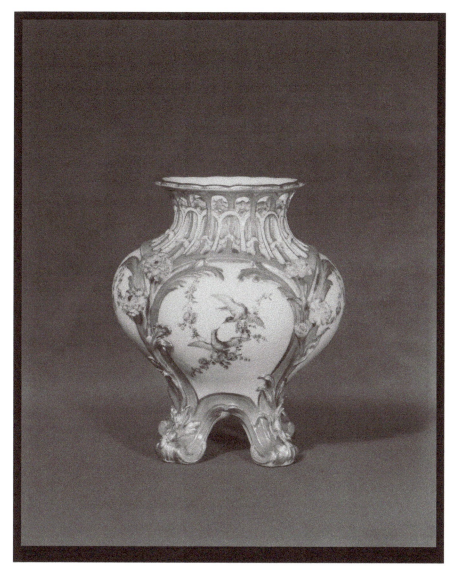

Figure 1.16 Jean-Claude Duplessis, Potpourri with paintings by Louis-Jean Thévenet, soft-paste porcelain, 1754; NY, Metropolitan Museum of Art; photo: MMA Open Access.

oblique suggestions of the animal as a social protagonist, but subsequent Rococo ornamentalists who took up the theme would sometimes use Aesop's or La Fontaine's fables to give their animal interactions recognizable stories. The small blue-green cabinet known as the "Asesop's Fables Room" in the Hôtel de Rohan,

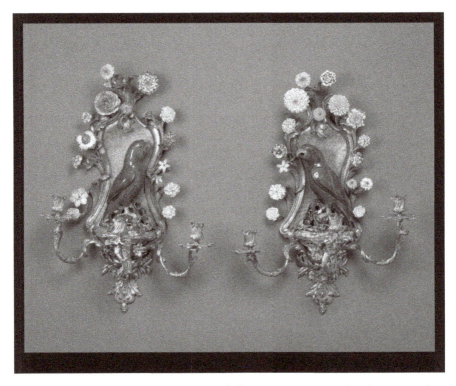

Figure 1.17 Wall Lights with Parrots and Flowers, Kangxi porcelain (1662–1722) and Vincennes soft-paste porcelain with gilded bronze (*c.* 1750); NY, Metropolitan Museum of Art; photo: MMA Open Access.

now transplanted to the Hôtel de Soubise in Paris, featured animal fables centered within elegant *boiserie* panels (Figures 1.18–19). Attributed to the master carver Jacques Verberckt and dating from the late 1730s, these tiny scenes subtly integrate the bodies of the animals into their ornamental environment. We can see this, for example, in the roundel of the "The Bear and the Bee Hives," in which animals, foliage, hives, and shed rhyme with the organic play of curves and tendrils that decoratively surround them. Although the designer based this tableau upon Barlow's illustration of the fable, the rich textural interplay of simulated matter creates a uniquely tangible effect. Interactive bodies and gilded wood mutually enliven one another and in turn fostered intimate sociability within the tiny room.

Oudry, meanwhile, was in the early 1730s working on a full set of drawings after all the fables of La Fontaine. Although probably made with an eye for publication as prints, as they finally would appear in the years just before and after his death, the drawings also served him in the 1730s as models

Figure 1.18 Jacques Verberckt (attrib.), Aesop's fable room with gilded *boiserie* panels, late 1730s; Paris, Hôtel de Rohan/Hôtel de Soubise; photo: France, Archives Nationales.

for tapestry designs at the Beauvais manufactory. In his initial position as designer for the Beauvais manufactory (he would subsequently become its director), Oudry produced numerous cartoons of animal fables taken from both La Fontaine and Aesop.[70] His sportive creatures appeared in many different woven configurations, from screens to sofas and chairs, enlivening elite interiors with animal protagonists whose interactions both echoed and physically accommodated those of the rooms' human inhabitants. These tapestries gave rise to numerous decorative offspring, best known today through the many chairs, settees, and other domestic furniture upholstered with designs featuring the most well-known animal fables. Many were produced at Beauvais after copies of Oudry's designs, but other manufactories purveyed their own imitations, such as chairs upholstered with Aubusson tapestries depicting pastoral human figures on the back and on the seat familiar animal fables such as the fox and stork (Figure 1.20). Directly pairing sensual human themes with interactive animal groups underscored and updated the parallel between human and animal material life that pervaded Desportes's animal *fêtes galantes*.

In the hands of Oudry himself, the invitation for a human user to identify with the animal subject could become more pointed, in effect transforming

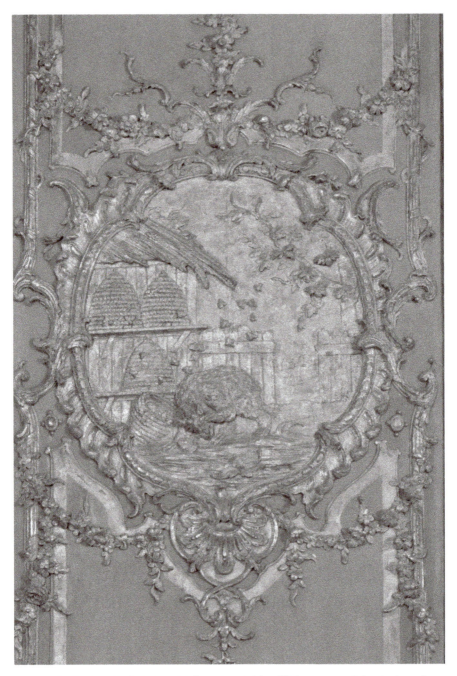

Figure 1.19 Detail of Figure 1.18 featuring Fable of "The Bear and the Beehives"; photo: France, Archives Nationales.

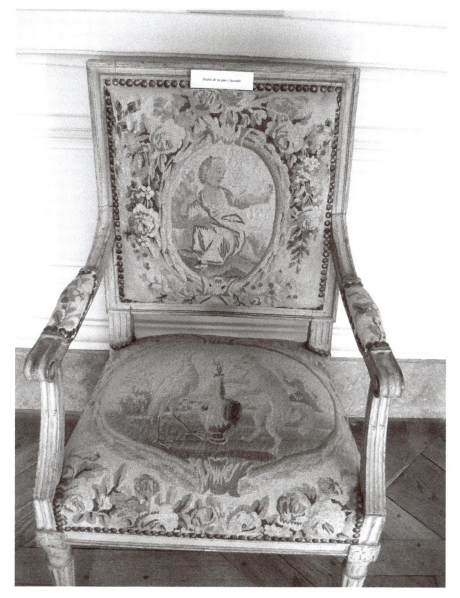

Figure 1.20 Chair (*fauteuil*) featuring fable of "The Fox and the Stork" on seat, Aubusson tapestry, *c.* 1750; Dijon, Musée des Beaux-arts; photo: author.

the incisive psychological spirit of the fable into material performance. A folding screen produced after six of Oudry's fable designs of 1739 at the Savonnerie carpet manufactory[71] features a sequence of sharply characterized animals enacting fables that project the all-too-familiar emotions of longing,

frustration, and missed opportunity. The rooster, in particular, employs a bird's rapid head movement and keen sense of vision to communicate silently with us: in seeking food amidst the matter on the ground, he finds a useless pearl, so lifts his head and shifts his eye to gaze directly outward, lest we miss this opportunity to share his ironic reflection on the relative value of all things (Figures 1.21–22). Gorgeously feathered through colorful tapestry wefts, the rooster resonates with vegetative scrollwork, decorative flowers, and even the picturesque straw, while standing out as the principal player like an animal actor on a stage. Meanwhile the useless, inedible pearl lies untouched in the foreground below.

Desportes also invited his viewers to reconsider the value of human institutions when compared with the lively agency of sensory animal existence. The painter who presented the *Self-Portrait as Hunter* as his *morçeau de reception* at the Academy in 1699 would go on to produce a number of works in which brooding humanistic subjects are displaced by noisy animal gatherings whose materiality clearly takes precedence over the representation of more abstract thought. In his large *Peacock, Monkey, Fruits and Bas-Relief*, for example (Figure 1.23), Desportes immerses the viewer in the panoply of sensual animal life unfolding in the foreground.[72] A simian actor vocalizes in the direction of a scolding peacock while reaching for a bunch of grapes; the bird's magnificent tail, the luscious fruit, and the monkey clutching his edible prize in both hands form a decorative triangle rich with sensory appeal. The chattering parrot on the right acts rather like a Greek chorus, observing, with us, the other animal players, while also calling attention to the painter's *trompe l'oeil* reliefs below the balustrade. Although peacock, grapes, and velvet fabric hide much of the mythological action depicted in this presumably modeled and fired clay, the centaur Nessus and the princess Deianeira, spouse of Hercules, are probably depicted on the left, perhaps at the very moment before the horse-man gives in to lustful temptation. Absorbed as we are in all this lively and sensuous matter, so vividly recreated by Desportes, it is only as an afterthought that we look up to find a Michelangelesque warrior lost in thought, head on hand in the traditional pose of Melancholy. This architectural sculpture, although presumably carved in marble, has none of the vibrant agency of the terracotta reliefs, or even their chipped surrounds: washed out and solitary, the pondering man has no share in the sociality nor in the life-giving properties of the material realm. Thus did the animal specialist demonstrate the value of nonhuman existence as an embodiment of artistic accomplishment.

Figure 1.21 Panel from six-panel screen featuring the fable of "The Rooster and the Pearl," after design by Jean-Baptiste Oudry; Savonnerie tapestry, before 1777; Vienna, MAK—Museum of Applied Arts; photo: © MAK.

Figure 1.22 Detail of Figure 1.21.

Figure 1.23 Alexandre-François Desportes, *Pidgeon, Monkey, Fruits and Bas-Relief*, oil, 1710s; Lyon, Musée des Beaux-Arts; photo: © MBA Lyon—RMN/René-Gabriel Ojéda.

Notes

1 See, e.g., Marc Bekoff and Jessica Pierce, *Wild Justice: The Moral Lives of Animals* (Chicago and London: University of Chicago Press, 2009), 45–6; *Random House Dictionary of the English Language*, 2nd ed., s.v., "sociality."

2 See especially Jacqueline Lichtenstein, *The Eloquence of Color: Rhetoric and Painting in the French Classical Age*, trans. Emily McVarish (Berkeley and Los Angeles: University of California Press, 1989).

3 Quoted in translation by Hannah Williams, *Académie royale: A History in Portraits* (Farnham, Surrey, and Burlington, VT: Ashgate, 2015), 83.

4 Pierre Jacky, "*L'Autoportrait en chasseur* (1699) d'Alexandre-François Desportes au Musée du Louvre," *La Revue du Louvre et des Musées de France* 3 (1997): 62.

5 Ibid., 58–65; Georges de Lastic and Pierre Jacky, *Desportes* (Saint-Rémy-en-l'Eau: Monelle Hayot, 2010), 66–71.

6 Jacky, "*L'Autoportrait en chasseur*," 58.

7 Ibid., 64.

8 Claude Lesné, "Un nouveau Santerre dans les collections du Louvre," *La Revue du Louvre et des Musées de France* (October 1989): 235–38; Jacky, "*L'Autoportrait en Chasseur*," 63–65. See also Freund, "Sexy Beasts."

9 See Jacky, "*L'Autoportrait en chasseur*," 64; Lastic and Jacky, *Desportes*, 50–2; 75–205, *passim*.

10 Louis Hourticq, "L'Atelier de François Desportes," *Gazette des beaux-arts* Ser. 5:2 (August–September 1920): 120.

11 A well-known example of an English hunt portrait is Paul van Somer the Elder's full-length depiction of Anne of Denmark with her horse and a pack of hounds (1617; Lamport, Lamport Hall). Prominent among Dutch hunt portraits is Jan Mijtens's *Mathijs Pompe van Slingelandt with Family* of c. 1655 (Stockholm, Nationalmuseum). For a reproduction of the portrait of Pieter Boel, an engraving by Conrad Lauwers after a painting by Erasmus II Quellinus, see Elisabeth Foucart-Walter, *Pieter Boel 1622–1674: Peintre des animaux de Louis XIV* (Paris: Réunion des musées nationaux, 2001), 18, Figure 1. Desportes also may have been remembering the portrait of the Dauphin embracing a spaniel on the left side of Pierre Mignard's *La Famille de Louis XIV*, 1687 (Versailles, Musée national du château); Jacky, "*L'Autoportrait en chasseur*," 62.

12 Jacky, "*L'Autoportrait en chasseur*," 60.

13 Hourticq, "L'Atelier de François Desportes," 121.

14 Lastic and Jacky, *Desportes*, 21–52; Jacky, "*L'Autoportrait en chasseur*," 61.

15 See Roger de Piles, *Cours de peinture par principes* [1709] (Paris: C.A. Jombert, 1766), 204–24.

16 Jacky, "*L'Autoportrait en chasseur*," 61.

17 Williams, *Académie royale*, 16–75, esp. p. 32.

18 Girardon's personal art collection included a bronze head of Julius Caesar, of which the work in Revel's painting is presumably a mold; Thierry Bajou, cat. entry no. 13 in *Les Peintres du roi*, 112.

19 Williams, *Académie royale*, 56–69.

20 Ibid., 131.

21 *Conférences de l'Académie royale de peinture et de sculpture pendant l'année 1667* (Paris: Frédéric Léonard, 1669), preface, n.p. The full passage, as translated by

Paul Duro, reads: "Those who make perfect landscapes are above those who only paint fruit, flowers, or seashells. Those who paint live animals are more worthy of estimation than those who only represent things that are dead and without movement. And as mankind is the most perfect work of God on earth, it is also certain that those who become imitators of God by painting human figures are more excellent than all the others. However, although it is no small thing to make the figure of a man appear as alive and to give the appearance of movement to that which has none, nevertheless a painter who only makes portraits has still not achieved this high perfection of art and may not pretend to the honor accorded to the most knowledgeable"; Paul Duro, *The Academy and the Limits of Painting in Seventeenth-Century France* (New York and Cambridge: Cambridge University Press, 1997), 9–10.

22 E.g., Aristotle, *De generatione animalium*, cited by Lovejoy, *Great Chain of Being*, 58 and 340, n. 44; Thomas Aquinas, *Summa contra Gentiles*; idem, 73–8. For the eighteenth century, see, e.g., Charles Bonnet, *Traité d'insectologie ou Observations sur les Pucerons*, 2 vols. (Paris: Durand, 1745), I, xxviii–xxix and corresponding foldout table illustration. Cf. Thomas Kirchner, "La Necessité d'une hierarchie des genres," in *La Naissance de la théorie de l'art en France 1640–1720*, ed. Christian Michel and Maryvonne Saison (Paris: Jean-Michel Place, 1997), 186–96.

23 Lovejoy, *Great Chain of Being, passim*.

24 " … Echelle des etres naturels"; Bonnet, *Traité d'insectologie*, I, xxviii–xxxi and corresponding foldout table illustration. Quotation from p. xxix.

25 For the Academy's likely political motivations in promoting the hierarchy of subjects, see Kirchner, "La Necessité d'une hierarchie des genres."

26 Leviticus 4:6; 17:11; Deuteronomy 12:23. Quotations from Leviticus 17:11.

27 "… Ce n'est que sur la figure humaine et sur l'antique, qu'on peut se former la véritable idée de la beauté des formes, de la convenance des proportions et de l'élégance des contours, pour l'appliquer ensuite aux animaux vivants, et même à ceux qui sont morts; ceux-ci n'ayant plus alors de forme apparente et déterminée, à moins que le peintre précédemment habile ne sache l'y trouver, et la débrouiller sous le poil et la plume qui les cachent, à peu près comme le peintre d'histoire doit savoir faire sentir le nu de ses figures sous les draperies qui les couvrent."; Claude-François Desportes, "La Vie de M. Desportes, peintre d'animaux" [read before the assembly of the Academy, 1748], in L. Dussieux et al., *Mémoires inédits sur la vie et les ouvrages des membres de l'Académie Royale de Peinture et de Sculpture*, 2 vols. (Paris: J.-B. Dumoulin, 1854), II, 100.

28 On this and subsequent commissions, see Lastic and Jacky, *Desportes*, 88–98; Xavier Salmon, "Cave Canem," in *De Chasse et d'épée: le décor de l'appartement du roi à Marly* (Paris: L'Inventaire, 1999), 69–76; Nicolas Milovanovic, *La princesse Palatine: protectrice des animaux* (Versailles: Perrin, 2012), 49–53.

29 See, e.g., Dumonstier's seventeenth-century chalk portrait of the duchesse de Longeville (Paris, Musée du Louvre).

30 Lastic and Jacky have shown that the landscape view depicted in *Ponne, Bonne, and Nonne* derives from a separate landscape study Desportes made and used for at least one other royal dog portrait as well; *Desportes*, 91–2.

31 Ibid., 95–8.

32 See also the oil on canvas in *L'Atelier de Desportes: Dessins et esquisses conservés par la Manufacture nationale de Sèvres* (Paris: Réunion des musées nationaux, 1982), 31, no. 12.

33 Despite the fact that this and numerous other drawings and oil paintings by Desportes formed part of the collection acquired by the Sèvres porcelain factory in 1784, the number that actually served as models for porcelain may have been limited; see Tamara Préaud, "L'Atelier de Desportes," *L'Atelier de Desportes*, 18–23.

34 Lastic and Jacky, *Desportes*, 204; Opperman, *J.-B. Oudry*, 124–8.

35 See Edgar Peters Bowron, "An Artist's Best Friend: Dogs in Renaissance and Baroque Painting and Sculpture," *Best in Show: The Dog in Art from the Renaissance to Today* (New Haven and London: Yale University Press for the Museum of Fine Arts, Houston and the Bruce Museum, Greenwich, 2006), 1–37.

36 Milovanovic, *La princess Palatine*, 52.

37 Ibid., 49; Pierre de Nolhac, *Le Château de Versailles sous Louis Quinze* (Paris: Champion, 1898), 46–7; 50, n. 7; 54.

38 Chevalier de Mailly, *Éloge de la chasse, avec plusieurs avantures surprenantes et agreables qui y sont arrivées* (Paris: Jean-Luc Nyon, 1723), 5: dogs are "comme de braves soldats ..." Early modern literature on the hunt unanimously praises the white dogs as the most "noble": see, e.g., Robert de Salnove, *La Vénerie royale* (1655] (Paris: Emile Nourry, 1929), 29; Antoine Gaffet, sieur de La Briffardière, *Nouveau traité de Venerie contenant la chasse du cerf, celles du chevreuil, du sanglier, du loup, du lievre et du renard ...*, rev. ed. (Paris: Nyon, 1750), 149–50.

39 The best-known examples of Renaissance *grottesche* made in emulation of ancient Roman design were those painted by Giovanni da Udine, under Raphael's direction, in about 1516–17 in the *Loggetta* of the Cardinal Bibbiena in the Papal Palace of the Vatican. These were inspired in part by the newly discovered subterranean rooms of Nero's palace (the *Domus Aurea*) in Rome.

40 See Sarah R. Cohen, *Art, Dance and Society in French Culture of the Ancien Régime* (New York and Cambridge: Cambridge University Press, 2000), 110–24.

41 Katie Scott, *The Rococo Interior: Decoration and Social Spaces in Early Eighteenth-Century Paris* (New Haven and London: Yale University Press, 1995), 137–40.

42 Lastic and Jacky, *Desportes*, 50; see also 286, n. 44. Cf. Kimball, *The Creation of the Rococo*, 107.

43 On the European menagerie and that of Versailles in particular, see especially Gustave Loisel, *Histoire des ménageries de l'antiquité à nos jours*, 3 vols. (Paris: O. Doin & fils, 1912), II. See also Gérard Mabille, "La Ménagerie de Versailles," *Gazette des Beaux-arts* 8:6 (January 1974): 5–36; Vincent Delieuvin, "Le Décor animalier de la Ménagerie de Versailles par Nicasius Bernaerts," *Bulletin de la Société de l'Histoire de l'Art Français Année 2008* (2009): 47–80; Gérard Mabille and Joan Pieragnoli, *La Ménagerie de Versailles* (Arles: Honoré Clair, 2010); Peter Sahlins, *1668: The Year of the Animal in France* (New York: Zone Books, 2017), 49–121.

44 In 1709, the main viewing salon of the Ménagerie featured sixty-one such lifelike paintings of animals; Loisel, II, 122.

45 See Meredith Martin, *Dairy Queens: The Politics of Pastoral Architecture from Catherine de' Medici to Marie-Antoinette* (Cambridge, MA and London: Harvard University Press, 2011), 103–5.

46 E.g., "Madame D …" [Marie-Catherine Le Jumel de Barneville, baronne d'Aulnoy], *Les Contes des fees*, 4 vols. (Paris: [publisher unknown], 1697); idem, *Contes nouveaux ou les fées à la mode* (Paris: [publisher unknown], 1698). Charles Perrault, *Histoire, ou contes du temps passé, avec des moralités [a.k.a. Contes de ma mère l'oye]* (Paris: C. Barbin, 1697). See also Mary Elizabeth Storer, *La Mode des contes des fées* (Paris: Champion, 1928); Anne Defrance, *Les Contes des fées et les nouvelles de Madame d'Aulnoy (1690-1698)* (Geneva: Droz, 1998), *passim* and esp. 115–54.

47 Jean de La Fontaine, *Fables choisies … mises en vers par m. de La Fontaine* (Paris: Claude Bardin, 1668); idem, *Fables choisies* (Paris: Claude Barbin, 1678); idem, *Fables choisies, mises en vers par Mr. de la Fontaine* (Paris: Claude Barbin, 1694). Numerous other editions of the *Fables* were published both in France and in Amsterdam in the decades around the turn of the eighteenth century.

48 Marie-Catherine Le Jumel de Barneville, baronne d'Aulnoy, *Les contes des fées de Madame D … …* [1697] (Paris: Tiger, 1815), 3–78.

49 See Defrance, *Les Contes … de Madame d'Aulnoy*, 134.

50 d'Aulnoy, *Les contes des fées de Madame D … …*, 23–4.

51 See Storer, *La Mode des contes des fées*, 9–24; Defrance, *Les Contes des fées et les nouvelles de Madame d'Aulnoy*, 12–13.

52 "Les animaux … sont si bien désignez, qu'ils semblent estre dans l'action mesme qu'ils representent, d'autant plus que l'eau qu'ils jettent, imite en quelque sorte la parole que la Fable leur a donnée"; Charles Perrault (attrib.), "Description du Labyrinthe de Versailles," in *Le Labyrinthe de Versailles* (Paris: Imprimerie royale, 1677), 4. On the Versailles Labyrinth, see also Élisabeth Maisonnier and Alexandre Maral, eds., *Le Labyrinthe de Versailles: du mythe au jeu* (Paris: Magwellan & Cie, 2013); Sahlins, *1668: The Year of the Animal*, 311–48.

53 Louis François de Bouchet, marquis de Sourches, *Mémoires du marquis de Sourches sur la Règne de Louis XIV*, 13 vols., VI (Paris: Hachette, 1882), 231–2; cf. Katrina

London, unpublished M.A. thesis, "Aping the Aristocracy: Animals in the Painted Decoration of French Interiors, 1690–1758," Bard Graduate Center, 2012, 12–13; 57–8.

54 E.g., Scott, *The Rococo Interior, passim*; Cohen, *Art, Dance and the Body, passim*.

55 Cohen, *Art, Dance, and the Body*, 166–241.

56 Lastic and Jacky, *Desportes*, 110–11; 302–5. The records of payment indicate that Desportes was employed both for painting these sculptures, and occasionally also for "retouching" or "repainting," so it is possible that some of his work there was restorative rather than original.

57 Documented in payments to Desportes; see ibid., 306–7.

58 Ibid., 32–3.

59 See Charissa Bremer-David, *Woven Gold: Tapestries of Louis XIV* (Los Angeles: The J. Paul Getty Museum, 2015), 115–21. Seven sets of *The Royal Residences* were produced in the Gobelins manufactory between 1668 and 1713 (117).

60 Lastic and Jacky, *Desportes*, 139.

61 For Watteau's development of this artistic approach, see Thomas E. Crow, *Painters and Public Life in Eighteenth-Century Paris* (New Haven and London: Yale University Press, 1985), 58–65; Cohen, *Art, Dance and the Body*, 186–94.

62 See Pierre Jacky, "Alexandre-François Desportes (1661–1743): quatre dessus-de-porte provenant du château de Bercy entrent à Chambord," *Revue du Louvre* (1996, no. 3): 62–70.

63 The versions of *The Enchanter* and *The Adventuress* reproduced in Figures 1.12–13 are the second Watteau made of these pendants. While his paintings mirror one another compositionally, Desportes's pair harmonize visually but present two quite different groups, in the spirit of his multi-panel screens. Only one of Desportes's overdoors for Bercy (Figure 1.10) features a bird gazing directly out at the viewer.

64 A small sampling can be found in *L'animal miroir de l'homme: petit bestiaire du XVIIIᵉ siècle* (Paris: Les musées de la ville de Paris and Musée Cognacq-Jay, 1996).

65 See Katie Scott, "Playing Games with Otherness: Watteau's Chinese Cabinet at the Château de la Muette," *Journal of the Warburg and Courtauld Institutes* 66 (2003): 189–248.

66 Lastic and Jacky, *Desportes*, 170, 172.

67 See, e.g., Hondecoeter's *Peacocks* of 1683 (New York, Metropolitan Museum of Art) and *Peacock and Peahen* of 1681 (Paris, Le Petit Palais, Musée des beaux-arts de la ville de Paris). In both paintings, sunflowers enhance the aura of nobility evinced by the showy birds.

68 Lastic and Jacky, *Desportes*, 170.

69 E.g., Aphra Behn, et al., *Aesop's Fables with His Life in English French and Latin Newly Translated with One Hundred and Twelve Sculptures …* (London: H. Hills for F. Barlow, 1687).

70 The exact nature and extent of Oudry's imagery used for tapestry have been much discussed, with no firm resolution as to the artist's direct participation. See Robert Genaille, "Les Fables de La Fontaine en tapisseries de Beauvais; contribution à l'étude de J.-B. Oudry," *Mémoires de la Société d'Archaeologie, Sciences et Arts du Départment de l'Oise* 27 (1933): 439 and 440–9; Alain-Marie Bassy, *Les Fables de La Fontaine: Quatre siècles d'illustration* (Paris: Éditions Promodis, 1986), 90, 262; Opperman, *Jean-Baptiste Oudry* (1977), 1:384–5; 2:925–6; idem, *J.B. Oudry* (1983), 150

71 See Elizabeth Benjamin, catalogue entry in Daniëlle Kisluk-Grosheide and Bertrand Rondot, *Visitors to Versailles: From Louis XIV to the French Revolution* (New Haven and London: Yale University Press for the Metropolitan Museum of Art, 2018), 200–1; Pierre Verlet, *The Savonnerie: Its History. The Waddesdon Collection* (Fribourg: Office du Livre for the National Trust, 1982), 302–3, Figure 185. The fables illustrated in the six panels were all Aesopian in origin but were included by Jean de La Fontaine in his own collections of fables, the most popular eighteenth-century source for fable literacy. The pose of the rooster in *The Rooster and the Pearl* bears some relation to Oudry's design for the animal in his illustration to the fables of La Fontaine, his ongoing graphic project of the 1730s. As Verlet notes (303–6), large Savonnerie folding screens such as Oudry's were highly valued by the French royalty, likely due to their costly, labor-intensive medium; they were used in eighteenth-century royal antechambers and given by Louis XV and Louis XVI as very select diplomatic gifts.

72 Desportes painted a variant on this painting in which animal bodies just felled in the hunt share the material stage with fruit, a bass viol, and a relief of sporting putti (Gien, Musèe international de la chasse).

The Sensitive Animal

Chardin's Animal Subjects

Charles-Nicolas Cochin, in his account of Jean-Siméon Chardin's artistic career written soon after the artist's death in 1779, attributed the origins of his still life painting to his close study of a rabbit[1]:

> The first lessons Monsieur Chardin had derived from nature committed him to continue studying it assiduously. One of the first things he did was a rabbit. The object itself seems very insignificant, but the way he wanted to do it made of it a serious study. He wanted to paint it with the utmost verity in every respect— with discernment, without any trace of slavishness which might have rendered the execution cold and dry. He had not yet attempted to render fur, fully realizing that one should not count the individual hairs nor render it in detail. 'Here,' he said to himself, 'is an object to be rendered. In order to paint it as it is, I have to forget all I have seen and even the way these things have been treated by others. I have to place it at such a distance that I no longer see its details. I must above all faithfully imitate its general masses, color tones, volume, and the effects of light and shadows.' In this he succeeded; his rabbit reveals the first fruits of that discernment and magical execution which ever since have characterized the gifts that have distinguished him.[2]

Pierre-Jean Mariette similarly claimed a hare as the key impetus for Chardin's formation as an artist: "Someone had made him a gift of a [hare]; he found it beautiful and hazarded an attempt at painting it. Some friends to whom he showed the first product of his brush perceived great promise in it and encouraged him as best they might."[3] At the request of the impressed collector who purchased the hare, Mariette reported that Chardin created a pendant painting of a duck.[4]

These accounts, especially that of Cochin, reflect the emphasis upon empiricism and sensory apprehension that had come to prevail in artistic discourse of the later eighteenth century. While rabbits and hares do figure prominently as subjects in Chardin's earliest still lives of the 1720s, Cochin's

story of the inspirational rabbit, as Christian Michel has shown, vividly illustrates Cochin's own theories of the artist's need to capture and recreate materially on the canvas the natural objects he perceives.[5] But the stories also underscore Chardin's very real interest in animals as subjects, beginning in his earliest known works and extending through to his late still lives. As Mariette claimed, Chardin found a rabbit—even a dead rabbit—"beautiful," or worthy of his artistic concentration. Although he had earlier studied with one or two history painters, Chardin in fact elected to be received into the Royal Academy of Painting in 1728 as a "painter skilled in animals and fruits."[6] His animals very subtly echo the decorative elegance of those featured in contemporary still lives by Desportes and Oudry. But they also display a material presence unique for their era: applying paint to canvas in varied, visible strokes, patches, and graphic stabs, Chardin made his own medium stand in for the substance of the animal's body. While recalling the painterly physicality of Netherlandish animal paintings from earlier in the seventeenth century by such artists as Rembrandt and Jan Fyt, Chardin's paintings also anticipated by several decades both the empiricism and the emphasis upon the artist's physical touch, or *le faire*, that prevailed in later eighteenth-century artistic practice and theory.[7]

It is not, of course, only animals that receive such treatment: substances of all kinds—animal, vegetable, mineral—emerge from Chardin's still lives as if conjured physically out of paint. Denis Diderot captured this quality most famously in his poetic invocation of 1763: "Oh, Chardin! What you mix on your palette is not white, red, or black pigment, but the very substance of things; it is the air and light itself which you take on the tip of your brush and place on the canvas."[8] "The very substance of things" was precisely the realm over which the nonhuman animal most fully presided, according to empirical philosophy as it had been developing in the seventeenth century and was now, in Chardin's era, approaching its early modern apogee. Although clandestine literature proclaiming the materiality of all souls, including that of the human, was beginning to appear by the outset of the century,[9] most eighteenth-century natural philosophers would still agree with the comte de Buffon that the nonhuman animal was unique among all other life forms in being both fully material and able to feel, move, and act in its own interests.[10]

As if to confirm substantive reality as the province of animals, Chardin in his still lives of the 1720s used animal characters quite literally to demonstrate the physical actions of sensing the world. In a series of paintings featuring cats and kittens in various stages of stalking and capturing "prey" in the form of gutted seafood, as well as intact mammals and birds recently killed for sport

or consumption, the artist examined the relationship between sight and touch from the perspective of an inquisitive feline. In other paintings, he emulated seventeenth-century Flemish kitchen scenes by portraying dogs as the principal investigators of dead prey or, in at least one case, an elegant table set for human consumption.[11] But it is in his depictions of dead game, particularly the rabbits and hares remembered by Cochin and Mariette, that Chardin most subtly probed the sensory experience of animals, inviting a viewer not only to regard and imagine touching the furry body, but even to empathize with the animal that, when alive, sensorially experienced both its own life and the moment of death. While iconographic flourishes within these paintings allude to exclusively human hunting and eating—game belts and bags, powder casks, cultivated oranges, a tureen—their animal characters, both living and dead, assume such compositional and thematic authority that human needs and desires are guided toward that which we share with the nonhuman. Death, the equalizer not only of human societies but of the compete "chain" of animal life, emerges from Chardin's paintings of stilled creatures as a force uniting high with low, a point he emphasized in his works of the 1720s by posing his vanquished rabbits and hares in the stricken poses of martyred saints.

Chardin employed a number of these strategies in his imposing *Soup Tureen with a Cat Stalking a Hare* of 1728–30 (Plate 3). Illuminated at the center of the scene is a hare with forelegs and hind legs crossed, the latter with fronds of celery or leek falling across the lower joints as if in a binding rope. The stilled heart of the creature lies exactly along the central vertical axis of the painting, while its once-vital blood hovers in small, viscous globs under the nose and mouth, simulated with exactly equivalent doses of red paint. Dabs of the same hue on the animal's fur suggest light smears of blood from unseen wounds, and dark indentations in the region of head and neck suggest the traces of a fatal canine bite. Further applications of red paint on the feathers of the partridge, in the bright apple and pear, and even smudged into the encompassing stone surfaces make the whole environment around the hare pulsate with the color of life and death.

Chardin must have studied the still lives and living animal paintings of the Flemish painter Jan Fyt,[12] which were well known in France, especially during the second quarter of the eighteenth century when Netherlandish art was coming to be avidly sought by French collectors. But it is not only in the closely studied, brushy figure of the hare that we see his debt to the Flemish painter but also in the "animal's eye view" with which he presents his principal subject: the small, mottled cat crouched in the lower left corner gazes, with us, at the

central spectacle, encouraging us to witness its blunt materiality as well as the prospect of self-nourishment it presents both to her and to us. The gleaming tureen placed beside the hare and partridge implies that "civilized" eighteenth-century consumers who prepared and ate their newly fashionable stews in fact harbored exactly the same bodily desires as the marauding feline. As Fyt often did, Chardin aggrandized the scale of the foreground objects on the right—the oversize apple, nuts, and pears. We may be witnessing here an artist still developing his skills in proportion and perspective, but we could also be seeing an arch device for engaging the viewer as animal. The fruit looms before us just as it would to the small cat, making us as much a surrogate viewer for the feline as she is for us.

As viewers both in the eighteenth century and today would recognize, our appetites and sensory experience unite us with nonhuman animals but it is we humans who possess the burden of death as an inescapable presence that we consciously carry through life. Although Chardin was less explicitly biblical in his references to mortality than were his Netherlandish predecessors, he nevertheless encouraged us to identify with the mortally stricken prey at the center of his painting, even if partly unconsciously. Viewers familiar with the scenes of Christian martyrdom that artists had been producing since the late Middle Ages—and were still producing occasionally in Catholic France—would have recognized the arched and highlighted body of Chardin's hare and its stiff, crossed legs as dramatic devices they had seen in human figural representations many times before. The passionate geometry of pointing legs, ears, and drooping head calls our attention to the last drops of life draining from the fallen body. Chardin's contemporaries might even have sensed in his captive hare an echo of the Lamb of God that seventeenth-century artists sometimes portrayed as a real animal, bound and vulnerable on a stony altar.[13]

Chardin's painting is, however, no traditional allegory of human *vanitas*: his tactile treatment of objects and bodies, as well as the cat that demonstrates our own act of looking, ensures that the work at least equally projects perception through physical sensation. The fur of the hare is physically summoned through a variety of brushwork devices: smeared wet-on-wet, projecting from the surface in textured impasto, and lightly streaked to form projectile hairs that recall the artist's own hairy brush. Sight intertwines directly with touch—sometimes working together, as when Chardin calls us to imagine through his brushwork what the hare's furry coat would feel like; and sometimes paralleling one another, as we spectators observe the gentle physical embrace between the sightless partridge and hare. The cat, whose left paw is but a collection of furry white

smears, puts all its sensory features on alert—pricked ears, raised nose, riveted eyes, slightly opened mouth—while setting its body in a position from which it could pounce. Sight, touch, life, and death overlap and inhabit one another within the animate matter of Chardin's painted surface, even to the point where we can imagine our own bodies participating in the vital matrix.

Sensory Animal Consciousness

By featuring a living animal in such works as the *Tureen with a Cat Stalking a Hare*, Chardin might have been appealing to the Academy's hierarchy that placed live animals above those which were "still."[14] The Academic valuation of the living over the dead was evidently intended to take the measure of an artist's skill in capturing an animal's movement, but Chardin's appropriation of the strategy surpassed the simple portrayal of momentary physical action. For his stalking cat, in convincing feline fashion, relies upon intensely focused poise, rather than gestural assertion, to register her fascination with the prey. It is, in fact, sensory perception of the material spectacle that demonstrates this animal's life and conscious awareness—and, for that matter, our own role as captivated viewer. A "painter skilled in animals and fruits" had a vested interest in highlighting matter and its perception, a process shared by the animals depicted within his paintings and the human witness outside them. In this respect Chardin's work as an artist fundamentally overlapped with philosophical considerations of sensory knowledge published in the decades surrounding his most active period of animal still life painting in the 1720s and early 1730s. By using the animal as his principal agent of sensory perception, Chardin moreover demonstrated how sensory knowledge *works* while also promoting the implicit value of such immediate material experience.

Almost thirty years before Chardin painted the *Soup Tureen with a Cat Stalking a Hare*, John Locke's *Essay Concerning Human Understanding* appeared in French translation, and although the greatest impact of this treatise would be felt in French philosophical writings only around the mid-eighteenth century and beyond, the empiricism and emphasis upon sensory perception Locke espoused had already emerged as a significant current in writings on animal awareness as early as the first half of the seventeenth century. Early proponents of animal soul, seeking alternatives both to the Cartesian animal "machine" and to what most still considered a uniquely human rationality, had located the motivational force of the animal within sensate consciousness, and used their own and others'

observations of animal behavior as primary evidence for their arguments. In doing so, they anticipated Locke's own theory of knowledge gained through sensory experience as well as eighteenth-century empiricism more generally.[15]

By the early decades of the eighteenth century, the debate that had catalyzed such publications had more or less subsided, but David Boullier's treatise on animal soul, first published in 1728 and then in a greatly expanded version in 1737, offered a fresh and influential perspective that compares on a number of points with Chardin's sensationalist strategies. Boullier, having carefully studied the seventeenth-century debate over animal soul set off by Descartes's theory of mechanistic animal behavior, offered his own, latter-day refutation of the animal-machine informed by principles of Lockean sensation as well as by his own, common-sense logic and observation. For Boullier, the soul of an animal contained an immaterial "sensitive principle" that we might today call "consciousness," through which the creature perceived, explored, and deliberately acted within the material world that formed its environment.[16] While steeped in the philosophical debates of the seventeenth century, a number of which he addressed directly in his treatise, Boullier also relied upon empirical observations of animals to provide his strongest evidence of the animal's sensitive principle at work.

Like Chardin's crouching cat, Boullier's exemplary animals "act in a consequential manner," which "proves that they have a sentiment of their own, and their own interest which is the principle and the goal of their actions."[17] It may, indeed, have been Boullier's common-sense empiricism that prompted the subsequent incorporation of his theories into the article on "Animal Soul" in the *Encyclopédie*.[18] Locke had explained the faculty of perception as encompassing both an animal's sensation and the judgmental ideas the animal forms in response to its sensations, and he used this perceptive faculty as the distinguishing mark of animals as opposed to the mechanistic operations of the vegetable kingdom.[19] Boullier, who had already read Locke by 1728 and would respond more extensively and specifically to the *Essay* in the revised 1737 edition of his treatise, focused particularly upon animal agency, or the "force" that impels an animal to move and act—a force that is invisible and immaterial in itself, but is made manifest to the observer through immediate physical evidence.[20]

In several works Chardin made during the later 1720s, he used animals in a similarly demonstrative manner, either as active performers of sensational experience or, more subtly, as agents of implied feeling in death. Consider the pair of paintings, almost certainly pendants, featuring calico cats reaching or pouncing to paw at the meat of a formerly living sea creature now killed and

opened for consumption (Figures 2.1 and 2.2). In both cases, the large, round eyes of the feline are accentuated by dilated pupils, while the physical touch of paw to "prey" provides the central intrigue. Living and dissected bodies visually rhyme: the s-curve of the calico claiming the salmon echoes the sloping pink smears of the fish, while her pendant's thrusting foreleg almost comically repeats the

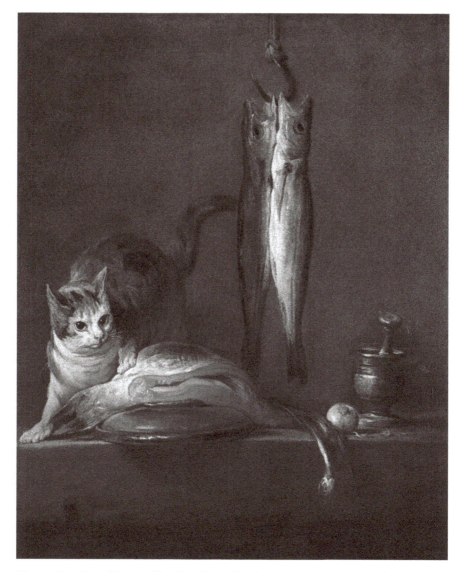

Figure 2.1 Jean-Siméon Chardin, *Cat with Salmon, Two Mackerel, Pestle and Mortar*, oil, 1728; Madrid, Museo Thyssen-Bornemisza; photo: Museo Nacional Thyssen-Bornemisza/Scala/Art Resource, NY.

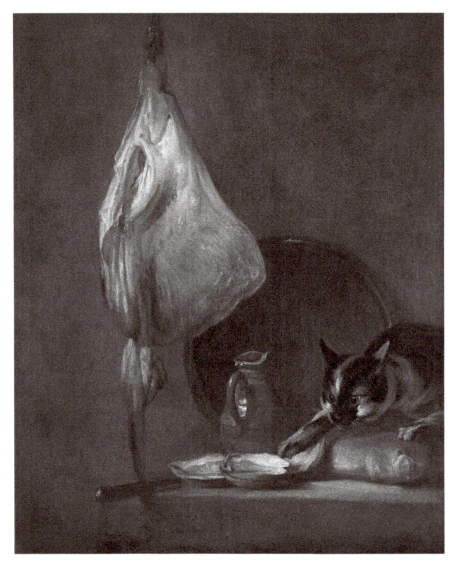

Figure 2.2 Jean-Siméon Chardin, *Cat with Ray, Oysters, Pitcher and Loaf of Bread*, oil, *c.* 1728; Madrid, Museo Thyssen-Bornemisza; photo: Museo Nacional Thyssen-Bornemisza/Scala/Art Resource, NY.

pendulant skin of the ray fish carcass hanging above. The knife projecting toward us on the ledge in this painting, while borrowed directly from Netherlandish precedent, also reminds us that our own act of opening an oyster hardly differs in kind from a predator's dismantling of its target. It is as if these two cats are showing us how we humans should respond to all of Chardin's materialistic kitchen still lives of this period: what we take in by sight alone is something so

meaty and present to us that we can imagine handling it, or even eating it if we can. The artist's tactile handling of paint in both of these works—gutsy smears of color defining the opened fish and short, furry strokes describing the calicos' bodies—further encourages multisensory response on the part of the human perceiver.

To touch is to see, to see is to touch: in theorizing how animals exercise their sensitive souls, Boullier highlighted sight and touch as having a dual advantage over the other senses in allowing the animal to perceive the solidity and extent—the actual substance—of material things. He would expand on this idea in the 1737 edition of his treatise, in which he took up the question originally raised by the Irish natural philosopher William Molyneux and made famous by Locke: could a congenitally blind man, whose sight was suddenly restored, at once recognize by sight objects he had learned to identify through touch alone? Boullier argued, against Locke, that the man with regained sight would, indeed, visually recognize the objects he had known previously only through touch. A globe once understood through handling, for example, must be accessible as such by sight, for seeing and touching are but "two different manners of perceiving the same object."[21] Animals, while lacking human rationality, surpass the human in the vividness of this kind of perception and memory: "the objects in their situations are painted to the smallest feature ... nothing which has struck their senses escapes their memory."[22] Such sensory beings were likewise especially useful to Chardin in the 1720s, invested as he was during this decade in establishing himself as a specialist in reproducing for others' sight things of haptic essence.

"Molyneux's question," as Michael J. Morgan has shown, would preoccupy European philosophers later in the century, including Condillac and Diderot, for whom a theory of the senses and their interrelations was essential to understanding human knowledge.[23] It is just possible that Chardin himself was conscious of the problem as highlighted by Locke, for art historians have suggested other ways in which this "painter's painter" showed a strikingly prescient interest in the theme of understanding gained through the senses. In his important analysis of Chardin's *Lady Taking Tea* (Glasgow, Hunterian Art Gallery), Michael Baxandall argued that Locke's theory of the subjectivity of visual perception takes pictorial shape in Chardin's painting, which works as an "enacted record of attention."[24] Dorothy Johnson has convincingly associated Locke's education theories with Chardin's paintings of children, for whom learning appears to be a process of continuous sensory perception, especially visual observation.[25] Johnson has emphasized Chardin's anticipation, by several

decades, of changing French attitudes toward education that would culminate in Rousseau's emphasis upon childhood as a crucial, distinct phase in human mental and emotional development. That Chardin's paintings of animals would likewise contribute to a larger philosophical debate, spurred on by Lockean empiricism, is thus in keeping with our emerging understanding of the artist as keenly engaged with the scientific and philosophical dimensions of his "everyday" subject matter.

By far the best known of Chardin's early "demonstrative cat" paintings is the large painting known as *The Ray*, in which a small feline, perhaps even a kitten, has just leapt onto a pile of oysters on the left side of the painting and arches her back in surprise and alarm as the shellfish clatter down onto the stone ledge (Figure 2.3). Netherlandish painters such as Fyt had previously developed the "surprised feline" device to draw a spectator physically into their still lives. In Chardin's painting, the cat's sudden shock exemplifies our own, more internalized stir as we confront the partly eviscerated fish glowing like a beastly ghost along the central axis of the painting. Its anthropomorphic "face" looks back at us as if challenging us to deny that we, too, are animals fundamentally dependent upon

Figure 2.3 Jean-Siméon Chardin, *The Ray*, oil, 1725–6; Paris, Louvre; photo: © RMN-Grand Palais/Art Resource, NY.

our senses. Although only very recently have scientists discovered that fish can feel, *The Ray* precociously evokes bodily pain, driven home by the knife projecting outward toward our own right hand, and the implications of consumptive bodily violence inflicted on the cartilaginous body.[26] Concentrating the organic matter of his still life on the left side of the painting, Chardin interconnected one animal substance to the next through brushwork, color, and line: the cat's streaky white fur could itself have inscribed the filaments of white that compose the interior of the oysters, while the glistening guts of the ray tumble down directly into the bodies of the fish below. Red paint highlights the chain upon which the ray is strung, as if smeared by the animal's blood, and a matching red patch on the nose of the cat reminds us that blood is the essence of animal vitality in life as well as in death.

Diderot, whose materialist praise of Chardin in the 1760s we have already noted, commended the *Ray* in his *Salon* of 1763 for its evocation of natural substance: "the subject is disgusting, but it is truly the fish's very flesh, skin, and blood: it affects us as though we saw the thing itself."[27] Daniel Cottam has argued that such a response characterized the "visceral turn" of eighteenth-century philosophy, whose pre-occupation with physical materiality encouraged an appreciation of the body's interior as manifested even on its surface.[28] In Chapter 4, we shall return to Diderot's and other philosophers' preoccupation with visceral animality when we examine the soup and stew tureens that began to be produced as trompe l'oeil birds, mammals, and fish toward the middle of the eighteenth century. Chardin's early interest in working the surfaces of his canvases probably motivated the many eighteenth-century comparisons of his works with those of Rembrandt,[29] and it is likely that in paintings such as *The Ray* he was deliberately recalling Rembrandt's varied use of brushwork, palette knife, and thick, impasto effects. The troubled status of Rembrandt's animals, reduced to material corpses while compared ambiguously to living humans near them, also resonates in Chardin's rendition of the looming ray, at once substantiated in paint and fraught with implications of human martyrdom.

Martyrdom indeed emerges as a central, if implicit theme of Chardin's numerous paintings of hares and rabbits from the 1720s, in which the suspended animals assume postures that recall the writhing agonies of violent expiration. Nailed through a hind foot as if crucified, often casting ghostly shadows against bare walls, the animals fall lengthwise in darkened, anonymous settings as if announcing the solitude of death (Figure 2.4).[30] The harshly textural quality of their depiction—so unlike the velvety, disguised brushwork of the creatures painted by late seventeenth-century Netherlandish artists such as Jan Weenix—only

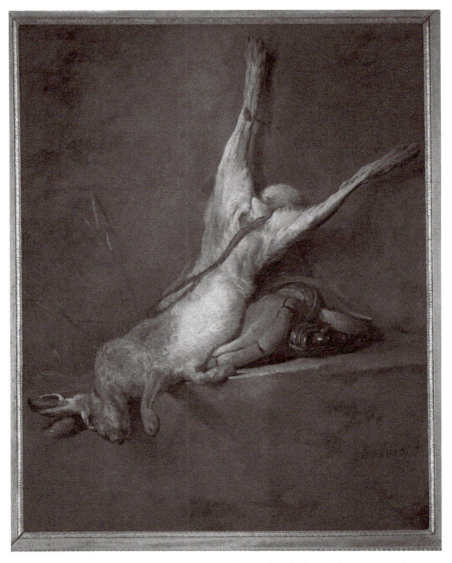

Figure 2.4 Jean-Siméon Chardin, *Hare with Powder Flask and Game Bag*, oil, 1728–30; Paris, Louvre; photo: © RMN-Grand Palais/Art Resource, NY.

exacerbates their implications of sensitive bodily experience (Figure 2.5). When hares or rabbits are grouped, or when a lagomorph is accompanied by a companion game species, the physical interpenetration of one body with another evokes the sensation of touch that philosophers since Aristotle had identified as fundamental to animal existence.[31] Such intimate tactility extended even to Chardin's painting process, as seen in his *Rabbit with Red Partridge and Seville*

Figure 2.5 Detail of Figure 2.4.

Orange of 1728–9: in defining with his brush the distinctive dark feathers that crown the head of the red partridge, the artist allowed his dark swipes of paint to extend over the inner joint of the rabbit's left foreleg, marks softly echoed in the avian shadow cast on the furry white chest (Figures 2.6 and 2.7). The partridge's own belly and wing slump against the precariously curved torso of the rabbit, as if the two creatures were supporting one another in death.

Although modern-day interpreters have sometimes drawn psychosexual implications from the vulnerably exposed and wounded bellies of Chardin's lagomorphs,[32] their evocations of torture and death, unrelieved by the scratchy brushwork, more directly invoke physical trauma. According to Cochin, Chardin received early training in the studios of the history painters Pierre-Jacques Cazes and Noël-Nicolas Coypel, and his biographer discerned in his treatment of human heads a talent for history painting that, had it been nurtured, would have surpassed that of Caravaggio.[33] Although in such passages

Figure 2.6 Jean-Siméon Chardin, *Rabbit with Red Partridge and Seville Orange*, oil, 1728–9; Paris, Musée de la chasse et de la nature; photo: Sylvie Durand.

Cochin was doubtlessly expressing his own prejudice in favor of the history genre, it is possible that Chardin himself was imparting lessons learned in the study of history painting to his mortally wounded hares and rabbits. Despite the iconography of such "benign" and familiar human institutions as hunting and cookery—such as the hunt bag in Figure 2.4 and the orange in Figure 2.6— the creatures' awkwardly suspended bodies, twisted torsos, and hanging limbs recall the imagery of Christian sacrifice, equally familiar to Chardin's cultured,

Figure 2.7 Detail of Figure 2.6.

Catholic audience (Figure 2.8). His paintings nevertheless stop short of overt anthropomorphism, appealing instead to that which human and nonhuman animals share: bodily sensation through touch, specifically the universal feeling of pain.

Seventeenth-century proponents of animal soul had argued in favor of a sensitive soul that humans and nonhumans shared—some, such as Marin Cureau de la Chambre, with the express purpose of underscoring the importance of the body as the foundation for establishing psychological character.[34] Although Locke and most of his eighteenth-century followers would continue to highlight a distinctively human rationality—not without conflict in the case of Locke, as Elisabeth de Fontenay has argued[35]—the Lockean principle that held sensation

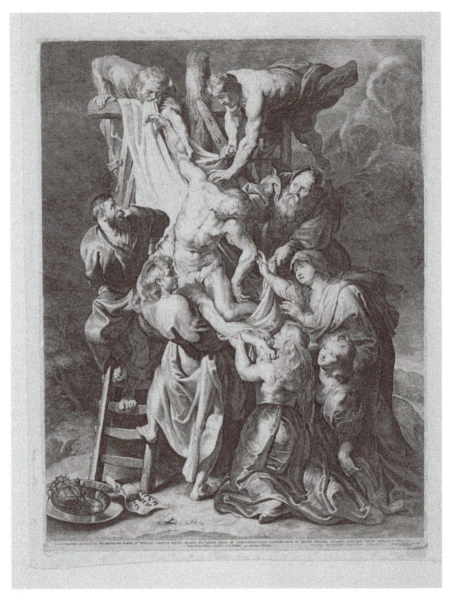

Figure 2.8 Lucas Vorsterman after Peter Paul Rubens, *The Descent from the Cross*, engraving, 1615–75; London, Victoria and Albert Museum; photo: © Victoria and Albert Museum.

as the basis of knowledge ensured that only a few Cartesian holdouts of this era would continue to deny nonhuman animals a feeling soul.[36] Boullier, although taking Descartes seriously enough to devote considerable energy to weighing his arguments, argued that God would be deceiving us had he made animals pure

machines: for can we not witness innumerable instances in which they move exactly as we do when feeling compels us? "I see my Soul in the form of a sensitive principle produce a thousand actions and move my body in a thousand ways, just the same as those ways in which animal bodies move in similar circumstances ... I conclude from this that there is in Beasts a principle of sentiment."[37] Boullier was a philosopher rather than a hands-on physician such as Cureau, but like the latter he asked his readers to consider what they could see for themselves every day as empirical, common-sense "proof" of sensitive animal soul for nonhuman and human alike.

Boullier's treatise, quite successful in its era and even better known after it was published in its revised and expanded edition of 1737, compellingly partners Chardin's rabbits and hares, whose signs of moribund pain and struggle visibly evince a "sensitive principle" that calls to a viewer vicariously. While Boullier appealed to his readers' own, human experience in arguing that animals must also possess conscious feeling, Chardin elevated his lagomorphic subjects by giving them an aura of human martydom as consecrated by painting tradition. The "ruggedness"[38] of his painting style, perhaps nowhere more extreme than in his simulation of the scrambled fur of an animal bitten by dogs, only exacerbates the confluence of painterly and animalistic feeling (Figure 2.5). Chardin's own touch becomes the touch of an animal—like the gentle sweep of a partridge wing along the soft white belly of a hare (Figure 2.7).

Monkey Artists

In thus entangling his own, animated practice of manipulating paint with the vital substance of the animal body, Chardin offered a material variation on Desportes's more declarative *Self-Portrait as Hunter* of 1699. Like such great colorists of the past as Titian and Rembrandt, Chardin used his brute depictions of animal life and death as an implicit metaphor for his own investment in the substance of his medium. Perhaps with these interests in mind, Chardin executed in about 1740 his well-known *Monkey as Painter*, in which a nattily dressed simian—a *Cercopithecid* resembling the species that the comte de Buffon would subsequently identify as the *Callitriche*[39]—wields chalk holder and mahlstick to sketch on a canvas while turning his head to look out over his shoulder toward us, the apparent subject of his picture (Plate 4).[40] At the time he painted this work, which he exhibited in the Salon of 1740,[41] Chardin had spent much of the previous decade focusing upon human figural painting, scenes of quotidian

life often featuring a character working in some kind of material practice: preparing food, embroidering, building a house of cards, and, in the case of two young male artists, drawing human figures in chalk (Fort Worth, Kimball Art Museum; Berlin, Gemäldegalerie). The *Monkey as Painter* suggests a lively and ironic self-portrait on the part of the artist who had recently deviated from the genre designated to him by the Academy, animals and still life, to direct his talents toward "aping" human behavior.

Simians, as H. W. Janson demonstrated in his classic study *Ars Simia Naturae*, had long served artists as an emblem of their practice in creating illusions of reality, and the theme of the monkey as artist figured prominently among the humanistic activities in which monkeys engage in seventeenth-century works by such Netherlandish painters as David Teniers the Younger (Figure 2.9).[42] But Chardin's monkey painter, who meets our own eyes with a penetrating glance, avoids Teniers's chatty comedy in favor of establishing a more personal, if slightly unsettling relationship with the viewer. For if we recognize in the simian artist a surrogate for Chardin himself, the portrait upon which he works—clearly based upon the fellow being he studies carefully over his shoulder—must be the painting's

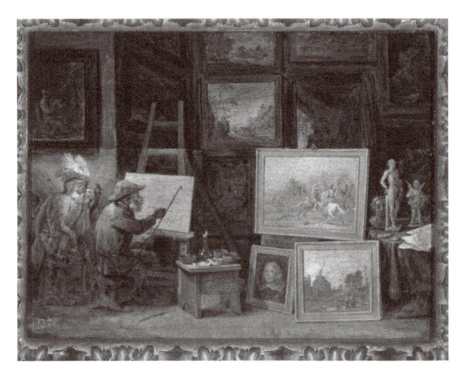

Figure 2.9 David Teniers the Younger, *The Monkey Painter*, oil, *c.* 1660; Madrid, Prado; photo: Erich Lessing/Art Resource, NY.

viewer, like him a primate in human clothing. It is easy for a viewer to distance himself from the simian dandy in Teniers's painting, who uses a lens to peer uncomprehendingly at the artist's composition, just as Teniers distances himself from his monkey artist counterpart by including a man's portrait—perhaps even a self-portrait—among the paintings in the foreground. Chardin's artist and viewer, by contrast, belong completely to the world of matter, as eighteenth-century animals were generally thought to do; but just as Enlightenment philosophy was coming increasingly to value the sensory knowledge that material experience could yield, Chardin's *Monkey as Painter* projects a modern, even precocious sensibility despite its roots in the *Ars simia naturae* tradition.

Not long after Chardin exhibited the *Monkey as Painter*, a new voice was heard in the philosophical literature on animals that would prove more radical in its leveling of human and nonhuman than any other that would emerge in France either before or after its writer's era. The French physician Julien de La Mettrie, whose intense valuation of animal feeling we noted in the Introduction, also had a vested interest in promoting the material functioning of the body as the essence of human experience on psychological as well as medical planes, arguing in several publications of the 1740s and '50s that human and nonhuman animals shared but one sensitive soul which provided the basis not only for feeling but for thought as well.[43] In the most famous of his publications, *L'Homme-machine* of 1748, La Mettrie used simians as his star nonhuman examples of what talented animals could and might possibly do to make a match for the human, for "man was trained like an animal ... a mathematician learnt the most difficult proofs and calculations, as a monkey learnt to put on and take off his little hat or to ride his trained dog."[44] Inspired by Descartes's likening of animal bodies to wondrous machines, but dispensing with his predecessor's theory of a rational human soul, La Mettrie defined all aspects of animal life, from mathematics to the actions of polyps, as products of the vital soul. So offensive was La Mettrie's contention that the human was identical with the nonhuman animal in possessing a sensitive soul but not a separate, rational one, that his books were ordered to be burned in France and their author forced to flee. Even in Leiden, where *Machine Man* first appeared, the religious authorities sanctioned its publisher, Elie Luzac *fils*.[45] Nevertheless, a robust undercover network of transmitting clandestine literature in the middle of the eighteenth century ensured that the radical physician's arguments would be absorbed by curious readers.[46]

Although not intended as a defense of materialist painting, La Mettrie's treatise could readily stand as a philosophical confirmation of Chardin's own artistic concerns both conceptually and in actual practice. Their shared

privileging of active matter, as epitomized in the animal subject, differed sharply from philosophical positions taken both in the Royal Academy of Art and in natural history that would equate the actions of humans with a superior mind expressing itself through face and gesture. While La Mettrie celebrated talented simians for what they could tell us about our own souls, the naturalist Buffon would explicitly reject the illusion that any animal could act, let alone think, as a human could. At the same time that Buffon was beginning to produce his multi-volume *Histoire naturelle*, a parallel movement was forming in and around the Academy to once again call attention to unique and eloquent human action, a shift in priorities we will return to at the end of this chapter. Chardin's monkey artist, a citizen of the less restricted realm of artistic practice that prevailed in the first half of the eighteenth century, allies with the radically humbling simians presented by La Mettrie as material surrogates for ourselves.

Singeries

Simians were a natural fit for the grotesques that were coming into prominence in French art around the turn of the eighteenth century, quite literally embodying the grotesque's spirit of anti-rhetorical provocation and wit. With their humanoid bodies, gestures, and actions, they also proved particularly useful in serving the interspecies play that dominated this genre. Occasionally appearing in fairy tales as metaphorical embodiments of ungainly humans,[47] actual monkeys were establishing themselves within elite social life in the role of entertaining household pets. As scholars have recently noted, increasing contact with Asia fostered trends for "exotic" commodities that included monkeys who were acquired by the elite and dressed in current urban fashions.[48] Artists who specialized in grotesques would exploit simians' ability not simply to "ape" but actively to usurp their human counterparts as protagonists of pictorial imagery.

A sketch for a decorative design by Audran, dating from the early 1700s, offers a witty example of the monkey performer literally rising into prominence (Figure 2.10). Above the lower border just to the left of center a fairy-like character dressed in classical garb holds aloft a decorative cartouche that doubles as a parasol for a female monkey. The monkey wears a fashionable *fontange* and mantua, and appears to be ascending to the top of the decorative pedestal. Her long tail forms an acanthus c-curve clutched by a cupid who dances on ornament below her. On the other side of the pedestal a diminutive, weary Gallic Hercules appears to have just stepped down, ceding his place as the center of attention to the aspiring simian lady. A sphinx—at once human, leonine, and avian—looks

Figure 2.10 Claude III Audran (attrib.), *Design for Decorative Grotesque*, pen and ink, *c.* 1700; Berlin, Kunstbibliothek, Staatliche Museen; photo: bpk Bildagentur/ Staatliche Museen/Martin Franken.

on in surprise at this artistic transition from the classical to the fashionable and from the human to the nonhuman.

Antoine Watteau, who as we have seen was employed early in his career, as Desportes was, to paint figures into Audran's grotesques, made full use of the monkey's potential to perform as a humanistic character with an animal essence.[49] Particularly important as a precedent for Chardin are Watteau's depictions of monkeys as musicians and artists—nurtured, no doubt, by Watteau's personal affinity to Flemish artistic traditions as represented by artists such as Teniers. Although most of Watteau's contributions to the *singerie* genre are no longer extant, a red chalk drawing attributed to Watteau, and very likely made with a decorative design in mind, suggests the strength of character with which the artist invested his monkey performers (Figure 2.11). A lively simian violinist wearing a Renaissance style cap and cape perches animatedly upon a fragment of a decorative scroll. The monkey's artistic authority is pointedly enhanced by his strikingly accurate manual technique in playing the instrument, despite the sketchy nature of the violin itself—a notable contrast with Desportes's sawing simian in the painting he made for La Muette (Plate 2).

Monkey artists of many kinds populate the extensive *singeries* painted by Christophe Huet for Louis-Henri, duc de Bourbon, at the château of Chantilly in the years around 1737. In addition to a monkey painting on an easel and another earnestly preparing a block of stone to carve a graceful female (human) figure, Huet also featured a geographer wielding calipers, several musicians, and a tightrope walker. One panel (Figure 2.12) features a "Chinese" human

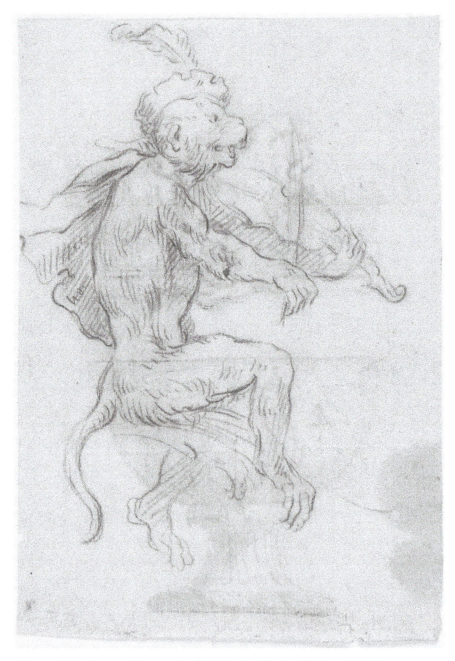

Figure 2.11 Antoine Watteau (attrib.), *Monkey Playing Violin*, red chalk, *c.* 1710; NY, Cooper-Hewitt, Smithsonian Design Museum; photo: Cooper-Hewitt, Smithsonian Design Museum/Art Resource, NY.

Figure 2.12 Christophe Huet, Detail of panel in "Grande Singerie," Château of Chantilly, *c.* 1737; Chantilly, France, Musée Condé; photo: © RMN-Grand Palais/Art Resource, NY.

alchemist—*chinoiserie* being another thematic thread of the room—flanked
by shelves containing jars of preserved animal specimens, an allusion to the
château's real natural history cabinet.[50] Monkeys perform complementary acts
of material creation on either side of the central alchemist: the artisan on the
left paints a ceramic vessel and on the right a decorative painter completes an
elegant grotesque panel, a witty "self-portrait" on the part of the artist.[51] It is not
only Huet whose practice is performed by an animal, but his eminent patron
as well: Nicole Garnier-Pelle has argued that both the porcelain painter and
the alchemist allude to the duc de Bourbon himself, who in 1730 established
an innovative soft-paste porcelain factory on the grounds at Chantilly and was
himself an amateur ceramicist and chemist.[52] One more materialist endeavor
connected with the prince appears within a cartouche below: a squirrel nibbles a
nut atop a printing press for paper currency—one of John Law's notorious failures
in which the duc de Bourbon had invested.[53] Such connections between alchemy,
ceramics, decorative painting, and printing paper for the sake of obtaining more
things imply a network of material production directly facilitated by the physical
body, as mediated through ornamental structure.

Perhaps the most important link between simians and humans as exploited
by artists such as Huet was their common reliance upon manipulating objects
through use of the hand: thus while the alchemist in Figure 2.12 reaches down to
stir the contents of the vessel heating on the brazier, his artist assistants display
their dexterity in carrying out their own constructive tasks. A soft-paste porcelain
ink stand produced at Chantilly drives home the human's investment in manual
practice as facilitated by a monkey (Figure 2.13). Holding between "hands" and
"feet" the vessels to be filled with ink, the monkey—awkwardly humanistic in
its smiling face—demonstrates that even the records of our exclusively human
language must be conveyed through bodily performance.[54]

Painting Matter

The diminutive "Chinese" humans in Huet's panels are so far from displaying
Cartesian cogitation they hardly detract from the sport of their simian
companions. While the racist and Sinophobic aspects of this and other
manifestations of *chinoiserie* are undeniable,[55] it should be remembered that
Huet also presents both his own and his patron's livelihood and avocations
performed by monkeys, thus extending to his own milieu the satire of "human"
embodiment. When presented as an independent pictorial subject in the work of

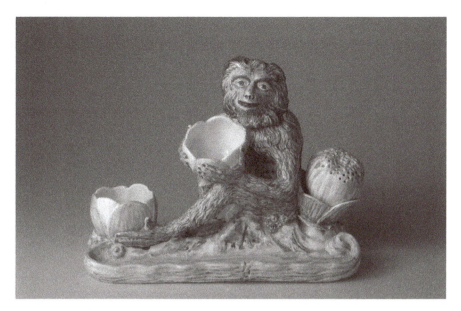

Figure 2.13 Writing Stand, soft-paste Chantilly porcelain, *c.* 1740; Sèvres, Cité de la Céramique; photo: © RMN-Grand Palais/Art Resource, NY.

Huet's contemporaries, the monkey artist functioned not only, or even primarily, satirically; he rather confirmed the materiality of his process and production as the essence of aesthetic value.

Watteau, probably during the period that he was still working as a decorative painter with Audran,[56] initiated the eighteenth-century incarnation of the monkey artist as a surrogate for the materialist practitioner. His original pendant paintings of *Painting* and *Sculpture*, each represented by a monkey absorbed in his respective art form, are now both lost, but are known today through engravings made by Louis Desplaces (Figure 2.14). *Sculpture* is also known through an eighteenth-century copy which displays Watteau's early painterly style and attention to substantive detail derived from his study of Rubens and Netherlandish genre painting (Orléans, Musée des beaux-arts).[57] As seen in Desplaces's engraving of *Painting*—the title and poem likely supplied by an employee of the publisher, the widow Chereau—the simian painter sits in a melancholic pose appropriate for a great artist,[58] head on hand as he gazes wistfully at his own creation on the easel. Above his head appears a variation upon one of Watteau's own *Commedia dell'arte* paintings,[59] suggesting that the painting on which the monkey is working features a similar subject. His materials—oil, palette knife, pigments, cloth—appear prominently on a table in the foreground. The monkey's soft, Renaissance-style beret and dressing gown

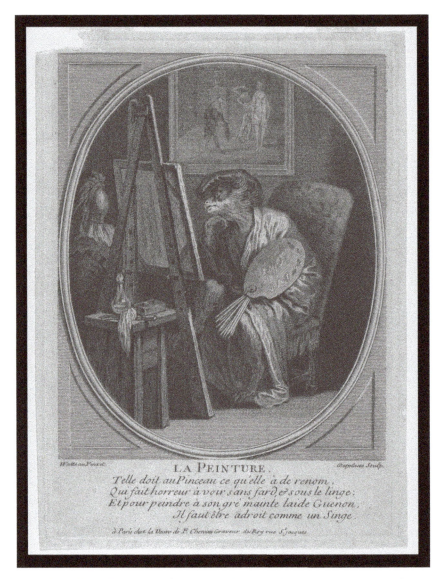

Figure 2.14 Louis Desplaces after Antoine Watteau, *La Peinture*, etching and engraving, *c.* 1700–39; NY, Metropolitan Museum of Art; © The Metropolitan Museum of Art/Art Resource, NY.

indicate his self-consciousness as an artist, as does the palette he holds out toward the viewer with his dexterous little thumb. Beside him the empty "face" of a manikin wearing the cap and collar of the *Commedia*'s Pierrot stares back at the painter like an alter ego. Watteau's personal identification with the character of Pierrot—a bumbling country bumpkin that the French would come to ally

with their own provincial scapegoat, Gilles—has long been argued by scholars.[60] The soulful monkey here occupying the place of the painter incarnates Watteau's own outsider status as a painter of Flemish roots who at this point specialized in lively decorative figures and paintings of the comic theater and rustic life.

Although not an artist per se, Jean-Baptiste Oudry's devious monkey Bertrand in his drawing of La Fontaine's fable of *The Monkey and the Cat* acts as the fiery intelligence behind the production of chestnuts acquired for his own consumption (Figure 2.15). Having tricked Mouser the cat into clawing the

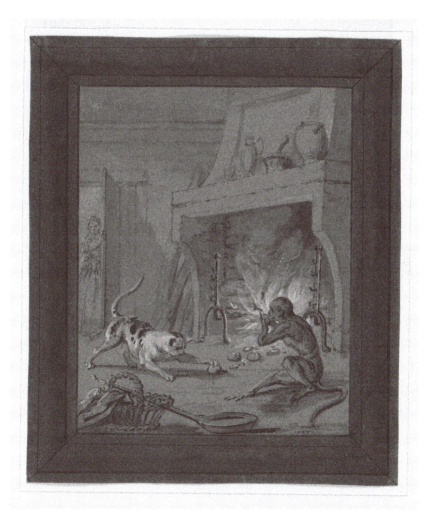

Figure 2.15 Jean-Baptiste Oudry, *The Monkey and the Cat*, pen, brush, and ink with tempera, 1732; NY, Pierpont Morgan Library, Dept. of Prints and Drawings; photo: The Morgan Library and Museum, 1976.6. Purchased on the Fellows Fund.

oversized objects from the fire, Bertrand sprawls in profile before the roaring flames, holding a chestnut to his mouth with his hairy hands. While the sensory monkey presides over the scene like a wizard in his lair, the feline extends a long foreleg to paw the chestnut, much as Oudry wielded brush and ink to sketch the objects in the scene. Just beyond the tip of Bertrand's tail, we discover Oudry's own signature and date, as if he were allying himself with this simian mastermind. In the following chapter, we will examine Oudry's personal investment in his animal characters as the rhetorical protagonists of his paintings and drawings. Here he draws upon simian creativity as a surrogate projection of his own.

Oudry was received into the Academy in 1719 as a history painter and would eventually become a professor there; Chardin, by contrast, held lower status in his designated genre and despite his subsequent positions as counselor, treasurer, and *tapissier* at the Academy his lack of denotation as a history painter prevented him from becoming a professor and receiving the honors of that position.[61] Although Chardin's works met with unanimous acclaim among his fellow artists and were purchased by the most elite collectors, his penetrating use of the monkey artist as a character in his works of the 1730s and 1740s suggests his awareness of the place assigned to him in the Academic hierarchy as a painter who placed particular value upon "lowly" material beings and things. In portraying artmaking as a process of brute animation, Chardin proposed another way of assessing pictorial creation in which the rich life of matter, rather than humanistic drama, became the object of exploration.

The monkey artist first appeared in Chardin's work in his large decorative overdoor known as the *Attributes of the Arts* (Figure 2.16), which had as its pendant the parallel *Attributes of the Sciences* (Paris, Musée Jacquemart-André). Both works feature an illusionistic niche with a low ledge, above and below which are arranged various objects emblematic of the respective fields of human endeavor. While the upper area of the *Attributes of the Arts* features a Roman portrait bust, carving implements, palette and brushes, and rolls of paper—the materials and products of the artist's work—the lower level shows a *trompe l'oeil* terra-cotta relief after François Duquesnoy representing *Eight Children Playing with a Goat*[62] and, on the left, a hunched, almost furtive monkey, sharpened red chalk in hand and paper spread before him. The monkey turns his head to look, as if for inspiration, toward the relief, while mimicking in the tilt of his body the brushes projecting from the palette above. The clay relief, whose Bacchic subject traditionally implied "base" sensuality, recalls those Desportes had included in his large still lives (Figure 1.23), but Chardin painted his relief in the same scumbled, earthy tones as the monkey, suggesting that the sculpture has not yet

Figure 2.16 Jean-Siméon Chardin, *Attributes of the Arts*, oil, 1731; Paris, Musée Jacquemart-André—Institut de France; photo: © Studio Sébert Photographes.

even been fired. Together, the monkey and the clay picture contrast with the loftier materials and artifacts posed on the ledge above, as if they embody the earth out of which human endeavor springs.

Pierre Rosenberg has interpreted the monkey emblematically, as a traditional sign of the artist's vanity in attempting to vie with the beauty of nature.[63] But taken more directly, Chardin's lowly, chalk-wielding monkey also makes base materiality—clay, goat, children, furry draughtsman—the implicit foundation of art. His visual correlate in the *Attributes of the Sciences* is a smoking incense burner—a symbol of evasion, as Rosenberg claims,[64] but also, more fundamentally, an object that appeals directly to the senses, much as the monkey relies upon sight to produce his drawing. The foundational sense of touch may also play a role in the monkey's perceptive strategies: his long tail extends along the ledge to nestle in a deft little spiral against the lower corner of the clay relief. Perhaps the Academy's curriculum of drawing from ancient statuary receives a subtle jab from Chardin's eager little simian as well.

Sight and touch collaborate in Chardin's full-scale *Monkey as Painter*, first exhibited as "a monkey painting" in the Salon of 1740 and replicated numerous times thereafter both as a painting and as a print.[65] The monkey artist has now, quite literally, "come up in the world," donning fashionable contemporary dress not unlike the coats in which actual monkeys were attired by eighteenth-century

French exotic pet-owners.[66] A sculpture of a child reminiscent of Duquesnoy's playful imps stands before the painter, but this is not what the artist looks at, nor what he paints: instead, as noted previously, he turns head and eyes to look directly outward. He appears to be sketching his initial drawing in red chalk, but the engraving after Chardin's painting, which fleshes out the sketch, proposes that his subject is a seated monkey.[67] Perhaps this is a self-portrait or, if not, the viewer of the painting finds himself cast as another, posing simian. The verse published with the print made after the painting emphasizes the mutual, monkey-like imitation of the artist and his subject,[68] and in the painting Chardin further links animal to human by deftly integrating the textured fur and facial markings of the monkey with the fashionable costume. The feathers in the tricorn hat, for example, wittily mimic the wisps of white fur around the animal's neck, while the natty brown coat coordinates with the animal's mud-colored, hairy limbs. The tail protrudes from a neat fold in the coat, as if the two had always gone together in the artist's body.

The pendant to the *Monkey as Painter* features a monkey-connoisseur whose hairy body blends with a gentleman's dressing gown; called "the monkey of philosophy" when it was exhibited with the "monkey painting" in the Salon of 1740,[69] this simian-human uses a magnifying glass to study a medal, as if in an attempt to understand his past through visual scrutiny. Janson has argued that Chardin's monkey pendants, taken together, connote the futility of studying the works of the past—the painter's antique bust, the connoisseur's medal—when one could be gaining much better inspiration from a direct study of nature.[70] Such an interpretation would have pleased Diderot and Cochin, and it is likely that Chardin did, indeed, have nature and empirical study in mind when he painted and exhibited these animal characterizations of his profession. But Chardin's monkey painter appears more personally enlightened in his agency than any mere emblem of artistic goals, for his outward glance, eyes highlighted by tiny white specks, makes direct psychological connection with the viewer. If we are his model, and the subject of his portrait, we are all the more implicated in his animal world.

The *Monkey as Painter*, although distinct in spirit from Chardin's dramatically vanquished rabbits and hares, like them vivifies painterly substance to suggest a continuum between depicted animal, physically engaged human spectator, and the material immediacy of paint. La Mettrie's sensitive soul, itself unembarrassed to have been "born in filth,"[71] comprises an even earthier connective essence redolent of the plastic arts: "Man is not moulded from a more precious clay;

nature has only used one and the same dough, merely changing the yeast."[72] For art itself, La Mettrie asserted, " … is the child of nature, and nature must have long preceded it."[73] Because of their strikingly humanistic capacities, monkeys proved particularly useful to La Mettrie in arguing that the learned and useful arts long associated with humans are in fact cognate with the actions of animals. Drawing upon the many reports of monkeys and apes that resembled humans both physically and in practical abilities, La Mettrie reasoned that with training they might be taught to speak human language, wanting only instruction—and perhaps some coaxing—to make them as capable of communication as their human counterparts.[74] Like the deaf schoolchildren of the famous Johann Konrad Ammann, who learned to speak by touching the vocalizing larynx and watching the subtle movements of the mouth, a simian with "the cleverest physiognomy," La Mettrie argued, might learn human speech in a similar manner.[75]

Chardin's monkey draughtsman who grasps his chalk while glancing at the earthenware relief on the foreground ledge of the *Attributes of the Arts* (Figure 2.16) might present just such a candidate for developing his communicative arts, naturally talented as he appears to be. One wonders if La Mettrie himself had the witty spirit of the *singerie* in mind when he offered what appears to be a half-serious, half-deliberatively exaggerated speculation, "If this animal were perfectly trained, we would succeed in teaching him to utter sounds and consequently to learn a language. Then he would no longer be a wild man, nor an imperfect man, but a perfect man, a little man of the town, with as much substance or muscle for thinking and taking advantage of his education as we have."[76]

La Mettrie's stake in human animality—which, despite his exaggerations for the purpose of irony, appears to have been very real—lay in his practice as a physician who cultivated an exceptionally concrete and hands-on approach to interpreting and caring for the body, as Kathleen Wellman has convincingly argued.[77] The particular wit with which he presented his theories, making full use of the monkey paradigm, correlates strikingly with the tongue-in-cheek portrayals of artistic self-consciousness on the part of Chardin, Watteau, and Huet. In their work as well as La Mettrie's writings, monkeys demonstrate their capacity to make things from matter—art being, after all, the very "child of nature." One suspects that had he seen it La Mettrie would have particularly appreciated Chardin's monkey painter, whose penetrating outward glance raises the inevitable question as to whether the viewer, like the artist, is but a "monkey full of wisdom."[78]

Rationality Redux

Although La Mettrie's materialism would earn a prominent place in later eighteenth-century French philosophy, his contention that the human soul was no more than a variation upon the sensitive soul of animals would be rejected by most of the subsequent *philosophes* in favor of rationality as the distinguishing trait of the human. In his monumental and widely read *Histoire naturelle*, whose first volume appeared in 1749, the comte de Buffon reconfirmed Descartes's separation of the uniquely human rational soul from the sensory "machine" that all animals shared.[79] Although the naturalist devoted an entire volume to simians, whose various types and characteristics he examined in extensive and often subtle detail, he strove to divest his lay readers of any illusions they might harbor as to the equivalency of these strikingly adept primates with the human species. While "wearing on the outside a mask of a human face, but stripped on the inside of thought and everything that makes a man," monkeys could and should not be confused with us—for, he implied, perceptions of externals can be deceiving.[80] Much later in the *Histoire naturelle* Buffon would blame the civilizing bent of the human for depriving nonhuman animals of their natural forms of expression, a change in tone that we will return to in Chapter 5. But his objection to any theory of natural history that did not privilege the superior position of rational man would remain essentially unchanged.

During the period in which the volumes of the *Histoire naturelle* were being published, monkey artists—and the *singerie* in general—correspondingly declined in favor among artists and patrons, a shift in taste confirmed by new mandates arising within the Royal Academy of Painting. Reflecting in part a stylistic shift away from the decorative *goût modern*, the decline of the monkey as protagonist was also motivated by the Academy's renewed promotion of history painting as the pre-eminent genre of art. Scholars have discerned in mid-eighteenth-century critical texts a humanist ideology that favored scenes of dramatic, meaningful action over the "lesser" genres. Among the earliest of these voices was Étienne La Font de Saint-Yenne, whose extensive reviews of the exhibitions held by the Royal Academy in the late 1740s and early 1750s advocated strongly in favor of history painting as "the painting of the soul"—by which he meant the speaking, rational soul that Buffon identified as unique to humankind.[81] Following earlier critics, La Font compared painting to poetry and used Charles Le Brun as an example of an artist who was able to portray human feeling and action through gesture and expression.[82] La Font acknowledged the

pleasing potential of the "most mediocre" genre, that depicting animals, fruits, and flowers, and he also displayed a progressive appreciation for the seductive power of color and landscape, a critical characteristic that he shared with such connoisseurs of sensory effects as Cochin and Mariette.[83] But in his estimation, true meaningfulness in art emanated from the painter of human history, the highest-ranking genre to which an artist could aspire.[84]

What made history painting pre-eminent, La Font implied, was its potential for bringing out the most forceful essence of human character. While everyone appreciates a convincing imitation of nature, the critic acknowledged,[85] human expression presented a more complicated, challenging, and—provided the artist achieved it—rewarding aesthetic experience. Critiquing a painting by van Loo featuring Saint Augustine, for example, La Font complained that its principal fault lay in its disappointingly uninformative treatment of this important character in Christian history. How would the public have admired this figure, the critic speculated, had the artist imparted to his characterization "the terror of heretics, and the most brilliant light of the church, the elevated physiognomy of an intrepid defender of the faith?"[86]

La Font's evaluation of Chardin betrays his prejudice in favor of human expression over imitation of nature for its own sake. In a review of the Salon of 1746, La Font had in mind Chardin's most recent paintings of everyday life when he praised the artist for his gifts as a skilled imitator, but he found in the artist's never-before-exhibited, life-sized portraits glimmers of a more worthy invention than his more vulgarly familiar subjects were capable of evincing.[87] Oudry's paintings of animal hunts, included in the same review, appealed to the critic precisely for their resemblance to history painting, as evinced in the creatures' expressive heads.[88]

While La Font had aesthetic predecessors such as the abbé Du Bos undergirding his art theory, Buffon provided an incisive, "scientific" argument for distinguishing the essentially mechanical process of rote copying from voluntary action that stems from the soul. For Buffon, the monkey offered a base material example. Although all mammals have bodily traits in common, the monkey resembles the human to such a degree that it appears consciously to adopt human actions—to the delight of many people unable to tell the difference between voluntary behavior and movement that is trained. The monkey's seeming deliberation in acting like a man is ultimately an illusion based upon surface resemblance, rather than a true result of independent thinking on the animal's part.[89] The monkey's performance is, in effect, an unconscious mirror rather than a work of art.

All humans differ from one another, according to Buffon, precisely because they have souls, whereas animals, who do not, must rely completely on their physiological design in order to act in the world.[90] La Mettrie, by contrast, had asserted in no uncertain terms that "thought is only a capacity to feel and … the rational soul is only the sensitive soul applied to the contemplation ideas and to reasoning!"[91] Thus, there is no need to distinguish between mechanical imitation and true learning: great apes, monkeys, and parrots all possess the ability to imitate gestural signs or sounds, so language and all of the thinking language entails can follow directly from there.[92] The monkey artist, like his simian brethren in La Mettrie's *Machine Man*, is not a contradiction in terms, for art itself, that "child of nature," could be said to have, in essence, the soul of willful animal. Monkey artists could intrigue as well as entertain during an era when princes allowed their cultural pursuits to be parodied by simians on the walls of their country *châteaux*; but by the second half of the eighteenth century, both natural philosophy and art were more firmly re-drawing the boundaries between human and nonhuman endeavor.

Notes

1 Certain parts of this chapter appeared in my earlier article: Sarah R. Cohen, "Chardin's Fur: Painting, Materialism, and the Question of Animal Soul," *Eighteenth-Century Studies* 37 (Summer 2004): 39–61. I am indebted to the editors of this issue, Paula Radisich and the late Angela Rosenthal, for their advice and encouragement.

2 "Les premières leçons que M. Chardin avait reçues de la nature l'engagèrent à en suivre l'étude assidûment. Une des premières choses qu'il fit fut un lapin. Cet objet paraît bien peu important; mais la manière dont il désirait le faire le rendait une étude sérieuse. Il voulait le rendre avec la plus grande vérité à tous égards et cependant avec goût, sans aucune apparence de servitude qui en pût rendre le faire sec et froid. Il n'avait point encore tenté de traiter le poil. Il sentait bien qu'il ne fallait pas penser à le conter ni à le rendre en détail. 'Voilà, se disait-il à lui-même, un objet qu'il est question de rendre. Pour n'être occupé que de le rendre vrai, il faut que j'oublie tout ce que j'ai vu, et même jusqu'à la manière dont ces objets ont été traités par d'autres. Il faut que je le pose à une distance telle que je n'en voie plus les détails. Je dois m'occuper surtout d'en bien imiter et avec la plus grande vérité les masses générales, ces tons de la couleur, la rondeur, les effets de la lumière et des ombres.' Il y parvint et y fit paraître les prémices de ce goût et de ce faire magique, qui depuis a toujours caractérisé les talents qui l'ont distingué." Charles-Nicolas

Cochin, "Essai sur la vie de Chardin", in *Documents sur la vie et l'oeuvre de Chardin*, ed. André Pascal and Roger Gaucheron (Paris: Galerie Pigalle, 1931), 4–5. English translation provided by Emilie P. Kadish and Ursula Korneitchouk in Pierre Rosenberg, *Chardin 1699–1779*, ed. Sally W. Goodfellow (Cleveland: Cleveland Museum of Art and Indiana University Press, 1979), 143.

3 "On lui avait fait présent d'un lièvre; il le trouva beau et il hasarda de le peindre. Des amis à qui il montra ce premier fruit de son pinceau en conçurent le plus favorable augure, et l'encouragèrent de leur mieux." "Notes de Pierre-Jean Mariette sur Chardin (1749)," in Pascal and Gaucheron, *Documents sur la vie et l'oeuvre de Chardin*, 27. English translation provided by Kadish and Korneitchouk in Rosenberg, *Chardin 1699–1779* [1979], 132. The name of the animal appears, incorrectly, as "rabbit" in this translation.

4 "Notes de Pierre-Jean Mariette sur Chardin," in Pascal and Gaucheron, *Documents sur la vie et l'oeuvre de Chardin*, 27.

5 Christian Michel, *Charles-Nicolas Cochin et l'art des lumières* (Rome: École française de Rome, 1993), 279–91. Michel directly links Cochin's story of Chardin painting the rabbit to Cochin's related theory of brushwork that captures optical effects, rather than following conceptual models (275–6).

6 Florence Bruyant in Pierre Rosenberg, ed., *Chardin*, trans. Caroline Beamish (New Haven and London: Yale University Press for the Metropolitan Museum of Art, 2000), 20.

7 Michel, *Charles-Nicolas Cochin et l'art des lumières*, 267–78. See also Marianne Roland Michel, *Chardin*, trans. Eithne McCarthy (New York: Harry N. Abrams, 1996), 116. On later eighteenth-century theories of the artist's touch, see Mary D. Sheriff, *Fragonard: Art and Eroticism* (Chicago and London: University of Chicago Press, 1990), 117–52. On Chardin and the importance of touch, see Lajer-Burcharth, *The Artist's Touch*, especially 111–21.

8 Denis Diderot, *Salon of 1763*, excerpted and translated by Lorenz Eitner, *Neoclassicism and Romanticism 1750–1850: Sources and Documents*, 2 vols. (Englewood Cliffs, NJ: Prentice-Hall, 1970), I, 58.

9 See Olivier Bloch, ed., *Le Matérialisme du XVIIIe siècle et la littérature clandestine: actes du table ronde des 6 et 7 juin 1980* (Paris: J. Vrin, 1982).

10 Buffon's *Histoire naturelle*, which will be addressed in more detail later in this chapter as well as in Chapter 5, served as the basis for Diderot's own text on "Animal" in the *Encyclopédie*; see Denis Diderot, *Oeuvres*, 5 vols. ed. Laurent Versini (Paris: Robert Laffont, 1994), I, 250. Characteristically, Diderot takes a skeptical stance to Buffon's insistence upon separating the material nonhuman animal from the spiritualized human by posing questions regarding the status of humans whose minds, and even consciousness, are compromised (251).

11 In the painting known as *The Buffet* (Paris, Louvre), one of those Chardin submitted to the Royal Academy of Painting and Sculpture to receive admission in

1728, a spaniel in the foreground raises his head to gaze (or sniff) toward a parrot perched beside a towering pyramid of lustrous fruits on a sideboard. Standard elements of Netherlandish still life painting crowd together on the table: an elegantly draped and bunched white cloth, a silver dish holding opened oysters, vessels of various shapes and materials, as well as a projecting knife and artfully peeled lemon. Even in this conservative work, Chardin invites a viewer to assume an animal's perspective on the scene by turning the spaniel so that his hindquarters project outward and the lifted head mirrors our own action in vertically scanning the scene before us. Cf. Lajer-Burcharth, *The Painter's Touch*, 106–8.

12 Cf. Horst Gerson, quoted in *Jean Siméon Chardin 1699–1779: Werk, Herkunft, Wirking* (Karlsruhe: Staatliche Kunsthalle, 1999), 283.

13 E.g., Francisco de Zurburán, *Agnus Dei* (Madrid: Museo del Prado).

14 Rosenberg et al., *Chardin* [2000], 19. Rosenberg attributes Chardin's use of living animals to competition with Desportes and Oudry; see, e.g., 131, 138.

15 Cf. Cohen, "Thomas Gainsborough's Sensible Animals."

16 David-Renaud Boullier, *Essai philosophique sur l'âme des bêtes: où l'on traite de son existence et de sa nature, et où l'on mêle en occasion diverses réflexions sur la nature de la liberté, sur celle de nos sensations, sur l'union de l'âme et du corps, sur l'immortalité de l'âme et où l'on refute diverses objections de Monsieur Bayle* (Amsterdam: François Changuion, 1728), 74.

17 "… Elles agissent d'une manière conséquent; cela prouve qu'elles ont un sentiment d'elles-mêmes, et un intérêt propre qui est le principe et le but de leurs actions." Ibid., 70.

18 Fontenay, *Le Silence des bêtes*, 458.

19 Locke, *Essay*, Book II, Chap. IX, Parts 8–14 (145–8).

20 Boullier, *Essai philosophique* [1728], 189–90. Several passages of the *Essai philosophique* make reference to Locke's theory of the infinite arrangement of beings from the most to the least complex; see, e.g., 113–14. In the 1737 version of his treatise, Boullier would specifically take up the Molyneux question, as discussed in the text below: David-Renaud Boullier, *Essai philosophique sur l'âme des bêtes* [1737], 329–31. Cf. Fontenay, *Le Silence des bêtes*, 461.

21 "… Deux manières différentes d'apercevoir le même objet"; Boullier, *Essai philosophique* [1737], 330.

22 "… Les Objets dans toutes leurs circonstances s'y peignent jusqu'au moindre trait … rien n'échape [*sic*] à la mémoire de ce qui a frappé les sens … "; ibid., 391.

23 Michael J. Morgan, *Molyneux's Question: Vision, Touch and the Philosophy of Perception* (New York and Cambridge: Cambridge University Press, 1977).

24 Baxandall, *Patterns of Intention*, 74–104, esp. 97, 102 (quotation from 102).

25 Dorothy Johnson, "Picturing Pedagogy: Education and the Child in the Paintings of Chardin," *Eighteenth-Century Studies* 24 (1990): 47–68.

26 Cf. Lajer-Burcharth's metaphor of the "bite": *The Artist's Touch*, 99.

27 Quoted in translation by Rosenberg, *Chardin* [1979], 117. Kate E. Turnstall has noted that in subsequently explaining how Chardin was able to achieve this "magic" through paint, Diderot paradoxically suggests that while the depicted fish is dead, the physical process of the artist, so vividly present in the painted surface, appears as if alive: Kate E. Turnstall, "Diderot, Chardin et la matière sensible," *Dix-huitième siècle* (2007/1): 588.

28 Daniel Cottam, *Cannibals and Philosophers: Bodies of Enlightenment* (Baltimore and London: The Johns Hopkins University Press), 2001. Cottam discusses Chardin's *Ray* on pp. 35–64; see especially his observations on p. 43. For the centrality of the body in eighteenth-century culture and thought, and a corresponding emphasis upon medical science, see also Vila, *Enlightenment and Pathology*.

29 See Roland Michel, *Chardin*, 118.

30 See also Chardin's paintings of dead hares in the Philadelphia Museum of Art; the Louvre; and the Musée de la chasse et de la nature, Paris.

31 Aristotle, *De Anima*, III: II, 412a. In his treatise on sensations of 1754, Condillac called touch the "fundamental sensation," "parce ce que c'est à ce jeu de la machine que commence la vie de l'animal: elle en depend uniquement." Condillac, *Traité des sensations* [1754], in *Œuvres philosophiques*, 3 vols., ed. Georges Le Roy (Paris: Presses universitaires de France, 1947–51), I, 51.

32 See especially René Démoris, *Chardin, la chair et l'objet* (Paris: Éditions Olbia, 1999), 39–48.

33 Cochin, "Essai sur la vie de Chardin," 1, 3, 12. Cochin also recounts (4) the circumstances surrounding one of Chardin's early figural paintings, in which he presumably depicted, from his own imagination, a scene of a surgeon treating a man wounded by a sword, intended as a shop sign for a surgeon. If accurately reported, this experience may also have inspired Chardin's subsequent series of wounded hares presented in dramatic postures.

34 See, e.g., Marin Cureau de La Chambre, *Traité de la connaissance des animaux* [1648] (Paris: Fayard, 1989); idem, *Les Caractères des passions* (Amsterdam: Antoine Michel, 1658).

35 Fontenay, *Le Silence des bêtes*, 375–83.

36 E.g., Antoine Dilly, *De L'Ame des bêtes, ou après avoir démontré la spritualité de l'ame de l'homme, l'on explique par la seule machine, les actions les plus surprenantes des animaux* (Lyon: Anisson et Posuel, 1676); reprinted several times through 1691. See also Louis Racine, *Epître à Madame la duchesse de Noailles sur l'âme des bêtes* ([publisher unknown], 1728[?]); l'abbé Macy, *Traité de l'âme des bêtes avec des réflexions phisiques* [sic] *et morales* (Paris: P.G. Le Mercier, 1737). Cf. Hastings, *Man and Best in French Thought of the Eighteenth Century*, 26.

37 Je vois que mon Ame en qualité de principe sensitive, produit mille actions et remue mon corps en mille manières, toutes pareilles à celles dont les Bêtes remuent

le leur dans des circonstances semblables … J'en conclus qu'il y a dans les Bêtes un principe de sentiment … " ; Boullier, *Essai philosophique* [1728], 75.

38 Cf. Cochin, "Essai sur la vie de Chardin, 9": "… En général son pinceau fût peu agréable et en quelque sorte raboteux … "

39 Buffon, *L'Histoire naturelle générale et particulière*, 13 vols. (Paris: l'Imprimerie royale, 1769–70), VII, 137–40 [hereafter cited as Buffon, *L'Histoire naturelle* (1769–70)]. As Buffon himself notes, the *callitriche* is also known as the "green monkey"— today's "African Green Monkey." According to Louise Robbins, this species and the New World capuchin were the most common types of monkeys sold as pets in eighteenth-century France; see Robbins, *Elephant Slaves and Pampered Parrots,* 130.

40 Although beyond the scope of this book, Chardin's late genre painting known as *La Serinette* also addresses, with subtle wit, the correlation between human and animal as perceptual agents; Elizabeth Amy Liebman, "The Bird Organ in Eighteenth-Century Art and Sound," unpublished paper, 2017.

41 See Rosenberg, *Chardin* [1979], 222.

42 H. W. Janson, "*Ars Sima Naturae,*" in *Apes and Ape-Lore in the Middle Ages and the Renaissance* (London: The Warburg Institute, 1952), 287–326. Janson discusses the Teniers painting illustrated in Figure 3.2 on p. 310.

43 For a helpful contextual analysis of La Mettrie's unorthodox proposal, see Aram Vartanian, "Quelques réflexions sur le concept d'âme dans la littérature clandestine," in Bloch, *Le Matérialisme du XVIII^e siècle et la littérature clandestine*, 149–65.

44 La Mettrie, *Machine Man*, in *Machine Man and Other Writings*, 13.

45 Ann Thomson, "Chronology," in La Mettrie, *Machine Man and Other Writings*, xxvii.

46 Ann Thomson, "Qu'est-ce qu'un manuscrit clandestin ?"," in Bloch, *Le Matérialisme du XVIII^e siècle*, 15.

47 Charles Perrault, "Riquet à la Houppe" (1697), in *Contes des fées* (Paris: Delarue, 1867), 71. In this passage, "… elle ne paraissait plus auprès d'elle qu'une guenon fort désagréable," Perrault plays upon the French colloquial use of *guenon* (female monkey) as signifying a particularly ugly woman.

48 Robbins, *Elephant Slaves and Pampered Parrots*, 130–1. Nicole Garner-Pelle, Anne Forray-Carlier, and Marie-Christine Anselm, *The Monkeys of Christophe Huet: Singeries in French Decorative Arts*, trans. Sharon Grevet (Los Angeles: The J. Paul Getty Museum, 2011), 19–20, 156–7.

49 See Garnier-Pelle et al., *The Monkeys of Christophe Huet*, 24.

50 Ibid., 50–1.

51 Another presumed self-portrait in simian form appears in a panel beneath the monkey working at his easel on the left entrance door: the panel features a bust "portrait" of a monkey suspended as if it is a painting on display.

52 Garnier-Pelle et al., *The Monkeys of Christophe Huet*, 50–1; Manuela Finaz de Villaine, Nicole Garnier-Pelle et al., *Singes et Dragons: La Chine et le Japon à*

Chantilly au XVIII^e siècle (Chantilly: Institut de France and Domaine de Chantilly, 2011–12), 3–5.

53 Garnier-Pelle et al., *The Monkeys of Christophe Huet*, 50–1.

54 Like many of the early soft-paste porcelains produced at Chantilly, the monkey ink stand emulates Asian models, in this case Chinese ink stands featuring simian actors; for example, a monkey in the guise of a portly Buddha guards an ink well in a Chinese hardstone ink stand in the collection of the Metropolitan Museum of Art (02.18.905). As an eighteenth-century European example of a ceramic animal providing a vessel for material human consumption the Chantilly porcelain is, however, notably innovative.

55 On this problem, see Christopher M. S. Johns, *China and the Church: Chinoiserie in Global Context* (Oakland, CA: University of California Press, 2016), especially 124–7.

56 Pierre Rosenberg and Ettore Camesasca, *Tout L'Oeuvre peint de Watteau*, rev. ed. (Paris: Flammarion, 1980), nos. 66–7; Scott, "Playing Games with Otherness," 193.

57 Rosenberg and Camesasca, *Tout L'Oeuvre peint de Watteau*, no. 66.

58 See Rudolf Wittkower and Margot Wittkower, *Born under Saturn: The Character and Conduct of Artists: A Documented History from Antiquity to the French Revolution* (London: Weidenfeld and Nicolson, 1963).

59 The work is known today through the print known as "Pour Garder L'Honneur d'une belle"; Rosenberg and Camesasca, *Tout L'Oeuvre peint de Watteau*, no. 15.

60 Dora Panofsky, "Gilles or Pierrot?" *Gazette des beaux-arts* 142 (1952): 319–40; Cohen, *Art, Dance, and the Body*, 269.

61 On the hierarchy of official positions in the Royal Academy of Painting and Sculpture and the assignment of painters' respective genres, see Williams, *Académie Royale*, 24, 80.

62 Rosenberg, *Chardin* [1979], 151.

63 Ibid., 151.

64 Ibid.

65 Ibid., 221–3 (quotation from 222).

66 Cf. Garnier-Pelle et al., *The Monkeys of Christophe Huet*, 156–7.

67 Rosenberg, *Chardin* [1979], 224.

68 Ibid., 222.

69 Ibid.

70 Janson, *Apes and Ape Lore*, 311–12.

71 La Mettrie, *Treatise on the Soul*, in *Machine Man and Other Writings*, 66.

72 La Mettrie, *Machine Man*, in *Machine Man and Other Writings*, 20.

73 Ibid., 13.

74 Ibid., 11–12. La Mettrie almost always uses the term *singe* (monkey) to refer to nonhuman primates, only once in *Machine Man* making explicit reference to the *grand singe* (great ape). Thomson, however, translates *singe* as "ape" in many of

these passages. See Julien de La Mettrie, *L'Homme Machine* (Leiden: Elie Luzac, 1748), 26.

75 La Mettrie, *Machine Man*, in *Machine Man and Other Writings*, 11. La Mettrie's discussion of Ammann's techniques of instructing the deaf appeared in his *Treatise on the Soul*: see Julien de La Mettrie, *Oeuvres philosophiques de Mr. de La Mettrie* [1750], 2 vols. (Amsterdam: publisher unknown, 1753), Chapter XV, *Histoire* 4, I, pp. 172–84.

76 La Mettrie, *Machine Man*, in *Machine Man and Other Writings*, 12. Julia Douthwaite has illuminated the eighteenth-century debates surrounding the so-called "wild" children that had been discovered living in a natural state resembling that of animals, and has shown that such debates evinced considerable disagreement and anxiety in eighteenth-century culture as to the relative status of humans and animals. See Julia V. Douthwaite, *The Wild Girl, Natural Man, and the Monster: Dangerous Experiments in the Age of Enlightenment* (Chicago: University of Chicago Press, 2002); La Mettrie is discussed on pp. 40–1.

77 Kathleen Wellman, *La Mettrie: Medicine, Philosophy, and Enlightenment* (Durham, NC and London: Duke University Press, 1992), 6.

78 "… Singe plein d'Esprit"; La Mettrie, *L'Homme Machine*, 1748, 105.

79 Buffon, *Histoire naturelle* (1769–70), XII, 36–7. Buffon's discussion of the apparent, but ultimately misleading, corporeal similarities between humans and apes is deeply compromised by the negative stereotypes of savagery he imparts to his characterizations of the indigenous people of Africa, especially the so-called "Hottentots."

80 "… Portant à l'extérieur un masque de figure humain, mais dénué à l'intérieur de la pensée et de tout ce qui fait l'homme …" ; ibid., XII, 58.

81 La Font de Saint-Yenne, *Réflexions sur quelques causes de l'état présent de la Peinture en France*, 8.

82 Ibid., 10–11; 84–5. Cf. Jean-Baptiste Du Bos, *Réflexions critiques sur la poésie et sur la peinture* [rev. ed., 1740] (Paris: École nationale supérieure des Beaux-Arts, 1993), 10, 28–37.

83 La Font de Saint-Yenne, *Réflexions sur quelques causes*, 31, 90–1.

84 Étienne La Font de Saint-Yenne, *Sentiments sur quelques ouvrages de Peinture, Sculpture et Gravure, Écrits à un Particulier en Province* (publisher unknown, 1754), 11.

85 Ibid., 5.

86 "… La terreur des hérétiques, et la plus éclatante lumière de l'église, la phisionomie [*sic*] élevée d'un défenseur intrépide de la foi ?" Ibid., 16.

87 La Font de Saint-Yenne, *Réflexions sur quelques causes*, 110. Perhaps these portraits, unknown today, resembled those which Chardin made in pastel during the latest period of his working career. Cf. Cochin on the latter: "Essai sur la vie de Chardin," 3, 12. La Font asserted that Chardin painted essentially for self-amusement,

presumably because of the official positions he held within the Academy; such an assessment, however, is shared neither by Cochin nor by Mariette. Cf., e.g., *Documents sur la vie et l'oeuvre de Chardin*, 10, 29.

88 La Font de Saint-Yenne, *Réflexions sur quelques causes*, 68.

89 Buffon, *Histoire naturelle* (1769–70), XII, 53–4.

90 Ibid., XII, 54. See also Buffon's disquisition on the uniqueness of the human soul that opens his volume on man: *Histoire naturelle* (1769–70), IV, 151–72.

91 La Mettrie, *Machine Man*, in *Machine Man and Other Writings*, 33.

92 Ibid., 11–12.

The Language of Brutes

In his critique of the Salon of 1746, La Font de Saint-Yenne chose to place the animal specialist Jean-Baptiste Oudry among the history painters—those who captured the soul—on account of the expressiveness the artist achieved in rendering the heads and postures of his animal actors.[1] While Chardin's recent paintings of everyday life appeared to the critic too banal to warrant discussion, "everything is to be noted" in Oudry's painting of dogs attacking a wolf, including the complicated actions of the animals captured by the artist and the "terrifying expression of their furor."[2] What appealed to La Font in Oudry's canines was exactly what appealed to him in the depictions of great human action by the likes of Le Brun, Antoine Coypel, and Carle van Loo: actions that communicated the essence of "character" and heads in which emotion was sensitively conveyed.[3]

La Font claimed to be speaking for "the public" in his assessments, and while he was exaggerating his own representative status as a critic, he was indeed articulating a growing acceptance among his peers that animals not only possessed sensitive souls but had their own ways of expressing their feelings. A number of writings on animal "language" appeared during the decades in which Oudry was exhibiting at the Salon, from the witty *Amusement philosophique sur le langage des bêtes* published by the worldly Jesuit Guillaume-Hyacinthe Bougeant in 1739 to the scientific theories of animal expression proposed by Étienne Bonnot de Condillac in the 1740s and 1750s.[4] We have observed La Mettrie speculating that great apes might learn to speak human language with the right instruction, and Boullier, too, noted an inherent sociality in animals that impelled communication with one another through bodily actions and signs.[5]

But it was Oudry himself who made the strongest case for the passionate, "articulate" animal,[6] both in such grandiose works as his many large hunt paintings, and in his remarkable series of illustrations to the *Fables* of La Fontaine, many of which he also exhibited in the Salon and probably made with the intention of publishing as prints in an illustrated edition of this perennially

popular work.[7] Shortly after the artist's death in 1755, Oudry's drawings were in fact reproduced in luxury volumes featuring a complete set of engravings made under the direction of Charles-Nicolas Cochin.[8] These fable illustrations, particularly when examined in their original form as drawings, evince a lifelike animal "language" whose fluency extends to all of the artist's work. While La Fontaine's animals speak in eloquent, witty French, Oudry's pictorial counterparts express themselves through a physical vocabulary that recalls and even directly overlaps with that found in his representations of woodland hunts. The forceful arguments in favor of animal intelligence which the poet expressed in the *Discourse to Madame de la Sablière* find visual corroboration in Oudry's beasts, who "speak" to one another through distinctively animalistic tongues.

By using bodily gestures characteristic of the various species he depicted as a means of imparting their communication, Oudry moreover redefined the model of language from humanistic semantics to sensory perception and physical action. His creatures, while sufficiently emotive to fulfill La Font's requirements for dramatic history painting, "speak" their material desires, aggressions, defenses, and needs through cultural patterns that the artist conveys as distinctively animal. This seemingly natural style of communication may have particularly attracted French audiences in the middle decades of the century, when even so sophisticated an institution as human language could be ascribed, at base, to sensory experience. French philosophers who posited an expressive animal language, whether for the purpose of "amusement," as in Bougeant's case, or to make a larger epistemological argument, as in Condillac's, indeed assumed that this language derived from sensational skills shared by human and nonhuman alike. As scholars such as Jessica Riskin have noted, the eighteenth-century "science" of the senses encompassed the moral as well as the empirical, since for the *philosophes* all kinds of feeling, from the instinctual to the emotional, stemmed essentially from sensory knowledge.[9] Although most writers on animal expression denied morality to animals, in fact there was considerable sentimental interpretation of animal behavior that coincided with, and even depended upon the conditions of "brute" existence. Artists such as Oudry and his follower Jean-Baptiste Huet found their own ways of capturing this exemplary union of the material and the emotive so as to encourage identification with their creatures on an immediate, visceral level. Descartes's contention, often repeated by his seventeenth-century defenders, that animals' inability to speak demonstrated their lack of consciousness effectively dissolved in a mid-eighteenth-century culture for which the expression of animal "feeling" constituted knowledge in itself.

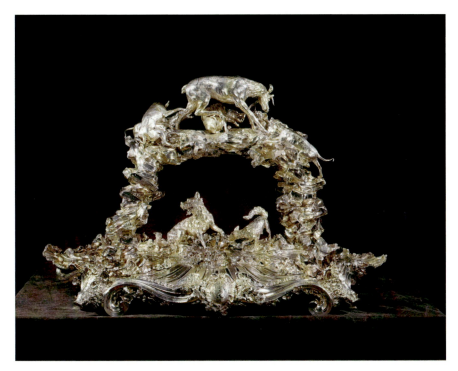

Plate 1 Jacques Roëttiers, *Table Centerpiece*, silver, 1730s; Paris, Louvre; photo: © RMN-Grand Palais/Art Resource, NY.

Plate 2 Alexandre-François Desportes, *Allegory of the Senses*, oil, 1717; Grenoble, Musée de Grenoble; photo: Ville de Grenoble/Musée de Grenoble—J.L. Lacroix.

Plate 3 Jean-Siméon Chardin, *Soup Tureen with a Cat Stalking a Hare*, oil, 1728–30; photo: ©The Metropolitan Museum of Art/Art Resource, NY.

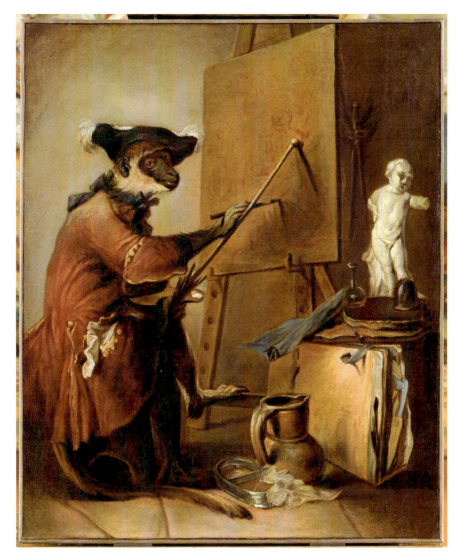

Plate 4 Jean-Siméon Chardin, *Monkey as Painter*, oil, 1740; photo: © RMN-Grand Palais/Art Resource, NY.

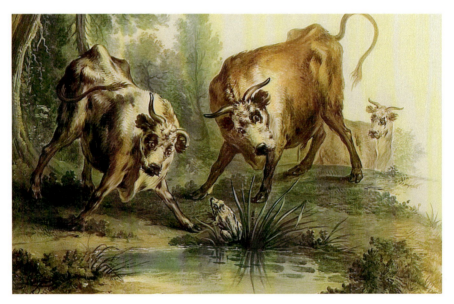

Plate 5 Detail of boudoir panel depicting "The Two Bulls and the Frog," from townhouse on Place Vendôme, Paris, 1750s; Paris, Les Arts Décoratifs, musée des Arts décoratifs, Dépôt du Musée du Louvre; © Paris, Les Arts décoratifs.

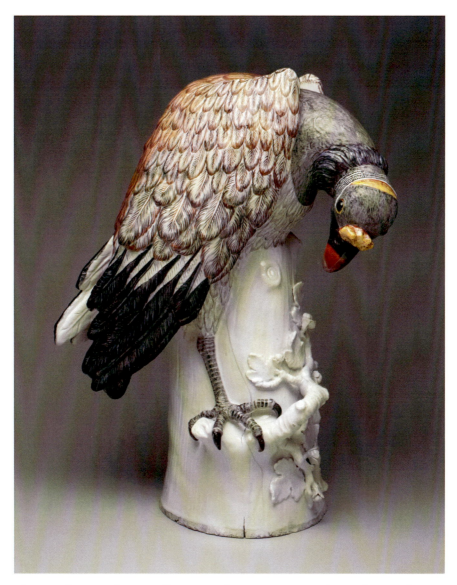

Plate 6 Johann Joachim Kändler, *King Vulture*, Meissen porcelain with enamel coloring, 1734; Chicago Art Institute; photo: The Art Institute of Chicago/Art Resource, NY.

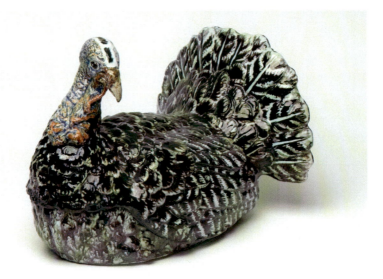

Plate 7 Anon., *Turkey Tureen*, Mombaers soft-paste porcelain, *c*. 1760; Paris, Les Arts Décoratifs, musée des Arts décoratifs; photo: ©Les Arts décoratifs/Jean Tholance.

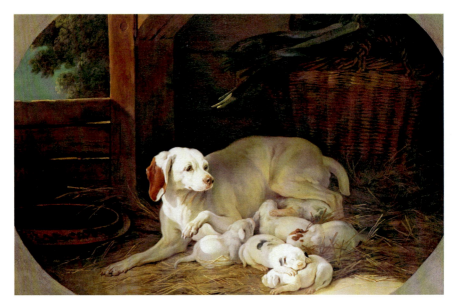

Plate 8 Jean-Baptiste Oudry, *Bitch-Hound Nursing Her Young*, oil, 1753; Paris, Musée de la chasse et de la nature; photo: Nicolas Mathéus.

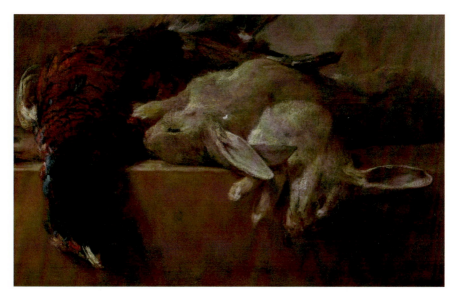

Plate 9 Detail of Jean-Siméon Chardin, *Two Rabbits, a Pheasant and a Seville Orange on a Stone Ledge*, oil, 1750s; Washington, D.C., National Gallery of Art; photo: Courtesy National Gallery of Art, Washington.

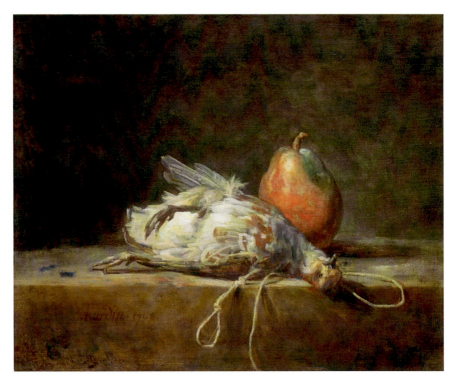

Plate 10 Jean-Siméon Chardin, *Grey Partridge, Pear and Snare on a Stone Table*, oil, 1748; Frankfurt am Mein, Städel Museum; photo: HIP/Art Resource, NY.

Oudry's Animal Actors

The *Wolf Hunt* that so impressed La Font when it appeared in the Salon of 1746 was one of numerous such depictions of woodland animal hunts that Oudry produced throughout his career (Gien, Musée international de la chasse). It figured among a series the artist was commissioned to make for the dining room of Louis XV's newly aggrandized château of La Muette (purchased for the young king by the Regent Philippe d'Orléans, who as we have seen had previously converted the small hunting lodge into a residence for his daughter, the duchesse de Berry).[10] Oudry's huge canvas brought the history of hunting on the site of La Muette back to its primal roots, with animals alone taking charge of the drama. A snarling wolf fends off four hunting dogs of three different *races*, or types,[11] in a dynamic pinwheel of canine combat.[12] Similar in composition and visual rhetoric is the *Wolf Hunt* Oudry first devised in a painting of 1724 and repeated almost verbatim for a 1734 commission from the duke of Mecklenburg, Christian Ludwig II, whose son Friedrich would write so excitedly to his father upon viewing the *Wolf in a Trap* in Oudry's studio a few years later.[13] Here another lone, ferocious wolf is attacked on all sides by a pack of eight hunting dogs, a confrontation which culminates in the central motif of two canines of different species squaring off with open jaws (Figure 3.1). The toothy physiognomies of these combatants exhibit the "terrifying expression of their fury" observed by La Font in Oudry's *Wolf Hunt* of 1746, and must have represented to the critic a valid animalistic equivalent to the expression of the passions that he and a number of his Academic counterparts were beginning to advocate for artistic practice and pedagogy.[14] They also suggest a peculiarly canine mode of communication that would become, upon repeated appearances in Oudry's painting, a characterizing language "spoken" by all of the *Canidae* in his repertoire. With no humans present, and none of the hounds even wearing collars, the loquacious group forms its own society of expressive action within their earthy surrounds.

Even when he turned to the humanistic poetry of the perennially popular *Fables* of La Fontaine, Oudry pursued his species-specific languages to convey distinctive animalistic personalities and interactions. Although the artist's principal engagement with the *Fables* lay in the graphic illustrations he made between 1729 and 1734 (many of which are lost), he also produced a number of independent paintings and sets of decorative designs featuring selected examples of his fables. One of these, *The Wolf and the Lamb*, which belonged to a set of four overdoors the artist painted for the Apartment of the Dauphine at

Figure 3.1 Jean-Baptiste Oudry, *Wolf Hunt*, oil, 1734; Schwerin, Staatliches Museum; photo: bpk, Berlin/Staatliches Museum, Schwerin/Elke Walford/Art Resource, NY.

Versailles in 1747,[15] features the very same wolf that is featured in the Schwerin *Wolf Hunt*, this time planting his forelegs in a stream while turning his head to "speak" to the placid lamb nearby (Figure 3.2).[16] Although to some extent Oudry's repeated use of the same posture and open-mawed head could be seen as artistic convenience, in the case of the fable of "The Wolf and the Lamb" the respective expressions of the two animals perfectly capture La Fontaine's ironic juxtaposition of the congenitally angry vulpine and his patient, but hopelessly naïve, victim.[17]

It is possible that Oudry originally developed the rhetorical motif of fang-to-fang canine interaction in a drawing depicting *Two Hounds Disputing Dead Game* (Figure 3.3), in which two dogs in plausibly dominant and submissive postures appear to "argue" through canine expressive signs. This canine argument would become the visual basis for Oudry's illustration to La Fontaine's "The Hound-Bitch and Her Friend," known today through the engraving made after it as well as in another painting from the series painted for the apartment of the Dauphine at Versailles (Figure 3.4).[18] In the fable illustration, we are intended to interpret the dogs' open mouths—as well as their relative high and low positions—as a depiction of their dispute (in

Figure 3.2 Jean-Baptiste Oudry, *The Wolf and the Lamb*, oil, 1747; Versailles, Châteaux de Versailles et de Trianon; photo: © RMN-Grand Palais/Art Resource, NY.

Figure 3.3 Jean-Baptiste Oudry, *Two Hounds Disputing Dead Game*, black-and-white chalk, 1726; Schwerin, Staatliches Museum; photo: bpk Bildagentur/Staatlisches Museum, Schwerin/Gabriele Bröcker/Art Resource, NY.

Figure 3.4 Jean-Baptiste Oudry, *The Hound-Bitch and Her Friend*, oil, 1747; Versailles, Châteaux de Versailles et de Trianon; photo: © RMN-Grand Palais/Art Resource, NY.

French) over which of the two rightfully owns the comfortable domicile in which one hound-bitch is raising her puppies. But so convincingly lifelike are their attitudes and "expressions" that one could also interpret the scene as a very specifically canine confrontation over territory and maternal protectiveness. As if to emphasize his implication of the animals' "natural language," Oudry used a similar open-mouthed gesture on the part of the young dog "speaking" to its sibling from its recumbent position on the straw.

We thus find Oudry moving back and forth between his "real life" images of the hunt and his "fictional" depictions of fables to develop a single mode of animalistic expression through posture and *airs de tête*—as artists' expressive and characterizing depiction of heads was often called in the art critical language of the eighteenth century.[19] Just as La Fontaine himself inserted a philosophical argument in favor of animal soul into the midst of his imaginative stories of talking animals, so Oudry made a case for the animal as an expressive subject by integrating, rather than separating his fable illustrations from his more empirically based *oeuvre*. The complexity and effectiveness of Oudry's animal language emerge particularly in the graphic works he made in both genres: in his drawing for La Fontaine's "The Wolf and the Fox," for example, Oudry used a plausibly wary attitude for the body of the wolf to portray the reluctant

efforts on the part of this master predator to instruct the fox in hunting sheep (Figure 3.5).[20] The hunched posture of the wolf corresponds closely to that which Oudry had already used for the canine dispute in his drawing of 1726 (Figure 3.3). The fox, meanwhile, laboring under his bulky wolf-skin disguise, conveys his inappropriateness as a big game hunter by snarling angrily but ineffectually in the direction of a puzzled sheep. Even if one interpreted the open-jawed animal in the fable drawing as a depiction of a "talking" fox,

Figure 3.5 Jean-Baptiste Oudry, *The Wolf and the Fox*, pen, brush, and ink with gouache, 1733; Los Angeles, J. Paul Getty Museum; photo: digital image courtesy of the Getty's Open Content Program.

a person could never learn the actual content of La Fontaine's text from examining Oudry's pictorial rendition. Rather, the artist makes a pictorial story of his own, communicated through animal actions.

The Language of Animal Subjects

Ever since Descartes had argued in the *Discourse on the Method* of 1637 that animals lacked language and therefore lacked a soul, the language question had riddled debates over whether animals were behavioral "machines" or conscious subjects. In his *Essay Concerning Human Understanding*, Locke recounted at length the story of an old Brazilian parrot kept as a house pet by Prince Maurits of Nassau, who conversed with the bird (with the help of a translator, since the parrot spoke Portuguese) in a strikingly rational manner. Although Locke's point was ultimately to controvert the categorization of species by abstract traits, he coincidentally refuted Descartes's theory that humans were defined and separated from nonhumans by their speech.[21] A desire for social intercourse presumably provided the motivating factor for the parrot to respond to the Dutch leader's many questions, and eighteenth-century theorists of animal language, while abandoning the notion that animals "speak" as humans do, would argue that social need did compel animals to communicate through physical systems of their own.

David Boullier, for example, writing in his treatise of 1728, argued that "intelligent signs" provided a means through which such highly social animals as dogs and horses engaged in mutual exchange with their human companions. "A certain society," moreover, prevailed among members of the same species and occasionally of differing species as well: "they appear to understand one another, act in concert, agree on the same plan."[22] La Mettrie, as we have seen, went much further than Boullier in speculating upon the potential of animals for using language to communicate, arguing that monkeys, given their physical similarity to humans, should with the correct training learn to speak through vocalization, as Ammann's deaf pupils were beginning to do. La Mettrie cited Locke's presumed belief in the story of Prince Maurits's talking parrot to lend support to his own suppositions.[23]

In his controversial but immensely popular *Amusement philosophique sur le langage des bêtes* of 1739, the abbé Bougeant further developed the argument that a need for society drove animals to fashion and use their languages in an intelligent manner. Unabashedly redolent of the talkative, cultured society for

which he himself was writing, Bougeant's treatise also recalls the fact that *salon* conversation had fostered many of the seventeenth-century writings on animal soul, including La Fontaine's poem dedicated to Madame de la Sablière.[24] His little treatise earned the author temporary exile from the Jesuit institution where he taught, but the book itself was reissued five times in 1739 alone, and was translated into English the very same year.[25] Sociality was essential to Bougeant's theory of animal language; he contended that animals had to have an intelligent means of communication within each species in order to plot their livelihood. Communication, in turn, prompted animal societies to flourish, much as language functions in human society.[26] Recounting at length the example (by that time well-known) of united beaver industry, he extended the notion of cooperative communication into the actions of numerous other species, even those that do not appear to be sociable at first glance. Although he acknowledged that animal language was much simpler than that of humans, he claimed that its function was comparable, and perfectly calibrated to collective animal need.[27] Humans, he noted in a dry aside, might in fact have too much language for their own good.[28]

Like Boullier, Bougeant grounded his arguments in empirical observation, claiming to hear in the utterances of birds not song but functional language, and perceiving in the bodily movements of other animals a whole vocabulary of expressive statements.[29] Once again the dog emerges as a telling case in point, not just of canine-to-canine communication, but of animal-to-human and human-to-animal as well.[30] The cultivated readers toward whom Bougeant directed his book must have appreciated his appeals to everyday experience, and they may also have seen themselves in the social networking, dialogue, and flirtation Bougeant used as proofs of animal intelligence. According to the author, "Madame C ..., " to whom he dedicated his book, communicates with her female dog all day long and knows that they understand one another. As soon as a male dog enters the scene, canine intelligence soars: "when coaxed by a male, she understands *him* even better and makes herself even better understood."[31] Perhaps remembering La Fontaine's fables, in which insects and arachnids take their place as conscious protagonists beside larger life forms, Bougeant recounted his own percussive dialogues with a tapping spider in his wall, a piquant source of entertainment for his guests.[32]

As its title implies, Bougeant's *Amusement philosophique* was philosophy for the purpose of entertainment, much as La Fontaine could be said to have argued in favor of animal soul through the medium of brilliant literary wit. Entirely in earnest, by contrast, was Bonnot de Condillac's writing on animal communication in his *Treatise on Animals* of 1755.[33] While acknowledging

that animals lacked the ability to speak—a uniquely human capacity—the *philosophe* argued that a fundamental "language of action" underlies all animal communication, including that of the human.[34] Condillac, in fact, appears to have directly relied upon the theories he developed for "The Origin and Progress of Language" in his *Essay on the Origin of Human Knowledge* of 1746 to create his subsequent theory of animal language, thus emphasizing a direct continuity amongst all creatures. Just as animals convey through "inarticulate cries and movements of the body the signs of their thoughts," the earliest pair of co-habiting humans found that "their mutual discourse made them connect the cries of each passion to the perceptions of which they were the natural signs."[35] Rousseau, who had proposed a similar theory of the origins of language in his *Discourse on the Origin and the Foundations of Inequality among Mankind* of 1753, called this primitive, animalistic communication the "cry of nature."[36] Condillac took the argument further in asserting that those animals that most resemble and rely upon humans in the modern world of domestication learn so well to understand the words we use to accompany our actions that they in a sense become conversant with human language. Unlike Locke, however, Condillac gave no credence to the potential for interchange between humans and parrots, both because the parrot's "language of action differs infinitely from ours," and because the bird simply has no need to understand what we are thinking.[37]

We, on the other hand, do feel the need to understand animals, and Condillac argues that the more attention we pay to how they act the better we will come to know them. It is a species' common need that causes a similar language of action among the individuals, rather than any pre-programed "mechanism" that determines their behavior.[38] Condillac directed his treatise on animals very specifically against Buffon and his Cartesian theory of the animal as "machine"; his own theory of animals' language of action was one way of validating animal understanding, and he indeed went so far as to assert that we cannot firmly separate ourselves from the other animals. He suspected that, in the scale of nature, the human is more distant from the angels than he is from the animals.[39]

Sensible Expression

The "sensitive soul" of the animal, an Aristotelian concept whose early modern reverberations extended even to La Mettrie's radical propositions, had undergone a transformation by the middle of the eighteenth century to become

the experiential source of all knowledge. When Condillac posited the animalistic language of action as the springboard for human speech, he was also defining emotional and physical feeling as the kernel of rational knowledge—a theory he would develop at length in his *Treatise on the Sensations* of 1754. Although La Mettrie represented an extreme position in positing no essential difference between human and animal, he was in fact not far from the stance Condillac would take in 1754 when the latter laid out the path to human understanding by first describing knowledge acquired through the five senses, each of which he addressed in turn, ultimately concluding that "all our understanding comes from the senses, and particularly from touch."[40] La Mettrie, yet more blunt and even more insistently material, asserted that "thought is only a capacity to feel and ... the rational soul is only the sensitive soul applied to the contemplation of ideas and to reasoning!"[41]

It is likely that La Font de Saint-Yenne harbored a similar appreciation for universal sensory apprehension and understanding when he placed Oudry's *Wolf Hunt* among the history paintings exhibited in the Salon and extolled "the action of these animals and the frightening expression of their fury," using language not unlike that which he employed to assess other artists' impassioned depictions of human exploits.[42] For although La Font favored histories over the quotidian, plotless subject matter of an artist such as Chardin, concerted expression of feeling through action appears to have been sufficient grounds for the critic to appreciate an artist's construction of character, whether human or animal. Oudry himself was joined by other animal specialists in the middle decades of the eighteenth century who capitalized upon a "language of feeling" with which human viewers could identify, even going so far as to alter their creatures' physiognomies to elicit the impression of internal sentiment.

Expressive physicality, particularly as manifested through the head, had been a fundamental tenant of Academic practice and pedagogy virtually from the inception of the institution in 1648, and in La Font's mid-eighteenth milieu it was undergoing a revival of emphasis on the part of Academicians, *amateurs*, and critics eager to see a return to serious history painting based upon the study of emotional communication. The comte de Caylus, who faulted his late friend Watteau precisely for the lack of such serious expressive display in his *fêtes galantes*, presented lectures at the Royal Academy in 1753 and 1759 on the potential of the head to communicate various emotional states, an effort culminating in his establishment of an expressive head competition, the *Prix d'expression*, in 1760.[43] Charles Le Brun's physiognomic lectures and

demonstrations loomed large as background to this effort within the Academy, although Caylus and others advocated a more empirically based approach than the heavily systematic model established by the seventeenth-century artist. For his competition, indeed, Caylus proposed using female models precisely to avoid masculine stereotypes imported from Le Brun, and to instead foster study of a natural and more spontaneous expressive language.[44] Oudry, himself an Academician who was presenting his own lectures on color and painting techniques in the middle years of the eighteenth century,[45] would have been well aware of the movement within the institution toward expressive bodies and heads in the later 1740s. The Academy's new emphasis upon empirical study and the recreation of natural emotional inflections moreover resonated with his own practice as a painter of animals, and likely encouraged the artist to create expressive animal head studies of his own.

There was precedent for Oudry's project in the work of Le Brun himself, who in his studies of human expression had already allowed a similar physiognomy of feeling in those animals that were considered closest to the human, principally horses and dogs, and he followed a long pictorial tradition by imparting an affective range of expressions to the lion, the most "noble" of wild beasts. In the eighteenth century, engraved collections based upon Le Brun's physiognomic drawings also accentuated the communicative potential of the animal head in selective species. In his *Recueil de lions* of 1729, the engraver Bernard Picart raided the works of past masters for suggestive depictions of this animal, claiming to have shunned those that were unrealistic in favor of those that appeared to have been taken directly from nature.[46] The heads engraved after Le Brun, such as the pair of profiles in Figure. 3.6, were probably some of those which Le Brun himself had copied after studies by his Flemish colleague Pieter Boel, although Picart, highlighting objectivity, claimed otherwise (Figure 3.6). To capture an expression of leonine anger, he asserted, Le Brun himself had prodded a live animal with a cane, yielding an appropriate fury.[47] Whatever their history as graphic creations, the two profiles that Picart chose to juxtapose indeed evince subtle differences of expression: while the lioness on the left appears to growl toothily in anger, the male lion appears more surprised than furious, largely due to the round eye set off by a circle of white and the steady forward gaze. The levelness of the lion's eye in fact matches that which Le Brun had used in a drawing depicting a lion and horse side by side, presumably to demonstrate how an artist could humanize the eyes of a noble animal.[48] The result, as fashioned by Picart in his leonine image, resembles the human physiognomy of "Admiration with astonishment" as depicted in an engraving after Le Brun by Jean Audran

Figure 3.6 Bernard Picart after Charles Le Brun, *Recueil des lions*, plate B.1, engraving, 1729; Paris, Bibliothèque nationale, Cabinet des estampes; photo: Bibliothèque nationale de France.

from a collection published in 1727 (Figure 3.7).[49] Closely based upon an original drawing by Le Brun—which itself served as the model for a figure in the *Tent of Darius* (Versailles, Châteaux de Versailles et de Trianon)[50]—Audran's surprised woman opens her mouth to reveal upper and lower teeth, as Picart's lion does, and exhibits a similar wide-eyed and highlighted gaze.

Three extant canine head drawings by Oudry, all probably executed in the 1740s, strongly suggest that the artist was creating his own version of the expressive animal head, now redolent of the empirical mandates of his era. Closely resembling communicative heads found in his interactive animal scenes, Oudry's highly finished physiognomic drawings were acquired as collector's pieces for the ducal court of Mecklenburg-Schwerin during Oudry's lifetime.[51] Most dramatic is the *Head of a Frightened Fox*, executed in vivid pastel: the animal's wide, intensely focused eye, pricked ears, and toothy vocalization imply that its every sense is alerted to the danger that lies beyond its swiveled and lifted head (Figure 3.8). That Oudry isolated the fox's head in the center of the once-blue paper suggests his awareness of Academic physiognomic tradition stemming from Le Brun, as Christine Giviskos has noted.[52] In keeping with his allegiance to nature, Oudry avoids Le Brun's purposeful anthropomorphizing

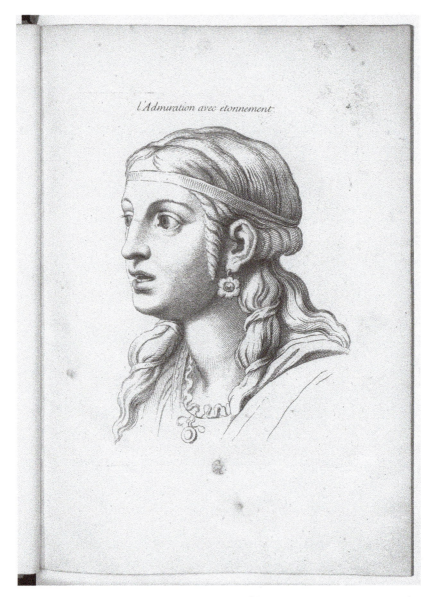

Figure 3.7 Jean Audran after Charles Le Brun, "l'Admiration avec étonnement," *Expression des passions,* plate 4, engraving, 1727; Paris, Bibliothèque nationale, Cabinet des estampes; photo: Bibliothèque nationale de France.

and conveys instead the appearance of drawing directly from life. "Life," however, still means a culturally learned and practiced language, just as it did in the human realm of the mid-eighteenth-century Academic head studies. For in fact the turned and raised position of the canine head, as well as the open maw

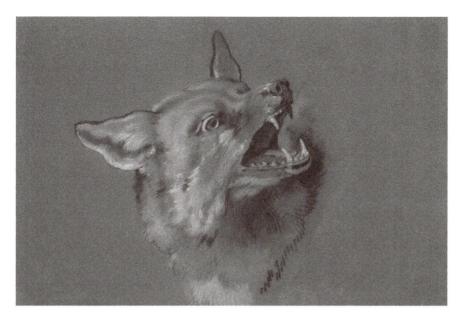

Figure 3.8 Jean-Baptiste Oudry, *Head of a Frightened Fox*, pastel, after 1740; Schwerin, Staatliches Museum; bpk Bildagentur/Staatliches Museum, Schwerin/ Gabriele Bröcker/Art Resource, NY.

and recoiling ears, repeats the "expression" of the masquerading fox in Oudry's drawing after La Fontaine (Figure 3.5).

Seamlessly moving between witty illustration and study "from nature," Oudry's animal language, like that proposed by the abbé Bougeant, implies the social context of the *salon*, where, as we have seen, much of his fable imagery could also be found in the form of furniture upholstered with his designs. But Oudry's head studies equally illuminate the theories of Condillac regarding the sensory language of animals: the notably enlarged, reflective eyes of his creatures, especially those of his hunting dogs, impart to these canines a distinct sensitivity and awareness, as manifested in the other two canine head studies purchased for the Mecklenburg-Schwerin court. In the drawing now called *Head of a Setter*, the animal turns as if in response to a sight, smell, or sound whose impact upon the sensitive creature is dramatically conveyed through illumination of the head in white chalk; its huge, liquid eyes and flared, moist nostrils convey the impression of a being whose high level of understanding lies fully in its senses (Figure 3.9). In his popular *Histoire naturelle*, Buffon himself would notably depart from his attempts at objectivity when turning to the domestic dog, going so far as to grant these animals a discerning sentiment equal to that of the human, and an impressionability more subtle than that of all other creatures.[53] But while Buffon's proof of the dog's

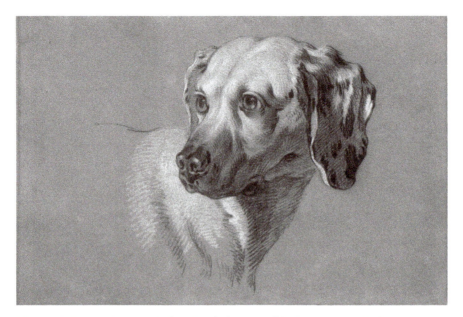

Figure 3.9 Jean-Baptiste Oudry, *Head of a Setter*, black-and-white chalk, *c.* 1740; Schwerin, Staatliches Museum; photo: bpk Bildagentur/Staatliches Museum, Schwerin/Gabriele Bröcker/Art Resource, NY.

"nobility" of feeling and action lay in its receptivity to the human, Oudry used variations on the attentive physiognomy of the hound in Figure 3.9 to convey the emotional states of animals interacting amongst themselves (Plate 8).[54]

Oudry's tendency to enlarge the eyes of his animal protagonists reflects a general stylistic trend on the part of mid-eighteenth-century French painters, a number of whom widened the eyes of their human characters in a similar effort to impart a quality of sensitive awareness expressed through the body and experienced emotionally. François Boucher, in particular, used saucer-like eyes for his sentimental pastoral folk, and sometimes for their domestic animal charges as well. In a painting known as *The Fool's Cap (La Marotte)*, for example, a boy gazes rapturously at a shepherdess who eyes him demurely from beneath heavy lids (Figure 3.10). The huge, contrasting eyes of the lovers—round and slanted—are almost exactly repeated by their respective animal companions, an alert mastiff on the left and a sleepy sheep on the right. Although aesthetic rather than scientific, Boucher's pastoral fantasy nevertheless confirms the "language of feeling," which, according to La Mettrie in his *Treatise on the Soul*, is "common to men and animals" and encompasses "all the expressions of pain, sadness … pleasure, joy, tenderness, etc." La Mettrie, for his part, provides a sensationalist

Figure 3.10 François Boucher, *Fool's Cap (La Marotte)*, oil, 1759; Paris, Assemblée Nationale; photo: © RMN-Grand Palais/Art Resource, NY.

rationale for Boucher's deceptively simple painting: "such energetic language has much greater power to convince us than all of Descartes's sophistry has to persuade us."[55]

Animal specialists inspired by Oudry would expand on his use of physiognomy to promote a "language of feeling" with which a sensitive mid-eighteenth-century viewer could identify. After the tax farmer François-Balthazar Dangé purchased a townhouse on the Place Vendôme in 1750, his wife, Anne, commissioned an artist (unknown today) to decorate her boudoir with scenes from La Fontaine's fables surrounded by delicate Rococo borders.[56] Recalling Oudry's animal actors, these mid-century descendants exhibit large, glossy eyes that seem themselves to "speak" for the feeling animal subject. For example, a panel that depicts the fable of "The Two Bulls and the Frog" features, in addition to the diminutive amphibian, two enormous bulls that peer down at the creature with startled, wide-eyed gazes, implying their frank surprise at the tiny creature's interruption of their pointless battle (Figure 3.11; Plate 5). Depictions of children with companion animals, a rising trend which encompassed genre paintings by Jean-Baptiste Greuze as well as commissioned

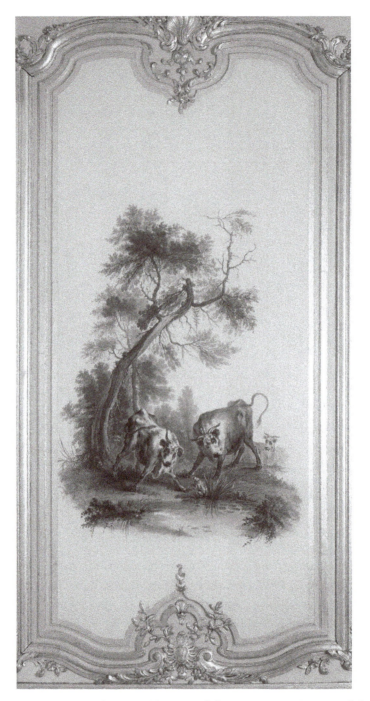

Figure 3.11 Anon., Boudoir panel depicting "The Two Bulls and the Frog," from townhouse on Place Vendôme, Paris, 1750s; Paris, Les Arts Décoratifs, musée des Arts décoratifs, Dépôt du Musée du Louvre; photo: © Paris, Les Arts décoratifs.

portraits by François Hubert Drouais, drew much of their expressive power from parallel sets of round, appealing eyes (Figure 3.12).[57]

Jean-Baptiste Huet, nephew of Christophe Huet and an animal specialist who rose to prominence in the last third of the century, developed the expressive eyes of his animals and the sensory drama of their actions into a consistent pictorial approach. Huet's reception piece into the Academy heralded both his

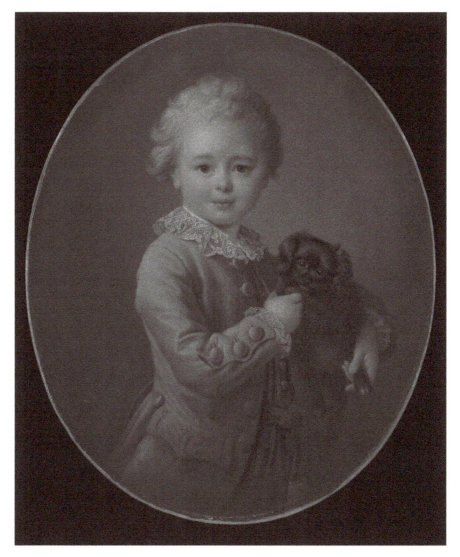

Figure 3.12 François Hubert Drouais, *Boy with Black Spaniel*, oil, artist's copy after original of 1766; NY, Metropolitan Museum of Art; photo: © The Metropolitan Museum of Art/Art Resource, NY.

articulation of animal emotion and his preference for sentimental themes: a mastiff and goose square off eye to eye and tooth to beak, while the goslings of the interrupted family group scatter and squawk in chaotic, panicked postures (Figure 3.13). Varied gazes of fury and alarm individuate the action and rivet our attention. A gosling on the right in fact calls out directly to the spectator, as if to enlist our aid in fending off the canine predator. As La Font had singled out Oudry's hunt scene for its expressive content, Huet's viewers likewise favored the display of an emotive bodily language with which they could identify. One commentator on the Salon of 1769 claimed actually to have heard the animals' cries, while another pretended to have himself recoiled in horror from the furious dog.[58]

While such responses to paintings as if they were "real" had become commonplace by Huet's era, an important feature of the artist's scene that no critic mentioned but undoubtedly contributed to its intended impact was its depiction of an endangered family. Taking a cue from the animal scenes of domestic harmony and distress fashioned by Hondecoeter in the seventeenth-century

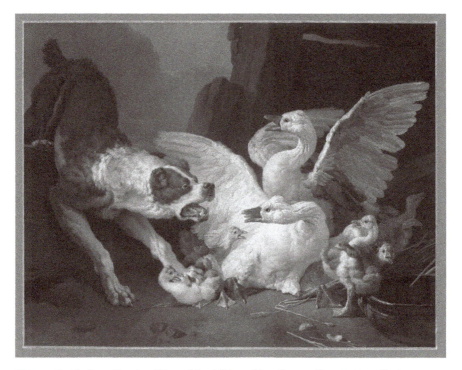

Figure 3.13 Jean-Baptiste Huet, *Mastiff Attacking Geese*, oil, *c.* 1768–9; Paris, Louvre; photo: © RMN-Grand Palais/Art Resource, NY.

Netherlands and developed by Oudry as well, Huet presents an entire goose "family"—mother, father, and offspring—as the victims of the horrific attack.[59] Perhaps the artist specifically chose geese as his actors because he knew that goslings, like human children, remain under the protection of both mother and father throughout their development to adulthood. (Perhaps this is also why Perrault had chosen *My Mother Goose's Tales* as the title of his famous story collection.[60]) Geese also possess a consistent "language of action" that humans can easily interpret, just as people can interpret the language of dogs such as the marauding mastiff. The Academy had long held up the depiction of the passions as a means of giving speech as well as reason to mute figural subjects in the visual arts.[61] For an animal painter, the language of bodily action and expression practiced by nonhuman creatures is, in this sense, cognate with his own.

Notes

1 La Font de Saint-Yenne, *Réflexions sur quelques causes de l'état présent de la Peinture en France*, 8, 68.

2 "Dans le grand Tableau du Sr. Oudri ... tout est à remarquer. L'action de ses animaux et l'expression effraïante de leur fureur ..."; ibid., 68. On Chardin see pp. 109–10.

3 See, e.g., La Font de Saint-Yenne, *Réflexions sur quelques causes*, 47, 50, 84–5. In keeping with his modern appreciation for landscape and the sensual effects of color, La Font followed up his admiring account of Oudry's *Wolf Hunt* with accolades for his landscape paintings, which he claimed rivalled the animal paintings in perfection (69).

4 Guillaume-Hyacinthe Bougeant, *Amusement philosophique sur le langage des bêtes* [1739] (Geneva: Droz, 1954); Étienne Bonnot de Condillac, *Essai sur l'origine des connaissances humaines* [1746], *Traité des sensations* [1754], *Traité des animaux* [1755], in *Œuvres philosophiques de Condillac*, I.

5 La Mettrie, *Machine Man and Other Writings*, 11–12; Boullier, *Essai philosophique sur l'âme des bêtes*, 230–1.

6 Cf. Martin Kemp, *The Human Animal in Western Art and Science* (Chicago and London: University of Chicago Press, 2007), 143.

7 See Sarah R. Cohen, "Animal Performance in Oudry's Illustrations to the Fables of La Fontaine," *Studies in Eighteenth-Century Culture*, ed. Downing A Thomas and Lisa Cody, 39 (2010): 35–76. Cf. Christine Giviskos, "Technique and Tradition in Oudry's Animal Drawings," in Morton, *Oudry's Painted Menagerie*, 85, 88; Elizabeth Amy Liebman, "Animal Attitudes: Motion and Emotion in Eighteenth-Century

Animal Representation," *Journal for Eighteenth-Century Studies* 33 (2010): 663–83, esp. 665–7.

8 Jean de La Fontaine, *Fables choisies mises en vers*, 4 vols. (Paris: Dessaint & Saillant, Durand, 1755–9 [60]).

9 Riskin, *Science in the Age of Sensibility*, 1–5. See also Vila, *Enlightenment and Pathology*, 43–107; idem, "Introduction," in idem, ed., *A Cultural History of the Senses in the Age of Enlightenment* (New York and London: Bloomsbury, 2014), 3–20; Lisa Roberts, "The Senses in Philosophy and Science," in ibid., 125–7. I will address the intersection of physical and moral sensibility in Enlightenment thought more extensively in Chapter 5.

10 See Michael W. Osborne, *A History of the Château of La Muette* (Paris: Organization for Economic Cooperation and Development, 1999).

11 Buffon used the term "race" to denote different types of animals within the same or similar species, following contemporary custom. See, e.g., his discussion of the dog: *Histoire naturelle* (1769–70), VI, 317, 319, 320, 322.

12 See Opperman, *J.-B. Oudry* (1983), 66–7.

13 See Droguet, Salmon, and Véron-Denise, *Animaux d'Oudry: Collection des ducs de Mecklembourg-Schwerin*, 110.

14 Markus A. Castor, "L'Oscillographie des passions: Académies et têtes d'expression dans la classe du modèle au XVIIIe siècle," in *De l'alcôve aux barricades: De Fragonard à David*, ed. Emanuelle Brugerolles (Paris: École national supérieure des beaux-arts, 2016), 12–19.

15 See Opperman, *Jean-Baptiste Oudry* (1977), I, 382–3.

16 Oudry's original drawing for "The Wolf and the Lamb" in his graphic fable series of 1729–34 (now lost) probably set the model for this later composition, judging by the engraving made after it for the edition published by Charles-Philippe de Monthenault d'Egly in 1755–60; see *Fables choisies mises en vers*, I:X. He may have drawn inspiration from Francis Barlow's depiction of this fable in an illustrated edition of Aesop's fables that the English engraver published in 1687; see Behn et al., *Aesop's Fables … with One Hundred and Twelve Sculptures … by Francis Barlow*, 5. Barlow's scene also features a viciously snapping wolf, his head rippling in anger; but Barlow's lamb keeps drinking, as yet oblivious of the predator upstream—in contrast to Oudry's patient listener.

17 See the text of La Fontaine's fable of "The Wolf and the Lamb"; *Fables choisies mises en vers*, I:X.

18 See ibid., II:VII.

19 Cf. Louis-François Dubois de Saint-Gelais on Watteau, in *Description des tableaux de palais royal* (Paris: d'Houry, 1727), excerpted in Pierre Rosenberg, ed., *Vies anciennes de Watteau* (Paris: Hermann, 1984), 21. The term *air de tête* could also encompass the more specific *têtes d'expression*, an Academic concept derived

from Charles Le Brun's language of expressive human heads, which was gaining increased emphasis in critical discourse and Academic practice around the middle of the eighteenth century. Its connection with Oudry's expressive animal "language" is discussed in the text, below.

20 See the text of La Fontaine's fable in *Fables choisies mises en vers*, XII:IX.

21 Locke, *Essay Concerning Human Understanding*, Book II, Chapter XXVII, Part 8 (334–5). Cf. Fontenay, *Le Silence des bêtes*, 375–6.

22 Boullier, *Essai philosophique sur l'âme des bêtes* [1728], 70–1 (quotations from pp. 71, 70).

23 La Mettrie, *Machine Man and Other Writings*, 11–12.

24 Henri Busson, "Introduction historique," in Jean de La Fontaine, *Discours à Madame de la Sablière (sur l'âme des animaux)* [1668] (Geneva: Droz, 1950), 15; John J. Conley, *The Suspicion of Virtue: Women Philosophers in Neoclassical France* (Ithaca and London: Cornell University Press, 2002), 77–8; Maya Slater, "Introduction," in *Selected Fables*, by Jean de La Fontaine, trans. Christopher Wood, ed. Maya Slater (Oxford and New York: Oxford University Press, 1995), xxv.

25 Hester Hastings, introduction, *Amusement critique*, 9–43. The part of Bougeant's book that most offended the Jesuit authorities was the first section (49–71), in which he proposed that animals served as temporary incarnations of damned human souls. How else could one explain, Bougeant wondered, the enormous sufferings animals endure both in nature and from human abuse (62–3)? This startling theory has no relation to the ideas put forth in the succeeding two chapters, in which Bougeant used (mostly) common sense observations of animal behavior as proof of their communication.

26 Bougeant, *Amusement critique*, 73–5.

27 Ibid., 74–84.

28 Ibid., 87–8.

29 Ibid., 89–105.

30 Ibid., 83–4, 96. Cf. Boullier, *Essai philosophique* (1737), 271–2.

31 Bougeant, *Amusement critique*, 84 (my emphasis).

32 Ibid., 100.

33 Condillac, *Traité des animaux*, in *Oeuvres philosophiques de Condillac*, I, 360–2.

34 Ibid., 361.

35 Ibid.; idem, *Essay on the Origin of Human Knowledge*, trans. and ed. Hans Aarsleff (New York and Cambridge: Cambridge University Press, 2001), 114. The foundational human couple Condillac used as his hypothetical prototype were not the miraculously endowed Adam and Eve but rather two innocents wandering about after the Flood (113). Cf. also La Mettrie, *Les Animaux plus que machines* [1750], in *Œuvres philosophiques*, 3 vols. (Berlin: C. Tutot, 1796), II, 81–2.

36 Rousseau, *Discourse on the Origin and the Foundations of Inequality among Mankind*, in The Social Contract *and* The First and Second Discourses, 101.

37 " … Parce que son langage d'action diffère infiniment du nôtre"; Condillac, *Traité des animaux*, 361.

38 Ibid.

39 The full title of Condillac's treatise is *Traité des animaux: Où après avoir fait des observations critiques sur le sentiment de Descartes, et sur celui de M. de Buffon, on entreprend d'expliquer leurs principales facultés.* He begins with an argument against the theory that animals are "de purs automates" (340). For his comments on the scale of nature, see p. 362. Elisabeth de Fontenay has astutely noted that despite Condillac's assertions of animal intelligence his ultimate aim was to understand humanity, whereas it was, in fact, Buffon who spent his entire career actually studying animals as a worthwhile end in itself; *Le Silence des bêtes*, 403–14. On contradictions within Buffon's text that complicate our assessment of his attitude toward animals, cf. Robbins, *Elephant Slaves and Pampered Parrots,* 195.

40 "… Toutes nos connoissances viennent des sens, et particulièrement du toucher …" Condillac, *Traité des sensations*, in *Oeuvres philosophiques de Condillac*, I; quotation from p. 313.

41 La Mettrie, *Machine Man and Other Writings*, 33.

42 La Font de Saint-Yenne, *Réflexions sur quelques causes*, 68.

43 Castor, "L'Oscillographie des passions," 15–16; Joachim Rees, *Die Kultur des Amateurs: Studien zu Leben und Werk von Anne Claude Philippe de Thubières, Comte de Caylus (1692–1765)* (Weimar: Verlag und Datenbank für Geisteswissenschaften, 2006), 397–407.

44 Castor, "L'Oscillographie," 16.

45 "Réflexions sur la manière d'étudier la couleur en comparant les objets les uns avec les autres," 1749; "Discours sur la pratique de la peinture et ses procédés principaux, ébaucher, peindre à fond, et retoucher," 1752. Opperman, *J.-B. Oudry*, 35.

46 Bernard Picart, *Recueil de lions, dessinez d'après nature par divers Maitres …* (Amsterdam: Bernard Picart, 1729), 1–2.

47 Ibid., 6.

48 Paris, Louvre, INV 28123 recto. The interpretation of this drawing as a "humanized" treatment of animal eyes was proposed by Le Brun's biographer Claude Nivelon; see Jennifer Montagu, *The Expression of the Passions: The Origin and Influence of Charles Le Brun's* Conférence sur l'expression générale et particulière (New Haven and London: Yale University Press, 1994), 22.

49 Jean Audran, *Expressions des passions de l'Ame. Representées en plusieurs testes gravées d'apres les desseins du feu Monsieur le Brun Premier Peintre du Roy* (Paris: Jean Audran, 1727).

50 For Le Brun's original drawing, see Montagu, *Expression of the Passions*, 146, Fig. 182.

51 Danièle Véron-Denise, catalogue entries in *Animaux d'Oudry*, 121, 132. See also Opperman, *J.-B. Oudry* (1983), 174–6.

52 Giviskos, "Technique and Tradition in Oudry's Animal Drawings," in Morton, *Oudry's Painted Menagerie*, 85. Giviskos specifically compares Oudry's fox to Le Brun's rendering of "Terror," as published in Louis Testelin's engraving after selected Le Brun physiognomic heads in his posthumous publication of the *Conférence sur l'expression* of 1696.

53 Buffon, *L'Histoire naturelle* (1786–91), I, 225, 231, 224.

54 See also Opperman's discussion of Oudry's dramatic uses of the inquisitive physiognomy he portrayed in the third Mecklenberg-Schwerin drawing; *J.-B. Oudry* (1983), 174–6.

55 La Mettrie, *Treatise on the Soul*, in *Machine Man and Other Writings*, 50.

56 See information and images provided on the Web site of the Musée des arts décoratifs, Paris, where the paintings are installed on long-term loan from the Musée du Louvre: http://www.lesartsdecoratifs.fr/francais/musees/musee-des-arts-decoratifs/parcours/xviie-xviiie-siecles/le-cabinet-des-fables/(1-6-20).

57 While Drouais draws direct parallels between his young human subjects and their companion animals, Greuze tends to complicate the relationship between the two: see, e.g., Greuze's *Wool Winder* (*c.* 1759, New York, Frick Collection), in which he pictures a wide-eyed kitten, whose attention is fixed in feline fashion on the moving strands of wool, together with a heavy-lidded young woman whose glassy eyes drift disconcertingly to the side. See also Emma Barker, "Imagining Childhood in Eighteenth-Century France: Greuze's *Little Girl with a Dog*," *Art Bulletin* 91 (December 2009): 426–45.

58 Beaucousin, *Lettre sur le Salon de peinture de 1769. Par M. B**** (Paris: Humaire, 1769), 28; M. de Camburet, *L'Exposition des tableaux du Louvre* (Geneva and Paris: Valade, 1769), 16. For other critical responses to Huet's painting, see the entry in Benjamin Couilleaux, *Jean-Baptiste Huet: Le plaisir de la nature* (Paris: Musée Cognacq-Jay, 2016), 30–2.

59 Cf. Couilleaux, *Jean-Baptiste Huet*, 30.

60 Perrault, *Histoire, ou contes du temps passé, avec des moralités [a.k.a. Contes de ma mère l'oye]*, 1697.

61 In his *Idée de la perfection de la peinture démontrée par les principes de l'art* of 1662, the art theorist Roland Fréart de Chambray characterized the passions as not only giving life to a painter's figures but making them seem to "speak" and "reason"; see Castor, "L'oscillographie des passions," 12.

Animating Porcelain

Although Descartes used animals' inability to speak as empirical proof of their mechanistic status, his underlying logic was founded upon the principle that thought and even consciousness were purely spiritual attributes and could not be found in matter. His detractors thus had to argue either that animals possessed immaterial minds, or that matter itself contained a vital force that motivated the animal as a thinking subject. Boullier, who evaluated Descartes's theories in considerable depth, tended toward the first solution: he posited an immaterial or at least invisible animal "soul" that was closely connected with the animal's sentience and was mortal rather than immortal.[1] By contrast, the rise of materialist philosophy in the middle decades of the eighteenth century saw an increasing acceptance of the notion that sensory apprehension and even reasoning could be found within matter itself—the most extreme exponent of this idea being La Mettrie, who argued, as we have seen, that even the human soul was purely material.[2] Vitalist philosophy, as formulated by physicians trained at the Montpellier medical school beginning in the 1740s, promoted the idea of a physically experienced "force, principle, or power whose origin and ontological status were unknowable."[3] Although materialism and vitalism differed in their respective languages and emphases,[4] both opened the potential for nonhuman animals to share with the human a vital essence grounded in the senses.

The question of animal soul had, in fact, grown less contentious by this era, so pervasive was the belief that knowledge and experience were based upon sensory perception and reaction to external stimuli. Sensibility, as Anne Vila has persuasively argued, suffused understandings of organic life among the mid-century vitalists as well as sensationalist philosophers such as Condillac and materialists such as Diderot; the physical and psychological were joined through their mutual dependence upon sensing and feeling.[5] But the question remained as to how beings molded essentially of earthy matter—what La Mettrie called *limon*, clay, or silt[6]—could become animated with conscious feeling and awareness in the first place. How to bridge the gap between inert matter and

a living animal endowed with its own, sensible state of being? Although these problems were not often raised in relation to nonhuman animals—the attention of eighteenth-century vitalists and materialists being now focused mainly upon the subtle workings of the sensible human—a new genre of art, by contrast, privileged the animal by fashioning "soul" from the stuff of pure matter. Life-sized ceramic animals, crafted out of the earth from clay, were given animate life and the illusion of "consciousness" through the process of firing in a kiln. Molded in both soft-paste and hard-paste porcelain, and assuming various incarnations in Saxony, France, and other parts of northern Europe through the middle decades of the century, these creatures seem to show through their dynamic postures, vivid expressions, and trompe l'oeil effects how sentient life can spring from mere silt.

The natural philosopher Pierre Gassendie had one hundred years earlier described animal soul as an ineffable flame, a metaphor repeated by numerous subsequent advocates of sensitive soul.[7] The most poetic of these was La Fontaine, who characterized animals' souls as a "stark quintessence / That is an atom, light tinctured to pure luminescence, / A something I cannot define, yet more alive, / More volatile, than fire." It was a process akin to alchemy, La Fontaine explained, whereby "the mind's emergence" is "like the gold / Extracted from the lead."[8] Porcelain, too, was considered a form of alchemy in the eighteenth century, especially in Saxony, where the recipe for hard-paste, "true" porcelain was discovered in 1708 by the alchemist Johann Friedrich Böttger to meet the exacting demands of his employer Augustus II, Elector of Saxony and King of Poland.[9] The transformative process of firing, by which a creature modeled or molded from earthy substance exited the flames as a brilliant incarnation of a living being, could be said to realize in artistic form the "mind's emergence" from mere matter.

In this chapter, I will examine two principal manifestations of animal porcelain in eighteenth-century Europe, which gained their evocations of mindful matter through a connection with alchemy in one case, and in the other with an intense valuation of material substance as the generative nexus of life. The first of the two chronologically was that of the approximately 600 illusionistic porcelain animals the Elector Augustus commissioned for his Japanese Palace in Dresden in the 1730s. Although the project was never completed in its entirety, the sculptors Johann Gottlieb Kirchner and Johann Joachim Kändler fashioned many species—when possible in life-size proportions—which were painted under the direction of Johann Gregorius Höroldt to appear as vividly real as possible. Drawing upon a belief in nature's inner secrets that had long underlain

the German *Kunstkammer* tradition as well as alchemical theory, the Dresden porcelain animals made matter "live" in technologically updated form.

More frankly visceral were soft-paste porcelain serving tureens, produced in eastern France, the Rhineland, Flanders, and England, which modelers fashioned to appear as trompe l'oeil animals whose lidded bellies were meant to contain the actual, material substance of the animal body prepared as soups and stews. As viewed on a dining table, these painted earthenware creatures would have appeared fully sentient and conscious in their own right, thus offering a neat demonstration of the interconnectedness of animal body (the interior flesh and juices) and animal mind (the porcelain sculpture). Joined by illusionistic tureens and other containers fashioned to look like vegetables, the animal tureens would have stood out within this mass of matter much as living animals do in still life painting: beings whose life force contained within it an ability to feel, to respond, and to act in a purposeful manner, while remaining fully within the substantive realm.

Porcelain Animals in the Dresden Court

The commission of an entire "menagerie" of porcelain animals for the Dresden court may have been the most ambitious single porcelain project of the eighteenth century, presenting not only an artistic challenge in the modeling, molding, re-forming, and final coloring of the many creatures, but the technological challenge of firing porcelain objects of unprecedented scale. The Elector Augustus II, better known as Augustus the Strong, had founded at Meissen only twenty years earlier, in 1710, the first royal porcelain factory in Europe. Samuel Wittwer, the leading expert on the commission, its outcome, and its cultural context, has detailed the extensive processes developed to fulfill the Elector's desire for a rich variety of mammals and birds, life-size or at least of large proportions, and naturally painted to achieve a realistic effect.[10] Using the Meissen manufactory's order lists, the last and most of complete of which dates from six months after Augustus's death in 1733, Wittwer has determined that the commission eventually totaled thirty-seven species of mammals and thirty-two species of birds; since these were produced in varying multiples, the total number of porcelain animals would have come to 296 mammals and 297 birds.[11] They were intended for the upper, "Meissen" floor of the newly redesigned Japanese Palace, a building intended to serve as a showcase for the Elector's huge collection of Asian and Dresden porcelain. Grouped all together in a large

gallery extending along one side of the rectangular structure, the animals took pride of place both as a demonstration of Meissen ingenuity and for their sheer creaturely magnificence—forming, in effect, a surrogate animal "court."[12]

The large variety of species in attendance represented virtually every animal group familiar to the European elite in this era. A court document of October 1730 made clear that the gallery was to be "furnished with all kinds of birds and animals, both native and foreign, made of pure porcelain, in their natural sizes and colors."[13] The most familiar of domestic animals, such as dogs, cats, goats, hens, and roosters, were joined by animals commonly hunted in the eighteenth century, including foxes, stags, bears, pheasants, grouse, and wolves (Figure 0.3). There were also numerous commissions for exotic species that Europeans could see only in princely menageries, first and foremost that of Augustus the Strong himself.[14] These included lions and lionesses, elephants, rhinoceroses, and ostriches, as well as a host of monkeys, whose variety and plenitude may reflect the popularity of these little primates as pets in courtly households.[15] A diverse group of birds both local and exotic added dynamism and a striking degree of naturalism to the collection, for virtually all the birds could be produced in life-sized proportions and some were also just small enough to allow for enamel glazing (Figure 4.1; Plate 6). The very large creatures had to be cold painted in oil after firing, for they were too fragile to endure the repeat firing that enamel coloring demanded. Almost all of the oil paint, never very stable, has by now worn away.[16] As with Greek statuary, whose sculptural verisimilitude modern viewers have come to appreciate through the lens of anachronistic whiteness, we should assess the lifelike qualities of the Dresden animals as sculptural forms while striving to keep in mind the coloristic effects originally intended, which would have more closely allied these animals, quite literally, with trompe l'oeil painting.[17]

As Wittwer has argued, the two principal modelers of the Meissen animals, Kirchner and Kändler, differed significantly in the way they responded to the demand for lifelike animals.[18] Kirchner, the elder of two artists, had previously specialized in stylized pieces based heavily upon Asian prototypes, undoubtedly in response to Augustus the Strong's passion for Japanese and Chinese porcelain, which he collected in great quantities. Such is the case with the wide-mouthed dragon vase—one of the few legendary creatures to be found in the animal gallery—which is attributed to Kirchner.[19] For his wild animals Kirchner sometimes turned to zoological publications for models, and as with so many European artists who had never seen a rhinoceros in the flesh, Dürer's famous prototype underlay his depiction of the curiously armored beast.[20] But Kirchner's animals also display

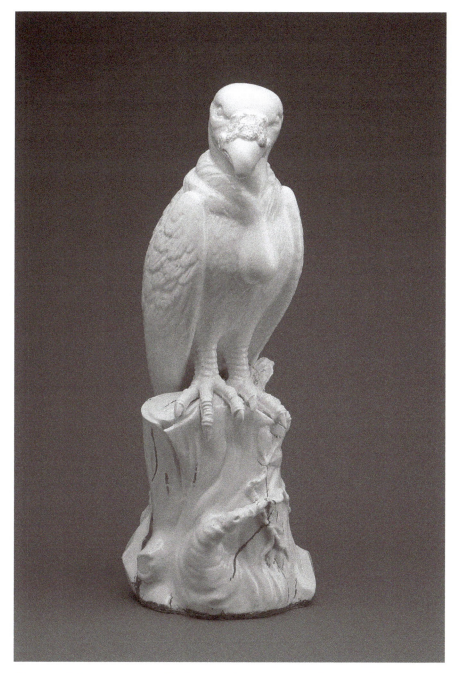

Figure 4.1 Johann Gottlieb Kirchner and Johann Joachim Kändler, *King Vulture*, Meissen porcelain, *c.* 1731; Boston, Museum of Fine Arts; photo: ©2021 Museum of Fine Arts, Boston.

a striking sense of individual animation: steps are taken, postures swivel, and eyes gaze significantly in particular directions, signaling the "life" these animals embody (Figures. 4.1, 4.2). Even the rhinoceros, while more static than the rest, conveys through its sheer physical presence and massive scale that the matter from which it was originally composed has become an integrated, living "force."

More committed to capturing nature from life was Johann Joachim Kändler, a sculptor first appointed as an assistant to Kirchner, specifically for the animal commission, in 1731. Kändler became the principal artist of the commission after Kirchner's death in 1732, and the majority of the animals, especially the birds, were executed by him.[21] He had originally worked at the Dresden court on the renovation of the "Green Vault" housing the Elector's collection of precious artifacts, and there is some documentary evidence that the young sculptor initially convinced Augustus the Strong to hire him for the animal project by deftly modeling a heron from life.[22] Although this tale is suspiciously in line with classic fables of artists finding favor with their notable patrons, it does appear that Kändler relied upon direct observation of animals when fabricating his models for the porcelain menagerie.[23] While he may have achieved accurate anatomical

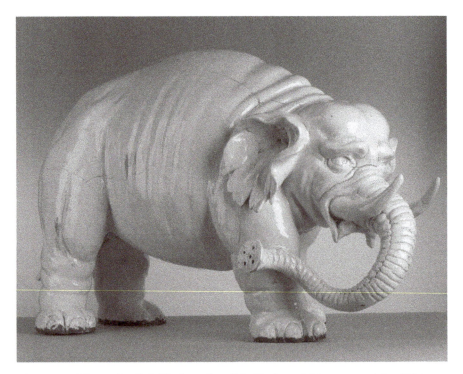

Figure 4.2 Johann Gottlieb Kirchner (attrib.), *Elephant*, Meissen porcelain, 1731; Dresden, Porzellansammlung, Staatliche Kunstsammlungen Dresden; photo: Herbert Jäger.

structures and feather patterns and markings from the taxidermy specimens and other animal *Naturalia* available in the Dresden court,[24] Kändler's uncanny simulation of sentient life probably came from watching and remembering the creatures as they moved about their habitats, whether in nature or in the domestic context of the court, its outbuildings, and menagerie. Wittwer has noted Kändler's skill in devising a naturalistic style in his clay models that would persist throughout the stages of casting the plaster mold and then forming, firing, glazing, and (when possible) re-firing the porcelain object. Kändler ingeniously adapted poses to avoid brittle protrusions, and he crafted stabilizing bases that also gave the creatures plausible environmental contexts.[25]

This close attention to recreating an animal's life in the natural world is vividly exemplified in the two variant sculptures of herons that Kändler artfully crafted from a single base (Figures 4.3 and 4.4).[26] Carefully tooled feathers on the back and neck and the heron's characteristic arched tuft behind the head—a delicate protrusion skillfully kept intact throughout the production process—demonstrate Kändler's attention to illusionistic realism gained through careful observation. Straddling a patch of reeds that do double duty in simulating the bird's preferred fishing site and supporting its large body, the heron in one version arches its long neck over its back to preen itself with a long, pointed beak. In the other version, the bird reaches all the way down to the base of the sculpture where, beside its large, three-digit foot, it snatches a carp in its beak. A frog just escapes the clever trap: we see it bounding away toward the opposite side of the sculptural base. Meanwhile a snail lurks just behind the bird's foot, showing that everywhere we look, if we look closely enough, we see life (Figure 4.5). The bird's purposeful lunge and successful snare, accentuated visually by the dramatic negative space formed by the arched and lowered neck and head, also force us to recognize that this is a creature with a will of its own, and the skills to sustain its existence.

The sheer variety of activities in which Kändler's animals engage, as manifested through their postures, their accoutrements, and, in the case of multi-figure groups, the way in which they interrelate, demonstrates the specificities of each animal's life and, implicitly, its unique intentionality. Although wolves were loathed, feared, and viciously hunted in eighteenth-century Germany, Kändler's wolf appears to have only maternal protection on her mind, as she ferociously protects the two small cubs who crouch between her legs and beneath her tail (Figure 0.3). Turning her head to lash out vocally against an implied intruder, the wolf mother rotates her head, widens her eyes, and opens her mouth to reveal her lifted tongue and finely wrought teeth (Figure 4.6). The wolf's gesture, and what can only be called her expression, closely recalls Oudry's portrayal of an angry

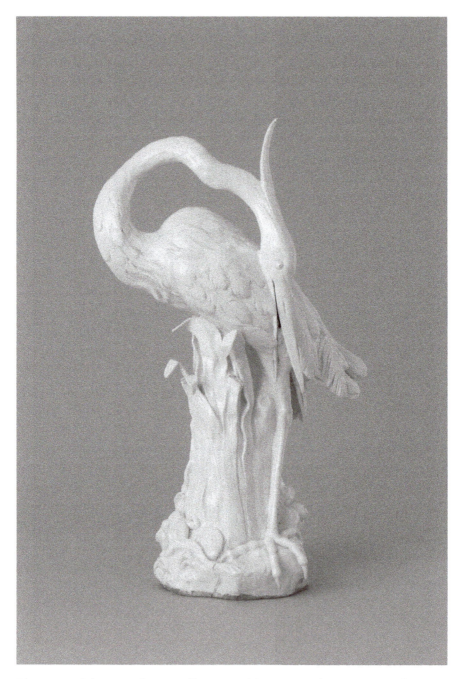

Figure 4.3 Johann Joachim Kändler, *Heron,* Meissen porcelain, 1732; Dresden, Porzellansammlung, Staatliche Kunstsammlungen Dresden; photo: Adrian Sauer.

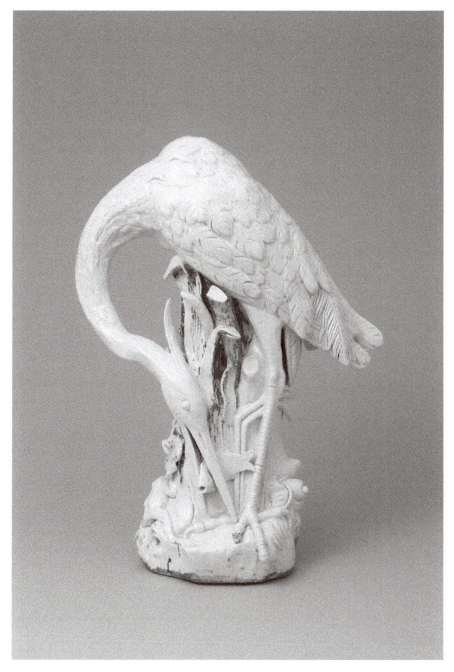

Figure 4.4 Johann Joachim Kändler, *Fishing Heron*, Meissen porcelain, 1732; Dresden, Porzellansammlung, Staatliche Kunstsammlungen Dresden; photo: Adrian Sauer.

Figure 4.5 Detail of Figure 4.4.

Figure 4.6 Johann Joachim Kändler, *She-Wolf*, detail of Figure 0.3.

fox (Figure 3.8)—suggesting not contact between the two artists but rather parallel study and characterization of a wild canid. As with all Kändler's animals, the wolf's lack of anthropomorphism inhibits sentimentality and keeps the focus upon animal behavior. Even so, Kändler subtly enhances the vulnerable status of the cubs by directing outward their round-eyed gazes (Figure 4.7).

The she-wolf and cubs form one of four mother-and-young groupings to be found among the Dresden animals,²⁷ all of which emphasize close physical

Figure 4.7 Johann Joachim Kändler, *Wolf Pups*, detail of Figure 0.3.

contact and bonds of dependency between the generations. Kändler's baby goat that nurses from his mother by standing behind her and sprawling over her back to grasp her teat may constitute the most awkward yet believable moment in eighteenth-century sculpture (Figures 4.8 and 4.9).[28] The mother goat, for her part, turns her head back to lick the shoulder of her feeding young, pleasingly integrating the sculpture's lines while also confirming the tactile, sensory-based experience of these familiar domestic creatures.

The strikingly lifelike sensibility of these animals represented a marked new departure for the Meissen porcelain factory. During the 1710s and 1720s, the factory had produced many pieces that emulated Asian wares, most of which took the form of tableware and similar services. For the Japanese Palace, much larger works in new themes were proposed[29]; among these, the animals were unique not only in their numbers but in the way they fused the look and animation of the natural body with an intensely decorative appeal. The creatures execute their wonted movements through a medium whose luster and intended coloring were

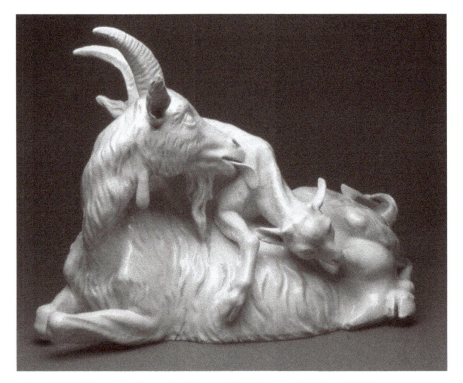

Figure 4.8 Johann Joachim Kändler, *Mother Goat and Suckling Kid: View from Front*, Meissen porcelain, 1732; NY, Metropolitan Museum of Art; photo: Metropolitan Museum of Art Open Content Program.

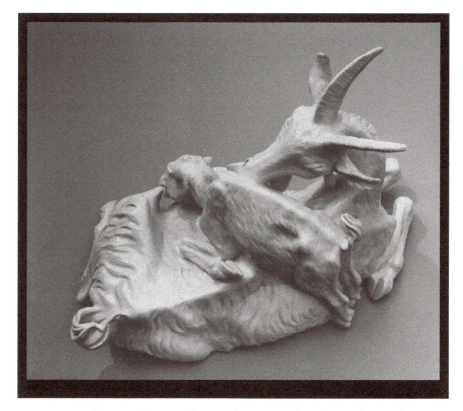

Figure 4.9 Johann Joachim Kändler, *Mother Goat and Suckling Kid: View from Behind*, Meissen porcelain, 1732; NY, Metropolitan Museum of Art; photo: © The Metropolitan Museum of Art/Art Resource, NY.

an eighteenth-century equivalent of crafting in gold, jewels, and precious stones. Its emergence from the science of alchemy gave European porcelain a particularly precious aura,[30] and in the case of the animals this alchemical transformation was not just from clay to lustrous object but from inert substance to illusionistic life. Their value was thus two-fold: at once examples of rare artistry and of the seemingly miraculous animation of matter.

There are at least two ways of considering the artistic "life" of the Meissen animals: when viewed from the perspective of their intended ownership, they undeniably signaled the authority and prowess of the Elector as ruler and collector of art and natural artifacts. This is, indeed, how the gallery of animals has usually been interpreted, as scholars have attempted to uncover meaning through the intentions of patronage. But when we view them as products of intense artistic study and industry, we find that their value and significance cannot necessarily

be circumscribed within the specific context of their royal sponsorship. Especially considering the exceptionally large numbers of these animals—far more, indeed, than would fit within the Japanese Palace—their lifelike presence, animated through the magical transformation of the kiln's fire, gives them status as independently significant objects, above and beyond the Emperor and his court. Taking this perspective, I submit, is akin to the efforts of naturalists, ethologists, and evolutionary biologists today to replace anthropocentric models of studying nonhuman animals with models that privilege animal behavior as meaningful in itself. Thus while I accept as historically viable Wittwer's claim that "the [Baroque] animal owed its *raison d'être* solely to its function as a symbol for human values and ideas,"[31] I believe that such a view is, at the same time, limited by an ideology that the works themselves controvert.

As Wittwer and other scholars have argued, animals permeated the culture of the Saxon court in the first half of the eighteenth century as a focus of spectacle, sport, and knowledge. Menageries filled with animals both local and exotic could be found both at the Dresden court and at the nearby hunting palace at Moritzburg, which Augustus the Strong was also re-building on a more magnificent scale during the 1720s. When the animals in the menageries died, they were often stuffed and put on display in the Zwinger Palace in Dresden; the Zwinger's taxidermy hall also featured displays of animal feathers, bones, and curiosities.[32] Augustus and his court hunted animals roaming in the royal woods on horseback with packs of dogs, following French *parforce* court practice. But they also favored the more particularly German *Eingestellte* hunt, in which large groups of animals were rounded up and released into festive enclosures where they were killed all together by the king and his courtiers.[33] Hunting in fact provided a key theme for Meissen porcelain of the middle decades of the century, taking the form of individual statuettes, painted scenes on vases and tableware, and entire display services featuring hunting groups.[34] Kändler himself modeled many of these; his animals, dogs as well as prey, embody a sense of realistic animation reminiscent of his large works for the Japanese Palace. At the Moritzburg Palace, courtiers socialized amidst walls covered with leather hides and decorated with antlers, many of them rare and of extremely old provenance.[35] For the antlers, Augustus the Strong commissioned Kirchner and his workshop to carve stag heads out of linden wood; these were painted illusionistically and set into gilded Rococo cartouches that played decoratively against the natural "art" of the antlers.[36]

Given Augustus the Strong's aggressive military pursuits and his demonstration of force over animals through the *Eingestellte* hunt, I must

concur with Wittwer that the Elector himself—and, he must have hoped, his courtiers and visitors as well—would have seen the vivid array of creatures in the Japanese Palace as an ideal projection of his realm. But there is in fact nothing in the *physical composition* of the Meissen animals that refers to the ruler or to any human being, other than the domestic belts sported by some of the monkeys.[37] Even within their original context of display in the Japanese Palace, the huge, lively group of porcelain creatures gathered in their own gallery must have exerted an allure surpassing any single "message" of might Augustus the Strong may have wished to convey. Their realism and naturalistic scale, combined with the seemingly miraculous "life" imparted to them by the precious fired clay, ensured that these mammals and birds so fully occupied in their own tasks of survival would hold their own as animate beings. Even in the eighteenth century, they moreover exceeded their royal containment: numerous versions of the smaller birds, brilliantly painted in fired enamel, found their way first to the residences of Saxon officials and subsequently to the wider European market (Figure 4.10).[38]

Other aspects of these innovative sculptures probed questions of material existence that had long pre-occupied Europeans (including Augustus himself): in fully uniting the natural with the artificial, so that every turn of a head and detail in a feather spoke at once of life and of art, the Meissen animals must have significantly advanced the compelling paradox of what constituted "creation" itself. Consider the early modern *Kunstkammer*, whose intermingling of *naturalia* and *artificialia* invited scrutiny of nature's "art," or *Scientia*, which a skillful artist could in turn try to capture and recreate.[39] Alchemy similarly posited that a *pneuma*, or life-force, burned within every material substance; the alchemist's job, like that of the artisan, was to discover and draw out the *Scientia* through which this force operated and use it to fashion new substances.[40] When the unprecedentedly life-sized animals emerged from the kilns of Meissen in the early 1730s, they would have vividly confirmed the twin alchemical beliefs that bodies could transform from one essence into another, and that art and life were inherent in one another. Using terms derived from *Kunstkammer* classification, one could say that the animals' *artificialia* was so miraculous it produced *naturalia*, individualizing these clay creatures as living beings. However much they may have reflected back the ruler's splendor, the animals also embodied that quintessential spark—La Fontaine's "pure flame"—which gave bodily matter the ability to think and to act.

Although the question of whether animals had souls does not appear to have generated the interest in the Elector's court that it did in French *salon* society,

Figure 4.10 Johann Joachim Kändler, *Green Woodpecker*, porcelain, modeled 1733–4, made *c.* 1740–5; London, Victoria and Albert Museum; photo: © Victoria and Albert Museum, London.

alchemy by contrast was a key pre-occupation of the Elector, who had effectively imprisoned Böttger in order to reap the benefit of whatever alchemical riches the ingenious scientist might achieve. Although he was unable to produce gold, Böttger's success in realizing "white gold"—as true porcelain was sometimes known in the seventeenth and early eighteenth centuries[41]—satisfied the Elector, who himself had been upgrading the centuries-old Dresden *Kunstkammer* into a repository for precious objects.[42] The porcelain animals in this context gained double preciousness as material riches and as manifestations of alchemy's transformative wonders.

Although likely unbeknownst to the animals' original spectators, there was also a third way in which alchemy distinguished these unprecedented creations: the unique, alchemy-inspired theory of animal soul that was proposed in the decades around the turn of the eighteenth century by Gottfried Wilhelm Leibniz, a Saxon contemporary of Augustus the Strong. Leibniz, whose first scientific position was as secretary for an alchemical society in Nuremberg, appears to have borrowed from alchemy the notion that all matter was "alive" with secret, inner forces as he sought to work out for animals a primary force that generated "something analogous to feeling and desire; and … must therefore be understood along the lines of our notion of *souls.*"[43]

Leibniz had taken several decades to arrive at his theory of animal soul, which he defined as an indivisible unity of matter and spirit, not unlike the Philosopher's Stone of alchemy, which similarly comprised "one and all: spirit and body."[44] As Mark Kulstad has argued, Leibniz was never entirely consistent as to the extent to which he allowed animals self-awareness and the ability to reflect,[45] and in his early writings he appears similarly to have vacillated between endorsing the Cartesian view of the animal as machine[46] and imagining for animals an internal, indestructible "kernel" whose material subtlety contained something of the spiritual. The latter notion he conveyed in a letter to his Hanoverian patron Johann Friedrich in a letter of 1671, in which he asserted, in an alchemical vein, that this kernel—a tiny, vital point—lay within the fetus of an animal and already comprehended within itself the creature's entire body.[47] This was the animal's indestructible essence. In his *New System of the Nature of Substances*, which Leibniz published in the French *Journal des Savants* in 1695, he presented his fully formed thesis of "real unities," an updating of the Scholastic theory of substantial forms, through which he understood the material souls of animals as entailing a spiritual dimension that made them persist from one life into the next.[48] "For," the philosopher rhetorically asked, "why could not God give to a substance at the outset a nature or internal force which could produce in it in

an orderly way ... everything that is going to happen to it, that is to say, all the appearances or expressions it is going to have?"[49]

Leibniz made his most direct case for animal soul in his *Commentatio de anima brutorum* of 1710, in which he reiterated his theory of an active agent that is "something more than matter" and, joined to passive substance, provides animals with indivisible souls. He also admitted, as French theorists of animal soul had long done, that "since all that concerns perception and sentiment acts in beasts as in man, and nature is uniform in its variety ... it is evident that beasts also have perception."[50] But Leibniz's most astonishing contribution to the early modern literature on animal soul was his theory that what gave animals their distinction as living, perceptive beings ultimately boiled down to an inner force—indestructible and invisible to the naked eye—that contained within it all that they would become. This force was neither purely material nor purely spiritual, but, through the principle of "real unities," both at once.[51]

The Meissen animals, fashioned out of earth and yet emerging from the fires of the kiln as fully "living" creatures, might themselves manifest the fruits of Leibniz's inner force—except in their case the secret, inner, "soul" that gave them sentient life was provided by the sculptors rather than by God. Alchemy, as Pamela Smith and other scholars have argued, had long served as a compelling analogy and surrogate for the artistic process, especially in northern European countries where the influence of Paracelsus was particularly strong and the re-creation of nature was an artistic mandate.[52] When marshalled for the fiery production of hundreds of expressive porcelain mammals and birds, one could say that alchemy had become a unique artistic "proof" that animals had souls.

Sensate Ceramics

It was probably the innovative Kändler, with his gift for enlivening animal porcelains, who created at Meissen the first serving vessel in the shape of animal.[53] His covered teapot in the form of a crowing cockerel, produced in 1734 when the commission for the Japanese Palace was ongoing, shares with those creatures a strikingly lifelike animation and brilliant coloring that together convey a feisty Galliforme persona (Figure 4.11). The loud squawk implied by the animal's open beak recalls the talking animals of fables, now materially assisted by the stream of liquid tea that would pour out of it when it was used.[54] At about the same time, Kändler fashioned a pot in the form of a life-sized red squirrel, shown carefully

Figure 4.11 Johann Joachim Kändler, *Covered Teapot in Form of a Cockerel*, Meissen porcelain, *c.* 1734; Arnhold Collection; photo: Maggie Nimkin.

lifting toward its mouth a nut that doubles as a pouring spout.[55] Kändler must have drawn inspiration for these objects from Chinese animal porcelains, which sometimes took the form of vessels;[56] but as with the many other animals he modeled for Augustus the Strong, Kändler's cockerel and squirrel appear more vividly lifelike than their Chinese forebears, uninhibited by additional decorations and bearing naturalistic colors, textures, and movements.[57]

By the 1740s, the production of animal vessels had spread to several ceramic manufactories along the Rhine in Germany and in France, and they were soon produced in other areas of these countries, as well as in Brussels and at the Chelsea manufactory in England (Figure 4.12).[58] The most prolific and best-known manufactory of animal tureens was that located at Strasbourg under the leadership of Paul-Antoine Hannong; in 1754, after the French crown established its own porcelain manufactory in Vincennes, the Strasbourg factory relocated to Frankenthal, where it continued to produce its distinctive wares (Figures 4.13 and 4.14).[59] As developed by Hannong and his team of Alsatian modelers, the animal vessels took on striking illusionism, a quality achieved both through skillful sculpting and through the technique of low firing, which allowed for detailed polychrome decoration on a pre-baked enamel surface. The Hannong vessels, and indeed most of the animal tureens, were fashioned from soft-paste porcelain, a less precious material than the "true" hard-paste porcelain which only a few European manufactories were capable of producing throughout much of the eighteenth century. Eventually porcelain animal tureens were also produced in China for the European export market, a clear indication that the animal serving vessel had become a European consumer fashion.[60]

Figure 4.12 *Rabbit Tureen*, Chelsea soft-paste porcelain, *c.* 1755, London, Victoria and Albert Museum; photo: © Victoria and Albert Museum, London.

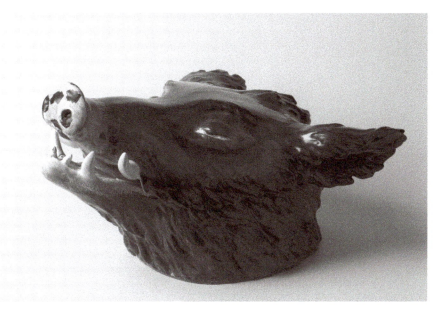

Figure 4.13 *Boar's Head Tureen*, Hannong soft-paste porcelain, *c.* 1748–54; Paris, Musée de la chasse et de la nature; photo: David Bordes.

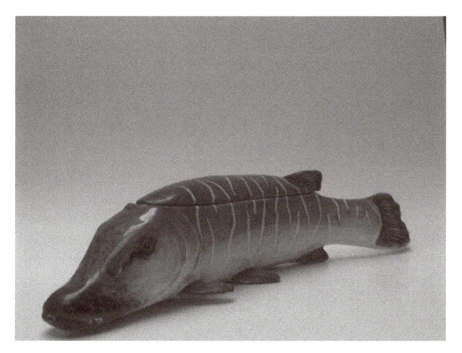

Figure 4.14 *Pike Tureen*, Hannong soft-paste porcelain, *c.* 1748–54; Avignon, Musée Louis Vouland.

The origins of the animal tureens are as complex as their impact and use must have been, and suggest how deftly these objects probed early modern understandings of the body—both animal and human—and its transforming acts of consumption. In court culture from the Middle Ages through the early seventeenth century, meats or pies presented ceremonially at the table were sometimes ornamented with the actual coat, feathers, heads, or even horns of the animal[61]—a festive, animal version of the careful dressing and coiffing of the dead human body for ritualistic display before burial. Judging from the evidence of paintings, such displays could achieve a semblance of "life," albeit in magnificent fragments.[62] Early modern European banquet tables also featured animals sculpted out of various edible materials, including butter, marzipan, sugar, and ice, as well as more thoroughly artful creations such as birds and beasts fashioned from folded napkins.[63] The eighteenth-century animal tureens, while building upon this tradition, more insistently called attention to the correlation between animate creatures skillfully fabricated and the cooked substance of the animal body. Like the Meissen animals before them, the tureens so vividly merged the familiar categories of *naturalia* and *artificialia* that they could be said to have established a new physical as well as artistic paradigm.

The artistic novelty of the animal tureens called attention to the relatively new culinary art of the complex soup and the stew, whose mixture of ingredients and sensitively seasoned preparation were becoming central features of eighteenth-century cuisine.[64] The stew was in fact coming to rival, or even replace, the serving of a whole animal at the table, a transition that the ceramic animals appear to herald. In France, stews and the tureens that held them also served the needs of the more informal dining practices that were coming to replace the elaborate, multi-course dinner during the period of Louis XV's reign.[65] Most animals whose meats and/or juices were consumed as soups and stews made their appearance in ceramic ware: partridge and other small fowl; wild boar (Figure 4.13), deer, duck, rabbit, and hare; fish such as the pike (Figure 4.14); turtle, chicken, turkey (Plate 7), and pheasant. The function of the tureen was thoroughly tailored to the body of the animal; the rim of a Hannong boar's head lid literally opens its crying mouth, while the inquisitive turkey's head in a faïence tureen made under the direction of Philippe Mombaers in Brussels doubles as a handle for the body. To lift the lid of a faïence rabbit tureen made at the Chelsea factory in England, one had only to grasp the long, alert ears—although the creature's eyes, nose, and mouth crunching upon a leaf would remain forever trained upon its own task (Figure 4.12).

The animals appealed to the human diners' sense of taste as well as sight and touch, for as the munching Chelsea rabbit suggests, when placed on the table they acted as centerpieces curiously akin to the human consumers themselves. In coordinating illusionistic animal imagery with their function as culinary vessels, these sculptures were far more earthy counterparts to the silver tureens that artisans such as Thomas Germain had begun to produce in the 1730s, which featured on their lids cast still lives of vegetables and dead animals, especially rabbits, with handles often composed of lifelike boar's heads (Figure 5.5). While tureens made of precious metals sometimes entailed whole services, however, the ceramic animal tureens appear to have been intended to stand independently, and in this sense they also differed from other kinds of porcelain tureens, especially those that began to be produced as elements in large services at Vincennes and Sèvres after the middle of the century. Perhaps most importantly, the ceramic animals were virtually always depicted as fully alive, even when existing only as heads, as was almost always the case with boars. The severed boar's head tureens, such as that illustrated in Figure 4.13, emit final, dying bellows which would have provided as much drama on a dining table as their prototypes in the Baroque still lives of Frans Snyders.[66] Virtually all the other animals made into tureens at various European manufactories comprised whole animal bodies, alert, animated, and colorfully painted to simulate the creature in life. They thus appeared not so much as trophies but as active, even purposeful deliverers of their own, bodily matter to the table.

A similar distinction holds true for the animal tureens when they are compared with their numerous counterparts from the vegetable realm, such as life-size cabbages, bunches of asparagus, and other types of produce, many of which were also used in soups and stews (Figure 4.15). As imitations of plants, rather than bodies, the vegetable tureens often evinced even more *trompe l'oeil* realism than the animal tureens, for no one would actually mistake a turkey or a boar's head tureen with the real creature, as one can do even today in the case of the vegetable vessels. The animal tureens, however, raise more intriguing questions as to the relation between the body as viewed from the outside, in all its sentient consciousness and finery, and the visceral matter within. Like it or not, human diners shared with their nonhuman animal counterparts just such a dichotomous existence, and the fact that they were about to take the "real" animal body into their own, living stomachs would only have highlighted this kinship.

Given the materialist turn of French philosophy during the middle decades of the eighteenth century—at the height of the animal tureens' production—it

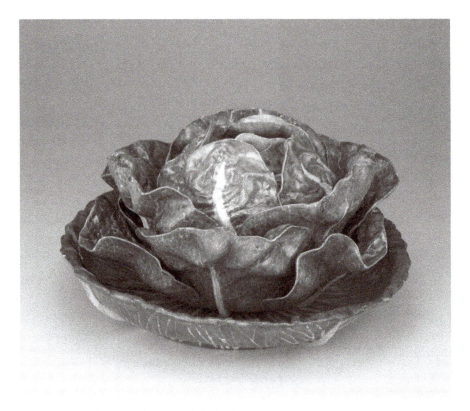

Figure 4.15 *Cabbage Tureen and Dish*, Hannong soft-paste porcelain, 1754; Minneapolis Institute of Art; photo: Minneapolis Museum of Art.

is possible that at least some diners who owned or encountered these objects would have appreciated this reminder of their own animal existence. When La Mettrie, in the spirit of Montaigne, humbled humans by likening us to the nonhuman animals we so resemble, he could have used as evidence the nibbling rabbit whose watchful eyes, ears, and nose guarded the inner flesh which would soon become our own. Even Buffon, despite his insistence upon animal mechanism and human rationality, strongly advanced the theory of nature as a continuum, in effect rendering human constitution as material as that of the nonhuman animal. Writing at the outset of the *Histoire Naturelle*, the great naturalist confessed: "the first truth that comes out of this serious study of nature is perhaps a humiliating truth for man, in that he must place himself into the class of animals that he resembles by all that is material."[67]

Buffon strove in subsequent volumes of the *Histoire naturelle* to reserve a distinction for the human as a rational being,[68] but La Mettrie, as we have seen,

moved in the opposite direction, using materialist arguments to liken the human almost completely to the animal. In his *L'Homme-Machine* of 1748, the physician argued that even the rational and moral qualities we habitually use to distinguish man from animal often break down in the face of behavioral evidence to the contrary. Here is where La Mettrie invoked his metaphor of *limon*, clay or silt, as the basic substance composing all life: "man is not moulded from a more precious clay; nature has only used one and the same dough, merely changing the yeast."[69] La Mettrie's imagery of earthy substances such as clay and dough to characterize the continuity of human and animal served his philosophical goal of promoting the materiality of the body as the essential basis of life, and the necessary medium of the soul. Acknowledging elsewhere his deliberate confusion of the soul with the bodily organs, La Mettrie argued that the human soul should confront itself in the mirror and "not … be embarrassed at being born in filth."[70] The serving tureens, much more a facet of quotidian life that any of the artworks we have previously examined, make a case for likening all bodies to "clay" or "dough," differentiated only through the most basic of chemical processes. One can imagine La Mettrie's glee at the dining table, had he confronted these colorful creatures, animated by virtue of fired clay and yielding from their ceramic bodies the very substance of their organic counterparts. Surely these animals convey, as wittily as he does, the material continuity of all vital matter.

The earthiness of the animal tureens might have stood out particularly in France, for here the Crown, after establishing its own means of producing hard-paste porcelain, protected its business with a strict monopoly that forced private fabricators to continue using the more prosaic mediums of soft-paste porcelain and faïence. The Hannong factory in Strasbourg had in fact been the first to produce hard-paste porcelain in France, and even after its move to the more permissive Frankenthal in 1755, it continued to use soft-paste porcelain or faïence for all of its animal tureens. No animal tureens were produced in "true" porcelain either at the royal manufactory of Vincennes or its successor at Sèvres, where tureens, as noted above, generally formed part of large, matched services of serving vessels. The animal tureens, visual loners on the table and almost certainly meant for less formal dining, exerted their witty, humbling appeal through an appropriately humble medium.[71]

For all their visceral appeal, the animal tureens also marked a turning point in the visual imagery of the Western consumption of animal meat. For in quite literally hiding the flesh of the slaughtered beast within the bright, lively "body" of a living animal, the tureens presaged our own, contemporary tendency to

ameliorate the violence of human carnivorousness through popular images of living animals—witness the many happy turkeys we confront in American Thanksgiving imagery. But considered in regard to their own pre-history, the tureens also advanced a progressive, materialist vision of the animal which linked flesh and sentient consciousness in a continuum extending across species boundaries. The notion of continuum was, indeed, coming to replace the Aristotelian hierarchy of beings: mid-century philosophers such as Leibniz, Buffon, Diderot, and Maupertuis posited gradations so subtle from one species to the next that there was, in effect, a single stream of sentient being from the blurry consciousness of the oyster through—in the words of Maupertuis—"the most sublime and complicated speculations of Newton."[72] Diderot's radically materialist vision of the continuum dissolved the boundaries separating living entities from one from the other and even from those only *potentially* alive. In the entry "Animal" in the *Enclyclopedia*, composed of long extracts from Buffon's text with interventions written by Diderot, the latter proposed that the borders of "animality" itself were difficult to distinguish in the nuanced transitions from one type of substance to the next.[73]

It was probably Diderot's friend Paul-Henri Thiry, baron d'Holbach, who first coined the term *s'animaliser* to describe the way in which matter, universally sensitive at least in potential, could transform into a fully animate being. In his fiercely argued *Système de la nature* of 1770, d'Holbach gave a simple example of this process in a person's consumption of milk, bread, and wine, which thereupon "change into the substance of the man … ; these base materials become sensitive when they combine with a sensitive whole."[74] Because of the constant movement of volatile matter in a materialist world, transformations from one form of being to another take place all the time and in fact are responsible for everything that exists around (and within) us: "from the stone formed deep in the guts of the earth … to the sun … from the dull oyster to the active and thinking man, we see an uninterrupted progression, a perpetual chain of combinations and movements, whose result are beings that differ among themselves only through the variety of their elementary materials."[75] For a given substance to "animalize" nothing more is needed than surmounting the obstacles that are preventing it from being active and sensitive.[76] The potential is always there.

While d'Holbach was in the process of completing the *Système de la nature* in 1769, Diderot laid out his own wide-ranging expression of the pervasiveness and continuity of matter in nature in the three *Entretiens* that compose *D'Alembert's Dream*. Here he vividly imagined the processes through which species merge into one another to the point of losing their taxonomic distinction.[77] Not only

animals (including the human), but vegetable and even mineral substance participate in the great cycle through which matter, always on the verge of sentience if it is not sentient already, passes from one state and one body to the next. In the opening conversation, between Diderot and the mathematician d'Alembert, the former asserts that all matter, regardless of how inert it appears, has the potential to become reanimated by passing into another state. He points out, as d'Holbach would do, that such a transformation happens every time a person eats. For in eating, one assimilates matter into oneself, "animalizing" the matter and making it fully sensible.[78] Even a finely crafted marble statue, Diderot claims, can become living flesh when it is ground into powder, mixed with earth, and used to raise the vegetables one eats.[79] In d'Alembert's feverish interpolation of this unsettling thesis through his subsequent dream sequence, expanded upon in a dialogue between his nurse, the *salonnière* Julie de L'Espinasse, and his physician, Théophile de Bordeu, sensate matter becomes an all-consuming "ocean" through which tiny *animalcules* coalesce to form first one type of animal and then the next, and even the earth itself constantly "begins" and "ends" without ruptures.[80] "Every animal is more or less a human being, every mineral more or less a plant, every plant more or less an animal ... There is nothing clearly defined in nature."[81]

Within this vast nexus of matter, however, animals do experience their own, integral existence through a "common center" that receives and processes the many threads of sensation they feel; it is here in this center that the memory and comparisons that constitute consciousness unfold.[82] Diderot avoids using the term "soul," which could have no place in his universally sensate continuum, although in his conversation with d'Alembert he claimed that his daughter equated soul with flesh[83]—the life force. Those beings composed of flesh and the "common center" of consciousness—that is, animals of all kinds—thus shared special kinship, whereby "animality" itself constituted a kind of fundamental sensitive soul.[84]

The animal tureens, distinguished on a dining table from their vegetable cousins precisely through their illusion of consciousness—the alert little rabbit and certainly the groaning boar are aware of themselves and know that they feel—also contribute to the great cycle of matter by serving up the very flesh of their bodies to humans who quite literally absorb the quadrupeds into their own viscera. The tureens' bodies, for their part, are composed of mineral matter made to appear animalistic and vital, thus extending the possibility that all substance, even clay, holds the potential for feeling life. At one point in the first conversation between Diderot and d'Alembert, the former alludes to alchemy

in proposing that it is heat, propelled by movement, that impels inert matter to pass into sensate vitality.[85] But rather than rely upon the abstruse *Scientia* of the alchemical tradition that appears to have inspired Leibniz to develop a new theory of life, Diderot instead invented a means of conceiving all of nature, animate and inanimate, as constantly in transition from one state into another. The animal serving tureens, each with its own apparent center of consciousness but serving up *animalcules* cooked for human consumption, offer their own, witty contribution to this new way of considering the vital flesh we all share.

Notes

1 Boullier, *Essai philosophique* [1737; 1985], 234. See also the treatise by Boullier's late seventeenth-century predecessor, the French priest Ignace-Gaston Pardies, *Discours de la connoissance des Bestes* [1672] (New York and London: Johnson Reprint, 1972), 193.

2 See also Jean-Baptiste de Boyer, marquis d'Argens, *Philosophie du bon sens, ou Réflexions philosophiques sur l'incertitude des connoissances humaines, à l'usage des cavaliers et du beau sex* (London: aux dépenses de la Compagnie, 1737), 372–82.

3 Elizabeth Williams, *A Cultural History of Medical Vitalism in Enlightenment Montpellier* (Burlington, VT: Ashgate, 2003), 3. See also Peter Hanns Reill, *Vitalizing Nature in the Enlightenment* (Berkeley and Los Angeles: University of California Press, 2005).

4 Williams, *A Cultural History of Medical Vitalism*, 6.

5 Vila, *Enlightenment and Pathology*, 1–79. Vila (2), like Reill (*Vitalizing Nature*, 31–55), assesses Buffon's *L'Histoire naturelle* as essentially vitalist in perspective; Reill points to the naturalist's emphasis upon generative forces and gradations among beings as opposed to systematic organization. Perhaps it was precisely this novel view of nature as developmental that made Buffon feel he needed to insist upon distinguishing mechanistic animals from soulful humans.

6 "L'homme n'est pas pétri d'un Limon plus précieux [i.e., than nonhuman animals] …"; Julien Offray de La Mettrie, *L'Homme-Machine* (1748), 54. Cf. Ann Thomson's translation in La Mettrie, *Machine Man and Other Writings* (20): "Man is not moulded from a more precious clay …"

7 See, e.g., Thomas Willis, *Two Discourses Concerning the Soul of Brutes, Which Is That of the Vital and Sensitive of Man* [1672], trans. S. Pardage (London: Thomas Dring, 1683), 6. Cf. John Henry, "The Matter of Souls: Medical Theory and Theology in Seventeenth-Century England," in *The Medical Revolution of the Seventeenth Century*, ed. Roger French and Andrew Wear (New York and Cambridge: Cambridge University Press, 1989), 108 and 109, n.44.

8 *The Complete Fables of La Fontaine*, trans. Craig Hill (New York: Arcade, 2008), 251. The original French of the *Discours à Madame de la Sablière*: "Quintessence d'atome, extrait de la lumière, / Je ne sais quoi plus vif et plus mobile encor / Que le feu … / La flamme en s'épurant peut-elle pas de l'âme / Nous donner quelque idée, et sort-il pas de l'or / Des entrailles du plomb ?"; La Fontaine, *Fables choisis, mis en vers*, IX:XXI.

9 On the alchemical understanding of porcelain production in the seventeenth and early eighteenth centuries, see Glenn Adamson, "Rethinking the Arcanum: Porcelain, Secrecy, and the Eighteenth-Century Culture of Invention," in *The Cultural Aesthetics of Eighteenth-Century Porcelain*, ed. Alden Cavanaugh and Michael E. Yonan (Burlington, VT and Farnham, Surrey: Ashgate, 2010), 19–38; see also Ingelore Menzhausen, *Early Meissen Porcelain in Dresden*, trans. Charles E. Scurrell (London: Thames and Hudson, 1988), 10–24.

10 Wittwer, *Die Galerie der Meissener Tiere*, 69–107; idem, *A Royal Menagerie: Meissen Porcelain Animals*, trans. David McLintock (Los Angeles: J. Paul Getty Museum, 2001), 10–26.

11 Wittwer, *A Royal Menagerie*, 12–13.

12 Cf. Wittner, *Die Galerie des Meissener Tiere*, 151–2 and *A Royal Menagerie*, 34. Large as it was, the gallery could not have contained the roughly 600 animals intended for production, and it is not known what other designs may have been conceived for their additional display. Wittwer notes that with the exception of small birds, which were produced from the royal molds and sold freely after the Elector's death, the larger animals were made uniquely for the Japanese Palace commission, as indicated by the destruction of their molds after the sculptures had been produced; *A Royal Menagerie*, 25, 36.

13 Ibid., 10.

14 Cf. Wittwer, *Die Galerie des Meissener Tiere*, 60–3.

15 The Meissen manufactory's order list of 1733 includes twenty-six monkeys, the largest single group of animal types. Some wear the belts often seen in European representations of monkeys—a reference to their status as household pets. See Wittwer, *A Royal Menagerie*, 49 and *Die Galerie des Meissener Tiere*, 291–4, 305–6.

16 Wittwer, *A Royal Menagerie*, 23.

17 According to Menzhousen, Kändler, the animals' principal sculptor, was unhappy with the brilliant coloring applied under the direction of Meissen's painter in residence, Höroldt, but this was an integral facet of the official commission; *Early Meissen Pocelain in Dresden*, 18.

18 Wittwer, *Die Galerie der Meissener Tiere*, 173–82.

19 Ibid., 296–7. Although, as Wittwer demonstrates (125–6), the ultimate model for the wide-mouthed canopic-style vase was an engraving after an ancient Roman original, the style Kirchner employed in modeling the creature, as well as its decorative glazing, evinces a strong aura of *chinoiserie*.

20 Ibid., 122–3.

21 Ibid., 70–2.

22 Ibid., 199.

23 Ibid., 128.

24 Ibid., 65–6.

25 Ibid., 183–204, *passim*.

26 Ibid., 199–202, 338–9.

27 Ibid., 148.

28 Examples of this large work may be seen at the Metropolitan Museum of Art, NY, and the Porzellansammlung in Dresden. It was originally painted in naturalistic dark and light tones, as seen in examples illustrated by Wittwer; ibid., 97, figure 78; 201, figure 194.

29 See Menzhausen, *Early Meissen Porcelain in Dresden*, 19.

30 Ibid., 10–13.

31 Wittwer, *A Royal Menagerie*, 9.

32 Wittwer, *Die Galerie der Meissener Tiere*, 60–6.

33 Ulrich Pietsch, "Porzellan und Jagd—Die Leidenschaften der sächsischen Kurfürsten," in *Porzellan Parforce: Jagdliches Meissner Porzellan des 18. Jahrhunderts*, ed. Ulrich Pietsch (Munich: Hirmer, 2005), 12–13.

34 Pietsch, *Porzellan Parforce*, *passim*.

35 Wittwer, *A Royal Menagerie*, 4.

36 Ralf Giermann, "'Nothing Comparable to This Moritzburg Is to Be Found Anywhere.' The Hunting Castle Moritzburg and Augustus the Strong's Collection of Antlers," in *The Glory of Baroque Dresden: The State Art Collections Dresden*, trans. Daniel Kletke (Munich: Hirmer, for The Mississippi Commission for International Cultural Exchange, Inc., 2004), 269.

37 A few of the medium-sized sculptures also bear the initials "AR" (i.e., Augustus Rex) painted on their undersides, out of view; Wittwer, *Die Galerie der Meissener Tiere*, 110.

38 The Elector Augustus III, who succeeded Augustus the Strong after the latter's death in 1733, gave permission for editions of birds modeled by Kändler to be manufactured and sold beyond the confines of Saxon court culture in the decades around the middle of the eighteenth century. As noted above, this was not the case for the larger animals, whose molds were deliberately destroyed after production of the porcelains for the Japanese Palace. On the European market for the Meissen birds, see Maureen Ann Cassidy-Geiger, "*An Jagd-Stücken, unterschiedenen Thieren, Feder Viehe, Hunden und Katzen*: A Context for the Meissen Porcelain Birds in the Sir Gawaine and Lady Baillie Collection," in *Property from the Sir Gawaine and Lady Baillie Collection* (London: Sotheby's, 2013), 10–15.

39 The bibliography on the early modern European *Kunstkammer* is vast. Some important secondary sources include: Horst Bredekamp, Jochen Brüning, and

Cornelia Weber, eds., *Theater der Natur und Kunst; Theatrum natural et artis: Wunderkammern des Wissens*, 2 vols. (Berlin: Henschel, 2000); Lorraine Daston and Katharine Park, *Wonders and the Order of Nature 1150–1750* (New York: Zone Books, 2001); Paula Findlen, *Possessing Nature: Museums, Collecting, and Scientific Culture in Early Modern Italy* (Berkeley and Los Angeles: University of California Press, 1994); Oliver Impey and Arthur MacGregor, eds., *The Origins of Museums: The Cabinet of Curiosities in Sixteenth- and Seventeenth-Century Europe* (Oxford: Clarendon Press, 1985); Peter Parshall, "Art and Curiosity in Northern Europe," Introduction to special issue of *Word and Image* 11:4 (October–December 1995): 327–31; Pamela H. Smith, *The Body of the Artisan: Art and Experience in the Scientific Revolution* (Chicago and London: University of Chicago Press, 2004); Pamela H. Smith and Paula Findlen, eds., *Merchants and Marvels: Commerce, Science, and Art in Early Modern Europe* (London and New York: Routledge, 2002).

40 See, e.g., William R. Newman, *Promethean Ambitions; Alchemy and the Quest to Perfect Nature* (Chicago and London: Chicago University Press), 2004; Smith, *Body of the Artisan*, 87–93; 129–51.

41 Before Böttger's discovery of its recipe in 1708, porcelain was known in Europe as "white gold" due to its rarity and availability only through the Asian trade; Charlotte Vignon, "Porcelain, No Simple Matter: Arlene Shechet and the Arnhold Collection," *The Frick Collection Members' Magazine* (Spring/Summer 2016): 10. In alchemical writings, the term was also used in describing the purification of the Philosopher's Stone, which emerged from the process, in the words of the seventeenth-century American alchemist George Starkey, as "their Swan, their Dove, their white stone of Paradise, their white gold … "; quoted by Adamson, "Rethinking the Arcanum," 23.

42 Dirk Syndram, *Renaissance and Baroque Treasury Art: The Green Vault in Dresden*, trans. Daniel Kletke (Munich and Berlin: Deutscher Kunstverlag for the Staatliche Kunstsammlungen Dresden, 2004), 8–13.

43 George MacDonald Ross, "Alchemy and the Development of Leibniz's Metaphysics," in *Theoria cum Praxi: Zum Verhältnis von Theorie und Praxis im 17. Und 18. Jahrhundert; Akten des III. Internationalen Leibnizkongresses, Hannover, 12. bis 17. November 1977*, 4 vols. (Wiesbaden: Franz Steiner, 1982), IV, 41; Leibniz, *New System of the Nature of Substances*, 12.

44 Leibniz, *New System of the Nature of Substances*, 12; Adamson, "Rethinking the Arcanum," quoting seventeenth-century British alchemist Thomas Vaughan, 24.

45 Mark Kulstad, "Leibniz, Animals, and Apperception," in *Leibniz*, ed. Catherine Wilson (Burlington, MA and Aldershot: Ashgate, 2001), 171–206.

46 As late as 1695, in his initial, mostly discarded draft for the *New System of the Nature of Substances*, Leibniz had included a short reiteration of the Cartesian thesis that animals had no souls, and thus possess a completely different sense of pain than does the human; in the final, published version, he states, by contrast,

that to "demote animals into mere machines" is "contrary to the order of things"; *Leibniz's "New System,"* 25, 11 (quotation from p. 11).

47 Leibniz, letter to Herzog Johann Friedrich, 1671, quoted by Ross, "Alchemy and the Development of Leibniz's Metaphysics," 44–5.

48 Leibniz, *New System of the Nature of Substances*, 11–13.

49 Ibid., 18–19.

50 "... Quelque chose plus que la matière ... Puisqu'en effet tout ce qui concerne la perception et le sentiment [*sensum*] se comporte chez les brutes tout comme chez l'homme, et que la nature est uniforme dans sa variété ... il est vraisemblable que les brutes ont aussi la perception"; Wilhelm Gottfried Leibniz, *Commentatio de anima brutorum* [1710], trans. into French by Chistiane Frémont as *Réflexion sur l'âme des bêtes*, in *Corpus* 16/17 (1991): 148. Leibnitz had met Gaston Ignace Pardies in Paris in 1672, the same year that the French Jesuit published his *Discours de la connoissance des bestes*, so it is likely that he gained knowledge of French theories of animal soul at least by this time. Maria Rosa Antognazza, *Leibniz: An Intellectual Biography* (New York and Cambridge: Cambridge University Press, 2009), 141.

51 Beginning in 1695, Leibniz would refer to these "real unities" as "monads," the theory for which he is perhaps best known today. See Antognazza, *Leibniz: An Intellectual Biography*, 351.

52 Smith, *The Body of the Artisan*, 129–51. See also idem, *The Business of Alchemy: Science and Culture in the Holy Roman Empire* (Princeton: Princeton University Press, 1994).

53 Claude d'Anthenaise, ed., *La Table du Chasseur: La gastronomie du gibier au XVIIIe siècle* (Paris: Musée de la chasse et de la nature, 2002), 47; Maureen Cassidy-Geiger, *The Arnhold Collection of Meissen Porcelain 1710–50* (New York: The Frick Collection and London: K. Giles Ltd., 2008), 365, cat. no. 133.

54 Cassidy-Geiger compares Kändler's teapot to the cock featured in Francis Barlow's etching of "The Cock and Precious Stone," from John Ogilby, *The Fables of Aesop Paraphras'd in Verse* (London: Thomas Roycroft, 1668); *The Arnhold Collection of Meissen Porcelain*, 365, Figure 133.1.

55 Ibid., 366, no. 134.

56 Margaret Kaelin Gristina, *17th and 18th Century Chinese Export Porcelain* (New York: Chinese Porcelain Company, 2001), 64.

57 Kändler also experimented with Galliforme teapots which more closely resemble Chinese prototypes, with more stylized shapes and coloring, as well as additional, miniature animals added as handles on the lids; cf. Cassidy-Geiger, *The Arnhold Collection of Meissen Porcelain*, 364, cat. nos. 132a, b. The Du Paquier porcelain manufactory, established in Vienna in 1718, likewise produced animal-shaped vessels in emulation of Chinese styles. See, for example, the elephant-shaped wine dispenser in the Frick Collection, NY from *c.* 1740; the small creature, elaborately

adorned with grape vines and a ceremonial fabric, may have originally supported a figure of Bacchus, as did a similar model made for a centerpiece to adorn the table of Empress Anna Ivanovna of Russia. https://collections.frick.org/objects/2171/ elephantshaped-wine-dispenser;jsessionid=75457369639F0DE6EA3F74DC3C5E95 B8?ctx=86098603-78b2-47b4-b706-8780a7c8e131&idx=0 (1-8-20)

58 D'Athenaise, *La Table du chasseur*, 47–8.

59 Jeannine Térrasson, *Les Honnong et leurs manufactures Strasbourg Frankenthal* (Paris: La Bibliothèque des arts, 1971), 88.

60 Gristina, *17th and 18th Century Chinese Export Porcelain*, 64.

61 D'Athenaise, *La Table du chasseur*, 43.

62 See, e.g., Jan Brueghel the Elder, *Taste, Hearing, and Touch, c.* 1620; Madrid, Prado.

63 D'Athenaise, *La Table du chasseur*, 44; Sarah Richards, *Eighteenth-Century Ceramics: Products for a Civilised Society* (Manchester: Manchester University Press, 1999), 14.

64 Marie-France Noël-Waldteufel, "Manger à la cour: alimentation et gastronomie aux XVIIe et XVIIIe siècles," in Saule and Savill, *Versailles et les tables royales en Europe*, 69, 72; d'Athenaise, *La Table du chasseur*, 13, 16.

65 Louis XV is well known to have favored dining in the 1750s and 1760s in the so-called "room of returns from the hunt" in the Petits Appartements at Versailles; participants at these gatherings clustered around a circular table to discourage hierarchy, and used buffets and other convenient serving furniture to minimize the need for servants. See Béatrix Saule, "Tables royales à Versailles 1682–1789," in *Versailles et les tables royales*, 56–64.

66 The "bellowing" boar's head appears repeatedly in Snyders's monumental dead animal still lives, suggesting that the motif was much appreciated by his international clientele; see, e.g., Snyders's *Still Life with Dead Game, Fruits, and Vegetables in a Market*, 1614 (Art Institute of Chicago).

67 "La première vérité qui sort de cet examen sérieux de la Nature, est une vérité peut-être humiliante pour l'homme; c'est qu'il doit se ranger lui-même dans la classe des animaux, auxquels il ressemble par tout ce qu'il a de matériel." Buffon, *Histoire naturelle* (1769–70), I, 16; cf. Fontenay, *Le Silence des bêtes*, 416. Buffon went on to qualify this admonition, however, in one of many passages in the *Histoire naturelle* where the naturalist sought to assert the uniqueness of the human animal: man, one learns, is ultimately the most "perfect" among the many life forms and substances the world contains (17).

68 Fontenay, *Le Silence des bêtes*, 415–28.

69 La Mettrie, *Machine Man and Other Writings*, 20.

70 La Mettrie, *Treatise on the Soul* [1750], in *Machine Man and Other Writings*, 66.

71 For a detailed consideration of the social implications of soft-paste porcelain in eighteenth-century French culture, see Christine A. Jones, *Shapely Bodies: The*

Image of Porcelain in Eighteenth-Century France (Lanham, MD: University of Delaware Press, 2013).

72 "… Le sentiment le plus léger ou le plus confus, qu'auroit une huître, suppose autant une substance simple indivisible que les spéculations les plus sublimes et les plus compliquées de Newton"; Pierre Louis Moreau de Maupertuis, *Lettre V: Sur L'Âme des bêtes*, in *Oeuvres de Mr. De Maupertuis*, nouv. éd., 4 vols. (Lyon: Jean-Marie Bruyset, 1756), 215–16; see also 219.

73 Denis Diderot, Article "Animal" in *Encyclopédie, ou, Dictionnaire raisonné des sciences, des arts, et des métiers* [1751–65], in Diderot, *Oeuvres*, I, 250. Cf. Fontenay, *Le Silence des bêtes*, 429–42, *passim*.

74 "C'est ainsi que le lait, le pain et le vin se changent en la substance de l'homme, qui est un être sensible; ces matières brutes deviennent sensibles en se combinant avec un tout sensible." d'Holbach, *Système de la nature*, I, 127. For d'Holbach's likely coining of the term *s'animaliser*, see Yvon Belaval's Introduction to this volume, X. On the relationship between d'Holbach and Diderot in the context of the baron's intellectual Parisian *coterie* see Alan Charles Kors, *D'Holbach's Coterie: An Enlightenment in Paris* (Princeton, NJ: Princeton University Press, 1976).

75 "Depuis la pierre formée dans les entrailles de la terre, par la combinaison intime de molécules analogues et similaires qui se sont rapprochées, jusqu'au soleil, ce vaste réservoir de particules enflammées, qui éclaire le firmament; depuis l'huître engourdie jusqu'à l'homme actif et pensant, nous voyons une progression non interrompue; une chaîne perpétuelle de combinaisons et de mouvemens, dont il résulte des êtres qui ne diffèrent entre eux que par la variété de leurs matières élémentaires …" ; d'Holbach, *Système de la nature*, I, 47.

76 Ibid., 127.

77 Cf. Annie Ibrahim, "Diderot et les Métaphores de l'animal: Pour un antispécisme?" *Dix-huitième siècle* 42 (2010): 83–98; Jacques Roger, "Introduction," in Denis Diderot, *Entretien entre d'Alembert et Diderot; Le Rêve de d'Alembert; Suite de l'entretien* [1769] (Paris: Garnier-Flammarion, 1965), 28; Vila, *Enlightenment and Pathology*, 70–9.

78 Diderot, *Entretien entre d'Alembert et Diderot; Le Rêve de d'Alembert; Suite de L'entretien*, 39.

79 Ibid., 40.

80 Ibid., 82.

81 "Tout animal est plus ou moins homme; tout minéral est plus ou moins plante; toute plante est plus ou moins animal. Il n'y a rien de précis en nature …"; ibid., 93. Translation taken from: Denis Diderot, *Rameau's Nephew and d'Alembert's Dream*, trans. Leonard Tancock (London: Penguin, 1966), 181.

82 Diderot, *Entretien entre d'Alembert et Diderot*, 145; see also 116.

83 Ibid., 41.

84 Caroline Jacot Grapa, "Des Huitres aux grands animaux: Diderot, animal matérialiste," *Dix-huitième siècle* 42 (2010): 107–8. As Grapa argues, Diderot's ultimate concern was likely to re-frame human rationality as sensate, so as to accommodate varying degrees of intellectual ability, and even consciousness itself, without sacrificing his materialism. Cf. Denis Diderot, *Thoughts on the Interpretation of Nature* §L [1754 ed.], in *Thoughts on the Interpretation of Nature and Other Works*, trans. David Adams (Manchester: Clinamen Press, 1999), 66.

85 Diderot, *Entretiens entre d'Alembert et Diderot*, 51.

Sentient Matter

In his *Analytical Essay on the Faculties of the Soul* of 1759, the entomologist and natural philosopher Charles Bonnet reimagined Descartes's famous dictum of the thinking soul. "Regarding itself, a sentient Being exists only to the extent that it feels: it thus exists more fully in proportion to its greater feeling." I feel, therefore I am. Nothingness, by the same token, is the complete absence of sensation, and awareness gradually increases in direct proportion to a living being's share of sentience.[1] Bonnet, as Anne Vila has illuminated,[2] was at the forefront of the sensibility movement in French philosophy, whose exponents included Diderot as well: sensation and bodily experience, rather than rational cogitation, served as the springboard for one's mental state, and differences among species were a matter of degree rather than kind. Although Bonnet allowed that no one had as yet proven that nonhuman animals have souls, he argued that all appearances suggest that they do, precisely because they appear to live so completely within their own, feeling bodies. Bonnet reasoned that caterpillars, an animal he himself had studied and written about extensively, must sense what takes place within themselves, and thus possess a form of consciousness, which he called "immaterial soul." This soul remains when the caterpillar transforms into a butterfly and gains new faculties: remembering its earlier experiences and feelings, the "self" (*Moi*) of the butterfly is inextricably linked to the self of the caterpillar whose form it once inhabited.[3]

Bonnet, like Boullier, believed that souls by their very nature had to be immaterial, and like Leibniz, he argued that they were thereby indestructible as well.[4] But his characterization of an animal's experience of the soul, or self, was in fact literally embedded in matter: a spider, he argued, does not build a web for the strategic purpose of catching flies, but rather out of a basic need she feels to spin her artful threads, an action in which her soul/self takes pleasure, because spinning webs is what spiders do.[5] In this respect, Bonnet's theory of soul resembles that of La Mettrie, who wrote in his *Treatise on the Soul* of

1745 that "he who would learn the properties of the soul must first seek those which clearly show themselves in the body, whose active principle the soul is."[6] La Mettrie would also have approved of Bonnet's emphasis upon sensational experience as the measure of self-awareness: "my soul manifests constantly, not thought, which is accidental to it whatever the Cartesians may say, but activity and sensibility."[7] It is particularly telling that both a physician and an entomologist would place primary emphasis upon sentient experience as the essence of soul: whether human or butterfly, a sensing being finds its happiness increasing as its sensations unfold in time and memory.[8]

La Mettrie, of course, was the more radical of the two in attributing to the human no rational advantage over the nonhuman animal, and in *Machine Man* he notoriously used the metaphor of mechanism to explain the "instigating and impetuous principle" of the soul. All our feelings—and those of the other animals as well—are driven by this principle, whose seat is the messy, nervous matter of the brain.[9] Can soul and matter really be so intertwined? La Mettrie argued that they had to be, since we are, after all, composed head to toe of physical substance, and although Bonnet's concern with spiritual consciousness prevented him from assigning soul directly to matter, he argued that the only way we can learn of the soul's existence in others is to watch what they physically do.

So accepting of nonhuman animals was the sensationalist notion of self that by the 1750s philosophers now hardly needed to make the argument that animals had souls. One cutting-edge thinker who did turn his attention to this by now hoary question was Maupertuis who, like Bonnet, claimed skeptical reserve as to really knowing what it was like to be an animal, but nevertheless argued that analogy offers fair evidence that their experiences were much like ours, albeit with perhaps a little less logical complexity.[10] For Maupertuis, all feelings and perceptions were in essence thoughts and thus necessarily implied consciousness, so there was no need any more to distinguish between rational and sensitive souls.[11] Perhaps the most innovative and foresighted of Maupertuis's writings on animals, however, was his letter on "The Rights of Animals," in which he argued that it was precisely animals' ability to feel that should prevent us from needlessly killing or tormenting them.[12] La Mettrie had also implied such sympathy for animals when he claimed that the animal was "steeped in feeling … which (in another sense) so many men lack."[13] Coming a good thirty to forty years before the English philosopher Jeremy Bentham's oft-cited hypothesis for giving rights to animals because of their ability to suffer,[14] Maupertuis's and La Mettrie's defense of the feeling animal heralded an era of dawning compassion.

Oudry's Sensitive Canines

Sensationalist philosophy's popular corollary was sentimentalism, a movement that overspread French culture during the second half of the eighteenth century and likely encouraged the interest that artists and audiences of this era also took in the physically based expressivity of animals.[15] In Chapter 3, we noted the pictorial trend for widened eyes as a means of signaling a feeling subject, whether child, pastoral lover, or non-human animal; if one accepts Bonnet's theory that sentience forms the basis of the conscious self, these large, expressive eyes could be taken as the essence of existence as well as a key ingredient of sentimentalist painting. However they may differ in specific emotional tone, Huet's and Drouais' depictions of mastiff, geese, boy, and spaniel strikingly accord in the technique and sensibility of the eye (Figures 3.13 and 3.14).

Oudry, we have seen, wielded the saucer-like, sentient eye to individuate emotions in his animals both domestic and wild. In his best-known, late work in a sentimentalist vein, the *Bitch-Hound Nursing Her Young* of 1753, he approached contemporary philosophical concerns by using canine eyes, both alert and still closed in neo-natal innocence, to probe the relationship between sight and touch as a means of knowing the world (Plate 8). Exhibited by the artist together with numerous other paintings of animals, the work received exceptional critical praise for its expressive precision, as underscored by the beam of sunlight that falls from the open window onto the head, chest, and paw of the mother dog.[16] Critics noted the concerned expression of "this mother," as well as her deliberate gesture of lifting her illuminated forepaw to protect the nursing pup on the left.[17] They remarked upon her watchful gaze toward something she has perceived off the right edge of the painting,[18] a sensitive psychology Oudry has accentuated through the dog's huge eyes and quivering nose glistening in the sunlight. Perhaps remembering the finished chalk drawing he produced in the 1740s (Figure 3.9), Oudry has now provided a material rationale for the animal's gestures and expression. It may have been this work, among others, that prompted Baillet de Saint-Julien to assert, in paying homage to Oudry in his review of the exhibition, "Descartes would have renounced his system in seeing your paintings: Bougeant would have written less frivolously his Language of Brutes."[19]

Today Oudry's painting is often considered as a counterpart to sentimentalist genre painting, especially given its evident invocation of Rembrandt's *Holy Family* (Paris, Louvre), a painting in the French royal collection that was known at the

time as the *Ménage du menuisier*.[20] Eighteenth-century viewers would likely also have noted that both the bitch and her newborn pups are of the most desirable white stock of hound, whose expertise in the hunt was reputedly passed down through the mother's milk.[21] Oudry has presented the dogs' environment much as the hunt treatises recommended: a cool shed safely distanced from the other dogs, with a fresh bed of straw to protect them from cold and humidity.[22] But close examination of Oudry's rendering of the scene reminds us that this artist was above all an observer and painter of nonhuman animals, however much his professional success was tied to the human culture of the hunt and the drawing room. In calling attention to the sentient awareness of the nursing hound—her turned head, her lifted paw, the illumination of that part of her chest where we know her heart to lie—Oudry made canine life and consciousness the central narrative of his celebrated painting. Considering the alacrity with which his contemporaries could identify psychologically with the domesticated dog—as witnessed in writings as diverse as those of the marquis d'Argens and Buffon[23]—it is understandable that the painting would also find such immediate favor in the public Salon.

The puppies, for their part, demonstrate the primacy of touch among the senses, for as a writer for the *Mercure de France* duly noted, they are so young they do not yet see.[24] Either sound asleep or groping for their nourishment, the puppies' experience is still limited to the haptic, a primal fact Oudry emphasizes through tiny canine gestures: in the foreground a puppy with black markings plants its upper body and miniature paws upon its all-white sibling, while at the bitch's teats another pup's foreleg covers the ear and shoulder of the adjacent puppy, who is no more disturbed by this intrusion than is the "underdog" in the foreground. In his description, the abbé Laugier referred to the "still blind" puppies as "rolling heavily onto one another,"[25] but this is not in fact what Oudry depicts; the puppies, while not yet part of the world of sight, show us rather pointedly that we might gain our first knowledge of the material world beyond our own bodies through laying a hand, or a paw, upon another living being. With age and experience come sight as well as a much more sophisticated understanding of how one's physical actions impinge upon the senses of others: for example, the mother dog, while taking in her litter out of the corner of her watchful eye, at the same time lifts her foreleg, without even looking down, physically sensing that she needs to make room for the nursing pup beneath.

However "touching" to Salon critics on an emotional level, Oudry's canines at the same time enact a complex interrelationship of physical sight and touch,

a vital process shared by most animals and a principal preoccupation of sensationalist philosophers of the early 1750s, notably Condillac and Diderot. Catalyzed around the turn of the eighteenth century by Locke and quickly taken up quickly by Boullier, as we have seen, "Molyneux's question" was still proving a useful touchstone for sensationalist philosophy in the years just after 1750, as a veritable science of sensory awareness emerged from the writings of Condillac, Diderot, and Bonnet, among others. While Boullier had essentially equated sight and touch, Condillac and Diderot, by contrast, perceived their relationship to one another as a challenging example of how complex were the ways the senses operate both singly and together within the conscious animal.[26]

For Condillac, as Michael J. Morgan has emphasized, Molyneux's question begged recognition of the fundamentally active nature of sensory perception.[27] Hardly a mere tool through which the thinking animal negotiates its world, the process of perception itself constitutes the interaction between animal and environment. In the *Treatise on Sensations* of 1754, Condillac argued that while the sensations are a function of the mind (*âme*), they provide the conduit through which one makes the first discovery about oneself: the existence of one's body. For "how would a new-born baby take care of its needs if it had no knowledge of its body, and if it did not as easily acquire some idea of bodies able to take care of it?" In order for the newborn to make such discoveries, "nature" allows the infant to perceive its sensations as modifications to the sensing organs themselves: "instead of being concentrated in the mind," the infant's self (*moi*) "becomes extended and somehow repeated in all parts of the body."[28] When Condillac subsequently considers "how a man limited to touch discovers his body and learns that there is something outside of himself," he uses his paradigmatic statue to argue that this formerly insensate body, in making its initial movement, will by nature touch both itself and nearby objects. "Placing its hands upon itself, it will discover that it has a body, but only when it has distinguished the different parts of it, and recognized the same sentient being in each. It will discover other bodies when it touches things in which it does not recognize itself."[29]

Although Condillac at this point was concerned with explaining human psychology through sensory experience, Oudry's puppies are at least as effective as the *philosophe*'s statue in providing a demonstration of the process through which one gains awareness through touch. Deprived of sight in their newborn state, the six pups cluster together such that each grapples at least one other, as well as the nursing mother. Likely these infant canines have not yet discovered the unique integrity of their own respective bodies—a capacity

so well demonstrated by the multi-tasking maternal hound. But Oudry sets up the puppies' potential for taking this crucial step by calling attention to the tiny paws that visibly press against the soft bodies of the siblings as well as the straw covered floor. One can vicariously feel the warmth generated by bodies folded against bodies—perhaps the very first instance of pleasure that newborn mammals gain through touch. The mother, in contrast to the young generation, has gained full alertness through all five senses: the huge eyes and ear, the glistening nose, the shapely paw, even the large water bowl so near at hand suggesting she has learned where to turn to slake her thirst when confined indoors. Condillac, who stressed the need to *learn* how to use one's senses, might have noted in Oudry's hound the attentive sight which constitutes true, active "looking," as opposed to passive reception of visual stimuli, a false premise that would prove unhelpful in gaining knowledge, let alone in protecting one's young.[30]

In his *Letter on the Blind* of 1749, Diderot likewise used the infant, as well as the blind man suddenly restored to sight, to argue that experience is necessary for perception to work, whether one is considering the operations of individual senses or their mutual cooperation.[31] The *Letter on the Blind* makes creative use of sight and its lack to argue for the primacy of the senses in one's acquisition of knowledge: Diderot claims that a person deprived from birth of the sense of sight, were he to attempt to create a paradigmatic man as Descartes did in his *Treatise on Man*, would surely locate the person's mind (*âme*) at the end of his fingers.[32] Diderot's skepticism of Cartesian reason allowed him to imagine empathetically not only the perspective of the blind man but also the perspective nonhuman animals might take of the human. In the spirit of Montaigne the *philosophe* mused, "he has arms, the fly might say to himself, but I have wings. If he has weapons, says the lion, don't I have claws? … We have so strong a tendency to overdo our qualifications and diminish our faults, that it would almost seem that it's man who should write the treatise on force, and the animal that on reason."[33] Considering the nonhuman animal allowed Diderot to undermine in various ways epistemological tendencies to value the rational at the expense of the sensate, a central concern of the *Letter on the Blind*. Although the human was his primary philosophical target and human understanding his central puzzle, he used pervasive animality as a metaphor to disrobe the humanist tradition.[34]

As a specialist in dramatic animal painting, Oudry needed no such skeptical hook to feature the knowledge gained from sensory experience as a function of the canine life cycle. Any parallel one might perceive between this barn-

dwelling family and human kinship must indeed have worked to his advantage in a sentimentalist era when the theme of family was itself on the ascendant. The Salon reviews certainly bore this out.[35] But the baron d'Holbach, who purchased the painting directly from the Salon, may well have appreciated its timely focus upon blindness vs. sightedness, innocence vs. experience, and perhaps also its arch demonstration of sensory learning not in the realm of the vaunted human but in a newborn pack of hounds.

Having initiated his intellectual gatherings in Paris in 1748, d'Holbach had, by the time he purchased Oudry's painting, become a central player in the circle of *philosophes* that included his friend Diderot, to whose *Encyclopedia* he would eventually contribute some 376 articles.[36] Although he did not publish his own *Système de la nature* until 1770, its radically materialist argument must have been many years in the making, and suggests the appeal Oudry's canine "family" might have had for this erudite and unorthodox thinker. In the *Système* d'Holbach noted that humans *think* they are "the center of the universe," seeing themselves and their ideas in everything around them, up to and including the fabrication of an "intelligence" that must by necessity have instilled order in nature. But intelligence, he countered, in fact lies in matter that has organized *itself* into beings who feel and act.[37] Oudry's painting, for all its appeal to French social interests in class and family life, could hardly be more materialist in showing how one type of substance can segue into another: the straw that covers the floor might be woven into a basket like the one seen in the right background; the puppies will soon open their eyes, learn to use them, and eventually gain the fully integrated sensory practices of their mother; the sun that slants into the shed nurtures all of the life it discovers there. For a *philosophe* who was conceiving the notion of dynamic continuum as a substitute even for God, Oudry's *Bitch-Hound Nursing Her Young* may have appeared progressive indeed.

For Oudry, as for Desportes and the many animal specialists of the seventeenth century who preceded them, fashioning a sensate animal psychology made for compelling characters with whom a human viewer could implicitly identify. Further from the realm of sentimentalist genre painting and much closer to the materialist universe of d'Holbach is Oudry's very late painting *Fox in Its Burrow*, which transplants the startled canine illumined by a shaft of light into a remote wooded den (Figure 5.1).[38] The painting, known today only through a wood engraving published at the end of the nineteenth century, sets up a confrontation between the solitary animal and the viewer of the painting, whoever or whatever we may be. The fox appears wary but

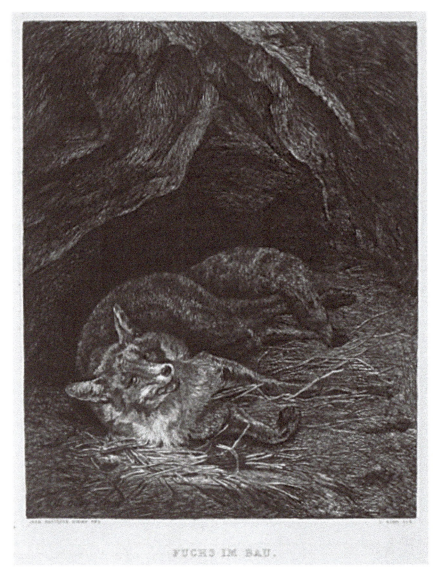

Figure 5.1 Anon. after Jean-Baptiste Oudry, *Fox in Its Den* [1754], wood engraving, *c.* 1891; published in Wilhelm Bode, "Die Italiener, Franzosen, Altniederländer, und Deutschen in der Schweriner Galerie," *Die Graphischen Künste* 14 (1891), between pp. 60–1.

remains recumbent, as if perceiving us as no great threat. Here it was the fox itself that scratched the dried grasses together to fashion a comfortable bed—what human owners do for their hunting dogs, we gather, only imitates what experienced animals quite naturally do for themselves in the wild. The patch of sun highlights the fox's erect ears, muzzle, and slightly opened, toothy

mouth, as well as the whites of its eyes, so that we immediately recognize the primary means through which it knows its world. It is as if the frustrated predator of Oudry's *The Wolf and the Fox* (Figure 3.5) shed not only the ridiculous wolf costume but the entire, babbling world of human speech and retreated into the simpler but in certain ways subtler realm of purely sensory understanding.

In his concurrent *Discourse on the Origin and Foundations of Inequality among Mankind*, Rousseau used the example of nonhuman animals to argue that wild nature contains essential powers lacking in the civilized world. Even domestic creatures "have generally a higher stature, and always a more robust constitution, more vigor, more strength and courage in their forests than in our houses."[39] Buffon may in turn have drawn upon Rousseau's idealistic portrayal of animals in a state of pure nature by the time he reached the fourteenth volume of the *Histoire naturelle*, originally published in 1766, for here he put forth his own, similar theory of the difference between domesticated and wild animals. Recounting the degenerative impact human society can levy upon natural beings, Buffon argued that the "empire of man," in "reducing animals to servitude," degrades their natural state of being.[40] Canines demonstrate such degradation in particular, as one can perceive through their differences in vocalization: Buffon noted that while domesticated dogs have developed a language of barking through their constant interactions with humans, canines in the wild are almost mute, employing howls only in rare cases of absolute need.[41] Throughout this section of the *Histoire naturelle*, Buffon almost suggests that many animals might in fact have been better off—or at least better equipped to make use of their distinct abilities—had the human not intervened in their naturally functioning world at all.

One might wonder whether Oudry, when he transferred his nursing hunting hound into a lone fox in its burrow, might also have had in mind the goal of returning the canine to its fully natural state. For an artist who had long furnished royal and noble salons with elaborate decorative schemes, it is notable that one of his very last paintings should remove all suggestions of human intervention and concentrate upon the subjective perceptions of a free and wild creature. The anguished wolf in Oudry's much earlier painting of a canine outside its den (Figure 0.1), howling from the pain inflicted by the cruelest of human inventions, could yet be interpreted as a successful conquest by an eighteenth-century sportsman such as Prince Friedrich of Mecklenburg. The fox in its den, by contrast, is woken from sleep by another being that might well not be human at all.

Mourning the Kill

A sentimentalist impulse to identify emotionally with those creatures commonly pursued in the hunt, while forming an important strain of English literature of the eighteenth century,[42] does not appear to have had a significant French counterpart. Oudry himself built his career around imagery of the hunt, although apart from his series of tapestry designs depicting the *parforce* hunts of Louis XV, he tended to restrict his hunting imagery to animal combat free from overt human intervention.[43] It is perhaps not surprising, then, to find a uniquely sorrowful French depiction of animal life extinguished by the hunt within the genre of stand-alone zoomorphic soft-paste porcelain tureens, whose innovative sculptural approach we have already examined in Chapter 4. A shell-shaped tureen and accompanying platter, attributed to the factory of the widow Perrin or Gaspard Robert in Marseilles, feature an exuberantly undulating body and richly painted floral motifs on a gold ground—unabashedly Rococo in an

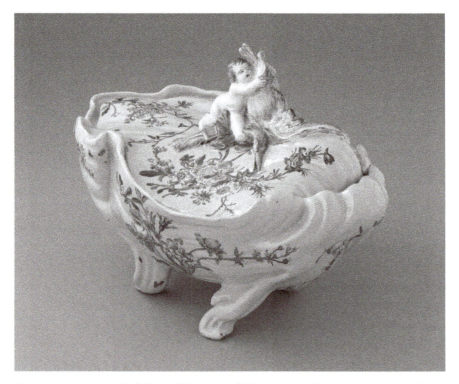

Figure 5.2 Anon., *Shell-Shaped Tureen and Platter*, Marseilles soft-paste porcelain, 1765–70; Paris, Louvre; photo: © RMN-Grand Palais/Art Resource, NY.

era, 1765–70, when the Neo-Classical style was already becoming fashionable in table ware (Figure 5.2). Despite the playful spirit of the form of the tureen, which might have simulated the opening of a succulent shellfish when one lifted the lid to taste the inner body of the "shell," the object's handle features a strikingly incongruent depiction of a cupid who has cast aside his quiver of arrows to embrace the wing of a felled waterfowl (Figure 5.3). Lest we mistake the little boy's action as a gesture of triumphant possession, the unknown modeler and painter, working in consort, fashioned a distinctly anguished expression of grief on the cupid face.

How did such a depiction of sorrow over the loss of animal life find its way into the handle of a Rococo serving tureen? The bird, although rather fancifully colored in greens, violets, and earthen tones, suggests the kinds of fowl regularly killed in the hunt, rather than an exotic species or favored pet. Imagery of the hunt often formed elaborate table centerpieces, where it was presumably intended to reinforce elite rituals of hunting as well as dining (Plate 1), and so-called trophies of the hunt had since early in the century appeared on more conventional luxury tureens, such those produced by the silversmith Thomas Germain (Figure 5.4). The crying cupid of the Marseilles tureen, rather than urging us to admire its maker's ability to recreate natural forms or to complacently

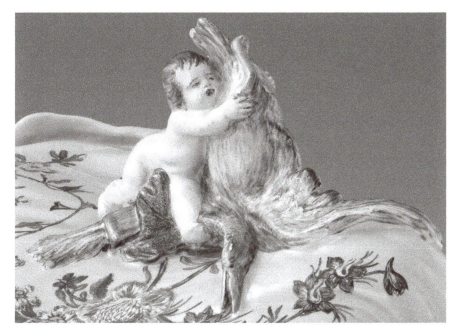

Figure 5.3 Detail of Figure 5.2.

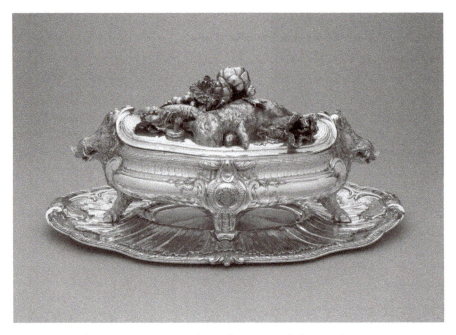

Figure 5.4 Thomas Germain, *Boar's Head Tureen and Platter*, silver, 1733 or 1734; Detroit Institute of Arts; photo: Detroit Institute of Arts, USA/Bridgeman Images.

ponder the bounties of a meal, urges us on the contrary to mourn the killing of an ordinary game bird. While the dead rabbit on the lid of Germain's tureen appears to be as lacking in emotional content as the vegetables that surround it, and "served up" as an object of consumption through its placement on the tray-like lid of the tureen, there is a strange incompatibility of mood, iconography, and even form between the body of the shell-shaped tureen and its tragic handle.

Perhaps what we are witnessing in this unusual object is a sentimentalist appeal to our empathy for the suffering animal. We have observed Maupertuis, who directly addressed the "rights of animals" in a discourse of 1756, arguing that our fellow creatures' experience to suffer should prevent us from killing or tormenting them. Rousseau brought this notion to much wider public attention in the *Discourse on the Origin and the Foundations of Inequality among Mankind* of 1753, in which he argued that human beings possess "an innate abhorrence to see beings suffer that resemble him ... I mean ... pity, a disposition suitable to creatures weak as we are."[44] Rousseau's Émile, a celebrated sentimental hero and prime exponent of this empathetic capacity, "suffers when he sees suffering," whether it be that of man or animal.[45] According to Rousseau, nonhuman creatures themselves possess such emotional awareness of the fate of their

fellows, for "one animal never passes unmoved by the dead carcass of another animal of the same species."[46] When it comes to commiseration, humans and animals form a continuum of sentiment.

The tiny cupid who mourns the dead or dying waterfowl indeed shares with the creature not only scale and an ability to feel, but the use of feathers as well. For, with the quiver cast aside in the boy's distress over the bird, the bundled arrows form an effective "third wing," symmetrically balancing the bird's left wing both in placement and in vibrant coloring (Figure 5.3). On the one hand this helps further to conjoin the two species awkwardly entangled on the top of the tureen, but it also adds an ironic note: for it may well have been an arrow, fashioned from feathers, that fatally shot the bird. La Fontaine had composed a fable on this very subject, in which a bird, struck down by an arrow, bemoans the insensitiveness of his human killer but also the irony of dying from weapons taken out of its own body. "Pierced by a feathered arrow, dying fast, a bird / Lamented its sad fate … Cruel humankind! You pilfer from our wings / The very vanes that guide these deathly flying things."[47]

In his illustration to this fable, which appeared with all the rest of the engravings after his drawings in the 1755 luxury edition of La Fontaine's *Fables*, Oudry made much of the bird's physical plight: centered in a deserted landscape, it rocks helplessly onto one wing, the other wing raised in a dramatic flourish not unlike that of the bird on the Marseilles tureen (Figure 5.5). Oudry's bird, whose fatal arrow is clearly shown, raises its head and opens wide its beak, presumably to suggest its outpouring of despairing words. Whether or not the Marseilles artisans were deliberately invoking Oudry's imagery, or La Fontaine's ironic observation that feathers are used to kill the very creatures from which they are stolen, they must have known that a stricken bird appearing on the top of a tureen would have no *emotional* impact without some guidance for the viewer and user of this object. The cupid performs this role as effectively as does Rousseau's Émile, who learns about suffering and death by hearing the cries of others, and by seeing "the convolutions of a dying animal [which] will give him untold agony before he knows whence these new emotions come to him." Émile must learn that empathy, even to the point of abandoning one's own species identification, is required for true pity to operate within us: "how shall we allow ourselves to be moved to pity if not by transporting us outside of ourselves and identifying ourselves with the suffering animal, by quitting, so to speak, our own being, in order to assume his … "[48] Beside himself with grief, the tureen's little cupid shows us without any words at all how we, too, might empathize with the suffering of a common bird.

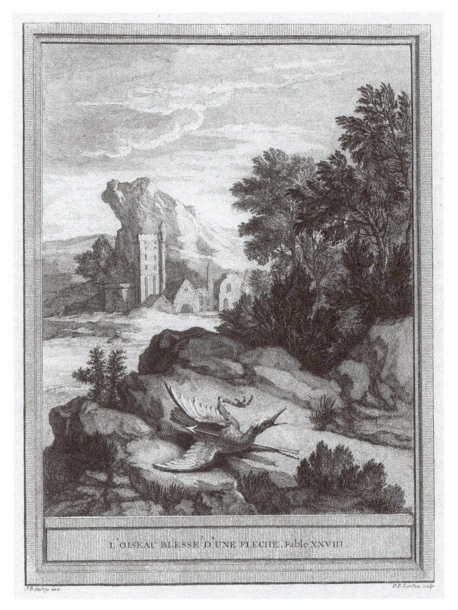

Figure 5.5 Pierre François Tardieu after Jean-Baptiste Oudry, *Bird Wounded by an Arrow*, engraving, early 1750s; from Jean de La Fontaine, *Fables choisies mises en vers*, 4 vols. (Paris: Dessaint & Saillant, Durand, 1755–9/60), II:IV; photo: WKR.11.3.1, Houghton Library, Harvard University.

Chardin's Material Creatures

Through much of his career, Chardin was no less concerned with calling attention to the animal body in all its physical experience than was Oudry or the anonymous artisans of the soft-paste tureens. In his case, however, life, death, sensation, and internal feeling became bound more closely with matter as his work matured and he increasingly focused upon conjuring the body through paint. The overtly tragic postures displayed by his martyred hares of the 1720s gave way in the later work to slacker, quieter bodies whose appeal to the viewer is through their dense coloration and the visible action of the brush, whose physicality appears in itself to reanimate the creatures and form a new kind of interiorized subjectivity. Surely connected to the new movement toward stirring the sentiments, Chardin's later animal still lives are nevertheless best seen through the developing materialist understandings of animal existence as proposed by La Mettrie, Diderot, Maupertuis, and d'Holbach. In a materialist universe, it is the sensate animal whose experience we must examine in order to understand life, death, and the rebirth of life through endless cycles of matter. Chardin's later paintings of animals call out, subtly but forcefully, for just such intensive study.

At the point when he was transitioning his focus from still life and animal painting to scenes representing modern life in French kitchens and sitting rooms, Chardin executed a large painting of a dead hare suspended vertically in an earthy, substantive environment (Figure 5.6). Perhaps made on commission from Carl Gustaf Tessin, who purchased it directly from the artist in 1739, Chardin's quiet, carefully balanced painting hung for the next several years in the bedchamber of Tessin's wife, the countess Ulrike Lovisa Tessin.[49] In content the painting blends Chardin's previous imagery of vanquished hares suspended in stony settings with elements of his kitchen still lives—the robust copper pot and the strategically placed chestnuts and quince. Although the juxtaposition of the hare with the pot suggests a culinary theme, neither the chestnuts nor the quince would belong with such a stew. The quince, in particular, was a notoriously sour fruit consumed exclusively in jellies and jams[50]: unlovely in its lumpen asymmetry, the quince may have appealed to Chardin for its dense, substantive body and textured surface, as well as its warm yellow hue. The whole painting indeed fairly pulsates with matter, as simulated through paint thickly stroked, dabbed, layered, and smeared quite visibly on the surface of the canvas (Figure 5.7). The brushy execution of Chardin's hares of the 1720s and early 1730s here transforms into substance that appears at once more fully

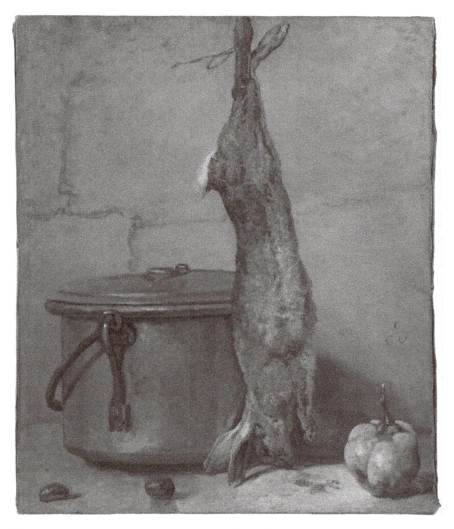

Figure 5.6 Jean-Siméon Chardin, *Rabbit, Copper Pot, Quince, and Two Chestnuts*, oil, 1739; Stockholm, Nationalmuseum; photo: Cecilia Heisser/Nationalmuseum.

composed of paint and, paradoxically, more constitutive of the animal body. As if to underscore the alliance between paint and body, Chardin smudged a trail of dry red paint from the hare's muzzle across the stone ledge to the left side of the quince. Although the wispy letters "c.d." hover on the wall above the fruit, the real signature seems to lie in the bright red paint, dually resonant of the artist's brush and the animal's vital matter.

The intense materiality of Chardin's 1739 still life appears particularly striking when the work is compared with a still life Oudry painted as a mantelpiece

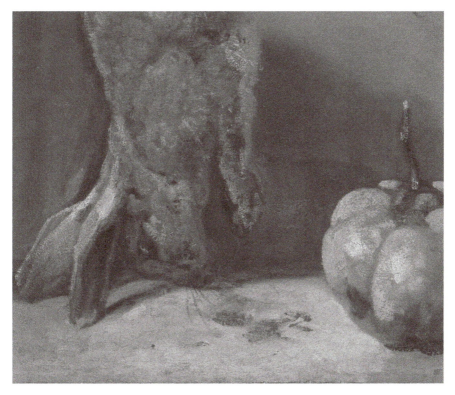

Figure 5.7 Detail of Figure 5.6.

for the dining room of the book seller Charles-Antoine Jombert in 1742 (Figure 5.8). Illusionistic in the manner of later seventeenth-century Netherlandish animal painters such as Jan Weenix and his own teacher, Nicolas de Largillière, Oudry's objects are rendered with small, precise strokes of paint that exactly simulate their optical appearance. Each hair and feather of the suspended animals receives its visual life through a process of painting that essentially hides itself within the illusion it produces. Chardin's painting is, by contrast, a dense conglomeration of colorful paint when viewed up close; as with the late works of Rembrandt, it is only in stepping considerably far back from the painterly action that the optical illusion coheres. For Cochin, who would himself contrast works by the two artists in an essay on painterly illusion, this was the product of Chardin's inimitable *faire*.[51]

Tactile materiality vs. objective illusion: while the difference between Chardin's and Oudry's paintings permeates the objects that inhabit them, it is in the depiction of the recently killed and suspended animals that Chardin's painterly investment in his subject emerges most tellingly. Oudry's hare and

Figure 5.8 Jean-Baptiste Oudry, *Still Life with Hare and Wild Duck*, oil, 1742; Paris, Louvre; photo: © RMN-Grand Palais/Art Resource, NY.

sheldrake, displayed to show off soft golden fur and gloriously patterned feathers, appear as devoid of previous life as the reflective bottles, crusty bread, and porous cheese that lie beneath them. Indeed, Oudry would go on to make something of an Academic science out of his still lives with dead animals, using the *White Duck* (location unknown), most famously, as an implicit demonstration of an artist's need to subtly inflect objects of the same color to achieve optical precision.[52] An incongruous drip of blood from the hare's nose in Jombert's painting—no one would really drain dead game above food ready for consumption—only heightens the aloof objectivity of these creatures as things to be admired. But Oudry's aim was not to conjure the substance of the here and now; indeed, the long shadow that flows along the body of his hare and wraps, shroud-like, under its head may allude in a glimmer of emblematic *vanitas* to the inevitability of death.

Chardin's hare, shifted off-center in the composition, by contrast vibrates with the urgency of the painter's brush, now streaked, now mottled, and changing colors wherever one looks. The body, moreover, sags from its own weight: ears, forelegs, and head droop downward through the effects of gravity—a stark contrast with the perpendicularity of the ears on Oudry's hare as well as the sheldrake's wings unfolded for impressive display. If Oudry's suspended animals evoke a pristine idea of "stilled life," the animation once embodied in Chardin's creature revives through the artist's active hand. Even in death a squiggle of white paint enlivens the hare's staring eye, calling attention to the organ once so central to its survival (Figure 5.7). It is precisely these evocations of sensitive physicality, redolent even in death, that distinguish Chardin's bloody hare from the objects that flank it.

The respective places where Oudry's and Chardin's paintings were displayed further suggest the different kinds of appeal their still lives generate. In Jombert's dining room, all of Oudry's assembled objects, animal, vegetable, and mineral, would have resonated with the civilized consumption of the wealthy bourgeois diner. Jombert and his guests may also have appreciated the artist's life-sized *trompe l'oeil* expertly handled in the tightly defined Netherlandish manner. Ulrike Lovisa, by contrast, must have been a connoisseur like her husband Count Tessin, for in her bedchamber Chardin's humble hare and kitchen things could only have been valued for their pictorial qualities, not for their culinary ring. Appreciating the work as an illusion from afar, up close the countess could have followed and even empathized with the artist's painterly touch. It would still be a couple more decades before French artists, critics, and connoisseurs would come particularly to value the visible touch of the artist—Cochin's *faire*— but those who prized Chardin's paintings in the first half of the century must

have appreciated their simultaneous appeal to sight and touch, as well as their ability to summon substance, weight, and even life itself through the material workings of paint.

In the latter part of his long career, Chardin would periodically return to the subject of dead hares, rabbits, and birds; no longer using live animals as surrogate perceivers of their fallen kin, the artist instead intensified his focus upon the substance of the dead creatures' bodies, as if seeking a painter's means of incarnating their material essence. While all of the well-considered objects in Chardin's compositions register such formal instantiation, when animals are included in the scene they always assume primary importance by virtue of centralized placement as well as through subtle evocations of physical sensitivity that stir vicarious response. One such painting is his mid-century still life of *Two Rabbits, a Pheasant and a Seville Orange on a Stone Ledge*, whose animal bodies are so folded into one another that they seem to form a single, corporeal entity (Figure 5.9). The bright little orange sits alone and to one side

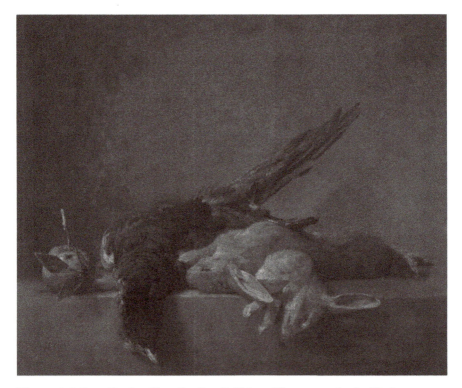

Figure 5.9 Jean-Siméon Chardin, *Two Rabbits, a Pheasant and a Seville Orange on a Stone Ledge*, oil, 1750s; Washington, D.C., National Gallery of Art; photo: Courtesy National Gallery of Art, Washington.

of the curves and angles of animal flesh, fur, and feathers; while crucial to the elegant rises and falls of the asymmetrical composition, and well worth study for its mottled signs of age and brilliant patches of color, the orange nevertheless appears quite literally as a thing apart from the fallen animals. Closest to us in the shallow pictorial space are the heads and ears that drop over the ledge in a gentle arc of sensory organs: beak, muzzle, ears, and eyes, as well as a pair of forelegs that remind us of our own sense of touch. Touch indeed permeates the group: we sense it in the softly overlapping bodies—ear against forelegs, paw against breast, the pheasant's lower leg and foot pressing into the pliant flesh of the rabbit beneath (Plate 9). At the same time, we recognize the artist's own touch in the variegated surfaces, stroked and blended in subtle layers of color, that simulate the texture of fur and feathers. The very spot where the paw of the rabbit in the center makes contact with the pheasant's breast, edged in pure white paint, could stand in for the hand of the artist, so redolent is it of process. Tiny dabs of vermillion here and on the rabbit's nose may or may not represent the creature's blood that has smeared onto its avian kin, but certainly it reminds us of vitality, if only of an artistic kind.

This rabbit's hind legs appear to trail off, as if the feet had been severed in the violence of a hunt, and there are slight indications of a hound's bite marks on its neck as well as on the shoulder of the rabbit on the right. Chardin, no outdoorsman,[53] probably invented the bite marks to recall the action of the hunt, following the practice of Flemish painters such as Fyt. It has been suggested that he terminated the legs for the more practical reason that the animals, upon whose physical presence he depended as models, were beginning to decay, an incident Diderot recounted in his *Salon* of 1769.[54] But these signs of injury, whatever their origin, underscore the fact of death in a manner more bluntly physical than the emblematic shadow that sets off Oudry's hanging hare. What gives all animals, including the human, the capacity to sense and feel is the living, conscious body, and all bodies that experience their life in the world must eventually experience their death.

Sensation, matter, feeling subjects that live and die—these intertwined themes come to the fore in the thickly brushed *Rabbit with Two Thrushes and Some Straw on a Stone Ledge* (Figure 5.10). One of Chardin's most painterly works of the 1750s, this small still life, although ostensibly focused upon death, pulsates with material animation in the visible movement of the brush. Even the vast, dark space above the animals on the ledge appears thick with organic potential through the scumbled treatment of its earth tones. Far from appearing as mere objects of study, the creatures are centralized and highlighted in an

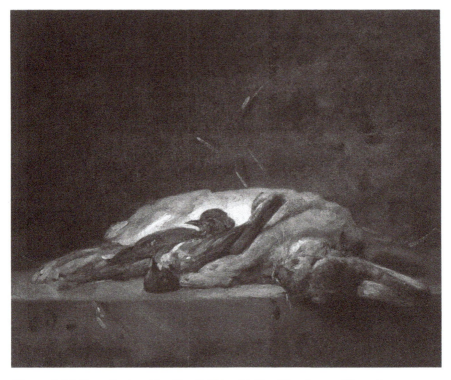

Figure 5.10 Jean-Siméon Chardin, *Rabbit with Two Thrushes and Some Straw on a Stone Ledge*, oil, *c.* 1750; Paris, Musée de la chasse et de la nature; photo: Sylvie Durand.

almost reverent manner: a glow seems to emanate from the brilliant white belly of the rabbit to warm the space immediately above, while wisps of yellow paint standing in for straw dance around the creatures like beams of light. The rabbit's fetal curve encloses the two thrushes so that no space separates one creature from another: just as the artist stroked and dabbed his warm earth tones as if modelling with them his hands, so we perceive the bodies of the three nestled animals as physical agents of feeling. With no hunting equipment in sight, and indeed only the barest wisps of human intervention in the ghostly presence of the straw, the rabbit and thrushes occupy our full attention and perhaps even our sensory empathy.

A Rabbit, Two Thrushes and Some Straw probably belonged in the eighteenth century to the French sculpture Jean-Baptiste Lemoyne, a provenance that reflects the intense admiration for Chardin's works on the part of his fellow artists.[55] One might imagine that a sculptor in particular might have appreciated the way Chardin appeared almost to model his animals in clay. Recent technical examinations of Chardin's still lives have confirmed the visible signs of his

intensely material execution: layering colors; using chalk in combination with oil paint to achieve luminosity; scumbling; and even, perhaps, using the handle of the brush to produce a grainy effect.[56] Marianne Roland Michel has demonstrated the later eighteenth-century appreciation for these technical subtleties, as when the abbé de Raynal compared the artist's substantive brushwork to mosaic or to *point carré* embroidery, or when Antoine Renou discovered the "magic of chiaroscuro" in his tonal gradations.[57] Diderot, as we noted in Chapter 2, rhapsodized poetically over Chardin's ability to capture "the very substance of things," transforming his pigments into vibrant embodiments of his pictorial subjects.

Amidst the "substantive things" that compose his later still lives, Chardin's animals stand out through the physicality of their presence: not only are they emphasized compositionally, but they also carry their own resonance as feeling subjects, even in a state of death. Although we are not called upon to mourn these deaths in the manner of the overtly sentimentalist Marseilles tureen, we nevertheless might implicitly empathize with an animal that, like ourselves, once used its senses to experience the world and still carries within its body visible traces of that sentience. Feeling at once physical and emotional was what Cochin claimed distinguished Chardin as an artist: Christian Michel has argued that for Cochin Chardin's emphasis upon process reflected not only his concern with capturing naturalistic effects but the individual feeling that he invested into his very act of painting.[58] As Desportes implied in his *Self-Portrait as a Hunter* a half-century earlier, an artist's investment in recreating the material world could bring out his kinship with the feeling animal.

Indeed, it is precisely because they *have* experienced the world as agents of feeling that we recognize Chardin's animals as inviolably distinct from the objects that surround them. Even at his most conventionally decorative Chardin emphasizes the corporeality of his animal subjects, as in the duck suspended over a table of familiar foods and table wares in the 1764 *Rafraîchissements* (Figure 5.11). Posed with one wing open and belly exposed, as if to show off, in conventional fashion, the magnificence of plumage expertly simulated, Chardin's duck instead reveals touch, substance, sensitivity to light and shade—qualities that recall animal sensation as well as painterly achievement. Reds, greens, and yellows enliven the white and earthy tones, while a variety of strokes stand in for layered wing feathers, downy breast, and distended neck and head (Figure 5.12). Although all of the objects below the duck are also materially executed—with the exception of the more crisply modeled white cloth—it is the animal alone whose substance reminds us of its experience as a sensory being.

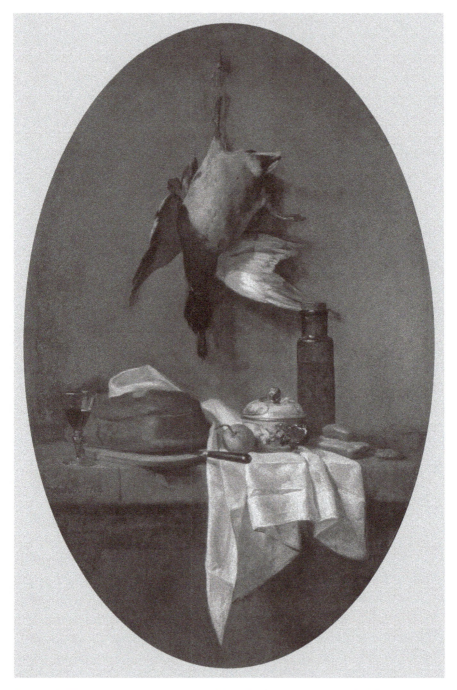

Figure 5.11 Jean-Siméon Chardin, *Still Life (Rafraîchissements)*, oil, 1764;
Springfield, MA, Michele and Donald d'Amour Museum of Art, James Philip Gray
Collection; photo: David Stansbury.

Figure 5.12 Detail of Figure 5.11.

The shadow that the animal seems to cast upon the wall when the painting is viewed from afar emerges upon closer inspection to be so coarsely brushed it appears almost as a *pentimento* or an extension of the animal's once-living substance.

As in the case of Oudry's late portrayals of living animals, we can gain insight into the vital role that animals play in Chardin's mid-century still lives by considering these works in relation to contemporary sensationalist philosophy. But while Oudry's perceptive creatures—like the curious felines in Chardin's works of the 1720s—exemplify the active experience of using the senses to understand and appreciate one's environment, in Chardin's later works it is the pulsating, touch-infused matter itself of his creatures that links them to sensible life. Philosophical materialism, as manifested in the writings of La Mettrie, Diderot, Maupertuis, and d'Holbach, as well as the sensationalist theories found in publications by Bonnet and Condillac, emphasizes in various ways that animal life springs from matter and—according to some—continues to reside within it even when the subjective awareness of the creature extinguishes at death. Taking matter seriously as the essential building block of life and sensitive awareness, these *philosophes* underscored the value of animal existence as a vital, substantive essence.

The Essence of Matter

Maupertuis, addressing the question of humans' ethical responsibility toward animals, emphasized the intrinsic significance of what it means to live a life: "If animals were pure machines," he reasoned, "to kill them would be a morally indifferent but ridiculous action: it would be like breaking a pocketwatch."[59] While some animals exist for only a few days, and others will outlive the philosopher himself, all experience their moments on earth through perceptions that lead to awareness and ideas.[60] It is this essential subjectivity, founded upon sensation, that distinguishes the animal from the artifice. However confounding it might be to accept that a purely material being can possess conscious sensitivity—for after all, how can one definitively prove the subjective consciousness of another being?—the profound similarity of animals' organs and actions to those of the human fairly demand such a conclusion.

This was also the argument Voltaire made in his thirteenth *Letter on the English*, in which he pondered the open question raised by Locke as to whether a purely material being can think.[61] As Boullier had done before him, Voltaire reasoned that God would not have equipped animals with everything they needed to experience their own sensory lives only to render such a complex design useless in the end.[62] Diderot, leaving God out of the reasoning altogether, noted in his article on "Animal" in the *Encyclopédie* what a difference there was between a tile that falls and breaks his arm and a dog who chooses voluntarily to bite him. In both cases, the arm suffers, but the cause—mechanistic action vs. purposeful agency—makes the one injury inevitable and the other unique.[63]

Diderot as well as La Mettrie would also push much further the sensitive potential of pure matter: La Mettrie sought the "motive principle" of thoughts as well as actions within the substantive bodies of animals, human, and nonhuman alike,[64] while for Diderot it was not soul but rather an "impetus of sensation similar to a dull, blunt feeling of touch granted to them by the creator of matter in its entirety" that caused organic molecules to shape themselves into the living system that constitutes the animal.[65] Whether or not one accepted—or even cared about—the question of whether pure matter can "think," the important point for all of these philosophers was that a material being could feel. Experiencing one's life, whether one was a caterpillar or a human, was predicated first and foremost upon the senses, as Condillac's statue discovers as she gradually comes to understand her world by trying out each of her sensory organs in turn.[66] And it is precisely her sensory awareness that leads the statue from pure stone to

living flesh and blood; she now has life, like Maupertuis's animal: material, but sensitively aware.

Charles Bonnet differed from the staunch materialists in arguing that the actual experience of sensation as well as more complex thought processes was immaterial in essence.[67] However he, too, argued that since we cannot access this immaterial realm we must study its physical operations, which in effect prove the existence of a "self" even in beings as small as the arthropods that formed his own scientific specialty.[68] In his *Observations sur les insectes*, Bonnet recounted his discovery of a nest of caterpillars in April 1738: closely observing their actions, he interpreted their motivations by empathetically imagining what they must be feeling as they set out to explore their environment. Since they always travelled in group processions, he supposed that these vulnerable animals did not dare to leave their nest on solo quests, and he noted a further tendency toward extreme caution when they refused, as a group, to cross a spot where he had experimentally broken the fine silken thread they used to navigate. Finally, one caterpillar that was "more daring than the others" boldly crossed the broken path and repaired it with a new slip of thread that allowed the others to pass, although not without exhibiting signs of trepidation as they did so.[69] It was likely drawing from such empirical observations that Bonnet later used the caterpillar as an exemplar of the "self" that experiences its life: "The *caterpillar* experiences different sensations and her *Memory* reminds her of what she has experienced. She compares her sensations. She senses that she is, or that she is not as she has been … She desires, fears, loves, or hates, as a result of her sensations."[70] Having focused his attention for decades upon creatures so small they seem to the inexperienced human eye to be a part of the earth within which they live and die, Bonnet appears to have concluded that it is deep within the material world that one finds the essential value of life.

No mid-eighteenth-century French philosopher would have been more likely to agree with this principle than La Mettrie, although he posited that the entire experience of living, from the self's slightest sensation to its most complex thought, should be regarded as substantive rather than immaterial. Far from demeaning what it means to live and be conscious, understanding the soul as a physical agent in fact recognizes its depths, for "the essence of the soul of man and animals is, and will always be, as mysterious as the essence of matter and bodies."[71] Deserving of our closest, endless study, the material body contains within its tangible substance the "motive power" that determines its existence, drives its sensory experience, and propels it to act in the world.[72] In *Machine Man* La Mettrie proposed that all sensate matter has the potential to move and

develop into ever more complex agency; it is only condition and organization that distinguish one kind of being from another.[73] As a physician whose primary objects of study were bodies, La Mettrie had a vested interest in promoting the intrinsic value of physical reality, and since "the human body is at its origin only a worm … why should one not be allowed to try to discover the nature or the properties of the unknown but obviously sensitive and active principle which makes this worm crawl conceitedly over the earth's surface?"[74]

Scholars have demonstrated that a considerable amount of clandestine literature on the material soul had circulated in France prior to La Mettrie's provocative (and banned) publications.[75] For example, an anonymous treatise appeared in Amsterdam in 1740 whose author argued that since animals clearly possess the ability to think, and "their thinking soul and their life are one and the same thing," we must conclude that matter itself is capable of thought.[76] D'Holbach would quote approvingly from this treatise in his own *Système de la nature* when he put forth his theory of dynamic sensitive matter as the operative principle of life through which matter becomes "animalized."[77] The marquis d'Argens also used the animal to argue for the material basis of the thinking soul: taking the perspective of a dog who learns through experience which behaviors will earn him a reward and which a beating, the dog uses conclusive reasoning to guide his subsequent actions.[78] Closest to La Mettrie's writings was the anonymous *L'Ame matérielle*, whose author pointed out that when Descartes demonstrated how well the body functions as a machine, he effectively opened the way for man as well as animal to be understood as essentially material beings, depending only upon certain adjustments and modifications to achieve their respective mental states.[79]

Perhaps the strangest of the clandestine materialist treatises was also the most prophetic of the later radicalism of Diderot and d'Holbach: Abraham Gaultier's 1714 publication in which he posited that there is but one substance that composes everything that exists in nature.[80] Although insensate in itself, this universal substance can assume all kinds of forms, including transformations from the inanimate to the living, as when sap draws from elements contained within the earth to nurture the life of a plant. One can observe a similar process in the birth of a living chick from an egg. Both plant and animal life in turn harbor the inevitable degeneration of aging and death, and in fact Gaultier asserted that because of this constant cycling of matter there is essentially no difference between life and death.[81]

Avowedly skeptical in outlook, Gaultier's treatise also relies upon the Biblical tenet of vanity to back up his contention that what we value as "life" is only death

in another form.[82] Far more life-affirming—and not at all biblical—in their considerations of universal matter were La Mettrie, Diderot, and d'Holbach. We have noted La Mettrie arguing in *Machine Man* that the human and the animal are modeled from one and the same "dough," varying only by virtue of their respective yeast.[83] Addressing sensitive matter in his revised and expanded version of the *Treatise on the Soul* of 1750, the physician posited that its motive force lay within "the unknown essence of matter other than extension." While Descartes's model of the body as machine depended upon physical matter as extension alone, La Mettrie's identification of a "mysterious essence" within matter allowed for the material body in and of itself to possess agency for action.[84] Matter, moreover, is universal and enduring: La Mettrie claimed to have all of pre-Christian and even most Christian philosophy behind him when he asserted that a "substantial principle of bodies had always existed and would always exist." The foundation of life itself, matter is simply "incapable of having a beginning or an ending."[85]

In the vast "ocean of matter" that comprises the world of Diderot's *Rêve de d'Alembert*, there is also but a single substance that composes all things, from the inert statue to man, animal, and plant.[86] But living things are endowed with an "active sensibility" that has also provided the impetus of their creation, by virtue of inherently sensitive molecules that relinquish their integrity as individuals in the interest of unification.[87] Instead of the old-fashioned term "soul," Diderot has his characters speak of a "common center" which serves as the locus of an animal's sensory life: impressions, memory, and sense of self.[88] The learned interlocutors of the *Rêve* include the vitalist physician Théophile de Bordeu, who together with his Montpellier colleague Paul-Joseph Barthez was himself developing a theory of life as a self-energized state of being coextensive with the material realm. Like La Mettrie, the vitalist physicians attributed the origins of life to an internally generated force that activated and sustained the body. As Elizabeth Williams has argued, we should nevertheless interpret Diderot's "Bordeu" as his own, fictionalized character rather than as a portrayal of the actual Montpellier physician.[89] While the vitalists themselves shunned pure materialism—their life-charging force was essentially unknowable and thus edged toward the spiritual[90]—Diderot drew inspiration from their vision of the world as "a teeming interaction of active forces vitalizing matter, revolving around each other in a developmental dance."[91]

By way of exemplifying the self-animation of matter in the *Rêve de d'Alembert*, Diderot presented the familiar case of a chick hatching from its egg, a demonstration already sketched much earlier in the century by Gaultier. Diderot

also uses this opportunity to refute the notion that the animal life so produced could be in any way mistaken for a mere mechanism. No sooner does the little bird break free from the prison of its shell than it begins to walk, fly, suffer, love, desire, and play. "It has all your feelings," Diderot claims to d'Alembert, "it performs all your actions. Will you claim with Descartes that this is purely an imitative machine?"[92] In so distinguishing animal life from mere mechanism, Diderot was also making a larger point about the sensible subject, whether it be a bird or a man: when an instrument possesses the "momentary consciousness of the sound that it makes," and holds within itself the memory of that experience, it can be called an animal.[93]

The essentially material nature of the animal nevertheless links it with the realm of inanimate substance, for as Diderot had speculated in his *Thoughts on the Interpretation of Nature* of 1753 (and as d'Holbach would later elaborate), the elements constituting sensate animal life might have very well always lain scattered and mingled with the "whole mass of matter." Perhaps

> these elements, happening to come together, had combined because it was possible for them to do so; that the embryo formed by these elements passed through an infinite number of structural changes and developments … that it is moving out of, or will move out of, that period into a long decline, during which it will lose its faculties just as it acquired them; that it will disappear from nature forever or, rather, that it will continue to exist in nature but in another form and with faculties quite other than those we observe in it at the present moment of its duration?[94]

Striking for its anticipation of modern evolutionary science, Diderot's theory of the development and degeneration of conscious life also demonstrates the value he placed upon elemental matter for its inherent forces of animation and change. The philosopher even allowed himself to wonder what really separates life from death at the level of pure matter: "How can it be that matter is not just one thing, either wholly living or wholly dead? Is living matter always alive? And is dead matter always and really dead? Does living matter never die? Does dead matter never begin to live?"[95]

Animal Life and Death

The animal still lives that Chardin began to produce around the middle of the eighteenth century raise their own questions regarding the once-living, material creatures on display: as substantive as the objects which surround them, his

rabbits and birds are nevertheless privileged as subjects, even in death, in ways both obvious and subtle. Chardin's dynamic, intensely tactile method of painting, so appreciated by artists and connoisseurs as signs of his own expertise, animates the limp bodies of his creatures and reminds us that they, too, once possessed the conscious sensitivity that made them no more like a piece of fruit or a pot than are we. Although this consciousness has now been extinguished, we might wonder, in scrutinizing the wealth of rich color and the palpable handling of the creatures, whether the matter we are seeing is really "dead" at all (Figures 5.6, 5.7). Does dead matter never begin to live? Can a still life artist, himself steeped in the painterly matter of his craft, make us question what we thought we knew about life and death in the material world?

Paintings such as *Two Rabbits, a Pheasant and a Seville Orange on a Stone Ledge* (Figure 5.9) and especially *A Rabbit, Two Thrushes and Some Straw on a Sone Table* (Figure 5.10) further invoke the presence of sentient life through the animals' implied sense of touch as they lie softly folded against one another. The latter painting, with light radiating from the centralized group as in a portrait by Rembrandt, sooner suggests sleep rather than death; although we know that mammals and birds do not rest in this way—such an impression stems from own tendency toward anthropomorphism—the painting nevertheless so evinces sensory life once experienced it is this, rather than any thought of these animals as trophies or food, which emerges as the painting's central theme. All of the philosophers most interested in what constitutes the nature of animal life include not only sensation as a primary qualification of the animal experience but also the memory of past feelings and situations. Chardin's animals, carefully arranged so that their sensory organs loom close to the viewer's own space, appear to carry within their actively brushed and scumbled bodies the memories of sensate existence, while also, perhaps, stirring our own. The artist's own touch captures, materially and visibly, the memory of touch, to form a constant cycle between life, death, immediacy, and memory—much like the dazzling play of matter in the universe as characterized by Diderot or d'Holbach.

From the marquis d'Argens to La Mettrie and Bonnet, regarding animal life was especially valuable for the study of nature because the animal epitomized what it meant to lead a material life that also entailed sensitivity and conscious awareness, however how small (in Bonnet's case) that conscious being might be. As a "painter of animals and fruits" known for carefully studying his objects from life, Chardin appears also to have highlighted his animals as subjects, even in death; his works suggest that the existence of animals mattered not just because they represented sophisticated examples of organic design but because

the lives of these sensitive creatures once mattered to *them*. Clearly they mattered to the artist as well: why else "sign" his painting of 1739 with the red paint that constituted the rabbit's blood (Figure 5.7)? Even the wispy fillets of golden straw that fly around the clustered bodies of his rabbit and thrushes suggest a mark of artistic authorship that doubles as radiating light (Figure 5.10).

We have noted that a number of the mid-century writers on animals, including the marquis d'Argens, La Mettrie, and Bonnet, argued that animal sensitivity constituted a soul, or subjective essence, that was inseparable from the animal's body. In Diderot's *Rêve*, Bordeu calls this concentration of sensitive awareness the "common center" of the animal. Chardin's return to still life painting around the middle of the century represented his own return to material essence as an artistic practice: at a time when modern painting was beginning to shift toward the tight handling and glossy surfaces that heralded Neoclassicism, Chardin by contrast intensified his use of paint to simulate substantive form. With the exception of the painting of the rabbit sold to Tessin in 1739, the first still life Chardin made upon turning his attention back to the genre also featured his most pointed reference to the sensitive agency of animal life: the *Grey Partridge, Pear and Snare on a Stone Table* (Plate 10).

Brilliantly brushed in broken strokes of orange-red, white, blue, gray, and a delicate lemon-yellow, the partridge lies stretched in a gentle curve, its highlighted breast falling just at the center of the painting. Beneath hangs the slip knot of the snare that caused the bird's strangulation;[96] it hovers eerily over the ledge like a hangman's noose. Snares frequently appeared with dead birds in Flemish and Dutch still lives of the seventeenth century, and despite being less familiar with biblical scripture than their northern neighbors, French audiences would almost certainly have recognized the allusion to *Ecclesiastes* 9:4: "For man also knoweth not his time: as the fishes that are taken in an evil net, and as the birds that are caught in the snare; so are the sons of men snared in an evil time, when it falleth suddenly upon them." But Chardin's image, in its painterly intensity, seems less a warning to "man" than a reminder of the animal whose intentional movement as it lived inadvertently caused its death. As he would do repeatedly in his subsequent still lives of rabbits and birds, Chardin thrust the head of the partridge—the "common center" that once received and remembered sensations—toward the viewer, while compositionally highlighting the legs, feet, and wing that allowed the animal freely to move as well as the breast that shielded the beating heart. Although the pear resembles the partridge, with its colorful, fleshy body and beaklike stem, the snare reminds us that a piece of fruit has no need of deceitful capture, insensate and unconscious as it always has been.

Everywhere in the diminutive painting Chardin left traces of his own moving hand: the streaks of white that impersonate wing and breast feathers, colorful dabs standing in for distinctive partridge markings, and above all the surprising colors that dart within and around the bird like painterly celebrations of its material presence. A smear of red paint under the head of the animal—not blood, in this case, but rather the grey partridge's orange mask broken free from its representational confines—attaches itself to the ledge below and finds echoes both in the glowing pear and in warm dabs that elsewhere enliven the ledge. Long, layered colors create the effect of a second wing folded beneath the bird, while certain other marks, such as the two green strokes that punctuate the left side of the ledge, appear not to have any descriptive function at all. One understands why Cochin quoted Chardin stating that an artist "uses colors ... but paints with feeling."[97] Feeling indeed seems everywhere at work in this vivid, tactile work of art, in which the physical presence of the living artist hovers within the material substance of the partridge and the pear.

Perhaps more than in any of his other animal still lives, Chardin emphasized in this painting the unique value of sentient life, so that "feeling" appears to extend beyond the artist's expert touch and inner sensibility into his avian subject as well. As he would do in the *Rabbit and Two Thrushes*, Chardin suffused the animal and its attendant fruit with a glow that radiates from the bird's white breast and in turn spreads over the stone ledge and thence into the scumbled background. This light, together with the brushwork so redolent of lively movement, counteracts the deathly noose and suggests a "life" that remains even after death. Recall that the materialists—La Mettrie, Diderot, d'Holbach—had emphasized that matter has no beginning and no end, whether one considers the vast cycles of life on earth or the trajectory of a single molecule. Animals die, and no afterlife awaits them, but if all matter at least has the potential for sentience, death can lead back to life once more through the process of "animalization."[98] Bonnet, a moralist who unlike the materialists strove to emphasize his allegiance to Christian doctrine, nevertheless used his beloved caterpillar as a means of explaining the evolution of the human soul: to the highest intelligence, he wondered, would not man appear as the caterpillar does to the expert naturalist? "Would death not be for him a preparation for a kind of Metamorphosis that would one day make him enjoy a new life?"[99]

God, Bonnet asserted, wants all creatures to achieve their fullest happiness in life, whether they be the fully metamorphosed butterfly or the human being.[100] Although Chardin's simple still life of the dead partridge and pear does not overtly solicit our pity, its appeal to physical feeling through color and touch

would be essentially meaningless without an appeal to emotion as well. While all of Chardin's late, painterly still lives pulsate with what we might call "sensate matter," thus stimulating many types of feeling at once, so reverently are his animals featured as pictorial subjects they lay claim to our empathy as kin. By the middle of the century a moral dimension had entered into philosophical considerations of animal life, so that we find Rousseau using animals as exemplars of the natural pity everyone feels for the suffering of "creatures weak as we are."[101] Ethically drawn to everything natural, Rousseau nevertheless recognized the distinction of the animal subject: "I see an exquisite feeling in my dog, but I see none in a cabbage."[102] Sentient in essence, conscious until the very moment of death, the animal—dog, partridge, rabbit, thrush, perhaps even the smallest insect—deserves to be seen, studied, and portrayed. For what are we, too, in the end but feeling creatures?

Notes

1 "Par rapport à lui-même, un Etre sentant n'existe, qu'autant qu'il sent: il existe donc d'autant plus, qu'il sent davantage"; Bonnet, *Essai analytique sur les facultés de l'ame*, 453–4, 455 (quotation from pp. 453–4).

2 Vila, *Enlightenment and Pathology*, 30–7.

3 Bonnet, *Essai analytique sur les facultés de l'ame*, 464–5, 469, 472. Bonnet reported his many experiments with, and observations of caterpillars in a number of his publications; see, e.g., Charles Bonnet, *Observations diverses sur les insectes*, in *Oeuvres d'histoire naturelle et de philosophie*, I, 270–467.

4 Bonnet, *Essai analytique*, 465–5.

5 Ibid., 497–8.

6 La Mettrie, *Treatise on the Soul*, in *Machine Man and Other Writings*, 43.

7 Ibid., 65.

8 Bonnet, *Essai analytique*, 472.

9 La Mettrie, *Machine Man and Other Writings*, 28.

10 Maupertuis, *Lettre V*, *Oeuvres*, II, 217–19.

11 Ibid., II, 215.

12 Maupertuis, *Lettre VI: Du Droit sur les bêtes*, *Œuvres*, II, 223.

13 La Mettrie, *Treatise on the Soul*, in *Machine Man and Other Writings*, 52.

14 Jeremy Bentham, *An Introduction to the Principles of Morals and Legislation* [1780; 1823] (Oxford: Clarendon Press, 1907), XVII:4, n. 122.

15 See, e.g., Emma Barker, *Greuze and the Painting of Sentiment* (New York and Cambridge: Cambridge University Press, 2005); Kevin Chua, "Dead Birds, or the

Miseducation of the Greuze Girl," in *Performing the Everyday: The Culture of Genre in the Eighteenth Century*, ed. Alden Cavanaugh (Newark: University of Delaware Press, 2007), 75–91; Mary D. Sheriff, *Moved by Love: Inspired Artists and Deviant Women in Eighteenth-Century France* (Chicago and London: University of Chicago Press, 2004).

16 See the reviews of Oudry's works exhibited in the Salon of 1753 quoted by Opperman, *Jean-Baptiste Oudry*, I, 206–14. Almost all of the reviewers, as well as the listing of the work in the Salon pamphlet, refer to the illuminating beam of sunlight.

17 Abbé Garrigues de Froment and one "Monsieur Estève," Salon reviews quoted in Opperman, *Jean-Baptiste Oudry*, I, 211, 208.

18 Salon reviews by Monsieur Estève and (probably) Friedrich Melchior Grimm; quoted by Opperman, *Jean-Baptiste Oudry*, I, 208, 205.

19 "Descartes eut renoncé à son systême en voyant tes Tableaux: Bougeant eut écrit moins frivolement son Langage des Bêtes"; Baillet de Saint-Julien, *La Peinture. Ode de Milord Telliab …* (1753); quoted by Opperman, *Jean-Baptiste Oudry*, I, 210.

20 Opperman, *J.-B. Oudry*, 185. Cf. Anik Fournier, catalogue entry in *The Age of Watteau, Chardin, and Fragonard: Masterpieces of French Genre Painting*, ed. Colin B. Bailey (New Haven and London: Yale University Press in association with the National Gallery of Canada, 2003), 204.

21 Gaffet, *Nouveau traité de Venerie*, 149-52; Jacques Fouilloux, *La Vénerie* [1561] (Paris: Abel l'Angellier, 1585; reprinted Paris: Émile Nourry, Librarie Cynégétique, 1928), 23.

22 Gaffet, *Nouveau traité de Venerie*, 152; Fouilloux, *La Vénerie*, 23.

23 Marquis d'Argens, *Philosophie du bon sens*, 382; Buffon, *L'Histoire naturelle* (1785–91), I, 224–33.

24 *Mercure de France*, October 1753, 160–1; quoted by Opperman, *J.-B.-Oudry*, 184. Monsieur Estève went so far as to suggest that the puppies had not even yet been thoroughly licked clean, having "cette espèce de duvet qu'ils apportent en naissant." Quoted in Opperman, *Jean-Baptise Oudry*, I, 208.

25 Abbé Laugier, *Jugement d'un Amateur sur l'Exposition des Tableaux*, quoted in Opperman, *Jean-Baptiste Oudry*, I, 211.

26 Marjolein Degenaar has pointed out that Boullier did not have the empirical evidence that Condillac and Diderot would gain from an actual operation performed by the English surgeon and anatomist William Cheselden. In 1728, Cheselden published in the *Philosophical Transactions* of the Royal Society his "Account of some Observations made by a young Gentleman, who was born blind, or lost his Sight so early, that he had no Remembrance of ever having seen, and was couch'd between 13 and 14 Years of Age." Having performed cataract operations on the boy's eyes in two successive years, Cheselden described in detail the boy's initial

experiences of sight. Both Condillac and Diderot made reference to Cheselden's observations in their writings on Molyneux's Question, discussed below. See Marjolein Degenaar, *Molyneux's Problem: Three Centuries of Discussion on the Perception of Forms*, trans. Michael J. Collins (Boston, London and Dordrecht: Kluwer Academic Publishers, 1996), 52–65.

27 Morgan, *Molyneux's Question*, 70–1.

28 Condillac, *Traité des sensations*, in *Œuvres philosophiques*, I, 254; translated by Morgan, *Molyneux's Question*, 72–3. Morgan translates *moi* as "ego," but to avoid humanist Freudian terminology I use the more inclusive "self."

29 Condillac, *Traité des sensations*, 255; trans. Morgan, 74.

30 Condillac, *Traité des sensations*, 281: "… Il ne suffit pas de voir pour se faire des idées, je dirai qu'ils [nos eux] ont besoin d'apprendre à regarder. C'est la différence entre ces deux mots, que dépendoit l'état de la question."

31 Denis Diderot, *Lettre sur les aveugles*, in *Œuvres philosophiques*, 131, 133–4.

32 Ibid., 97.

33 Ibid., 88–9. Cf. also 123, 145.

34 Annie Ibrahim, "Diderot et les métaphors de l'animal," 83–98; see also Grapa, "Des Huîtres aux grands animaux," 99–117.

35 In 1754, Oudry painted another version of the painting, in which only two, larger puppies curl against the nursing mother. Opperman speculates that this painting was made at the request of the marquis de Marigny, then Surintendant des Bâtiments, in compensation for his not being able to acquire the celebrated original; Opperman, *J.-B. Oudry* (1983), 195.

36 Ibid.,183; Yvon Belaval, Introduction to d'Holbach, *Système de la nature*, I, V–VI.

37 D'Holbach, *Système de la nature*, I, 79–82; quotation from p. 79: "L'homme se fait toujours le centre de l'univers …"

38 Opperman, *J.-B. Oudry*, 185. The wood engraving was published by Wilhelm Bode in "Die Italiener, Franzosen, Altniederländer, und Deutschen in der Schweriner Galerie," *Die Graphischen Künste* 14 (1891), between pp. 60–1.

39 Rousseau, *Discourse on the Origin and Foundations of Inequality among Mankind*, in The Social Contract *and* The First and Second Discourses, 93–4; quotation from p. 94.

40 "Si l'on ajoute à ces causes naturelles d'altération dans les animaux libres, celle de l'empire de l'homme sur ceux qu'il a réduits en servitude, on sera surpris de voir jusqu'à quel point la tyrannie peut dégrader, défigurer la Nature"; Buffon, *Histoire Naturelle* (1785–91), VII, 157. Although the naturalist had made similar points at the outset of his volumes on Quadrupeds, referring to domestic animals as "slaves" and their wild counterparts as "natural," he also argued that the empire of mind (*esprit*) over matter justified the subjugation of animals by the human; I, 1.

41 Buffon, *Histoire Naturelle* (1785–91), VII, 163–4.

42 The principal English writer to oppose the hunt's sanctioned violence against
 animals was Alexander Pope: see, e.g., Tobias Meneley, "Sovereign Violence
 and the Figure of the Animal, from *Leviathan* to *Windsor Forest*," *Journal for
 Eighteenth-Century Studies* 33 (2010): 567–8; idem, *The Animal Claim: Sensibility
 and the Creaturely Voice* (Chicago and London: University of Chicago Press, 2015);
 Katherine M. Quinsey, "'Little Lives in Air': Animal Sentience and Sensibility in
 Pope," in *Animals and Humans: Sensibility and Representation*, 141–72.

43 On Oudry's depictions of the *parforce* hunts of Louis XV, see Plax, "J.-B. Oudry's
 Royal Hunts and Louis XV's Hunting Park at Compiègne." On Oudry's animal-
 centered hunts see Sarah R. Cohen, "Animals as Heroes of the Hunt," in *Sporting
 Cultures 1650–1850*, ed. Daniel O'Quinn and Alexis Tadié (Toronto and London:
 University of Toronto Press, 2017), 114–35; Freund, "Good Dog! Jean-Baptiste
 Oudry and the Politics of Animal Painting."

44 Rousseau, *Discourse on the Origin*, 105.

45 Jean-Jacques Rousseau, *Émile or Treatise on Education* [1762], trans. William H.
 Payne (Amherst, NY: Prometheus Books, 2003), 227.

46 Rousseau, *Discourse on the Origins*, 105.

47 "Mortellement atteint d'une flèche empennée,/Un Oiseau déplorait sa triste
 destinée … Cruels humains tirez de nos ailes/De quoi faire voler ces machines
 mortelles." La Fontaine, *Fables choisies mises en vers*, II:IV; English translation from
 The Complete Fables of La Fontaine, 32.

48 Rousseau, *Émile*, 203.

49 In 1749, Tessin sold the painting to Frederick the Great of Prussia, who gave it to
 his sister Princess Louisa Ulrika. Colin B. Bailey, catalogue entry in *Treasures from
 the Nationalmuseum of Sweden: The Collections of Count Tessin* (New York: The
 Morgan Library and Museum, 2016), 60.

50 See the quotation from the *Encyclopédie* entry on the quince provided by Bailey,
 Treasures from the Nationalmuseum of Sweden, 61.

51 Cited by Turnstall, "Diderot, Chardin, et la matière sensible," 580. Cf. also Lajer-
 Burcharth, *The Painter's Touch*, 112.

52 In the first of the two lectures he presented to the Academy, that of 1749, Oudry
 addressed this need for tonal mastery, citing the admonitions of Largillière. After
 he exhibited the *White Duck* at the Salon of 1753, to great acclaim, Melchior
 Grimm noted its correlation with the principles the artist had emphasized in his
 lecture. See Jean-Baptiste Oudry, *Réflexions sur la manière d'étudier la couleur en
 comparant les objets les uns avec les autres* [1749], transcribed in E. Piot, *Le Cabinet
 de l'Amateur et de l'Antiquaire*, III, 1844, 33–54; reprinted by Getty Conservation
 Institute, Los Angeles. https://www.getty.edu/conservation/our_projects/science/
 coll_res/reflexions_fr.pdf (1-8-20). For a full discussion of this painting and
 its pendant, the *Still Life with Hare, Pheasant, and Red-Legged Partridge* (Paris,
 Louvre) see Opperman, *J.-B. Oudry*, 209–13.

53 See Philip Conisbee, *Chardin* (Oxford: Phaidon, 1986), 85.

54 The suggestion was first made by Marianne Roland-Michel; see Rosenberg, *Chardin* (2000), 270.

55 Rosenberg, *Chardin* (2000), 268.

56 Roland Michel, *Chardin*, 134; Claire Berry, "The Painting Technique of Anne Vallayer-Coster: Searching for the Origins of Style," in *Anne Vallayer-Coster: Painter to the Court of Marie-Antoinette*, ed. Eik Kahng and Marianne Roland Michel (New Haven and London: Yale University Press for the Dallas Museum of Art, 2002), 99–100.

57 Roland Michel, *Chardin*, 139. The painterly method used by Chardin was sometimes also referred to as *la manière heurtée*; see Eik Kahng, "Vallayer-Coster/Chardin," in Kahng and Roland Michel, *Anne Vallayer-Coster*, 48–50.

58 Michel, *Charles-Nicolas Cochin*, 253–91; cf. Roland Michel, *Chardin*, 115.

59 "Si les bêtes étoient de pures machines, les tuer seroit un acte moralement indifférent, mais ridicule: ce seroit briser une montre"; Maupertuis, *Lettre VI: Du Droit sur les bêtes*, in *Œuvres in Mr. de Maupertuis*, II, 224.

60 Ibid., 220.

61 Voltaire, *Letters on the English* or *Lettres philosophiques*, no. 13 [*c.* 1778]. Paul Halsall, ed., *Fordham University Internet History Sourcebooks Project*. http://sourcebooks.fordham.edu/Halsall/mod/1778voltaire-lettres.asp (7-6-17); cf. Ann Thomson, "Materialistic Theories of Mind and Brain," in *Between Leibniz, Newton, and Kant: Philosophy and Science in the Eighteenth Century*, ed. Wolfgang Lefèvre (Boston, London and Dordrecht: Kluwer Academic Publishing, 2001), 152.

62 Voltaire, *Letters on the English*, no. 13.

63 Denis Diderot, article "Animal," from *Encyclopédie*, in *Oeuvres*, I, 260.

64 La Mettrie, *Treatise on the Soul*, in *Machine Man and Other Writings*, 43–4.

65 Denis Diderot, *De L'Interpretation de la nature* [1753], in *Œuvres philosophiques*, 231; translation by Adams in Diderot, *Thoughts on the Interpretation of Nature and Other Works*, 68–9.

66 Condillac, *Traité des sensations*.

67 As Guichet makes clear, this was very much the case for Rousseau as well. See *Rousseau L'Animal et l'homme*, 129–70.

68 Bonnet, *Essai analytique sur les facultés de l'ame*, IX–X.

69 Charles Bonnet, *Observations sur les insectes*, I, 276–7.

70 "La *Chenille* éprouve différents Sensations, et sa *Mémoire* lui rappelle celles qu'elle a éprouvées. Elle compare ses Sensations. Elle sent qu'elle est, ou qu'elle n'est pas comme elle a été …. Elle desire, craint, aime, ou haït, en conséquence des Sensations …" ; Bonnet, *Essai analytique sur les facultés de l'ame*, 468.

71 La Mettrie, *Treatise on the Soul*, in *Machine Man and Other Writings*, 43.

72 Ibid., 47–8.

73 La Mettrie, *Machine Man*, 25.

74 La Mettrie, *Treatise on the Soul*, in *Machine Man and Other Writings*, 44.

75 See, e.g., Aram Vartanian, "Quelques Réflexions sur le concept d'âme dans la littérature clandestine," in *Le Matérialisme du XVIII^e siècle et la littérature clandestine*, ed. Bloch, 149–63; Ann Thomson, "Materialistic Theories of Mind and Brain," in *Between Leibniz, Newton, and Kant*, ed. Lefèvre, 149–73.

76 Anon., "Dissertation V: Dissertation sur l'immortalité de l'Âme," in *Dissertations mêlées sur divers sujets importans*, 2 vols (Amsterdam: J.F. Bernard, 1740), I, 256–7.

77 D'Holbach, *Système de la nature*, footnote on I, 127–8.

78 Marquis d'Argens, *Philosophie du bon sens*, 382.

79 See the discussion of this text by Vartanian, "Quelques Réflexions sur le concept de l'âme," in *Le Matérialisme du XVIII^e siècle*, ed. Bloch, 151–4.

80 Abraham Gaultier, *Réponse en forme de dissertation à un théologien qui demande ce que veulent dire les sceptiques qui cherchent la véritié ... lorsqu'ils pensent que la vie et la mort sont la même chose ...* (Niort: J. Elies, 1714).

81 Ibid., 22–6, 15.

82 Ibid., 28–30.

83 La Mettrie, *Machine Man*, 20.

84 La Mettrie, *Treatise on the Soul*, in *Machine Man and Other Writings*, 44, 48.

85 Ibid., 44–5. See also 44, n. 4, in which the editor, Ann Thomson, identifies Scholastic and early modern sources for La Mettrie's concept of eternal matter.

86 Diderot, *Entretien entre d'Alembert et Diderot*, 37; *Le Rêve de d'Alembert*, 82, 89.

87 Diderot, *Entretien entre d'Alembert et Diderot*, 37; *Le Rêve de d'Alembert*, 89.

88 Diderot, *Le Rêve de d'Alembert*, 116, 145.

89 Williams, *A Cultural History of Medical Vitalism in Enlightenment Montpellier*, 172–7; see especially p. 175.

90 Ibid., 3–5.

91 Reill, *Vitalizing Nature in the Enlightenment*, 7.

92 "... Il marche, il vole ... il souffre, il aime, il désire, il jouit; il a toutes vos affections; toutes vos actions, il les fait. Prétendrez-vous, avec Descartes, que c'est une pure machine imitative ?" Diderot, *Entretien entre d'Alembert et Diderot*, 52.

93 "... Il a la conscience momentanée du son qu'il rend ..." ; ibid., 50–1; quotation from p. 50.

94 Diderot, *De L'Intérpretation de la nature*, 241; translation from *Diderot's Selected Writings*, trans. Derek Coltman, ed. Lester G. Crocker (New York: Macmillan, 1966), 86–7.

95 "Mais comment se peut-il faire que la matière ne soit pas une, ou toute vivante, ou toute morte? La matière vivante est-elle toujours vivante ? Et la matière morte est-elle toujours et réellement morte ? La matière vivante ne meurt-elle point ? La matière morte ne commence-t-elle jamais à vivre ?" Diderot, *De L'Intérpretation de la nature*, 242.

96 Rosenberg, *Chardin* (2000), 260.

97 Quoted by Roland Michel, *Chardin*, 138. As I have discussed in Chapter 2, Cochin
 so infuses his own theories into his descriptions of Chardin's approach that we
 must take them only in part as fact: they tell us as much, if not more about what
 Cochin himself appreciated in the artist's work.

98 D'Holbach, *Système de la nature*, I, 127.

99 "La *Mort* ne seroit-elle point pour lui une préparation à une sorte de
 Métamorphose qui le feroit jouïr d'une nouvelle Vie ?" Bonnet, *Essai analytique*,
 473.

100 Ibid., 472.

101 Rousseau, *Discourse on the Origins*, 105.

102 "Je vois un sentiment exquis dans mon chien, mais je n'en aperçois aucun dans
 un Chou"; Jean-Jacques Rousseau, *Dictionnaire de botanique*, quoted by Guichet,
 Rousseau L'Animal et l'homme, 150.

Conclusion

Chardin's paintings featuring rabbits, hares, and small birds share with all of his still lives a "deep materiality"—to use Ewa Lajer-Burcharth's apt term[1]— that appears to have been appreciated above all by other artists such as Cochin and Le Moyne as well as by critics and connoisseurs such as Diderot and the Swedish countess Ulrika Lovisa. As with virtually all of the artists whose works have been examined in this book, what we can glean of Chardin's "intentions" comes principally from close study of the substantive evidence of the paintings themselves. In subtly privileging his animal subjects as physical bodies, as opposed to the vegetables and manufactured objects that surround them, the artist offered quiet testament to their special status as once animate creatures, now vivified through paint. Unlike Oudry's dramatic depictions of living animals engaged in the business of sustenance and survival, Chardin's paintings do not appear to have elicited from contemporary viewers any direct associations with contemporary debates over animal subjectivity or communication. My efforts to interpret Chardin's animal paintings through the lens of sensational and materialist philosophy spring rather from what I perceive as the particular value the artist brought to his animal subjects: they represent, in my view, the essence of Cochin's reported claim on the part of Chardin that an artist paints "with feeling." Feeling, for eighteenth-century sensationalists such as Condillac as well as materialists such as La Mettrie, underlay not only physical sensation but emotion and all forms of knowledge as well. These philosophers were themselves drawn to the animal precisely because its mind presumably lacked the human's rational components and thus exemplified how crucial feeling is to all subjective experience and relations. Whether or not Chardin actually used the words Cochin attributed to him, the younger artist clearly perceived Chardin's animated handling of paint as embodying this sentient potential.

La Mettrie, seeking a way to define the vital soul through entirely material terms, himself used the physical act of painting as his metaphor: "the soul and

the body were created together in the same instant and as if at a single brush stroke."[2] An artist devoted to careful study of matter could arrive at a similar solution: although partridges and paint share no organic connection, the painter's brushy touch materially revives the feeling substance of the animal. We have seen that Chardin, like Watteau before him, had used the dexterous monkey as an avatar of his own professional practice (Plate 4 and Figure 2.16), as if to proclaim early on in his career an allegiance to the realm of matter shared by painter and animal alike.[3] Desportes had similarly allied his own artistry with the animal subject both in his boundary-crossing *Self-Portrait as Hunter* (Figure 1.1) and in his subsequent still lives with living animals that appear overtly to assert their centrality as subjects over sidelined men (Figure 1.23). When Oudry took it upon himself to illustrate, without commission, the complete *Fables* of La Fontaine, he forged a novel vocabulary of animal expression and dramatic action that his own contemporaries would perceive as a viable statement of artistic authority (Figures 3.5 and 3.8). Painters rather than philosophers, all three of these artists claimed a stake in earthly matter by making their animals uniquely compelling.

Although the Enlightenment is still often generalized as the "age of reason," the paintings, drawings, ceramics, and upholsteries examined here present sensation as the "common center" through which a living subject makes its way in the world. The very ubiquity of the animal in eighteenth-century art— enacting fables on walls and chairs (Figures 3.11 and 1.20), offering soups and stews on dining tables (Plate 7), crowding into a princely gallery in often life-size proportions (Figure 4.9)—suggests that the creature who understands by virtue of its senses coincided quite literally with material existence when transformed into tangible artifact. Perhaps because many of these incarnations of the animal were made to furnish rooms as decorative sets or objects of actual use, comparatively little interpretive attention has been paid to them by art historians, with the exception of such celebrated elite commissions as the porcelains made for Augustus the Strong.[4] But as I have argued throughout this book, matter itself conveyed meaning in an eighteenth-century context, especially when the object in question configured a being that virtually all philosophers and scientists agreed was fully material in essence. Both the porcelain animals made for Augustus and their more humble kin providing sustenance at the table conveyed through the transformative substance of fired clay and trompe l'oeil paint that the animal in all its lively awareness could gain vitality through art. Tapestry, especially when designed to seat human subjects or protect their bodies from a fire or a draft, also proved to be a medium

through which designers and weavers could elicit the sensate experience of an animal by appealing directly to a user's sense of touch (Figures 1.8 and 1.21). Touch, long the most fundamental of the senses in philosophical discourse, had become by the era of Condillac and Diderot the essence of knowledge—indeed, of all "reason"—as well.

Although I have speculated throughout this study upon the significance of human responses to the art in question, I have specifically chosen to prioritize the animal subject as the object of my inquiry, much as writers of treatises on animal understanding relied to a great extent upon their own observations of creaturely behavior. The rapidly growing interdisciplinary literature on animals in eighteenth-century culture has focused overwhelmingly upon humanist concerns, with the animal often assuming a more instrumental role as servant, admonishment, or complicating agent for the concerns of the problematic human.[5] But if we are really to shift our focus and de-center the human figure from its privileged position within our field of scholarly vision, we might do well to attend to the needs and actions of other "vital agents" within the ecologies of artmaking. The artist and theorist Erin Manning uses the concept of sympathy to encompass the nonhuman into our understanding of art's agency: through "intuitive linkages … art becomes less an object than a conduit or vector toward a seeing-with, a sympathizing-across, a moving-through."[6] The "material turn" that art history has taken in recent years has likewise opened paths toward new interpretations that are grounded in the relational physicality of the objects themselves, a methodology particularly useful for examining those works, such as many of the depictions of animals addressed here, whose textual documentation is minimal.

Although beyond the scope and aims of this book, a further area of research raised by close scrutiny of the animal in eighteenth-century art is the correlation between what Europeans defined as "animal" and their volatile, contested, and indeed paradoxical understandings of the varieties and status of humans of other regions and races. As many scholars have demonstrated, the very concept of "race" was undergoing significant change, especially in the latter part of the century, and theories of human hierarchy based upon external traits were often predicated upon those of the animals—perhaps the best known being the supposed "missing link" supplied by those humans thought to be closest to the apes.[7] While La Mettrie wondered at the orangutan ("man of the woods"[8]) for its likeness to humans as a general group, other theorists used this creature to argue its specific correlation with the "savages."[9] The science of physiognomy, as developed by Petrus Camper and Johann Caspar Lavater, relied specifically

upon aesthetic assessments of human appearance, for which animals, especially the apes, could provide a useful foil.[10]

In their writings on sensory animal understanding, none of the philosophers I have examined in this study used the animal as an instrument of ranking human beings by their external appearance or capabilities, nor did the art that featured animals as central protagonists offer such anthropological comparisons.[11] Indeed, as art historians have demonstrated, when non-Europeans are associated with animals in earlier eighteenth-century art, *both* are generally placed in subservient positions as supporting actors, presumably allied by their inferiority to the white Europeans who take center stage.[12] However, I propose that further study of eighteenth-century understandings of life in all its manifestations, culturally as well as naturally defined, can reveal new insights through close scrutiny and interpretation of medium and matter—especially, perhaps, in those art forms hitherto often overlooked for their meaningful potential. For example, the jolly "Chinese" figures that filled European markets in the second half of the century, often called, in their own era, *magots*, took their nomenclature directly from the term for a type of ape that Buffon characterized as the most adaptable to the European climate and even capable of being trained to "dance and gesture in rhythm and to allow itself calmly to be dressed and coiffed."[13] The decorative "Chinese" counterparts of these living examples of humanized animality were often painted in a deep brown varnish known as *vernis Martin*, thus giving them the visual veneer of the hairy jungle creatures through the darkness of their ornamental "skin." That eighteenth-century Europeans were indeed avidly keeping monkeys as pets and dressing them in fashionable clothing would have popularized the surface interplay between simian and *chinoiserie* figurine.

The many scholars who are currently addressing the problems of racial stereotyping in historical art and culture are informed and motivated by crises that directly affect our world today. Similarly, my own aim in this book has been guided throughout by the catastrophic danger to which animals are currently exposed. To a great extent, this extremity derives from worldviews that insistently place human desires above actual human needs, and in the process treat the nonhuman animal as an expendable instrument of human will. In giving prominence to those eighteenth-century artists and artworks that privileged animal life in its sensory, material essence, I protest the anthropocentric system of values that currently prevails in much of the developed world today. And my efforts to advance such extraordinary thinkers as La Mettrie and Bonnet might, I hope, open doors for other scholars to discover how the process of studying this complex century can better help us re-evaluate our own.

Notes

1 Lajer-Burcharth, *The Painter's Touch*, 89.

2 La Mettrie, *Treatise on the Soul*, in *Machine Man and Other Writings*, 43.

3 When he depicted a male art student diligently copying a drawing of an Academic nude figure, Chardin positioned the unselfconscious young man as sitting directly on the floor, legs splayed; *Young Student Drawing*, Salon of 1738; Stockholm, Nationalmuseum.

4 My understanding of the critical value eighteenth-century users placed upon such design elements as decorative sets and the physical arrangements of material objects within their interiors owes considerably to the work of Mimi Hellman. See, e.g., Mimi Hellman, "The Joy of Sets: The Uses of Seriality in the French Interior," in *Furnishing the Eighteenth Century: What Furniture Can Tell Us about the European and American Past*, ed. Dena Goodman and Kathryn Norberg (London and New York: Taylor and Francis, 2006), 129–53; idem, "Furniture, Sociability and the Work of Leisure in 18th-Century France," *Eighteenth-Century Studies* 32 (Summer 1999): 415–45. See also Martina Droth et al., *Taking Shape: Finding Sculpture in the Decorative Arts* (Los Angeles: Getty Publications, 2009); Scott, *The Rococo Interior*.

5 Notable exceptions to this trend can be found especially in literature that addresses Romantic portrayals of the animal, such as those produced by Théodore Géricault. See, e.g., Eisenman, *The Cry of Nature*, 147–61; Katie Hornstein, "From Museum to Menagerie: Théodore Géricault and the Leonine Subject," *Art Bulletin* 101 (March 2019): 26–47.

6 Erin Manning, "Artfulness," in *The Posthuman Turn*, ed. Grusin, 45–79; quotation from p. 71. See also, from this volume, Grusin, "Introduction," vii–xxix; Brian Massumi, "The Supernormal Animal," 1–18; Steven Shaviro, "Consequences of Panpsychism," 19–44.

7 See, e.g., Silvia Sebastiani, "Challenging Boundaries: Apes and Savages in Enlightenment," in *Simianization: Apes, Gender, Class, and Race*, ed. Wulf D. Hund, Charles W. Mills, and Silvia Sebastiani (Zürich: Lit Verlag, 2015), 105–37; David Bindman, *Ape to Apollo: Aesthetics and the Idea of Race in the Eighteenth Century* (London: Reaktion Books, 2002).

8 La Mettrie, *Machine Man and Other Writings*, 11; in Malay *orangutan* translates as "person of the forest." Eighteenth-century Europeans such as La Mettrie were introduced to the orangutan and its seeming correlations with the human through Edward Tyson's book purporting to address this new-found wonder: Edward Tyson, *Orang-outang, sive Homo sylvestris, or the Anatomy of a Pigmie Compared with That of a Monkey, an Ape, and a Man* (London: T. Bennett and D. Brown, 1699).

9 See, e.g., Buffon, *Histoire naturelle* (1785–91), VII, 7: he notes that while "... le Nègres sont presque aussi sauvages, aussi laids que ces singes ..." they nevertheless gave the orangutan the nomenclature of an animal rather than a man.

10 See especially Miriam Claude Meijer, *Race and Aesthetics in the Anthropology of Petrus Camper (1722–1789)* (Atlanta, GA and Amsterdam: Rodopi, 1999).

11 An exception might be found in the simian actors that populate the room of the "Grande Singerie" at Chantilly, whose activities are presented with a considerable veneer of *chinoiserie*. However, any one-to-one comparison between monkeys and Chinese people in the iconography is complicated by its simultaneous references to the duc de Bourbon, his household, and his personal interests. See Chapter 2, "Singeries." Buffon, as noted above, compared the external appearance of simians and Africans, with ambiguous conclusions.

12 See, e.g., Judy Sund, "Middleman: Antoine Watteau and *Les Charmes de la vie*," *Art Bulletin* 98 (March 2009): 59–82; Anne Lafont, "How Skin Color Became a Racial Marker: Art Historical Perspectives on Race," *Eighteenth-Century Studies* 51 (Fall 2017): 106.

13 "J'en ai vu d'autres de la même espèce [magot] qui en tout étoient mieux, plus connoissans, plus obéissans, même plus gaies, et assez dociles pour apprendre à danser, à gesticuler en cadence et à se laisser tranquillement vêtir et coiffer." Buffon, *Histoire naturelle* (1785–91), VII, 92–93. On the *magot* in French portable arts, see, e.g., Shuang Situ, *Le Magot de Chine: ou trésor du symbolisme chinois: à la recherche du symbolisme dans les motifs de "chinoiseries"* (Paris: Éditions You-Feng, 2001).

Bibliography

Académie royale de peinture et de sculpture. *Conférences de l'Académie royale de peinture et de sculpture pendant l'année 1667*. Paris: Frédéric Léonard, 1669.

Adamson, Glenn. "Rethinking the Arcanum: Porcelain, Secrecy, and the Eighteenth-Century Culture of Invention." *The Cultural Aesthetics of Eighteenth-Century Porcelain*, 19–38. Ed. Alden Cavanaugh and Michael E. Yonan. Burlington, VT, and Farnham, Surrey: Ashgate, 2010.

Adamson, Glenn and Victoria Kelley, eds. *Surface Tensions: Surface, Finish and the Meaning of Objects*. New York and Manchester: Manchester University Press, 2013.

Animal, All Too Animal. Special edition of *The Eighteenth Century: Theory and Interpretation*. Lucinda Cole, ed. 52 (Spring 2011).

Anon. "Dissertation V: Dissertation sur l'immortalité de l'Âme." *Dissertations mêlées sur divers sujets importans*, 2 vols. Amsterdam: J.F. Bernard, 1740, I.

Anthenaise, Claude d', ed. *La Table du Chasseur: La gastronomie du gibier au XVIIIe siècle*. Paris: Musée de la chasse et de la nature, 2002.

Antognazza, Maria Rosa. *Leibniz: An Intellectual Biography*. New York and Cambridge: Cambridge University Press, 2009.

Argens, Marquis d'. *Philosophie du bon sens, ou Réflexions philosophiques sur l'incertitude des connoissances humaines, à l'usage des cavaliers et du beau sex*. London: aux dépenses de la Compagnie, 1737.

Aristotle, *De Anima*. Trans. J. A. Smith. In *The Works of Aristotle*, 12 vols. Ed. J. A. Smith and W.D. Ross. Oxford: Clarendon Press, 1910, III.

Audran, Jean. *Expressions des passions de l'Ame. Representées en plusieurs testes gravées d'apres les desseins du feu Monsieur le Brun Premier Peintre du Roy*. Paris: Jean Audran, 1727.

Aulnoy, Marie-Catherine Le Jumel de Barneville, baronne d'. *Les Contes des fees*, 4 vols. Paris: publisher unknown, 1697.

Aulnoy, Marie-Catherine Le Jumel de Barneville, baronne d'. *Les contes des fées de Madame D … …* [1697]. Paris: Tiger, 1815.

Aulnoy, Marie-Catherine Le Jumel de Barneville, baronne d'. *Contes nouveaux ou les fées à la mode*. Paris: publisher unknown, 1698.

Auricchio, Laura, Elizabeth Heckendorn Cook, and Giulia Pacini, eds. *Invaluable Trees: Cultures of Nature 1660–1830. Studies on Voltaire and the Eighteenth Century 2012*. Oxford: Voltaire Foundation, 2012.

Bailey, Colin B. *The Age of Watteau, Chardin, and Fragonard: Masterpieces of French Genre Painting*. New Haven and London: Yale University Press in association with the National Gallery of Canada, 2003.

Bailey, Colin B., Carina Fryklund, John Marciari, Magnus Olausson, and Jennifer
 Tonkovich. *Treasures from the Nationalmuseum of Sweden: The Collections of Count
 Tessin*. New York: The Morgan Library and Museum, 2016.

Bajou, Theirry, ed. *Les Peintres du roi 1648–1793*. Paris: Réunion des musées nationaux,
 2000.

Barad, Karen. *Meeting the Universe Halfway: Quantum Physics and the Entanglement of
 Matter and Meaning*. Durham and London: Duke University Press, 2007.

Barker, Emma. *Greuze and the Painting of Sentiment*. New York and Cambridge:
 Cambridge University Press, 2005.

Barker, Emma. "Imagining Childhood in Eighteenth-Century France: Greuze's *Little
 Girl with a Dog*." *Art Bulletin* 91 (December 2009): 426–45.

Bassy, Alain-Marie. *Les Fables de La Fontaine: Quatre siècles d'illustration*. Paris:
 Éditions Promodis, 1986.

Baxandall, Michael. *Patterns of Intention: On the Historical Explanation of Pictures*. New
 Haven and London: Yale University Press, 1985.

Behn, Aphra, Francis Barlow, Thomas Philipot, Robert Codrington, Thomas Dudley
 and Aesop. *Aesop's Fables with His Life in English French and Latin Newly Translated
 with One Hundred and Twelve Sculptures by Francis Barlow*. London: H. Hills for
 F. Barlow, 1687.

Bekoff, Mark and Jessica Pierce. *Wild Justice: The Moral Lives of Animals*. Chicago and
 London: University of Chicago Press, 2009.

Belon, Pierre. *Portraits d'oyseaux, animaux, herbes, arbres, hommes et femmes, d'Arabie
 & Egypte*. Paris: Guillaume Cavellat, 1557.

Bennett, Jane. *Vibrant Matter: A Political Ecology of Things*. Durham and London: Duke
 University Press, 2010.

Bentham, Jeremy. *An Introduction to the Principles of Morals and Legislation* [1780;
 1823]. Oxford: Clarendon Press, 1907.

Berchtold, Jacques and Jean-Luc Guichet, eds. *L'Animal des Lumières. Dix-huitième siècle*
 42 (2010). Paris: La Société française d'étude du 18e siècle and CNRS.

Bermingham, Ann. *Sensation and Sensibility: Viewing Gainsborough's* Cottage Door.
 New Haven and London: Yale University Press for the Yale Center for British Art,
 2005.

Bindman, David. *Ape to Apollo: Aesthetics and the Idea of Race in the Eighteenth
 Century*. London: Reaktion Books, 2002.

Bloch, Olivier, ed. *Le Matérialsme du XVIIIe siècle et la littérature clandestine: actes du
 table ronde des 6 et 7 juin 1980*. Paris: J. Vrin, 1982.

Bode, Wilhelm. "Die Italiener, Franzosen, Altniederländer, und Deutschen in der
 Schweriner Galerie." *Die Graphischen Künste* 14 (1891): 60–1.

Bonnet, Charles. *Essai analytique sur les facultés de l'ame* [1759]. Copenhagen: Frères Cl.
 & Ant. Philobert, 1760.

Bonnet, Charles. *Observations sur les insectes* [1776]. *Œuvres d'histoire naturelle et de
 philosophie*, 8 vols. Neuchatel: Samuel Fauche, 1779, I.

Bonnet, Charles. *Traité d'insectologie ou Observations sur les Pucerons*, 2 vols. Paris: Durand, 1745.

Bougeant, Guillaume-Hyacinthe. *Amusement philosophique sur le langage des bêtes* [1739]. Geneva: Droz, 1954.

Boullier, David. *Essai philosophique sur l'âme des bêtes: où l'on traite de son existence et de sa nature, et où l'on mêle on occasion diverses réflexions sur la nature de la liberté, sur celle de nos sensations, sur l'union de l'âme et du corps, sur l'immortalité de l'âme et où l'on refute diverses objections de Monsieur Bayle*. Amsterdam: François Changuion, 1728.

Boullier, David. *Essai philosophique sur l'âme des bêtes* [rev. ed. 1737]. Paris: Fayard, 1985.

Bowron, Edgar Peters, Carolyn Rose Rebbert, Robert Rosenblum, and William Secord. *Best in Show: The Dog in Art from the Renaissance to Today*. New Haven and London: Yale University Press for the Museum of Fine Arts, Houston, and the Bruce Museum, Greenwich, 2006.

Bredekamp, Horst, Jochen Brüning, and Cornelia Weber, eds. *Theater der Natur und Kunst; Theatrum natural et artis: Wunderkammern des Wissens*, 2 vols. Berlin: Henschel, 2000.

Bremer-David, Charissa. *Woven Gold: Tapestries of Louis XIV*. Los Angeles: The J. Paul Getty Museum, 2015.

Buffon, Georges-Louis Leclerc, comte de. *Histoire naturelle générale et particulière*, 13 vols. Rev ed. Paris: Imprimerie royale, 1769–70.

Buffon, Georges-Louis Leclerc, comte de. *Histoire naturelle générale et particulière: avec la description du Cabinet du Roi*, 36 vols. Paris: Imprimerie royale, 1749–1788.

Buffon, Georges-Louis Leclerc, comte de. *Histoire naturelle générale et particulière*, 32 vols. Rev. ed. 1785–1791. Paris: Sanon & Co. https://www.e-rara.ch/zut/doi/10.3931/e-rara-22933.

Camburet, M. de. *L'Exposition des tableaux du Louvre*. Geneva and Paris: Valade, 1769.

Cassidy-Geiger, Maureen. *The Arnhold Collection of Meissen Porcelain 1710–50*. New York: The Frick Collection and London: K. Giles Ltd., 2008.

Cassidy-Geiger, Maureen Ann. "*An Jagd-Stücken, unterschiedenen Thieren, Feder Viehe, Hunden und Katzen*: A Context for the Meissen Porcelain Birds in the Sir Gawaine and Lady Baillie Collection." *Property from the Sir Gawaine and Lady Baillie Collection*, 10–15. London: Sotheby's, 2013.

Castor, Markus A. "L'Oscillographie des passions: Académies et têtes d'expression dans la classe du modèle au XVIIIe siècle." *De l'alcôve aux barricades: De Fragonard à David*, 12–19. Ed. Emanuelle Brugerolles. Paris: École national supérieure des beaux-arts, 2016.

Chua, Kevin. "Dead Birds, or the Miseducation of the Greuze Girl." *Performing the Everyday: The Culture of Genre in the Eighteenth Century*, 75–91. Ed. Alden Cavanaugh. Newark: University of Delaware Press, 2007.

Cohen, Sarah R. "Animals as Heroes of the Hunt." *Sporting Cultures 1650–1850*, 114–35. Ed. Daniel O'Quinn and Alexis Tadié. Toronto and London: University of Toronto Press, 2017.

Cohen, Sarah R. "Animal Performance in Oudry's Illustrations to the Fables of La Fontaine." *Studies in Eighteenth-Century Culture*. Ed. Downing A Thomas and Lisa Cody 39 (2010): 35–76.

Cohen, Sarah R. *Art, Dance and Society in French Culture of the Ancien Régime*. New York and Cambridge: Cambridge University Press, 2000.

Cohen, Sarah R. "Chardin's Fur: Painting, Materialism, and the Question of Animal Soul." *Eighteenth-Century Studies* 37 (Summer 2004): 39–61.

Condillac, Étienne Bonnot de. *Essay on the Origin of Human Knowledge*. Trans. and ed. Hans Aarsleff. New York and Cambridge: Cambridge University Press, 2001, 114.

Condillac, Étienne Bonnot de. *Œuvres philosophiques*, 3 vols. Ed. Georges Le Roy. Paris: Presses universitaires de France, 1947–51.

Conisbee, Philip. *Chardin*. Oxford: Phaidon, 1986.

Conley, John J. *The Suspicion of Virtue: Women Philosophers in Neoclassical France*. Ithaca and London: Cornell University Press, 2002.

Corval, Andrée. *Histoire de la chasse: l'homme et la bête*. Paris: Perrin, 2010.

Cottam, Daniel. *Cannibals and Philosophers: Bodies of Enlightenment*. Baltimore and London: Johns Hopkins University Press, 2001.

Couilleaux, Benjamin. *Jean-Baptiste Huet: Le plaisir de la nature*. Paris: Musée Cognacq-Jay, 2016.

Crow, Thomas E. *Painters and Public Life in Eighteenth-Century Paris*. New Haven and London: Yale University Press, 1985.

Cuneo, Paula, ed. *Animals and Early Modern Identity*. Farnham, Surry, and Burlington, VT: Ashgate, 2014.

Cureau de La Chambre, Marin. *Les Caractères des passions*. Amsterdam: Antoine Michel, 1658.

Cureau de La Chambre, Marin. *Traité de la connaissance des animaux* [1648]. Paris: Fayard, 1989.

Daston, Lorraine and Katharine Park. *Wonders and the Order of Nature 1150–1750*. New York: Zone Books, 2001.

Defrance, Anne. *Les Contes des fées et les nouvelles de Madame d'Aulnoy (1690–1698)*. Geneva: Droz, 1998.

Degenaar, Marjolein. *Molyneux's Problem: Three Centuries of Discussion on the Perception of Forms*. Trans. Michael J. Collins. Boston, London, and Dordrecht: Kluwer Academic Publishers, 1996.

Delieuvin, Vincent. "Le Décor animalier de la Ménagerie de Versailles par Nicasius Bernaerts." *Bulletin de la Société de l'Histoire de l'Art Français Année 2008* (2009): 47–80.

Démoris, René. *Chardin, la chair et l'objet*. Paris: Éditions Olbia, 1999.

Desportes, Claude-François. "La Vie de M. Desportes, peintre d'animaux" [1748]. *Mémoires inédits sur la vie et les ouvrages des membres de l'Académie Royale de Peinture et de Sculpture*, 98–114. Ed. L. Dussieux, E. Soulié, Ph. de Chennevières, Paul Mantz, and A. de Montaiglon. Paris: J.-B. Dumoulin, 1854, 2 vols, II.

Diderot, Denis. *Diderot's Selected Writings*. Trans. Derek Coltman. Ed. Lester G. Crocker. New York: Macmillan, 1966.

Diderot, Denis. *Entretien entre d'Alembert et Diderot; Le Rêve de d'Alembert; Suite de l'entretien* [1769]. Ed. Jacques Roger. Paris: Garnier-Flammarion, 1965.

Diderot, Denis. *Oeuvres*, 5 vols. Ed. Laurent Versini. Paris: Robert Laffont, 1994, I.

Diderot, Denis. *Œuvres philosophiques*. Ed. Paul Vernière. Paris: Garnier Frères, 1964.

Diderot, Denis. *Rameau's Nephew and d'Alembert's Dream*. Trans. Leonard Tancock. London: Penguin, 1966.

Diderot, Denis. *Thoughts on the Interpretation of Nature* [1754 ed.]. *Thoughts on the Interpretation of Nature and Other Works*. Trans. David Adams. Manchester: Clinamen Press, 1999.

Dilly, Antoine. *De L'Ame des bêtes, ou après avoir démontré la spritualité de l'ame de l'homme, l'on explique par la seule machine, les actions les plus surprenantes des animaux*. Lyon: Anisson et Posuel, 1676.

Donald, Diana. *Picturing Animals in Britain 1750–1850*. New Haven and London: Yale University Press for the Paul Mellon Centre for Studies in British Art, 2007.

Douthwaite, Julia V. *The Wild Girl, Natural Man, and the Monster: Dangerous Experiments in the Age of Enlightenment*. Chicago: University of Chicago Press, 2002.

Drew, Erin and John Sitter. "Ecocriticism and Eighteenth-Century English Studies." *Literature Compass* 8 (2011): 227–39.

Droguet, Vincent, Xavier Salmon, and Danièle Véron-Denise. *Animaux d'Oudry: Collection des ducs de Mecklembourg-Schwerin*. Paris: Réunion des musées nationaux, 2003.

Droth, Martina and Penelope Curtis. *Taking Shape: Finding Sculpture in the Decorative Arts*. Los Angeles: Getty Publications, 2009.

Duclaux, Lise and Tamara Préaud. *L'Atelier de Desportes: Dessins et esquisses conservés par la Manufacture nationale de Sèvres*. Paris: Réunion des musées nationaux, 1982.

Duro, Paul. *The Academy and the Limits of Painting in Seventeenth-Century France*. New York and Cambridge: Cambridge University Press, 1997.

Eisenman, Stephen F. *The Cry of Nature: Art and the Making of Animal Rights*. London: Reaktion Books, 2013.

Eitner, Lorenz. *Neoclassicism and Romanticism 1750-1850: Sources and Documents*, 2 vols. Englewood Cliffs, NJ: Prentice-Hall, 1970, I.

Finaz de Villaine, Manuela and Nicole Garnier-Pelle. *Singes et Dragons: La Chine et le Japon à Chantilly au XVIIIᵉ siècle*. Chantilly: Institut de France and Domaine de Chantilly, 2011–12.

Findlen, Paula. *Possessing Nature: Museums, Collecting, and Scientific Culture in Early Modern Italy*. Berkeley and Los Angeles: University of California Press, 1994.

Fontenay, Elisabeth de. *Le Silence des bêtes: la philosophie à l'épreuve de l'animalité*. Paris: Fayard, 1998.

Foucart-Walter, Elisabeth. *Pieter Boel 1622–1674: Peintre des animaux de Louis XIV*. Paris: Réunion des musées nationaux, 2001.

Fouilloux, Jacques. *La Vénerie* [1561]. Paris: Abel l'Angellier, 1585. Reprinted Paris: Émile Nourry, Librarie Cynégétique, 1928.

Freund, Amy. "Good Dog! Jean-Baptiste Oudry and the Politics of Animal Painting." *French Art of the Eighteenth Century: The Michael L. Rosenberg Lecture Series at the Dallas Museum of Art*, 67–79. Ed. Heather MacDonald. New Haven and London: Yale University Press for the Dallas Museum of Art, 2016.

Freund, Amy. "Sexy Beasts: The Politics of Hunting Portraiture in Eighteenth-Century France." *Art History* 42:1 (February 2019): 40–67.

Fudge, Erica, Ruth Gilbert, and Susan Wiseman, eds. *At the Borders of the Human: Beasts, Bodies and Natural Philosophy in the Early Modern Period*. New York and Basingstoke: Palgrave, 1999.

Gaffet, Antoine, sieur de La Briffardière. *Nouveau traité de Venerie contenant la chasse du cerf, celles du chevreuil, du sanglier, du loup, du lievre et du renard…* [1742]. Rev. ed. Paris: Nyon, Damonneville, Guillyn, 1750.

Gamelin, Jacques. *Nouveau Recueil d'ostéologie et de myologie, dessiné d'après nature par Jacques gamelin … pour l'utilité des sciences et des arts*. Toulouse: J.F. Desclassan, 1779.

Garner-Pelle, Nicole, Anne Forray-Carlier, and Marie-Christine Anselm. *The Monkeys of Christophe Huet: Singeries in French Decorative Arts*. Trans. Sharon Grevet. Los Angeles: The J. Paul Getty Museum, 2011.

Gaultier, Abraham. *Réponse en forme de dissertation à un théologien qui demande ce que veulent dire les sceptiques qui cherchent la véritié … lorsqu'ils pensent que la vie et la mort sont la même chose …* Niort: J. Elies, 1714.

Genaille, Robert. "Les Fables de La Fontaine en tapisseries de Beauvais; contribution à l'étude de J.-B. Oudry." *Mémoires de la Société d'Archaeologie, Sciences et Arts du Départment de l'Oise* 27 (1933): 429–81.

Giermann, Ralf. "'Nothing Comparable to This Moritzburg Is to Be Found Anywhere.' The Hunting Castle Moritzburg and Augustus the Strong's Collection of Antlers." *The Glory of Baroque Dresden: The State Art Collections Dresden*, 267–73. Ed. Sabine Seidel. Trans. Daniel Kletke. Munich: Hirmer, for The Mississippi Commission for International Cultural Exchange, Inc., 2004.

Grapa, Caroline Jacot. "Des Huitres aux grands animaux: Diderot, animal matérialiste." *Dix-huitième siècle* 42 (2010): 99–117.

Gristina, Margaret Kaelin. *17th and 18th Century Chinese Export Porcelain*. New York: Chinese Porcelain Company, 2001.

Guerrini, Anita. *The Courtiers' Anatomists: Animals and Humans in Louis XIV's Paris*. Chicago and London: University of Chicago Press, 2015.

Guerrini, Anita. *Experimenting with Humans and Animals From Galen to Animal Rights*. Baltimore and London: The Johns Hopkins University Press, 2003.

Guichet, Jean-Luc. *Rousseau l'animal et l'homme: L'aimalité dans l'horizon anthropologique des Lumières*. Paris: Les Éditions du Cerf, 2006.

Hastings, Heather. *Man and Beast in French Thought of the Eighteenth Century*. Baltimore and London: The Johns Hopkins University Press, 1936.

Hellman, Mimi. "Furniture, Sociability and the Work of Leisure in 18th-Century France." *Eighteenth-Century Studies* 32 (Summer 1999): 415–45.

Hellman, Mimi. "The Joy of Sets: The Uses of Seriality in the French Interior." *Furnishing the Eighteenth Century: What Furniture Can Tell Us about the European and American Past*, 129–53. Ed. Dena Goodman and Kathryn Norberg. London and New York: Taylor and Francis, 2006.

Henry, John. "The Matter of Souls: Medical Theory and Theology in Seventeenth-Century England." *The Medical Revolution of the Seventeenth Century*, 87–113. Ed. Roger French and Andrew Wear. New York and Cambridge: Cambridge University Press, 1989.

Hitt, Christopher. "Ecocriticism and the Long Eighteenth Century." *College Literature* 31 (Summer 2004): 123–47.

Hodacs, Hanna. "Cheap and Cheerful: Chinese Silks in Scandinavia, 1731–1751." *Eighteenth-Century Studies* 51:1 (Fall 2017): 23–44.

Holbach, Paul-Henri Thiry, baron d'. *Système de la Nature ou des lois du monde physique et du monde moral* [1770], 2 vols. Ed. Yvon Belaval. Hildesheim: Georg Olms, 1966.

Hoquet, Thierry. Introduction to *Buffon illustré: les gravures de l'*Histoire Naturelle *(1749–1767)*. 2 vols. Paris: Publications Scientifiques du Muséum national d'Histoire naturelle, 2007, I, 13–175.

Hornstein, Katie, ed. "Animal." *Journal 18* 7 (Spring 2019). http://www.journal18.org/past-issues/7-animal-spring-2019/

Hornstein, Katie, "From Museum to Menagerie: Théodore Géricault and the Leonine Subject." *Art Bulletin* 101 (March 2019): 26–47.

Hourtic, Louis. "L'Atelier de François Desportes." *Gazette des beaux-arts* Ser. 5: 2 (August–September 1920): 117–36.

Hunter, Matthew C. "Joshua Reynolds's 'Nyce Chymistry': Action and Accident in the 1770s." *The Art Bulletin* 97:1 (March 2015): 58–76.

Ibrahim, Annie. "Diderot et les Métaphores de l'animal: Pour un antispécisme?" *Dix-huitième siècle* 42 (2010): 83–98.

Impey, Oliver R. and Arthur MacGregor, eds. *The Origins of Museums: The Cabinet of Curiosities in Sixteenth- and Seventeenth-Century Europe*. Oxford: Clarendon Press, 1985.

Jacky, Pierre. "Alexandre-François Desportes (1661–1743): quatre dessus-de-porte provenant du château de Bercy entrent à Chambord." *Revue du Louvre, Revue des musées de France* 3 (1996): 62–70.

Jacky, Pierre. "*L'Autoportrait en chasseur* (1699) d'Alexandre-François Desportes du Musée du Louvre." *Revue du Louvre, Revue des musées de France* 3 (1997): 58–65.

Janson, H. W. *Apes and Ape-Lore in the Middle Ages and the Renaissance*. London: The Warburg Institute, 1952.

Johns Christopher, M.S. *China and the Church: Chinoiserie in Global Context*. Oakland: University of California Press, 2016.

Johnson, Dorothy. "Picturing Pedagogy: Education and the Child in the Paintings of Chardin." *Eighteenth-Century Studies* 24 (1990): 47–68.

Jones, Christine A. *Shapely Bodies: The Image of Porcelain in Eighteenth-Century France.* Lanham, MD: University of Delaware Press, 2013.

Kahng, Eik and Marianne Roland Michel. *Anne Vallayer-Coster: Painter to the Court of Marie-Antoinette.* New Haven and London: Yale University Press for the Dallas Museum of Art, 2002.

Keenleyside, Heather. *Animals and Other People: Literary Forms and Living Beings in the Long Eighteenth Century.* Philadelphia: University of Pennsylvania Press, 2015.

Kemp, Martin. *The Human Animal in Western Art and Science.* Chicago and London: University of Chicago Press, 2007.

Kimball, Fiske. *The Creation of the Rococo.* Philadelphia: Philadelphia Museum of Art, 1947.

Kirchner, Thomas. "La Necessité d'une hierarchie des genres." *La Naissance de la théorie de l'art en France 1640–1720*, 186–96. Ed. Christian Michel and Maryvonne Saison. Paris: Jean-Michel Place, 1997.

Kisluk-Grosheide, Daniëlle and Bertrand Rondot. *Visitors to Versailles: From Louis XIV to the French Revolution.* New Haven and London: Yale University Press for the Metropolitan Museum of Art, 2018.

Kolbert, Elizabeth. *The Sixth Extinction: An Unnatural History.* New York: Henry Holt and Company, 2014.

Kors, Alan Charles. *D'Holbach's Coterie: An Enlightenment in Paris.* Princeton, NJ: Princeton University Press, 1976.

Kulstad, Mark. "Leibniz, Animals, and Apperception." *Leibniz*, 171–206. Ed. Catherine Wilson. Burlington, MA, and Aldershot: Ashgate, 2001.

La Font de Saint-Yenne, Étienne. *Réflexions sur quelques causes de l'état présent de la Peinture en France. Avec un examen des principaux Ouvrages exposés au Louvre le mois d'Août 1746.* The Hague: Jean Neaulme, 1747.

La Font de Saint-Yenne, Étienne. *Sentiments sur quelques ouvrages de Peinture, Sculpture et Gravure, Écrits à un Particulier en Province.* [place and publisher unknown], 1754.

La Fontaine, Jean de. *The Complete Fables of La Fontaine.* Trans. Craig Hill. NY: Arcade, 2008.

La Fontaine, Jean de. *Discours à Madame de la Sablière (sur l'âme des l'animaux)* [1668]. Ed. Henri Busson. Geneva: Droz, 1950.

La Fontaine, Jean de. *Fables choisies … mises en vers par m. de La Fontaine.* Paris: Claude Bardin, 1668.

La Fontaine, Jean de. *Fables choisies mises en vers*, 4 vols. Paris: Dessaint & Saillant, Durand, 1755–9/60.

La Fontaine, Jean de. *Selected Fables.* Trans. Christopher Wood. Ed. Maya Slater. Oxford and New York: Oxford University Press, 1995.

La Mettrie, Julien Offray de. *L'Homme Machine.* Leiden: Elie Luzac, 1748.

La Mettrie, Julien Offray de. *Machine Man and Other Writings*. Trans. and ed. Ann Thomson. New York and Cambridge: Cambridge University Press, 1996.

La Mettrie, Julien Offray de. *Oeuvres philosophiques de Mr. de La Mettrie* [1750], 2 vols. Amsterdam: publisher unknown, 1753. Republished Berlin: C. Tutot, 1796, 3 vols.

Lafont, Anne. "How Skin Color Became a Racial Marker: Art Historical Perspectives on Race." *Eighteenth-Century Studies* 57 (Fall 2017): 89–113.

Lajer-Burcharth, Ewa. *The Painter's Touch: Boucher, Chardin, Fragonard*. Princeton and Oxford: Princeton University Press, 2018.

Landes, Joan B., Paula Young Lee, and Paul Youngquist, eds. *Gorgeous Beasts: Animal Bodies in Historical Perspective*. University Park: Pennsylvania State University Press, 2012.

Lastic, Georges de and Pierre Jacky. *Desportes*. Saint-Rémy-en-l'Eau: Monelle Hayot, 2010.

Leibniz, Gottfried Wilhelm. *New System of the Nature of Substances* [1695]. In *Leibniz's "New System" and Associated Contemporary Texts*. Trans. and ed. R. S. Woodhouse and Richard Francks. Oxford: Clarendon Press, 1997.

Leibniz, Gottfried Wilhelm. *Réflexion sur l'âme des bêtes* [1710]. Trans. Christiane Frémont. *Corpus* (1991): 147–51.

Lesné, Claude. "Un nouveau Santerre dans les collections du Louvre." *La Revue du Louvre et des Musées de France* 3 (1989): 235–8.

*Lettre sur le Salon de peinture de 1769. Par M. B****. Paris: Humaire, 1769.

Lichtenstein, Jacqueline. *The Eloquence of Color: Rhetoric and Painting in the French Classical Age*. Trans. Emily McVarish. Berkeley and Los Angeles: University of California Press, 1989.

Liebman, Elizabeth Amy. "Animal Attitudes: Motion and Emotion in Eighteenth-Century Animal Representation." *Journal for Eighteenth-Century Studies* 33 (2010): 663–83.

Liebman, Elizabeth Amy. "The Bird Organ in Eighteenth-Century Art and Sound." Unpublished paper, 2017.

Liebman, Elizabeth Amy. "Painting Natures: Buffon and the Art of the 'Histoire naturelle." PhD diss., University of Chicago, 2003.

Locke, John. *An Essay Concerning Human Understanding* [4th ed., 1700]. Ed. Peter H. Nidditch. Oxford: Clarendon Press, 1979.

Locke, John. "*Epitome* of *An Essay Concerning Human Understanding* [1684 or 1685]." Translated into French by Jean Le Clerc. *Bibliothèque universelle et historique* VIII (1688): 49–142.

Lohr, Charles H. "Metaphysics and Natural Philosophy as Sciences: The Catholic and the Protestant Views in the Sixteenth and Seventeenth Centuries." *Philosophy in the Sixteenth and Seventeenth Centuries: Conversations with Aristotle*, 280–95. Ed. Constance Blackwell and Sachiko Kusukawa. Aldershot and Brookfield, VT: Ashgate, 1999.

Loisel, Gustave. *Histoire des ménageries de l'antiquité à nos jours*, 3 vols. Paris: O. Doin & fils, 1912, II.

London, Katrina. "Aping the Aristocracy: Animals in the Painted Decoration of French Interiors, 1690–1758." M.A. thesis, Bard Graduate Center, 2012.

Lovejoy, Arthur O. *The Great Chain of Being: A Study of the History of an Idea.* Cambridge, MA: Harvard University Press, 1936.

Mabille, Gérard. "La Ménagerie de Versailles." *Gazette des Beaux-arts* 8:6 (January 1974): 5–36.

Mabille, Gérard. "Les Surtouts de table dans l'art français du XVIIIᵉ siècle." *Estampille* 126 (October 1980): 62–73.

Mabille, Gérard and Joan Pieragnoli. *La Ménagerie de Versailles.* Arles: Honoré Clair, 2010.

Mack, Arien, ed. *Humans and Other Animals.* Columbus: Ohio State University Press, 1995.

Macy, l'abbé. *Traité de l'âme des bêtes avec des réflexions phisiques [sic] et morales.* Paris: P.G. Le Mercier, 1737.

Mailly, Chevalier de. *Éloge de la chasse, avec plusieurs avantures surprenantes et agreables que y sont arrivées.* Paris: Jean-Luc Nyon, 1723.

Maisonnier, Élisabeth and Alexandre Maral, ed. *Le Labyrinthe de Versailles: du mythe au jeu.* Paris: Magwellan & Cie, 2013.

Martin, Meredith. *Dairy Queens: The Politics of Pastoral Architecture from Catherine de' Medici to Marie-Antoinette.* Cambridge, MA, and London: Harvard University Press, 2011.

Maupertuis, Pierre Louis Moreau de. *Oeuvres de Mr. De Maupertuis.* Rev. ed., 4 vols. Lyon: Jean-Marie Bruyset, 1756.

Meijer, Miriam Claude. *Race and Aesthetics in the Anthropology of Petrus Camper (1722–1789).* Atlanta, GA, and Amsterdam: Rodopi, 1999.

Menely, Tobias. *The Animal Claim: Sensibility and the Creaturely Voice.* Chicago and London: University of Chicago Press, 2015.

Menely, Tobias. "Sovereign Violence and the Figure of the Animal, from *Leviathan* to *Windsor Forest,*" *Journal for Eighteenth-Century Studies* 33 (2010): 567–8.

Menzhausen, Ingelore. *Early Meissen Porcelain in Dresden.* Trans. Charles E. Scurrell. London: Thames and Hudson, 1988.

Mervaud, Christiane. *Bestiaires de Voltaire. Studies on Voltaire and the Eighteenth Century* 2006. Oxford: Voltaire Foundation, 2006, 1–200.

Michel, Christian. *Charles-Nicolas Cochin et l'art des lumières.* Rome: École française de Rome, 1993.

Mikhail, Alan. "Enlightenment Anthropocene." *Eighteenth-Century Studies* 49 (Winter 2016): 211–31.

Milovanovic, Nicolas. *La princesse Palatine: protectrice des animaux.* Versailles: Perrin, 2012.

Montagu, Jennifer. *The Expression of the Passions: The Origin and Influence of Charles Le Brun's* Conférence sur l'expression générale et particulière. New Haven and London: Yale University Press, 1994.

Morgan, Michael J. *Molyneux's Question: Vision, Touch and the Philosophy of Perception.* New York and Cambridge: Cambridge University Press, 1977.

Morillo, John. *The Rise of the Animal and the Descent of Man, 1660–1800: Toward Posthumanism in British Literature between Descartes and Darwin.* Newark: University of Delaware Press, 2017.

Morton, Mary, ed. *Oudry's Painted Menagerie: Portraits of Exotic Animals in Eighteenth-Century Europe.* Los Angeles: J. Paul Getty Museum, 2007.

Nash, Richard. *Wild Enlightenment: The Borders of Human Identity in the Eighteenth Century.* Charlottesville: University of Virginia Press, 2003.

Nemerov, Alexander. *The Body of Raphaelle Peale: Still Life and Selfhood, 1812–1824.* Berkeley and Los Angeles: University of California Press, 2001.

Néto, Isabelle and Pascal de La Vaissière. *L'animal miroir de l'homme: petit bestiaire du XVIII^e siècle.* Paris: Les musées de la ville de Paris and Musée Cognacq-Jay, 1996.

Newman, William R. *Promethean Ambitions: Alchemy and the Quest to Perfect Nature.* Chicago and London: Chicago University Press, 2004.

Nolhac, Pierre de. *Le Château de Versailles sous Louis Quinze.* Paris: Champion, 1898.

O'Neal, John C. *The Authority of Experience: Sensationist Theory in the French Enlightenment.* University Park: Pennsylvania State University Press, 1996.

Opperman, Hal. *J.-B. Oudry 1686–1755.* Seattle and London: University of Washington Press for the Kimbell Museum of Art, 1983.

Opperman, Hal. *Jean-Baptiste Oudry,* 2 vols. New York and London: Garland, 1977.

Osborne, Michael W. *A History of the Château of La Muette.* Paris: Organization for Economic Cooperation and Development, 1999.

Oudry, Jean-Baptiste. *Réflexions sur la manière d'étudier la couleur en comparant les objets les uns avec les autres* [1749]. Transcribed in E. Piot, *Le Cabinet de l'Amateur et de l'Antiquaire,* III, 1844, 33–54; reprinted by Getty Conservation Institute, Los Angeles. https://www.getty.edu/conservation/our_projects/science/coll_res/reflexions_fr.pdf (1-8-20)

Palmieri, Frank, ed. *Humans and Other Animals in Eighteenth-Century British Culture.* Farnham, Surrey and Burlington, VT: Ashgate, 2006.

Panofsky, Dora. "Gilles or Pierrot?" *Gazette des beaux-arts* 142 (1952): 319–40.

Pardies, Ignace-Gaston. *Discours de la connoissance des Bestes* [1672]. New York and London: Johnson Reprint, 1972.

Park, Katharine. "The Organic Soul." *The Cambridge History of Renaissance Philosophy,* 464–84. Ed. Charles B. Schmitt, Quentin Skinner, Eckhard Kessler and Jill Kraye. Cambridge and New York: Cambridge University Press, 1988.

Parshall, Peter. "Art and Curiosity in Northern Europe." *Word and Image* 11:4 (October–December 1995): 327–31

Pascal, André and Roger Gaucheron, eds. *Documents sur la vie et l'oeuvre de Chardin.* Paris: Galerie Pigalle, 1931.

Perrault, Charles (attrib.). *Le Labyrinthe de Versailles.* Paris: Imprimerie royale, 1677.

Perrault, Charles. *Histoire, ou contes du temps passé, avec des moralités [Contes de ma mère l'oye]*. Paris: C. Barbin, 1697. Republished Paris: Delarue, 1867.

Picart, Bernard. *Recueil de lions, dessinez d'après nature par divers Maitres …* Amsterdam: Bernard Picart, 1729.

Pietsch, Ulrich, ed. *Porzellan Parforce: Jagdliches Meissner Porzellan des 18. Jahrhunderts*. Munich: Hirmer, 2005.

Piles, Roger de. *Cours de peinture par principes* [1709]. Paris: C.A. Jombert, 1766.

Plax, Julie-Anne. "J.-B. Oudry's *Royal Hunts* and Louis XV's Hunting Park at Compiègne: Landscapes of Power, Prosperity, and Peace." *Studies in the History of Gardens and Designed Landscapes* 37:2 (2017): 102–19.

Prown, Jules David. "Mind in Matter: An Introduction to Material Culture Theory and Method," *Winterthur Portfolio* 71:1 (Spring 1982): 1–19.

Quinsey, Katherine M., ed. *Animals and Humans: Sensibility and Representation, 1650–1820*. Oxford: Oxford University Studies in the Enlightenment, 2017.

Racine, Louis. *Epître à Madame la duchesse de Noailles sur l'âme des bêtes*. [place and publisher unknown], 1728.

Rees, Joachim. *Die Kultur des Amateurs: Studien zu Leben und Werk von Anne Claude Philippe de Thubières, Comte de Caylus (1692–1765)*. Weimar: Verlag und Datenbank für Geisteswissenschaften, 2006.

Reill, Peter Hanns. *Vitalizing Nature in the Enlightenment*. Berkeley and Los Angeles: University of California Press, 2005.

Richards, Sarah. *Eighteenth-Century Ceramics: Products for a Civilised Society*. Manchester: Manchester University Press, 1999.

Ridley, Glynis, ed. *Animals in the Eighteenth Century. Journal for Eighteenth-Century Studies* 33 (December 2010).

Riskin, Jessica. *Science in the Age of Sensibility: The Sentimental Empiricists of the Eighteenth Century*. Chicago and London: University of Chicago Press, 2002.

Robbins, Louise. *Elephant Slaves and Pampered Parrots: Exotic Animals in Eighteenth-Century Paris*. Baltimore and London: The Johns Hopkins University Press, 2002.

Roland Michel, Marianne. *Chardin*. Trans. Eithne McCarthy. New York: Harry N. Abrams, 1996.

Rosenberg, Pierre and Ettore Camesasca. *Tout L'Oeuvre peint de Watteau*. Rev. ed. Paris: Flammarion, 1980.

Rosenberg, Pierre, ed. *Chardin*. Trans Caroline Beamish. New Haven and London: Yale University Press for the Metropolitan Museum of Art, 2000.

Rosenberg, Pierre. *Chardin 1699–1779*. Trans. Emilie P. Kadish, Ursula Korneitchouk. Ed. Sally W. Goodfellow. Cleveland: Cleveland Museum of Art and Indiana University Press, 1979.

Rosenberg, Pierre, ed. *Vies anciennes de Watteau*. Paris: Hermann, 1984.

Rosenfield, Leonora Cohen. *From Beast-Machine to Man-Machine: Animal Soul in French Letters from Descartes to La Mettrie*. New York: Octagon Books, 1940.

Ross, George MacDonald. "Alchemy and the Development of Leibniz's Metaphysics." *Theoria cum Praxi: Zum Verhältnis von Theorie und Praxis im 17. Und 18.*

Jahrhundert; Akten des III. Internationalen Leibnizkongresses, Hannover, 12. bis 17. November 1977, 4 vols., IV, 40–5. Wiesbaden: Franz Steiner, 1982.

Rousseau, Jean-Jacques. *Discourse on the Origins and Foundations of Inequality among Mankind* [1753]. The Social Contract *and* The First and Second Discourses. Ed. Susan Dunn. New Haven and London: Yale University Press, 2002.

Sahlins, Peter. *1668: The Year of the Animal in France*. New York: Zone Books, 2017.

Salmon, Xavier. "Cave Canem." *De Chasse et d'épée: le décor de l'appartement du roi à Marly*, 69–76. Ed. Musée-promenade de Marly-le-Roi-Louveciennes. Paris: L'Inventaire for Musée-promenade de Marly-le-Roy-Louveciennes, 1999.

Salnove, Robert de. *La Vénerie royale* [1655]. Paris: Emile Nourry, 1929.

Saule, Béatrix and Rosalind Savill, eds. *Versailles et les tables royales en Europe XVIIème-XIXème siècles*. Paris: Réunion des musées nationaux for the Musée national des châteaux de Versailles et de Trianon, 1994.

Sawday, Jonathan. *The Body Emblazoned: Dissection and the Human Body in Renaissance Culture*. New York and London: Routledge, 1995.

Scott, Katie. "Playing Games with Otherness: Watteau's Chinese Cabinet at the Château de la Muette." *Journal of the Warburg and Courtauld Institutes* 66 (2003): 189–248.

Scott, Katie. *The Rococo Interior: Decoration and Social Spaces in Early Eighteenth-Century Paris*. New Haven and London: Yale University Press, 1995.

Sebastiani, Silvia. "Challenging Boundaries: Apes and Savages in Enlightenment." *Simianization: Apes, Gender, Class, and Race*, 105–37. Ed. Wulf D. Hund, Charles W. Mills and Silvia Sebastiani. Zürich: Lit Verlag, 2015.

Sheriff, Mary D. *Fragonard: Art and Eroticism*. Chicago and London: University of Chicago Press, 1990.

Sheriff, Mary D. *Moved by Love: Inspired Artists and Deviant Women in Eighteenth-Century France*. Chicago and London: University of Chicago Press, 2004.

Situ, Shuang. *Le Magot de Chine: ou trésor du symbolisme chinois: à la recherche du symbolisme dans les motifs de "chinoiseries."* Paris: Éditions You-Feng, 2001.

Sloboda, Stacey. *Chinoiserie: Commerce and Critical Ornament in Eighteenth-Century Britain*. New York and Manchester: Manchester University Press, 2014.

Smith, Pamela H. *The Body of the Artisan: Art and Experience in the Scientific Revolution*. Chicago and London: University of Chicago Press, 2004.

Smith, Pamela H. *The Business of Alchemy: Science and Culture in the Holy Roman Empire*. Princeton: Princeton University Press, 1994.

Smith, Pamela H. and Paula Findlen, eds. *Merchants and Marvels: Commerce, Science, and Art in Early Modern Europe*. London and New York: Routledge, 2002.

Sourches, Louis François de Bouchet, marquis de. *Mémoires du marquis de Sourches sur la Règne de Louis* XIV, 13 vols. Paris: Hachette, 1882, VI.

Spary, E. C. *Eating the Enlightenment: Food and the Sciences in Paris, 1670–1760*. Chicago and London: University of Chicago Press, 2012.

Spary, E. C. *Utopia's Garden: French Natural History from Old Regime to Revolution*. Chicago and London: University of Chicago Press, 2000.

Spary, E. C. *Eating the Enlightenment: Food and the Sciences in Paris, 1670–1760.*
 Chicago and London: University of Chicago Press, 2012.
Staatliche Kunsthalle Karlsruhe. *Jean Siméon Chardin 1699–1779: Werk, Herkunft,*
 Wirking. Karlsruhe: Staatlliche Kunsthalle, 1999.
Steintrager, James A. *Cruel Delight: Enlightenment Culture and the Inhuman.*
 Bloomington and Indianapolis: Indiana University Press, 2004.
Storer, Mary Elizabeth. *La Mode des contes des fees.* Paris: Champion, 1928.
Sund, Judy. "Middleman: Antoine Watteau and *Les Charmes de la vie.*" *Art Bulletin* 98
 (March 2009): 59–82.
Syndram, Dirk. *Renaissance and Baroque Treasury Art: The Green Vault in Dresden.*
 Trans. Daniel Kletke. Munich and Berlin: Deutscher Kunstverlag for the Staatliche
 Kunstsammlungen Dresden, 2004.
Térrasson, Jeannine. *Les Honnong et leurs manufactures Strasbourg Frankenthal.* Paris:
 La Bibliothèque des arts, 1971.
Thomas, Keith. *Man and the Natural World: Changing Attitudes in England 1500-1800.*
 New York and Oxford: Oxford University Press, 1983.
Thomson, Ann. "Materialistic Theories of Mind and Brain." *Between Leibniz, Newton,*
 and Kant: Philosophy and Science in the Eighteenth Century, 149–73. Ed. Wolfgang
 Lefèvre. Boston, London, and Dordrecht: Kluwer Academic Publishing, 2001.
Turnstall Kate, E. "Diderot, Chardin et la matière sensible." *Dix-huitième siècle* 39
 (2007): 577–93.
Tyson, Edward. *Orang-outang, sive Homo sylvestris, or the Anatomy of a Pigmie*
 Compared with That of a Monkey, an Ape, and a Man. London: T. Bennett and D.
 Brown, 1699.
Verbeek, Theo. *Descartes and the Dutch: Early Reactions to Cartesian Philosophy.*
 Carbondale and Edwardsville: University of Southern Illinois University Press, 1992.
Verlet, Pierre. *The Savonnerie: Its History. The Waddesdon Collection.* Fribourg: Office
 du Livre for the National Trust, 1982.
Vila, Anne C. *Enlightenment and Pathology: Sensibility in the Literature and Medicine of*
 Eighteenth-Century France. Baltimore and London: The Johns Hopkins University
 Press, 1998.
Vila, Anne C., ed. *A Cultural History of the Senses in the Age of Enlightenment.* New York
 and London: Bloomsbury, 2014.
Voltaire (François-Marie Arouet). *Dictionnaire philosophique* [1769]. 2 vols. Paris:
 Garnier Frères, 1935.
Voltaire (François-Marie Arouet). *Letters on the English* or *Lettres philosophiques* [*c.*
 1778]. *Fordham University Internet History Sourcebooks Project.* Ed. Paul Halsall.
 http://sourcebooks.fordham.edu/Halsall/mod/1778voltaire-lettres.asp (7-6-17)
Wellman, Kathleen. *La Mettrie: Medicine, Philosophy, and Enlightenment.* Durham, NC,
 and London: Duke University Press, 1992.
Williams, Elizabeth. *A Cultural History of Medical Vitalism in Enlightenment*
 Montpellier. Burlington, VT: Ashgate, 2003.

Williams, Hannah. *Académie royale: A History in Portraits*. Farnham, Surrey, and Burlington, VT: Ashgate, 2015.

Willis, Thomas. *Two Discourses Concerning the Soul of Brutes, Which Is That of the Vital and Sensitive of Man* [1672]. Trans. S. Pardage. London: Thomas Dring, 1683.

Wittkower, Rudolf and Margot Wittkower. *Born Under Saturn: The Character and Conduct of Artists: A Documented History from Antiquity to the French Revolution*. London: Weidenfeld and Nicolson, 1963.

Wittwer, Samuel. *Die Galerie der Meissener Tiere: Die Menagerie Augusts des Starken für das Japanishche Palais in Dresden*. Munich: Hirmer, 2004.

Wittwer, Samuel. *A Royal Menagerie: Meissen Porcelain Animals*. Trans. David McLintock. Los Angeles: J. Paul Getty Museum, 2001.

Wolloch, Nathaniel. *The Enlightenment's Animals: Changing Conceptions of the Animal in the Long Eighteenth Century*. Amsterdam: Amsterdam University Press, 2019.

Wolloch, Nathaniel. *Subjugated Animals: Animals and Anthropocentrism in Early Modern European Culture*. Amherst, NY: Prometheus Books, 2006.

Yolton, John W. *Locke and French Materialism*. Oxford: Clarendon Press, 1991.

Yonan, Michael. "The Suppression of Materiality in Anglo-American Art-Historical Writing." *The Challenge of the Object/Die Herausforderung des Objekts. Proceedings of the 33rd Congress of the International Committee of the History of Art (CIHA), Nürnberg, 15–20 July 2012*. 5 vols. I, 63–66. Eds. Georg Ulrich Großmann and Petra Krutisch. (Nürnberg: Verlag des Germanischen Nationalmuseums, 2014).

Yonan, Michael. "Toward a Fusion of Art History and Material Culture Studies." *West 86th* 18: 2 (Fall–Winter, 2011), 232–48.

Zuroski, Eugenia and Michael Yonan, eds. *Material Fictions*. Special edition of *Eighteenth-Century Fiction*, 2 vols. 31 (Fall 2018).

Index

Boldface locators indicate figures and tables; locators followed by "n." indicate endnotes